WORLDS

BEYOND

WORLDS BEYOND

MINIATURES AND

VICTORIAN FICTION

Laura Forsberg

Yale

UNIVERSITY PRESS

New Haven & London

Published with assistance from both the Ronald and Betty Miller
Turner Publication Fund and the Louis Stern
Memorial Fund.

Yale University Press books may be purchased in
quantity for educational, business, or promotional use.
For information, please e-mail sales.press@yale.edu
(U.S. office) or sales@yaleup.co.uk (U.K. office).

An earlier version of Chapter 7 appeared in *The Papers of
the Bibliographical Society of America,* and a condensed version of
Chapters 3 and 4 together in *Victorian Studies.*

Set in type by IDS Infotech Ltd., Chandigarh, India.
Printed in the United States of America.

Library of Congress Control Number: 2020944887
ISBN 978-0-300-23381-0 (hardcover: alk. paper)

A catalogue record for this book is available from the
British Library.

This paper meets the requirements of
ANSI/NISO Z39.48-1992 (Permanence of Paper).

10 9 8 7 6 5 4 3 2 1

To Carl

CONTENTS

CONTENTS

Part Three: Miniatures and Childhood

Part Four: Miniatures and the Book

ACKNOWLEDGMENTS

Though this book examines miniatures my debts in writing it are large indeed.

The book was made possible by the mentorship that I have found in the intellectual communities to which I have belonged. My first thanks go to my extraordinary advisors. Elaine Scarry offered inspiration throughout the writing process in large ways and small. Every conversation planted seeds that germinated and eventually bloomed in unexpected and delightful ways. Leah Price's insights guided the project and defined its limits. And Amanda Claybaugh taught me to be skeptical of my own writing in ways that have made me a better writer, teacher, and thinker. Maria DiBattista, Diana Fuss, and Deborah Nord showed me how to ask interesting questions and to pursue complicated answers. Philip Fisher, James Simpson, and Nicholas Watson cultivated intellectual rigor and substantive thought. And Larry Buell guided my first forays into thinking about miniatures. I am grateful to all of you.

I was fortunate, throughout the writing of this book, to have the support of friends and colleagues whose intellectual and personal generosity made

the process of writing a pleasure. In Boston, I found myself surrounded by friends who shaped this book and its writer. Diana Chien, Michelle DeGroot, Cassandra Nelson, Adrienne Raphel, and Emily Silk—I am deeply fortunate to have you in my life. Special thanks to Emily Garcia, whose infinite capacity to see the goodness in me and my writing and whose companionship over scones and at dinners buoyed me week after week. I have garnered support from friends far and near, including Lovell Holder, Chenxin Jiang, Georgie Sherrington, Charlie Stone, to name a few. And thanks to Shannon Lee Clair, whose friendship and laughter have been sources of constancy and strength during a period of enormous change.

I am truly fortunate to have colleagues at Rockhurst University whose *cura personalis* helped me to complete this book and to stay sane in the process. Jason Arthur, Christina Byers, John Kerrigan, Jameelah Lang, Dan Martin, Leslie Merced, Craig Prentiss, and many others—I am grateful that you welcomed me to the university and offered wisdom and camaraderie. Special thanks to Elizabeth Barnett, whose abundant generosity and unflagging friendship have helped me celebrate each victory and persevere through every crisis. To my students: you inspire me every day with your energy and your insights.

This book was powerfully shaped by my year as a long-term fellow at the Huntington Library. The Huntington gave me access to unparalleled collections, offered space and time to write and think, and, most importantly, brought me into conversation with a truly extraordinary group of fellow scholars. Thanks to all the other fellows, especially to my companions on Mahogany Row, including Jon Mee, Margo Todd, and Fuson Wang. The generous insights of François and Carol Rigolot and Sharon Oster helped me at a critical juncture. J. K. Barret and Tiffany Werth—your friendship, savvy advice, and generous insights guided this project toward its completion and me toward a place in academia. Steve Hindle's intellectual and personal generosity have made the Huntington a place of unparalleled community, conversation, and connection. My gratitude also goes to the staff of the Huntington Library, including Dan Lewis, Catherine Wehley-Miller, and especially Steve Tabor, whose patience and helpfulness never cease to astonish. None of this would have been possible without the ample financial support offered by the National Endowment for the Humanities and the Huntington Library.

In writing this book, I also owe much to the generous financial support of other institutions, awards, and grants, including Harvard University, the Everett Helm fellowship at the Lilly Library at Indiana University, the visiting scholar fellowship at the Bridwell Library at Southern Methodist University, the University of North Texas Special Collections, the New Scholars program at the Bibliographical Society of America, and Rockhurst University. Thank you to Dave Frasier and all the librarians at the Lilly Library, to Eric White and the staff of Bridwell Library at Southern Methodist University, to Courtney Jacobs and the staff at the University of North Texas Special Collections, to Katie Coombs and the curators at the Victoria and Albert Museum, and to the librarians at the Houghton Library (Harvard University), the Ransom Center (University of Texas at Austin), and the British Library.

A version of Chapters 3 and 4 appeared in *Victorian Studies* and part of Chapter 7 appeared in *The Papers of the Bibliographical Society of America*. In both cases, I benefited from the thoughtful and detailed guidance of editors and anonymous readers. Special thanks to Mary Bowden and Ivan Kreilkamp for their generosity in developing my arguments about fairies and microscopes and in bringing them into print. At Yale University Press, Sarah Miller's guidance and advocacy for this project have been essential.

This book would not have come into being without the help, guidance, and support of my parents, Bill and Jane Johnson. You raised me to believe that reading is necessary to life and that learning is a process that never ends. Even a decade after I began work on this project, you never tired of discussing it and rereading drafts for clarity, purpose, and missing commas. Thank you to my sister, Noreen Sedgeman, whose belief in me is unshakeable and whose guiding influence cannot be understated. And to my extended family, Jack and Genelle Forsberg, Anna Forsberg, and Joel Sedgeman, for your unbounded encouragement of this project and of me. To my niece, Elizabeth Sedgeman—you are a pure joy, and I look forward to much imaginative play together in the years ahead.

My deepest gratitude goes to Carl Forsberg, whose faith in this project and in me never wavered. You have talked through every idea, read innumerable drafts, and counseled in every crisis. Your love inspires

me every day to strive toward the good, knowing that, with you, all things are possible. And one final note of thanks to Jonathan, who joined the book-writing journey toward its conclusion and who taught me all over again of the joys of the very small. You have made my world a place of enchantment.

INTRODUCTION

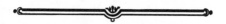

In 1856, Elizabeth Gaskell discovered a trove of handmade miniature books created by Charlotte and Branwell Brontë in their youth that, as Gaskell later recalled, "contain[ed] an immense amount of manuscript, in an inconceivably small space."[1] Initially crafted to imitate contemporary periodicals on the scale of a set of toy soldiers, the Brontës' miniature manuscripts measure just two by one and a half inches in size and are written in a tiny script that is virtually impossible to read without a magnifying glass (Fig. I.1). For the past one hundred and sixty years, these volumes have hovered at the peripheries of scholarly and popular consciousness as objects almost too strange to be believed. Far from being singular wonders, however, the Brontë miniature books belong among a wide array of miniature marvels that filled the dressers, drawers, and pockets of middle- and upper-class Victorians. Individually, these portraits, printed books, and dollhouses impress us as curiosities. Together, they reveal a Victorian fascination with the miniature, which expressed itself in art galleries and scientific laboratories, in nurseries and publishing houses, in drawing rooms and lecture halls. Victorian miniatures pressed

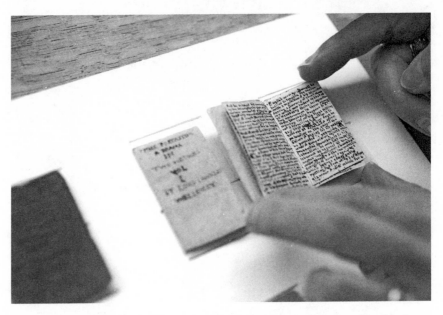

FIGURE. I.1. Miniature books by Charlotte and Branwell Brontë. Stephanie
Mitchell/Harvard University.

against the boundaries of mechanical production and human perception.
To touch a miniature was to imagine what lay beyond these boundaries.

These miniatures require that we reexamine the material preoccupations
of Victorian culture. It is, by this point, a critical truism that the Victorians
defined themselves through their relationship to material things. But while
other objects tethered the Victorians to increasingly complex networks of
imperial trade and commercial practices, miniatures remained stubbornly
personal and localized in their significance.[2] Miniatures are particularly easy
to overlook for those critics and readers who accept the idea, articulated and
challenged by J. K. Gibson-Graham, that "power inheres in greater size and
spatial extensiveness."[3] Yet their potency, and their significance to Victorian
culture as a whole, derived precisely from their scale, which gave an explor-
atory and provisional character to the ideas and actions they inspired.
Miniatures offered a multiplicity of branching narratives that blurred the
boundaries between science and imagination, between what is and what
could be. To engage with miniatures was to abandon scientific and social
certainties for proliferating and sometimes vertiginous possibilities.

The worlds of Victorian miniatures are heterogeneous. Miniatures offer diverse experiences of intimacy (portrait miniatures), power (toys), wonder (microscopes and fairies), and knowledge (miniature books). Fiction represents the generative upheaval that these miniature worlds bring: a portrait miniature of George Sedley in *Vanity Fair* allows his widow Amelia to create a space of sanctified memory that keeps others at bay; Maggie Tulliver's doll in *The Mill on the Floss* inspires the child to enact narratives of destructive agency; and images of fairyland muddle the mind and memory of the adult protagonist of Lewis Carroll's *Sylvie and Bruno*. These examples, though diverse, are nevertheless governed by two constant conditions.

First, to hold a miniature object was to experience full-sized reality transformed. Objects cannot be scaled up or down in size while retaining the same proportions. As Galileo first demonstrated, an object's area and weight increase by powers of two and three respectively when it is enlarged. For example, doubling the dimensions of a bridge increases its cross-sectional area by fourfold (2^2) and its weight by eightfold (2^3). In order to ensure its structural integrity, an actual bridge requires considerably more structural support than a small-scale model of it.[4] Artisans who create miniatures also change the proportions of the original in order to make the miniature look and function correctly; these alterations maintain the illusion of sameness when perceived by the human eye.[5] In both cases, miniatures represent reality with a difference.

Second, while miniatures perpetually engage with the realities of full-scale life, familiar things become newly strange when miniaturized.[6] Victorian encounters with miniatures destabilized the owner's understanding of the world, creating an uncertainty that drew on a burgeoning awareness of the microscopic world.

The enchantment of Victorian miniatures emerged in tandem with the era's growing acceptance of empirical science. Nineteenth-century science has often been conceived of, both in the nineteenth century and today, as a banner under which false superstitions might be eradicated and, by extension, tales of enchantment might be relegated to children's books and rural firesides. Max Weber characterized the advent of empirical science as marking the disenchantment of the world; subsequent scholars have upheld it as a disciplinary divide separating superstitious intuitions

from empirical discoveries, literary fantasy from scientific fact. Yet this "two cultures" model, which separates science from literature, does not stand up well under scrutiny: as recent scholarship has noted, scientific writing, including that of Darwin, bursts with extravagant metaphors and fantastic extrapolations, while fiction of the period often engages earnestly with scientific studies about the world.[7]

The materiality of miniatures aligned them with scientific knowledge rather than placing them in opposition to it. Miniatures resemble the prompters of make-believe described by Kendall L. Walton in that they "broaden our imaginative horizons. They induce us to imagine what otherwise we might not be imaginative enough to think of."[8] But while miniatures may seem to be promoting a game of make-believe, they do not simply facilitate or prompt imaginative play, as Walton describes, but actually materialize the possibility of alternate realities, generating a sense of undefined and open-ended uncertainty around the idea of life on an alternate scale. This materialization linked Victorian miniatures directly to microscopes, which offered scientific evidence of a material world that lay beyond the limits of ordinary vision. Microscopes, which became widely available to the middle class in the 1840s and 1850s, offered glimpses into a world of plant and animal life that remained outside of scientific understanding and existed largely out of human view. The widespread popularity of microscopes served to heighten, rather than diminish, popular belief in an enchanted natural world. The subjectivity of vision, coupled with irregularities in instruments and in their use, meant that many users saw fairies alongside flagella in their hand-collected samples of water. Microscopes and miniatures posed questions and prompted fancies that were defined by their openness to possibilities, creating material avenues to conceive of worlds beyond vision and offering flexible scripts to aid their owners in imagining what these worlds might be.

Miniatures, unlike microscopes, made no claims about the truth of the fancies they inspired. Few Victorians believed miniatures proved that another world existed in concrete, material terms, at least until 1917, when the Cottingley fairy photographs offered "proof" that convinced Arthur Conan Doyle and others of the existence of fairies.[9] Miniatures, rather, opened up what Michael Saler describes as "as if" possibilities—possibilities that assumed the shape of reality if and when individuals chose to suspend belief. Saler describes the emergence of an "ironic imagination" in fin de siècle lit-

erature, which allowed individuals to suspend their knowledge of the unreality of the London of Sherlock Holmes or the Africa of H. Rider Haggard in order to engage fully in the fiction of these worlds' existence. In so doing, Saler argues, they sought "to secure the marvels that a disenchanted modernity seemed to undermine, while remaining true to the tenets intellectuals ascribed to modernity at the time, such as rationality and secularism."[10] Saler uses the concept of "as if" to chart what he describes as a literary prehistory of virtual reality, but the same concept may productively be used to describe the aura of possibility surrounding miniature objects. To encounter a miniature object was to engage with the possibilities suggested by its proportions without suspending one's rational knowledge of its limited existence in space and of its mechanical or artisanal construction by human actors. The "as if" aura permitted individuals to fancy that miniature books were written by the fairy Puck and dedicated to Titania, that the brushstrokes of portrait miniatures were made with butterfly wings, or that fairies dwelt amidst the flowers of the garden.[11]

While children and adults alike often engaged with the possibility of miniature worlds under the auspices of play, these fantasies offered resonant critiques of the world as it was and opened up disorienting possibilities about the limits of human agency. Miniatures, in some cases, envisioned a world of greater thought and feeling. What if the sum total of all human knowledge could be miniaturized and placed in the palm of the hand? What if material objects possessed memory, consciousness, and empathy? At other times, miniatures drew attention to the limitations of human knowledge. What if humans were subject to forces, whether fairies or microbes, beyond human control? What if consciousness itself was an illusion? Miniatures destabilized certainty by pointing to a seemingly infinite range of possibilities for what lay beyond—beyond the limits of empirical understanding, beyond the boundaries of sensory perception, and beyond the tactile limits of material culture. Indeed, Victorian miniatures offered an alternative mode of understanding reality itself, less as a series of certainties than as a set of uncircumscribed fancies.

In this book, I describe the role of miniatures in British culture and fiction, focusing on the period from 1830 to 1900. In so doing, I relate how the nineteenth century cultivated a form of enchantment that was grounded in materiality but pointed toward immaterial possibilities. The sheer diversity

of Victorian miniatures and of the fantasies they inspired has caused them to be overlooked by critics. But in recovering a common language of scale shared across the diverse domains of art, science, childhood, and the book, I show a common Victorian impulse to reimagine the world in ways that liberated individuals, especially women and children, from the need for cultural, scientific, or social certitude. Fiction plays a crucial role both in representing and in developing the world-making possibilities of miniatures; for fiction, like miniatures themselves, concerns itself not with realities but with possibilities—things that *might* be real. When miniatures appear in fiction, they alternately expand the amplitude of the imaginative world and puncture the fabric of literary realism by introducing alternative fictions. Reading across genres and across disciplinary bounds, this book shows how miniatures functioned as gateways to worlds beyond.

Victorian Miniatures

Miniatures have existed since ancient times, assuming various forms across centuries, continents, and cultures. Ancient Egyptian miniatures were formed into household scenes intended to accompany the deceased beyond the grave; Dutch boxwood miniatures from the sixteenth century feature intricate tableaux of biblical scenes that functioned as objects of devotion; Persian miniatures, which flourished from the thirteenth to seventeenth centuries, developed a poetic language of illustration; sailors transformed the ivory of whales into American scrimshaw miniatures during their idle hours aboard ship.

The enduring fascination with miniatures across diverse cultural and historical contexts has led many critics to consider them an ahistorical aesthetic form. Gaston Bachelard, for example, in his illuminating study *The Poetics of Space*, theorizes that the shift in scale releases both object and observer from the laws of daily life. Miniatures, he argues, enlarge space itself as "[l]arge issues from small, not through the logical law of a dialectics of contraries, but thanks to a liberation from all obligations of dimensions, a liberation that is a special characteristic of the activity of the imagination."[12] Bachelard states that the shift in scale suggested by miniatures creates an unbounded space of poetic fancy and reverie while also liberating the possessors of miniatures from the restrictions of cul-

ture. To gaze upon a miniature, for Bachelard, is to return to an experience of wonder, common across cultures, and to regain "the enlarging gaze of a child."[13]

Other critics have followed Bachelard's lead in identifying miniatures as aesthetic objects of expansive thought and imagination. Susan Stewart, in her influential book *On Longing: Narratives of the Miniature, the Gigantic, the Souvenir, the Collection,* posits that the exquisite intricacy of miniature objects suspends the experience of lived time, transfixing the observer in what she terms "the infinite time of reverie . . . which negates change and the flux of lived reality."[14] Whereas Bachelard emphasizes the expansiveness of the reveries inspired by miniatures, Stewart focuses on their capacity to turn the observer toward inward-facing reflection. John Mack, in his transhistorical study *The Art of the Small,* similarly argues that miniatures can be understood through a series of almost self-evident propositions that reappear across cultures, including "Small is Beautiful" and "Small as Powerful."[15]

While these works make a powerful case for an aesthetics of miniatures, they obscure the ways in which miniatures both reflect and resist the historical norms of the places and people that produced them. In Britain, miniatures first rose to prominence in the sixteenth century. Renaissance miniatures possessed jewel-like qualities that reflected the nation's increasing wealth and growing interest in ornamentation.[16] Tiny, bejeweled portrait miniatures adorned the hair and dress of Queen Elizabeth and her subjects; miniature fairies flitted through the poetry of Shakespeare; miniature books, including the ornate prayer book that Anne Boleyn carried with her to the scaffold, reduced the scale of religious devotion. Miniatures declined in popularity during the seventeenth century before rising to prominence again in the second half of the eighteenth. In contrast to the delicate and ornate miniatures of the Renaissance, eighteenth-century miniatures were, as Melinda Rabb argues, "increasingly about the everyday world of common experience and consumption."[17] Architects produced miniature models of their buildings; the Royal Society ordered scale replicas of mechanical devices, diving bells, pumps, and carts; and artisans crafted miniature objects out of costly materials like silver and porcelain. Eighteenth-century miniatures were rarely intended for children; self-designated "toy" shops of the period sold small-scale objects

that were designed for adults as proof of wealth and tokens of artistry intended for drawing rooms and dressing chambers alike.[18]

At the same time, the eighteenth century saw the emergence of a culture of childhood play, which, by the nineteenth century, became crucial in defining the significance of miniatures in culture. Nineteenth-century miniatures were understood as tokens of childish wonder rather than as articles of commercial production, despite the fact that they were being produced in greater numbers and with greater sophistication through mechanical means.[19] Nineteenth-century writers often fallaciously reasoned that miniatures were scaled to the child, despite the fact that a female child reaches half her adult height at the age of approximately eighteen months (male children reach the same landmark at twenty-four months), while miniatures are typically produced not on a one-half but on a one-twelfth scale. The same faulty logic allowed Victorian writers and observers to associate miniatures, by virtue of their size and seeming otherness, with the chronological past or with "primitive" cultures in the present. The perception that miniatures possessed a transporting power became tied to a cultural nostalgia for both the innocence of childhood and the magic of "primitive" cultures.

The shifts in the cultural associations around miniatures from the eighteenth to the nineteenth centuries are illuminated by the differing interpretations of *Gulliver's Travels* over time. When Jonathan Swift first wrote of Lemuel Gulliver's travels to Lilliput, he used the size of the Lilliputians, who measure less than six inches in height (about one-twelfth the size of a typical adult), to underline the pettiness of their political squabbles. Lilliput defamiliarizes and satirizes well-known institutions and persons using scale, much like a caricaturist might. to distort appearances for the purpose of pointed critique. Gulliver's physical size allows him both to dominate the Lilliputians physically and to gain a bird's-eye view that, in the literal workings of the narrative, makes it possible for him to aid the Lilliputians in producing more accurate maps of the city.[20] At other times, the tininess of the Lilliputians is simply a gag. Gulliver, for example, famously transports miniature sheep back from Lilliput to England, installing them on the green in a way that suggests neither satirical political commentary nor comprehensive cartographic knowledge, but merely the frivolous pleasure derived from miniature things. Throughout the eighteenth century, Swift's

satire was firmly attached to the world of adults. Bawdy productions of David Garrick's play *Lilliput* (1757) centered on the allegedly amorous connection between Lemuel Gulliver and the Lilliputian Lady Flimnap, casting children as the Lilliputians in order to suggest an alternative scale. This casting raised disturbing implications of pedophilia even while dismissing the logistical complications of sex between adults of impossibly different sizes.[21]

In the early nineteenth century, Swift's Lilliput was recast as a symbol of childhood and childish play. The publisher John Harris created a miniature library for children in 1802 that he titled *The Cabinet of Lilliput, Stored with Instruction and Delight*. Harris's invocation of Swift's novel connotes the scale of childish learning and the delights of miniature (here read as childish) things. In the 1860s and 1870s, William Brighty Rands published a series of books that represented Lilliput as a space governed by children and their laws. In the titular poem of *Lilliput Levee: Poems of Childhood, Child-fancy and Child-like Moods* (1867), Rands playfully instructed the reader:

Nail up the door, slide down the stairs,
Saw off the legs of the parlour—chairs—
That was the way in Lilliput-land,
The Children having the upper hand.[22]

Lilliput had become synonymous with a topsy-turvy space of childhood play and childish fancies.

While miniatures were closely associated with childhood, children played with them in ways that often failed to conform to social expectations and norms. Consider, for example, the contrast offered by the Sedley sisters' play in Mary Mister's 1816 novel *The Adventures of a Doll*. Sophia Sedley mimics the domestic virtues of Victorian femininity, keeping the titular doll neat and orderly, with a white dress, pocket handkerchief, apron, and pincushion.[23] Marianna Sedley, by contrast, invents new identities for the doll every month, dressing her as a country bumpkin, a village schoolmistress, a picture and pincushion seller, and a "beggar, with a ragged brat at my back." Marianna does not just change the work and class status of her doll, but also the doll's race and gender, darkening the doll's skin with "burnt cork" to imagine her a "negro" and transforming her into both a

naval officer and a butcher.[24] Identity becomes malleable and adventures possible through doll play. Domestic spaces turn into places of danger and excitement as Marianna reexamines them from her doll's scalar point of view; the doll is elevated in the air atop a crutch to look at a picture (before falling into a paint pot), brought close to smell a pot of soup (before being dropped inside it), and tied to a snowman (where she suffers from cold). In each case, Marianna imagines that the doll, like herself, must have "a vast deal of curiosity."[25] Indeed, the doll offers a means by which Mariana herself may cycle through dozens of identities and journey to exotic locales inside her own home. Despite the protestations of both doll and author that the doll is unhappy with the adventures Marianna takes her on, Marianna's play occupies much more narrative space than the staid and approved play of her sister. Indeed, Marianna conceives of her doll as being more fully sentient than does the author, imagining her as actively undertaking adventures, whereas the narrator describes the doll as the passive subject to forces beyond her control. In freeing her from the boundaries of prescribed play, Marianna transforms her doll into an agent of adventure who defies prescriptions of race, class, and sex.

The enchanting material properties of miniatures spurred Victorian makers and purchasers to generate alternative narratives of their creation, imagining artifacts as emerging from the hands of fairy craftspeople rather than from their human manufacturers. To do so, printers, artists, and manufacturers expended additional labor to conceal their own roles in the process of production. Victorian cabinet miniature painters, for example, meticulously layered many coats of paint to create the illusion that their works were reduced versions of oil paintings on canvas, when in fact they were painted in watercolor on ivory. Miniature books often claimed to belong to a fairy world of artifactual creation. *The English Bijou Almanac for 1837*, for example, declares that "our little book seems planned / By elfin touch, in elfin land, / And sent by Oberon, I ween, / An offering to our English queen."[26] The Brontës similarly ascribed the authorship of their miniature volumes to the imagined denizens of Glass Town. The avowed (though rarely actual) belief in the fairy or toy origins of miniature objects gained its persuasive force precisely from the human skill in manufacture; the more beautiful and intricate a miniature object was, the more powerfully it summoned other worlds.

In obscuring the origins of miniatures, the Victorians also tied their manufactured or handmade miniatures to marvels found in nature, turning to the microscope both as a source of inspiration and as a license for extravagant imaginings. Microscopes and miniatures shared a preoccupation with scale and a partialness of vision. Both miniature objects and microscopic observations suggestively held out the possibility of an entire new world—a proximate unknown. To understand how the Victorians saw their miniatures, therefore, we must also understand how they looked through their microscopes.

Scale Effects: Microscopes and Miniatures

While microscopes and miniatures both raise questions of scale, they do so in dramatically different ways. Miniatures are definitionally reduced scale versions of larger things; their identity hinges upon this recognition. Miniature dollhouse furnishings, for example, precisely recall their full-scale counterparts, most frequently on a one-to-twelve scale. Microscopic organisms, in contrast, differ in both form and function from larger creatures and must be viewed with magnifications of 50× or higher. Their unique physical characteristics reflect biological adaptations to their scale. While microscopic organisms have the same essential needs as larger creatures (eating, drinking, moving), they perform these tasks in ways that are suited to their scale: bacteria, for example, use the rotation of flagella to propel themselves forward and absorb their food rather than consuming it with mouths. These adaptations speak to the fact that life in the natural world cannot simply be scaled up or down; each living thing is peculiarly adapted to its environment according to its size. Yet for nineteenth-century audiences, the swarming world of microscopic life recalled nothing so much as the astonishing intricacy of human-made miniatures.

The microscope had thrilled observers with the glimpses it offered into an invisible world since the invention of the compound microscope in the 1580s. In the seventeenth century, microscopists like Antonie van Leeuwenhoek and Robert Hooke offered the first and, for a century and a half, definitive textual and visual accounts of what Hooke terms in his preface "a new visible World discovered to the understanding."[27] Hooke's

text and illustrations blended realistic description and fanciful imagery to convey a sense of wonder. Thus he describes the "beauty" of a flea, observing that "the *Microscope* manifests it to be all over adorn'd with a curiously polish'd suit of *sable* Armour, neatly jointed, and beset with multitudes of sharp pinns, shap'd almost like Porcupine's Quills, or bright conical Steel-bodkins."[28] In Hooke's rendering, the microscope not only furnishes information but also transforms vision, rendering one of the insignificant creatures of the earth into a medieval knight, gleaming with beauty under the microscope's artificial light. The particular metaphors that Hooke chose—armor, pins, quills, steel bodkins—are drawn from the chronicles of romance, a choice that simultaneously underlines the enchanting effects of microscopic vision and transforms the insect into a figure of nostalgia for medieval romance. At the same time, his descriptions and illustrations are remarkable for their detail and accuracy; Hooke describes the flea as a medieval knight, not because he fails to see the creature as it is, but rather precisely *because* he sees it fully and believes that the beauty of its parts can only be communicated in imaginative language.

The vivid language employed by Hooke and other microscopists posed problems for the standardization of microscopic inquiry, particularly when describing forms of life that were invisible except through the microscope's lens. In the eighteenth century, the question of standardization took precedence, and scientists focused on generating verifiable methods of inquiry using objects and creatures that were readily visible to the naked eye.[29] The famous unreliability of the microscope as an instrument—caused by the distortions of the lens and the difficulty of instrumental manipulation—made it all the more important to the scientific community that it be rigorous in developing a language and a system for microscopic measurement.

Technical advances in the production of microscopes in the early nineteenth century opened up the so-called invisible world for public viewing. Microscopes proliferated at a wide range of price points, with the promise that anyone and everyone could be an explorer and discoverer in the world of invisible life. Microscopic periodicals, clubs, and soirées sprang up across Great Britain, promoting a culture of "diatomaniacs" eager to observe and name minute creatures that were invisible to the naked eye.[30] For those unable or unwilling to participate in microscopic study them-

selves, popular accounts of discoveries and sensational demonstrations with the solar and oxyhydrogen microscopes presented microscopic life to the public.[31] Victorian scientists and amateur users alike mingled scientific measurements with elaborate literary metaphors and descriptions. Microscopic organisms might be described in terms of their shape as resembling eggs or the wheels of a cart; they could be analogized to animals, most commonly eels, snakes, and worms; they could be seen as domestic objects, from funnels to pitchers and flasks; they could even be compared to architectural forms, including spires and cupolas.[32] In describing these organisms as miniature hybrids of familiar forms, Victorian observers both reduced the anxiety produced by their strangeness and, like Hooke, expressed their admiration for the intricacy of these miniature forms.

A reciprocal relationship emerged between microscopy and the manufactured arts; microscopic creatures were analogized to human-made forms even as human manufacturers aspired to the perfection and detail witnessed in microscopic forms of life. Observers were astonished to discover that objects of human manufacture showed imperfections when observed through the microscope's lens, while the natural world manifested layer upon layer of perfection. Under the microscope's lens a small needle, for example, appeared "full of ruggedness, holes and scratches," while "the sting of a bee ... showed every where a polish amazingly beautiful, without the least flaw, blemish or inequality."[33] The microscope revealed an ideal of beauty akin to the perfection of Lilliputian parts in the unblemished intricacy of its forms, setting new standards to which human makers could—and did—aspire.

This aspiration held potency for the Victorians as part of a quest both to attain national prestige and to match God's creative power. Engravers, including most famously William Webb, showcased samples of microscopic writing in which diamond implements engraved letters on glass using a series of levers. The size of the letters was measured by the number of times that the Bible's full text might be written inside a single square inch; one copy of the Lord's Prayer was written on a scale of fifty-nine Bibles per square inch.[34] Microphotographs, which reproduced the images of celebrities, monuments, and works of art on a microscopic scale, achieved faddish popularity in the 1850s by transforming their monumental subjects into secret treasures that could be seen only with the aid of a

microscope. Sold in catalogues alongside prepared microscopic samples taken from the natural world, these slides effectively equated natural and artificial wonders.[35] Meanwhile, slide manufacturers like Henry Dalton intricately arranged the scales of butterflies' wings on slides in patterns that also could only be seen through the microscope. All three of these efforts—the equating of natural and human-made marvels, the reduction of God's word to a microscopic scale, and the "perfecting" of nature through aesthetic arrangements—represented a human aspiration to match the achievements both of nature and of the divine. "This," one of Dalton's contemporaries remarked of one of his micromosaics, "is what I call one of the wonderful achievements of the century."[36]

Even as the microscope heightened Victorians' ambition to demonstrate preeminence in aesthetic realms, it also, more disconcertingly, altered their relationship to the surrounding world by revealing that the unknown existed in the ostensibly known spaces of daily life. In his popular 1846 book *Thoughts on Animalcules; or, A Glimpse of the Invisible World Revealed by the Microscope*, Gideon Algernon Mantell posits that the microscope opens up an "Ideal Invisible World." Through the microscope, the observer comes to see that "the air, the earth, and the waters teem with numberless myriads of creatures, which are as unknown and as unapproachable to the great mass of mankind, as are the inhabitants of another planet."[37] Linking interplanetary and microscopic observation, Mantell underlines the radical otherness and distance of microscopic observation that made it nearly impossible to assimilate such observations into the lived experience of daily life. As the twentieth-century philosopher Georg Simmel observed, "coming closer to things [through microscopic or telescopic observation] often only shows us how far away they still are from us."[38]

The scale effects of microscopic observations fundamentally changed Victorian understandings of their relationship to the environment. These scale effects, indeed, parallel changing conceptions of the human impact on the environment brought about by the beginning of the Anthropocene, a period characterized by the profound impact of humans on the earth's environment. The Anthropocene, which some scientists say developed with the beginning of the Industrial Revolution around 1800, prompts us to conceive of human influence on a global scale of time and space. One effect of this reframing is to shift emphasis from the individ-

ual to the collective impact on the natural world, often achieved through multiplication. As Timothy Clark observes, "[t]he size of my carbon footprint is of no interest or significance in itself except in relation to the incalculable effect of there being so many millions of other footprints having an impact over an uncertain timescale."[39] The Anthropocene requires imaginative extrapolation; a single person's impact on greenhouse gases must be multiplied by millions in order for its significance to be understood. For the Victorians, microscopic observation required a similar act of extrapolation. An observer who saw microscopic forms of life in a sample of water was encouraged to multiply their observations by every drop of water in the world in order to arrive at a sense of the impossible scale of microscopic life.[40] This type of extrapolative reasoning is, of course, highly inaccurate and open to sensational exaggeration: bodies of water contain drastically different proportions of biological species, and even within the same water mass different depths and regions offer different proportions of plant and animal life. But this linear form of extrapolation functions to expand many amateur microscopists' sense of space itself: a drop of apparently clear water might contain a multitude of living beings, while a speck of dust might harbor a whole colony of beings. The world became infused with a new sense of proximate, vibrant life. Gazing through the microscope, Victorian observers gained a vertiginous sense of infinite space, conceivable through ever-diminishing scales of minute beings. Such vastness could not truly be grasped even when it was glimpsed through the microscope's lens.

While theorists of the Anthropocene emphasize human impact on the environment, Victorian popular audiences were more concerned about the reverse: namely, the possibility that an infinite microscopic world held dangerous power over human life and health. Consider, for example, an 1828 etching by William Heath entitled *Monster Soup, commonly called Thames Water,* that shows a woman gazing through a magnifying lens at a drop of water filled with grotesquely shaped microorganisms (Fig. I.2). Horrified, she has dropped her cup of tea, which is full of water that, presumably, came from the same source. The illustration was created in response to an 1828 report on the quality of Thames drinking water by a commission on the London water supply. This caricature, however, does not merely represent the profusion of life but also erodes the separation

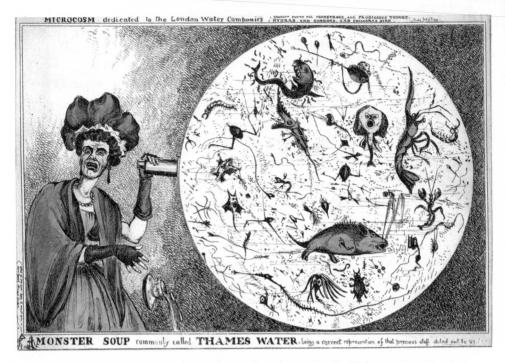

FIGURE. I.2. William Heath, *Monster Soup, commonly called Thames Water being a correct representation of that precious stuff doled out to us!!!*, 1828, hand-colored etching, 22 × 34 cm. World Digital Library. Wellcome Collection. CC BY.

between the microscopic and the human, between nature and culture, and between familiarity and difference. Although the microscopic creatures are visually sequestered in a circle representing the microscopic stage, both the woman in the cartoon and the observer of the image surmise that the creatures on display are also present in that time-honored symbol of civilized British life—the cup of tea. Indeed, the caricature taunts the observer with the possibility that microscopic forms of life are being consumed with some frequency in food, drink, and even perhaps, air. The well-dressed female tea drinker wears an expression of horror on her face, but one microorganism wears an almost identical look of shock at being intruded upon in this way. Where, the caricature implicitly asks, is the distinction between humans and microbes? Both live their lives, it would seem, independently of one another, but both inhabit the same physical space, as the microbes pass in and out of the tea drinker's body.[41]

16

The familiarity and difference of the microscopic scale—and the horrifying possibilities contained in each framing—are represented in Lewis Carroll's philosophical fairy novel, *Sylvie and Bruno* (1889), composed from fragments toward the end of his life. The novel features an elderly, unnamed narrator who passes from the human world into fairyland as he continually dozes off to sleep. At one point during his waking moments, he joins a conversation about how the revelations offered by the microscope disturb human aesthetic standards. "[B]eauty, in our sense of the word," the narrator's friend Arthur observes, "seems to diminish as we go down [in scale]."[42] Arthur notes in particular the inverse relation between the size of creatures and the number of their legs, beginning with bipedal humans and culminating in the "terribly uncouth" spectacle of animalculae, visible only through the microscope "with a terrible number of legs!" By revealing creatures with unfamiliar forms and unsettling features, the microscope upsets understandings of the natural world's harmonious beauty (recall the Victorian lady dropping her tea cup). One of Arthur's companions, the Earl, suggests an alternative model of nature that would be built, not around microscopic difference, but around miniature replications. What if, he posits, the natural world were characterized by "a *diminuendo* series of repetitions," in which every animal and plant existed discretely on multiple scales?[43] In this case, some humans would reach six feet in height but others would measure a foot and a half, six inches, or only an inch at their adult size. In order to prevent the larger creatures from tyrannizing over the smaller ones, the Earl adds, creatures on smaller scales would need to possess more intelligence than the larger ones. But this idea, too, unsettles decorum. The sole woman in the group, Lady Muriel, reacts with distaste to the possibility, stating, "I would *not* argue with any man less than six inches high! . . . one couldn't sacrifice one's *dignity* so far."[44]

All of this, of course, reflects Carroll's signature whimsy. But it also demonstrates the ways in which any invisible world unsettles a human-centric ordering of the world. Difference suggests disorder; sameness promotes petty tyranny. While the microscopic and miniature framings of scale initially seem opposite to one another (one reveals grotesque distortions, the other promises perfect repetitions), they actually work in tandem to disconcert understandings of the world. Miniatures suggest not

just an appealing aesthetic repetition but also a horrifyingly uncanny chain of endless sameness within which the human becomes relegated to insignificance. Microscopes reveal not only unfamiliar beings with monstrous forms but also creatures on different scales whose lives and bodies, even when unseen, are entangled with our own. Carroll's text, existing on the periphery of the literary canon, cuts to the core of the era's preoccupations with the limits of knowledge and the potentials contained in the worlds beyond these limits. Indeed, Carroll's position as a whimsical children's author peculiarly situates him to draw out the unfurling possibilities latent in microscopic instruments and scientific texts.

In the nineteenth century, both miniatures and microscopes were understood to contain profound possibilities. Fancies concerning them both began with observation, but were sustained less by these physical realities than by an outward extrapolation. The disconcerting weirdness of microscopic organisms, with their forms and proportions that could not be fully assimilated into existing systems of knowledge, infused Victorian understandings of miniatures with a similar otherness, a vertiginous sense of possibility. Microscopes detached miniature objects from their comprehensible relationship to their full-scale counterparts, associating them instead with the unseen and unknown. In the process, microscopes brought the methods of science to the enchantment of miniatures, intermingling them to script fantasies of worlds beyond sight and knowledge.

Reading Victorian Miniatures

How should we read miniature objects? In the wake of Bill Brown's landmark 2001 essay on "Thing Theory," literary and cultural critics have reconceived objects in literature as reverberating with meaning that exceeds their use or symbolic functions. Objects often become things, Brown posits, at moments of failure, when the object attracts our attention because it is no longer functioning in the way we think it should.[45] It is at these moments that we must reconcile ourselves to the thingness of things, to the fact that the objects have physical properties and material histories of their own.[46]

Miniatures, following Brown's definition, were almost always things in the Victorian period. The makers of miniatures often formulated claims for the objects' utility, noting that they sustained intimacy across distance

(portrait miniatures), offered practice for eventual adult responsibilities (dolls), and provided useful information in a portable form (miniature books). But miniatures rarely functioned straightforwardly in the ways their makers prescribed. Indeed, the didactic or practical claims made by producers of miniature objects served to highlight the thingness of miniatures by the very difficulty of executing their suggestions. How could a person exchange intimate glances with a rectangular full-length cabinet miniature housed in an oversized velvet case? How could the child coerce the dollhouse doll into the sitting posture that marks domestic correctness? How could a reader easily find a geographical reference in a tiny book whose pages and print made reading it difficult? Insisting upon their utility, rather, endows these objects with a socially sanctioned meaning behind which miniatures might provide more enchanting and disorienting interactions.

Literary and cultural critics, responding to the call of thing theory, have powerfully challenged earlier understanding of objects within Victorian fiction. Pressing against Roland Barthes's understanding of objects as passively contributing to the descriptive effects of realism, they have focused on uncovering how individual objects fit into complex historical and cultural networks of production, distribution, exchange, and consumption. In *The Ideas in Things*, Elaine Freedgood models what she calls deep reading by reconstructing the historical and cultural significance of objects that appear in the background of texts and by showing how these recovered meanings form a vital part of the literary text. In Freedgood's reading, the checkered curtains in *Mary Barton* become powerful symbols of the rivalry between British and Indian production of fabrics, while the mahogany in *Jane Eyre* attests, as clearly as Bertha's Caribbean heritage, to the global networks of consumption in which the Britain of the time was embroiled. This method of cultural contextualization has embedded Victorian texts in matrices of historical and cultural meaning that extend through and beyond the text.[47]

These studies have overlooked the significance of scale in the cultural imagination and in Victorian fiction, perhaps in part because the physical dimensions of objects are obscured on the page. Like the objects that Freedgood chooses for her analysis (checkered curtains, mahogany furniture), miniatures are rarely described at any length; in both fiction and nonfiction, the extraordinary dimensions of miniatures are reduced to

adjectival insignificance. While the difference between an oversized arm-chair and a dollhouse chair is impossible to miss in real life, the two may be distinguished in narrative by a single adjective to which the reader may or may not attend. If, as Stewart suggests, "verboseness is also a matter of multiplying significance," then the relative paucity of descriptions of miniatures could be taken to signify that they do not matter.[48]

Miniatures, as this book argues, did matter to Victorian fiction. But the mode of their "mattering" appears less through descriptions of the objects than in an attention to what the objects did to and for their possessors. Victorian fiction overwhelmingly records miniatures being put to use—in ways both intended and unintended by their makers. Consider, for example, portrait miniatures. In William Makepeace Thackeray's *Vanity Fair*, Amelia Sedley retreats from society in order to personally tend to the portrait miniatures of her deceased husband and living son, weeping over them and insisting to her maids that she personally tend to their cleaning and upkeep. While Amelia enacts stereotypical scenes of sentimental (and tactile) attachment to the men in her life, she also deftly keeps the courtship of Colonel Dobbin at bay, maintaining her feminine independence through careful deployment of the miniatures. Dorothea Brooke, in George Eliot's *Middlemarch*, exhibits a similar attachment to portrait miniatures, retreating to an upstairs boudoir to visit the portrait miniature of Casaubon's Aunt Julia, which she eventually takes from the wall, presses to her cheek, and weeps over. In a period of social and personal isolation, the portrait offers consolation and connection, linking her suffering to the suffering of other women in ages past.

Portrait miniatures function not just by engaging individual observers, but also by facilitating interactions. Jane Eyre, when she wishes to encourage St. John Rivers to act upon his feelings for Rosamund Oliver, paints a miniature of her and places it in St. John's hands. St. John, in turn, rejects the possibility of proposing to Rosamund by setting the object on the table and covering it with a sheet of paper. Miniatures are in each case actively deployed to create a space of feminine independence (Amelia Sedley's deft rejection of Colonel Dobbin's courtship), to join an imagined community of persons (Dorothea Brooke's imagined communion with Aunt Julia), or to propel narrative courses of action (Jane Eyre's use of the miniature to bring St. John's feelings to the fore). Fiction does

not, of course, accurately record the ways in which the Victorians used portrait miniatures. Rather, it illuminates the stories that the Victorians told themselves about the power of miniatures. These fictions represent miniatures, not just as visually transfixing objects (an "infinity of detail," as Stewart notes), but also as tangible tools for action.[49]

In all these cases, the possessors of miniatures respond to the properties of the objects themselves, finding in them scripts for action. In her description of what she terms "scriptive things," Robin Bernstein notes that her goal in analyzing material culture "is not to determine what any individual did with an artifact but rather to understand how a nonagential artifact, in its historical context, prompted or invited—scripted— actions of humans who were agential and not infrequently resistant."[50] This concept importantly develops anthropological concepts of object agency. The scale of miniatures, like the properties of Bernstein's nonagential artifacts, prompted or scripted a set of behaviors that typically did not match the uses spelled out by Victorian makers of miniature things. Literary representations of miniatures are particularly illuminating because of the world-making power of literature itself: both miniatures and fiction conjure imaginative worlds that possess a potency which rivals that of life itself. Indeed, both miniatures and fiction invite the reader or observer to imagine a world that is complete even if its depiction is only partial.[51]

This book, as the previous paragraphs suggest, adopts a historicist approach insofar as it examines the cultural history of miniatures more than the theory of these objects. At the same time, understanding nineteenth-century miniatures means asking what it meant for the Victorians to think, with and through them, about scalar differences and scalar possibilities. Victorian miniatures are, I argue, what Steven Connor terms "thinking things" that vacillate between being things (with discernable material forms and limits) and no-things (which transcend their own objecthood). A miniature, like Connor's thinking things, "must offer a picturing of the unpictureable, in a form with limit, definition and internal continuity. It must make present the impresent [*sic*] or unpresentable. But it must do so in such a way as always to suggest its own insufficiency."[52] Victorian miniatures perpetually make present the otherwise unpictureable possibilities of other worlds on another scale, but they remain objects with distinct

limits. Indeed, the imperfection of Victorian miniatures (in Connor's term, their "insufficiency") is essential to inviting and involving the imagination of the user. The disproportions of a dollhouse and the unresponsiveness of a doll both invite the child to animate them much as the imperfect capture of the sitter's features in a portrait miniature does. The unreality of fairies spurs the child to imagine an endlessly unfolding fairyland; the compressed dimensions of a miniature book prompt its owner to conceive of it as a tome of infinite knowledge. To gaze on miniatures in the Victorian period was not just to encounter the potency of the object but also to encounter the power of the thinking mind, all the while questioning whether the fancies sprang from the mind (within) or from the object's form (without). My book does not make the claim that miniatures are animated themselves, but rather that they scripted animation, exceeding their objecthood through the transporting effects of their scale.[53]

This book is organized around four distinct domains of culture—art, science, childhood, and the book. Part I identifies how the most traditional form of miniatures, portrait miniatures, came under pressure during an age of large-scale portraiture and photography. As portrait miniatures struggled to retain relevance as works of art, they became objects of nostalgia and narrative that might be manipulated to their owners' ends. Part II develops the entwinement of miniatures and microscopes, showing how microscopy licensed fairy imaginings even as fairies redefined microscopic vision. Part III moves from questions of the natural world to those of epistemology and belief, examining how play with dolls and toys generated a sense of vertiginous and disorienting possibility that challenged the durability of the child's self. Part IV examines how miniature books reflected an ambition to unite beauty and knowledge in a form whose size implied and guaranteed complete possession.

In its scope, this book departs from past scholarship on miniatures. Portrait miniatures, microscopes, fairies, toys, and (to a lesser extent) miniature books have all received their share of critical attention, but rarely in relation to one another. The sentimental possibilities of portrait miniatures, therefore, have been treated by art historians as entirely separate from the world-making possibilities of toys discussed in childhood studies, or from the scientific possibilities of microscopy examined by historians of science. These differences are accentuated by gaps in disciplinary ap-

proaches, which ensure that critical conversations employ almost entirely distinct vocabularies and frames of references. This book unites these conversations by identifying the common impulses governing the creation and function of miniatures across disciplinary divides. Miniatures equally bridge divides between apparently major and peripheral literary forms. Unusual genres like toy narratives, fairy science tracts, and thumb Bibles offer us essential insights into the workings of miniatures in Victorian culture and in major works of fiction.

Worlds Beyond: Miniatures and Victorian Fiction begins with the tradition of portrait miniatures in British art and literature and concludes with the transformation of literature itself into a miniature object. In so doing, it illuminates a century-long relationship between the British and their miniature possessions. Victorian miniatures were alternately imperiled by technological advances (as with portrait miniatures), empowered by the expansion of childish play (as with toys), transformed through the yoking of science and fancy (as with microscopes and fairies), and extended to the very limits of human dexterity and production (as with miniature books). Individually and together, miniatures pointed beyond their physical forms and gave rise to both world-making imaginings and epistemological uncertainties. Victorian miniatures emerge in this book as material traces of imagined worlds that lay just beyond human perception.

Part One
Miniatures and Art

CHAPTER ONE

VICTORIAN PORTRAIT MINIATURES

Private Attachment and Public Display

In 1848, Prince Albert decided to move the royal collection of historical portrait miniatures to the Royal Library at Windsor Castle. As Queen Victoria later recalled, Albert "kept nothing for himself—but placed *all* in the Royal Collection saying 'I can see them here just as often, & I know they are safe & cannot be lost'—whereas if they were carried about in boxes or left in drawers—they were forgotten & might be lost & injured. How true, how wise!"[1] Prince Albert's impulse, framed by Queen Victoria as a selfless act of forward-thinking preservation that worked against the inevitability of neglect at home, reflects a transformation in views of portrait miniature painting, as the art was increasingly understood as a historical rather than a contemporary form. But at the same time when Prince Albert sent away the collection of historical portrait miniatures, Queen Victoria retained "those [portrait miniatures] of Albert and the Children, which I always have with me."[2] Her collection of miniatures of her immediate family was substantial, including dozens of portrait miniatures and copies bordered with precious jewels and set in hairpins, brooches, bracelets, necklaces, earrings, and even rings. If on the one hand portrait miniatures

were being reconfigured as relics of Britain's historical past, on the other they remained living and occasionally gaudy expressions of sentimental attachment.

Portrait miniatures have traditionally been conceived of as signs of private affection; they were worn on the body, kept in the pocket, and kissed in the privacy of a bedchamber. From the mid-sixteenth to late eighteenth centuries, small and portable portrait miniatures functioned as external and private signifiers of intimate affection. The small scale of portrait miniatures meant that they could not be seen from across the room; they required close viewing, often in the palm of the admiring observer's hand. This physical intimacy was reinforced aesthetically by the delicacy of the painting itself; close, almost microscopic observation was needed to reveal the delicate strokes and stippling that brought the sitter's features to life. Portrait miniatures were typically oval in shape, making it easy to encase these images in precious stones and to wear on the body as jewelry. During the eighteenth century, portrait miniaturists began to paint in watercolor upon ivory, crafting artifacts of otherworldly beauty that emphasized the pallor and delicacy of British skin and that often used locks of hair to deepen the connection to the sitter's body. This association with physical and emotional intimacy endured throughout the nineteenth century; as one writer observed in 1894, "The portrait in oil hangs upon the wall; we stand afar and gaze upon it as a thing apart; we admire and pass on; but the miniature comes closer to the heart. Almost cheek to cheek we study the glint of the hair, the coloring of the brow, the infinitesimal curve of the lip, until it seems to smile back to us in token of the nearness of the moment."[3] Portrait miniatures seemingly hovered between objecthood and personhood; holding a portrait miniature close, the observer came "[a]lmost cheek to cheek" with its subject, as the portrait "smile[d] back."

Although portrait miniatures retained their association with intimacy, changes in the artistic and social landscape in the nineteenth century transformed portrait miniature painting and precipitated its decline. Artistic preferences at the end of the eighteenth century shifted to favoring large-scale compositions. Portrait miniatures increasingly became associated with the world of commercial art that was accessible to a growing middle class. Portrait painters decried miniature painting as a "hack" art, which played upon the sentiments of purchasers but lacked the artistic

prestige (and high prices) of larger-scale portraiture. To counteract this decline in prestige, portrait miniaturists, often under the patronage of Queen Victoria, began to produce larger, "cabinet" miniatures, which featured complicated compositions on a flattened rectangular ivory base. But cabinet miniatures as a form were awkwardly in-between; they did not invite physical intimacy like smaller, more traditional miniatures, but they also could not compete with the visual impact of full-scale portraiture. The advent of photography famously assured the portrait miniature's decline by offering a more affordable, accurate, and expedient mode of small-scale portraiture. As one writer declared in 1859, "The fact that stares you in the face is just this: that photography has annihilated miniature-painting."[4]

In fact, histories of portrait miniature painting have typically devoted limited attention to Victorian portrait miniatures, typically ascribing the "death" of the form to the introduction of photography. Critics often observe a decline in the quality of practitioners in the nineteenth century and understand the turn to a larger size and a rectangular format as a "retrograde step" in the history of the form.[5] As Graham Reynolds explains, the portrait miniature's expansion in size meant that it had "lost in intimacy accordingly, and was helpless to defend itself against the photograph which, a glazed rectangular portrait, stands in its position on the desk today."[6] More recent critics, including most notably Vanessa Remington, have disputed this claim, observing that Victorian portrait miniatures are distinguished both by their ambition and by their technical achievements. Physically, Victorian portrait miniatures pressed against the definitional limits of the miniature, extending at times to several feet in length. In the process, they aspired to a form of small-scale grandeur, conveying through their substantial proportions an ambition toward cultural centrality and artistic significance.

Portrait miniature painting endured in the nineteenth century, but the art of the period was deeply in flux. Portrait miniatures continued to function as tokens of intimate exchange, but they also became objects of public discourse and display, entangled in discussions of artistic merit, technological change, and rational organization. Victorian portrait miniatures aspired toward a microscopic completion that invited a scientific scrutiny; rather than relying upon the soft and beautifying effects of watercolor on ivory,

these miniatures resembled small-scale oil paintings in their complex compositions, jewel-like colors, and high degree of finish. Even as portrait miniaturists sought to transcend the intimate associations of the form, vying for public display in galleries and staking a claim upon the interest of a broader public, historical portrait miniatures were put on display for the first time in a series of public art exhibitions, which aspired to a scientific organization of art. Yet the sticky sentimental claims of portrait miniatures remained strong in both cases. Despite the ambitions of nineteenth-century portrait miniaturists, their works were sought after primarily as intimate representations of beloveds; and despite the rationalizing ambitions of exhibitors, families insisted that their collections be displayed together according to loaning families rather than being split up by era or artist. The peculiar cultural potency of portrait miniatures in the nineteenth century derived from their position at the junctures of past and present, of public and private, of science and sentiment, of expansive compositions and intimate gazes. Victorian portrait miniatures attested, beyond their materiality, both to the unbounded ambitions of artists and collectors and to the enduring affections of their owners.

By the mid-century, portrait miniatures were losing their place as a dominant model for thinking about scale in the Victorian period, displaced not just by the rise of photography as a mode of small-scale portraiture but also by the increasing prevalence of microscopes that fused scientific and imaginative modes of seeing and conceiving of life on alternative scales. Portrait miniatures retained cultural currency through their claim to historical importance, but eluded scientific categorization due to their strength and the endurance of their personal ties. In this sense, even as they grew in size and came into the public sphere, they continued to resist attempts to make them artistically relevant or historically legible, retaining an association with worlds of private experience that lay just beyond the observer's view.

Transformations of Scale in Victorian Portrait Miniatures

Portrait miniatures have long been considered tokens of private and sometimes secret intimacy. The nature of this intimacy, however, changed over the centuries. The first portrait miniatures emerged in the 1520s, when

Henry VIII and François I almost simultaneously sent one another portrait miniatures as a form of diplomatic exchange. Early examples, small in size and oval in shape, were painted in oil on vellum or card and bear the rich appearance of painted jewels. The fashionably pale faces of the sitters, painted without shadows, stood out against bright-blue backgrounds; faces were framed by delicate ruffs around the sitter's neck and by painted jewels that sparkled in the subject's hair and clothing. Ambiguous inscriptions wound around the sitter's head, emphasizing that these miniatures were also puzzles that could be deciphered only through prior knowledge. Early modern miniatures were often housed in jeweled cases with closures that both emphasized the value of the object and made it possible to wear them as brooches or necklaces in public while keeping the identity of the beloved concealed beneath the case's lid. At strategic moments, the subject of the portrait miniature might be disclosed in a performance of self-exposure that, as Patricia Fumerton has convincingly shown, shares much with the form of the sonnet in its riddling ability to both disclose affection and conceal identity.[7] In one example, Queen Elizabeth I invited an ambassador from Mary Queen of Scots into her state apartments in order to see her collection of portrait miniatures. Elizabeth first reminded the ambassador of her previous proposal that Mary wed the Earl of Leicester by disclosing an image of the lord, which she then refused to turn over to the ambassador. In silent answer to his query about her feelings toward Mary Queen of Scots, Elizabeth I took out an image of her cousin and kissed it in a theatrical gesture of affection.[8] If Elizabeth's first gesture functioned as a veiled reminder of her displeasure, her second diplomatically reasserted her affection for her cousin.

Portrait miniatures in Britain diminished in popularity during the seventeenth century, due in part to the civil war and political upheaval that rocked the country. In the early eighteenth century, the Venetian miniaturist Rosalba Carriera introduced the use of ivory as a medium, and a new era and style of portrait miniature painting began. While early modern miniatures were painted with concentrated and rich colors on vellum or card to mimic the appearance of jewels, eighteenth-century portrait miniaturists relied upon the translucence of the ivory to impart a delicate, luminescent glow to the sitter's skin. This technique depended upon a light touch; the miniaturist left the palest portions of the sitter's skin uncovered

to allow the ivory to shine through and used a pastel palette for the sitter's features, clothing, and background so as not to draw too strong a contrast with the sitter's skin. To further accentuate the delicate and otherworldly beauty of the image, late eighteenth-century miniaturists, led by Richard Cosway, painted their female subjects in particular as paragons of an ethereal beauty: Cosway elongated the face and neck of his sitters and arranged pale curls to echo the buoyant shape of the clouds in the gauzy blue sky background. In composition, coloration, and medium, these miniatures summon an alternative, imagined world of ethereal existence, even as the objects took on considerable monetary value due to their jeweled settings.[9] The otherworldliness of these eighteenth-century miniatures is particularly evident in the production of eye miniatures, which lovers exchanged as an intimate declaration of affection (an exchange of windows to the soul) that could not be decoded by outsiders' eyes. With gauzy clouds surrounding the single eye on the painted canvas and with diamonds representing tears in the eyes, these objects are poetic renderings of love itself as much as they are specific representations of a beloved.[10]

The intimacy of these portrait miniatures was heightened through both representational and material strategies. Portrait miniaturists often depicted their sitters wearing other portrait miniatures. Richard Cosway, for example, painted an ivory sketch of his wife Maria wearing his own portrait miniature facing outward as an intimate expression of her affection directed toward the observer (Fig. 1.1). At other times, the subject's body was incorporated alongside her portrait. Locks of a beloved's hair were often either braided or arranged into the form of plants and flowers. Sometimes, the hair was chopped into tiny fragments and dissolved into a water-based pigment, allowing portrait miniature painters to paint sentimental and symbolic watercolors of rural landscapes or of burial grounds using pigment from the beloved's hair.

By the late eighteenth century, portrait miniatures were becoming more widespread as a growing middle class increasingly possessed the income to spend on art and a burgeoning group of artists emerged to meet this need. In 1798, the Earl of Fife scornfully noted that "every body almost who can afford twenty pounds, has the portraits of himself, wife, and children, painted."[11] Portrait miniatures cost even less. While Joshua Reynolds charged 200 guineas for a large-format, full-length portrait and

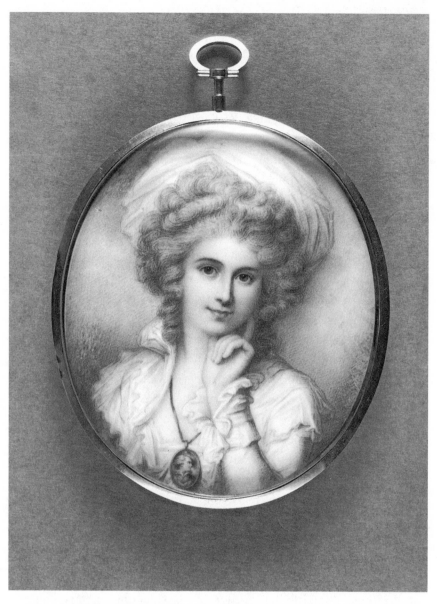

FIGURE. 1.1. Richard Cosway, Portrait of Maria Cosway, mid-eighteenth–early
nineteenth century, watercolor on ivory, 3 × 2 3/4 inches. Courtesy Huntington
Art Collections.

50 guineas for the sitter's head, George Engleheart, the official miniaturist to George III, charged only 8 to 12 guineas for a portrait miniature.[12] Differences in price depended on the size of the portrait miniature, the number of sitters, and, of course, the prestige of the artist. But portrait miniatures could be completed with a speed that made works by even the best artists relatively affordable. Richard Cosway bragged that he could complete twelve or thirteen sittings in a day, painting a complete miniature after just three half-hour sittings.[13] Engleheart painted 4,853 paintings over the course of thirty-nine years (1775–1813), including at least 228 miniatures in 1788 alone, while William Wood, only somewhat less prolifically, painted some 1,211 portraits, averaging over 60 per year during his nineteen-year career (1790–1808).[14]

The growing popularity of portrait miniatures obscured a looming crisis. Toward the end of the eighteenth century, artistic preferences shifted from small-scale, intimate portraiture to large-scale, stately compositions by artists like Sir Joshua Reynolds and Thomas Gainsborough. Portrait miniatures were increasingly scorned as a form of commercial rather than high art. In 1809, Martin Archer Shee lambasted portrait miniaturists as "blockheads" and "graphic dunces" who had already failed at other artistic endeavors. He adds, "from the prompt means of subsistence which miniature-painting affords to every manufacturer of a face, it will always be the refuge of imbecility; a receptacle for the poor and disappointed in art; where all who want the vigour that impels to higher game, or the means to support a longer pursuit, will sit down with humbled expectations, consoled by the reflection, that if their fame be more confined, their profit is less precarious."[15] Shee's critique was supported by the practices of some portrait miniaturists, who honed methods to mass-produce portrait miniatures with more attention to accessories than to the sitters' features. Frederick Buck, a portrait miniaturist in Cork during the Peninsular War (1808–1814), took to pre-painting military uniforms on ivory, so that the portrait was "practically finished" before the sitter even arrived, completing two or three dozen portraits in a single day.[16] Customers, he observed, were more likely to complain about errors in the military insignia than about a lack of resemblance to themselves: the forgiving eyes of the purchaser compensated for any such lack of resemblance.

In response to shifting artistic preferences and to critiques of the form, early nineteenth-century portrait miniaturists like Andrew Robertson took to crafting portrait miniatures that differed in size and format from those that came before, striving to attain what Robertson terms a "modern excellence in Miniature."[17] The average size of portrait miniatures grew, from one and a half inches in height in 1760, to three inches in 1800, and six inches in 1820. In 1821, the death of Richard Cosway, whose name was synonymous with portrait miniatures, furthered the widespread sense that the form needed to transform in order to survive. Artists increasingly abandoned the traditional oval shape of the portrait miniature and adopted a rectangular format that permitted more complex compositions and shifted attention from the sitter's face to her dress and figure. These larger "cabinet" miniatures could no longer be worn on the body or cradled in the palm of the hand; they were, as their name suggests, designed to be displayed in standing frames or enclosed in large mahogany cases. Portrait miniaturists also turned away from the pastel palette popularized in the eighteenth century and instead employed rich jewel tones and clearly defined edges to create an artistic effect using watercolor on ivory that mimicked the appearance of oil on canvas and that aspired to a microscopic finish. As they adopted new colorations, formats, and scales, portrait miniaturists became critical of the delicate style of miniaturists who had preceded them. Robertson, for example, deprecated Cosway's ethereal portraits in 1802 as "pretty things, but not pictures. No nature, colouring, or force."[18] On another occasion, he disparaged oval miniatures as being "at best, but *toys*," adding "I should like to aspire to paint *pictures*."[19]

This aspiration to "paint *pictures*," as Robertson put it, led to the production of works that strained the limits of what might be termed miniatures and that clearly signaled their own aspirations to stately grandeur. The proportions of these objects meant that they no longer offered intimate forms of consolation. An 1826 cabinet miniature by Simon Jacques Rochard, which measured nine and a half by six inches, depicts twelve-year-old Patrick Stirling and his sister Mary Wedderburn Stirling at full length, with Patrick holding a small cello and Mary leaning upon her brother's upholstered seat.[20] After Patrick died prematurely at the age of twenty-five as the result of a fall, his mother, Catherine Georgiana

Stirling, gave the cabinet miniature to her older son "with the request that it may remain at Kippenross [the family estate] where Patrick was so much beloved."[21] Whereas in earlier centuries a mourning mother might have carried the portrait miniature with her as a reminder of her beloved son, Catherine Stirling installed the cabinet miniature as a memorial marker—a painted gravestone of sorts—for their home.

At times, cabinet miniatures ballooned to elephantine proportions that actively prohibited easy transport. In 1845, Sir William John Newton produced two cabinet miniatures depicting the marriage of Queen Victoria to Prince Albert and the christening of the Prince of Wales, each of which measured twenty-seven by thirty-seven inches.[22] Such objects were understood as miniatures, not because of their proportions, but rather because they employed the techniques associated with portrait miniature painting, using the stippling of watercolor on ivory to achieve their effects.

These large-scale cabinet miniatures placed extraordinary demands on the artists who produced them. First, no elephant tusk was sufficiently large to provide a surface for portrait miniatures of this size. Cabinet miniaturists therefore needed to develop new techniques to create their ivory canvases. Whereas portrait miniaturists in the eighteenth century cut the ivory from tusks in horizontal rounds, nineteenth-century artists soaked the ivory tusk in phosphoric acid, shaved a sheet from around the circumference of the softened tusk, flattened the sheet using hydraulic pressure, washed and dried the sheet, and then, finally, using india rubber, affixed it to a mahogany panel.[23] In 1826, veneer-cutting machines simplified the process, cutting single sheets of ivory measuring up to 30 by 150 inches.[24] The resulting ivory surface in time often began to return to its original curved shape and, especially when placed under glass, had a tendency to crack across the center of the image. Undeterred by such challenges, Sir William Charles Ross developed a method to join multiple sheets of ivory together in order to create even larger surfaces to paint. But the seams between sheets of ivory were difficult to hide, and each panel remained prone to cracking.

Obtaining an ivory "canvas" upon which to paint was only the first challenge for cabinet miniature painters. Painters typically aimed for a high degree of finish in order to mimic the appearance of oil paintings,

but achieving this effect with watercolor on ivory was extremely difficult, especially on a comparatively larger scale. In order to prevent the watercolors from running, portrait miniaturists carefully prepared the ivory by degreasing, bleaching, and sanding it. The artist then applied the watercolors in layers, using stippling, cross-hatching, and short brushstrokes to achieve precision and waiting for each color to dry before moving on to the next layer. Even then, watercolors only gave a bright finish suggestive of oil painting if the artist gummed the pigments and applied multiple layers of each color of paint. If the painter failed to wait long enough before the application of a new layer, colors bled across the ivory. Skilled portrait miniaturists found ways to turn the extreme responsiveness of the medium to their advantage, breathing on their miniatures in order to blend the colors smoothly.[25] But incautious artists might damage their miniatures in a variety of ways: touching the image might leave fingerprints; holding the ivory in the palm of the hand might cause it to warp from the warmth; and even talking too close to the miniature might introduce moisture that might blot the image.[26]

These challenges meant that cabinet miniatures took considerably more time and effort to paint than oil paintings of the same size. Andrew Robertson calculated that a single image took at least thirty-five hours or "a week's hard labour" to produce, including fifteen hour-and-a-half sittings, ten to twelve hours of background painting, three hours for the coat, and additional time to experiment with alternative backgrounds and colors.[27] All of this labor, of course, came at a high cost. A single portrait by Ross cost Queen Victoria £319 in 1847.[28] Less prominent portrait miniature painters often left the background unfinished to reduce the cost and time required, but such images did not resemble oil paintings. The rich jewel tones of cabinet miniatures, moreover, meant that the sitter's face looked ghastly wherever the ivory was left exposed. Cabinet miniature painters, as a result, often added some color to their sitters' faces. In the process, they obscured the luminescence of the ivory, which had originally constituted the chief attraction of ivory as a medium.

Considering the difficulties of watercolor on ivory painting, why use this medium at all? Ivory as a medium contributed in two important ways to the value of the art. First, it imparted an aura of otherworldliness that was present in the ivory's luminescent properties (even when mostly

obscured) and, by association, in the knowledge that the ivory had origi-
nated as part of an elephant's tusk from British India. Portrait miniatures
on ivory therefore reminded the observer of Britain's global power, even
though this power was condensed into miniature form. India, the "Jewel
in the Crown" of the British Empire, became the base material from
which jewels of artistic perfection could be produced. Practically, this
compression of the power of empire into the form of portrait miniatures
solidified British ties across space, allowing family members to send por-
traits to one another in packages and letters.[29] Ivory portrait miniatures,
as Viccy Coltman has pointed out, could be sent overseas more safely and
less expensively than their canvas counterparts; at the same time, the ma-
teriality lent a pallor to the complexions of sitters in India who, in their
letters home, described the darkening of their complexions under the
Indian sun.[30] In this way, the exotic materiality of empire (ivory) both
bound together networks of dispersed family and friends and heightened
(perhaps artificially) the pallor of British complexions in paint.[31]

The exotic aura of ivory can be seen most clearly in orientalist portrait
miniatures. To choose one particularly suggestive example, in 1850 Prince
Albert commissioned Sir William Charles Ross to paint a cabinet minia-
ture of the Princess Victoria in Turkish dress as a gift for her mother's
birthday. The princess is painted sitting cross-legged in a recess on a rug,
wearing a caftan, loose trousers, slippers, and a turban, which may have
come from a play the royal children put on for their parents (Fig. 1.2).[32] By
depicting the princess in exotic dress and framed by oriental cushions and
drapery, Ross imaginatively relocated the queen's daughter from Britain
to a far-off corner of the empire. The portrait employs exotic trappings to
defamiliarize Princess Victoria's form and uses a forward-protruding cor-
ner of carpet to create distance between her and the viewer. Ross's por-
trait was celebrated by critics when it was shown at the Royal Academy in
1851; the critic for the *Art Journal* praised his portrait of Princess Victoria
as having "all the best qualities of a beautiful picture—the features are
most charming in colour—this is one of the painter's very best produc-
tions."[33] Queen Victoria similarly appreciated the image, hanging it in
Albert's Audience Room at Windsor and commissioning a reduced copy
for the Crown Prince of Prussia, who wore it constantly as a locket. The
ivory base of this portrait (and its copy) give tangible meaning to the prin-

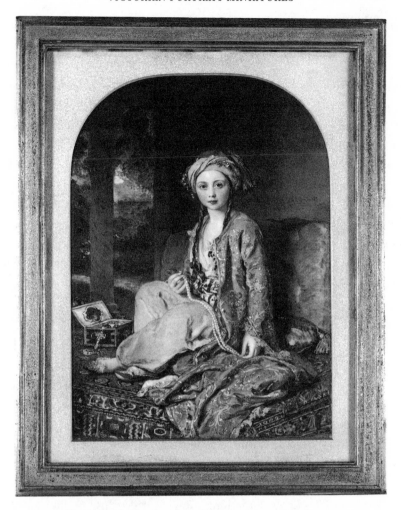

FIGURE. 1.2. Sir William Charles Ross, *Victoria, Princess Royal*, 1850, watercolor on ivory, 23.8 × 18.3 cm. Windsor, Royal Collections Trust. © Royal Collections Trust.

cess's exotic dress: while her representation as an Indian princess marks an exotic fantasy, her image on ivory recalls the global trade upon which the miniature and much of the British empire depended.

For cabinet miniature painters, the difficulty of painting on ivory in itself amounted to a second attraction of the medium insofar as it challenged the skill of the artist even as it required knowledge on the part of the viewer to recognize the difficulty of the feat. For some miniaturists,

it became a matter of pride to conceal the ivory base. Andrew Robertson, for example, proudly records a conversation he had with Richard Cosway in which the older artist asked if Robertson's miniature was painted on vellum. "No," Robertson replied, "upon ivory, a plain, common miniature."[34] Robertson, who repeated this story often in letters to family and friends, clearly considered his ability to obscure the medium of his painting as a point of distinction; he had successfully created the impression of oil painting on a medium that resisted this level of finish. During a time when portrait miniature painting was under attack as being a "hack" art, these cabinet miniatures triumphantly reasserted the great skill and intense labor of the artists. Indeed, cabinet miniatures that achieved what some critics described as a "microscopic finish" could claim to have brought a scientific exactitude to an art typically associated with sentiment.[35]

Even as they precisely delineated their sitters' features, Victorian cabinet miniatures created a separation between sitter and viewer. While eighteenth-century miniaturists painted cloudy miniatures that invited intimate encounters, Victorian miniaturists placed their sitters in stately real-world settings, often using curtains, chairs, and tables to circumscribe the observer's view of the sitter. In contrast to eighteenth-century paintings that often showed individuals wearing outward-facing miniatures, Ross's 1840 cabinet miniature of Margaret the Duchess of Somerset shows the sitter holding a large oval miniature in her hand, the image facing away from the viewer.[36] Margaret, bearing a slight, elusive smile on her face, seems to know something the viewer does not. Victorian sitters often also used tools of vision to look back at their spectators. An 1827 portrait of Rosamund Croker by Charles Hervé depicts her holding a pair of spectacles casually in her hand, as if ready to scrutinize the portrait's viewer.[37] An early 1840s cabinet miniature by Thomas Carrick similarly shows an unknown woman with a magnifying glass hanging idly in front of her.[38] Far from facilitating the intimate exchange of glances, Victorian portrait miniatures carefully demarcated the limits of the viewer's gaze and suggested worlds of interior experience hidden from view. No longer objects of unmediated intimacy, Victorian cabinet miniatures resisted the observer's penetrating gaze, eluded simple comprehension of the medium, and aggressively asserted the skill of the artist.

Portrait Miniatures in Crisis: Painting and Photography

Looking back at its history, critics see the demise of the portrait minia-
ture as inevitable and the brief rise of cabinet miniatures as a misguided
attempt to save a dying art. But as late as the 1860s, it seemed possible
that portrait miniature painting had only "been temporarily superseded
by the advance of chemical discovery."[39] Some portrait miniaturists, in-
deed, saw an opportunity to reconceive small-scale painting altogether.

In 1845, Alfred Tidey painted an unusual genre miniature, entitled
White Mice, in which a half-clothed boy with a sickly complexion is shown
sitting on the ground gazing mournfully into the distance with a box of
mice next to him (Fig. 1.3). In composing this image, Tidey reflected that
"the dawn of Photography was threatening to annihilate Miniature
Painting as an Art."[40] By painting "a street Arab with his pets,"[41] Tidey
aimed to expand the range of subjects and to reclaim the position of por-
trait miniature painting as a vital art. The painting attracted public atten-
tion, but failed to attract a purchaser. Tidey later recalled, in an 1885
letter, "I called on [Samuel Richards] early one morning and found him
with two gentlemen (strangers to me) to whom he was shewing my
Picture, 'The White Mice' ... When alone with him afterwards he
strongly advised me to continue to work in the same style, but I told him I
could not do so, at which he said, 'What is to hinder you,' but I had not
the courage to tell him, that tho' many admired the work no one had of-
fered to Buy it, in fact I had discovered that apart from Portraits, paint-
ings on ivory would not be remunerative."[42] Tidey's failure to sell the
image is, of course, not entirely surprising. His ambitious genre miniature
bizarrely mismatches a small-scale format that encourages intimacy with
a dramatic scene of poverty that creates distance between observer and
observed; the anonymous boy's mournful gaze and solitary pose do not
invite caresses or long gazes.

Tidey's frustration reflects the ever-increasing precariousness of paint-
ing in miniature by 1845. More and more portrait miniaturists struggled to
make a living, and saleable miniatures rarely gained artistic acclaim.
Looking back forty years later, Tidey understood this year as marking the
end and not a new beginning for the art. He writes: "About this time [ca.
1845] the sun of the Miniature Painter was setting in all its Glory for then

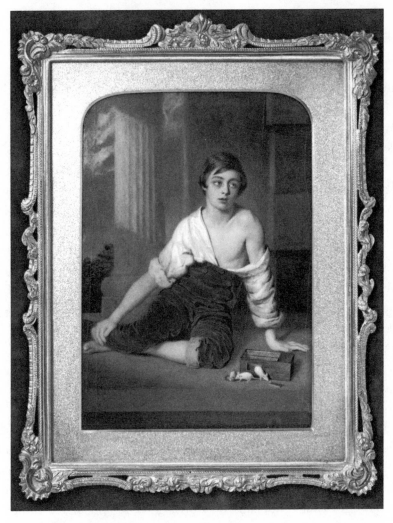

FIGURE. 1.3. Alfred Tidey, *White Mice*, ca. 1845, watercolor on ivory, 19.3 × 13.7 cm. Victoria and Albert Museum, London, Great Britain. © Victoria and Albert Museum.

the works of Ross and Thorburn, Carrick and Others, were at their best— and the thickest of the crowd of visitors to the Royal Academy was usually found in the Miniature room . . . Efforts are [now] being made to recover this 'Art of the past,' but the great perfection to which Photography has attained goes so far to satisfy the never ceasing and most cherished feelings of humanity, and which the Miniature painter alone could formerly supply

(viz) *likeness in little,* that I fear it will be but a vain struggle."[43] Part of Tidey's pessimism about the future of the art in 1885 came from a series of losses; the miniaturists William Charles Ross and Thomas Heathfield Carrick died in 1860 and 1875 respectively. Robert Thorburn abandoned portrait miniature painting for large-scale oil painting around 1861 and died in November 1885, the same month that Tidey wrote this letter. A generation of portrait miniaturists had passed away, and no new artists had taken their places.

Although some Victorian miniatures reflected ambitions for an origi-nality of composition and a reinvention of the art, such aspirations were in fact quite limited in scope. Most Victorian portrait miniatures were sen-timental objects and copies with little claim to artistic prestige. While Queen Victoria commissioned a considerable number of original cabinet miniatures, she employed many more portrait miniaturists to copy both full-scale and cabinet miniatures in small as personal mementos, gifts for family and courtiers, and diplomatic tokens to send abroad. Miniaturists, including Guglielmo Faija, Mrs. Magdalena Dalton, and William Watson, regularly made miniature copies of other works, sometimes reproducing identical versions and sometimes altering the composition to focus more attention on the sitter's face and features.[44] Victoria often used these por-trait miniatures as part of her complicated negotiation of her public role; she wore portrait miniatures in photographs, including Gunn and Stuart's official Diamond Jubilee portrait, displayed them in the Audience Room at Windsor, and wrote about them in her letters, frequently offering to make copies for her network of family and friends.[45] She also gave out copies of miniatures as tokens of her favor; each of her ladies-in-waiting received a gold bracelet with a miniature of Queen Victoria for which the queen paid twenty-five guineas apiece.[46]

Portrait miniatures functioned for Queen Victoria and her family not only as public symbols of favor but also as sentimental talismans that sig-naled the importance of family for the monarch and her family circle. On the queen's birthday every year, Feodora decked her sister Victoria's min-iature with a floral wreath that she compared to a coronet. In 1837, Princess Feodora recounted how "Your *dear* picture has been a sort of con-solation and friend to me in these trying times; I held it for hours in my hands looking at it, and the quiet expression in your beloved countenance

reassured me, as if you had done so yourself; it is a sort of shrine."[47] Victoria adorned herself with family portrait miniatures on their birthdays and on special occasions and, after 1840, wore a diamond-framed brooch bearing a miniature of Albert every day.[48] She commissioned William Essex and Annie Dixon to paint each of her children at the age of four and placed these images side-by-side in two matching bracelets, one bracelet bearing six images and the other five. A lock of each child's hair on the reverse of the image completed the intimacy of the object.[49] The sentimentality of these objects is at times heightened through shape and decoration. One 1841 brooch, designed and commissioned by Prince Albert, frames the angelic face and clasped hands of Princess Victoria (copied from a miniature by Ross) with diamond-encrusted wings and a dangling crucifix. These miniatures served as the monarch's daily companions. Victoria observed that one miniature of Prince Albert by Sir William Charles Ross "is now and always standing before me. It is quite speaking, and is my delight,—the dear, angelic, beautiful eyes look at me so dearly."[50]

However, these elaborately bejeweled portrait miniatures did little to buoy the form following the introduction of photography, which offered a faster, cheaper means of personal reproduction and had the additional attraction of scientific accuracy. In 1839, a daguerreotype cost an average of four guineas, while a portrait miniature on ivory was likely to cost ten.[51] Daguerreotypes and, a decade later, ambrotypes and tintypes, were not just more affordable than portrait miniatures, they were also widely accessible, as photographers traveled the countryside taking portraits of locals (sometimes of dubious quality). Photographs could be produced with a speed that was unmatched by any portrait painter. As *The Times* observed, the daguerreotype "furnished in the short space of five seconds . . . a more correct miniature likeness than the most accomplished artist could paint on ivory, after days of laborious study."[52]

Early Victorian critics frequently remarked that portrait miniatures and photographs differed in the agency behind each depiction; whereas portrait miniatures represented the sitter through the artistic perception (and license) of the artist, daguerreotypes relied upon the action of the sun to inscribe the sitter's image. The first announcement of Daguerre's invention describes how it "combine[s] with the *camera obscura* an *engraving power*—that is, by an apparatus, at once to receive the reflection of the scene without,

and to fix its forms and tints indelibly on metal in *chiaroscuro*."[53] Contemporary writers echoed Daguerre's rhetoric, describing photography as "seizing a shadow" or as "stamp acts of the sun."[54] Such action not only involved the agency of the sun, but also preserved a portion of the sitter's body. Elizabeth Barrett Browning observes of the daguerreotype in an 1843 letter to Mary Mitford, "It is not merely the likeness which is precious in such cases but the association, and the sense of nearness involved in the thing . . . the fact of the very shadow of the person lying there fixed for ever! . . . I would rather have such a memorial of one I dearly loved, than the noblest Artist's work ever produced."[55] Barrett Browning's remarks highlight the perceived corporeality of the photograph as a means of preserving part of the beloved's body (the shadow) much as a lock of hair or a nail clipping might. The photograph, in this framing, functions less as a representational likeness than as a synecdochical memorial, in which new technologies of light and image making preserve the shadows of the past across the gap of time and into the present.

Contemporary critics have compellingly charted how the rise of photography shaped both perception and discourses surrounding literary realism, as photographs offered a mediated fantasy of unmediated vision (as Nancy Armstrong has argued), normalized fragmentary views of the body (as Daniel A. Novak has contended), and gave rise to a nostalgic relationship to both past and present (as Jennifer Green-Lewis and Helen Groth have demonstrated).[56] Photography, as these critics have shown, was something more than a new mode of representation; it fundamentally altered the relationship between observer and image. While portrait miniaturists used their artistic techniques to render the sitter's features on a new and reduced scale, photographers reproduced the beloved's shadow through a mechanical reduction in size that did not require the photographer to grapple, as the portrait miniaturist had to do, with unique aesthetic requirements of this new scale. The understanding of photography as a mechanical form of capture undercut the aspiration of cabinet miniature painters to present images with a microscopic precision; their artistic attention to detail could not compete with the scientific lens of the camera.[57]

Portrait miniaturists attempted to make the most of their imperiled position, claiming a unique union of scientific and artistic visions to which the photograph, with all its scientific precision, could not aspire. As

one journalist observed in 1846, "the Daguerreotype does nothing more than copy nature in the most servile manner—it elaborates a pimple as carefully as the most divine expression. It has no power of selecting what is fine and discarding what is mean in its representation of an object."[58] In his choice of language, the author claims that the photographic lens intrinsically magnified the most unpleasant features of the sitter, rendering them as visible as the pores of the Brobdingnagians in Swift's *Gulliver's Travels*.[59] By implied comparison, portrait miniatures minimized their sitters' flaws through miniaturization, making the sitters as beautiful as Swift's Lilliputians. By 1865, the *Art Journal* suggested that displays of portrait miniatures were "peculiarly grateful to eyes wearied with the utter veracity—the 'justice without mercy'—of photography."[60] While the artistic rendering of the sitter was touted as a key advantage of portrait miniature painting, this advantage was also, more bluntly, characterized as a glorification of the painter's powers of flattery. Thus when Queen Victoria assured the miniaturist Alfred Chalon that photographs could never replace portrait miniatures, the artist supposedly replied, "Ah, non, Madame, photographie can't flattère."[61]

From the 1850s onward, the distinction between portrait miniatures and photographs eroded, as artists and artisans developed methods to combine the two approaches by coloring photographs and crafting miniatures modeled after photographs. William Edward Kilburn, who took the first daguerreotypes of the royal family in 1847, praised the colored photograph as possessing "all the delicacy of an elaborate miniature, with the infallible accuracy of expression only obtainable by the photographic process."[62] While painted miniatures often look awkward to twenty-first-century viewers, the form achieved widespread prominence until the beginning of the twentieth century.[63] In 1857, Elizabeth Eastlake noted that all photographic studios of note employed painters, paying them at least one pound a day to color and touch up photographic images lightly printed on card or ivory.[64]

These changes meant that fewer and fewer portrait miniatures were original works taken from life. In her catalogue of 1,083 Victorian miniatures from the Royal Collection, Vanessa Remington offers tentative assessments of the source of almost every nineteenth-century portrait miniature belonging to the monarchy. According to Remington's identifi-

cations, 6 percent of the Royal Family's miniatures were painted on a photographic base, 11 percent were copies of photographs, 22 percent were copies of other miniatures, 35 percent were partial or full copies of large or half-length portraits (usually in oil), and 5 percent were painted from sketches or engravings. Only 21 percent, or about one-fifth, are presumed to be original works.[65] While the royal family's collections certainly cannot be taken to be representative, the numbers are nonetheless suggestive of the decline of portrait miniature painting as an original art.

While portrait miniaturists throughout the first half of the nineteenth century made tenuous attempts to resuscitate the form by merging the imaginative capacity of the miniature (associated with the medium of ivory) with a desire for artistic prestige and a scientific precision of vision, the art was increasingly eclipsed by the attractions of photography. By the second half of the nineteenth century, portrait miniatures were increasingly associated not with present-day Britain but with the nation's historic past.

Portrait Miniatures at the Museum

Over the course of the nineteenth century, portrait miniatures were included both less frequently and less prominently in exhibitions of contemporary art. The decline in their prominence can be seen in the decreasing numbers included in the Royal Exhibition; while three hundred miniatures were shown in 1830, this number decreased to sixty-four in 1860 and to thirty-three in 1870.[66] Whereas miniatures filled entire exhibition rooms in the late eighteenth century, the included nineteenth-century miniatures fit on a single wall.

However, even as portrait miniatures appeared less frequently at the Royal Exhibition, museums began to organize public exhibitions of historic portrait miniatures. Because most of them were housed in family collections, many of the miniatures in these exhibitions were being shown publicly for the first time. The first major exhibition appeared as part of the larger Art Treasures Exhibition in Manchester in 1857, which showcased art from private collections in Great Britain. In 1862, the South Kensington Museum (later the Victoria and Albert Museum) gathered 900 portrait miniatures for an exhibition dedicated wholly to the art.

Three years later, the South Kensington Museum held a second exhibition, this time amassing 3,081 objects for display in just over three months. More exhibitions followed, including the Royal Academy in 1879, the Burlington Arts Club exhibition of 1889, which featured 2,000 works from collections across Great Britain, and the Fine Arts Society of London exhibition in 1897.

These exhibitions framed the portrait miniature as an art of the past. In his preface to the 1865 South Kensington exhibition catalogue, Samuel Redgrave explicitly described portrait miniature as a moribund art, observing, "strange to say, miniature painting, which had during nearly three centuries been practised by so many great artists, suddenly collapsed before the cheap mechanical processes of photography, and is now almost lost."[67] Exhibitions of portrait miniatures therefore honored a historical and national art form that had been obliterated by technological progress, recalling a past defined not by the accuracy of mechanical reproduction but by the intimacy of paint. The Burlington Arts Club actively excluded portraits produced after their heyday, asking for the loan of portrait miniatures produced "from the earliest times to the death of Cosway in 1821."[68] The use of Cosway's death, rather than, say, the introduction of the daguerreotype in 1839, to mark the end of the age of the portrait miniature created a buffer between the art on display and the visitors to the exhibition. So, whereas a visitor to the Royal Exhibition was likely to see family and friends (or those who resembled their family and friends) on the walls, a visitor to the Burlington Arts Club exhibition saw images that represented persons at a historical remove. The display of portrait miniatures in museums functioned, as Jonah Siegel has suggested is true of objects in museums more generally, as "a sign of a loss"—a commemoration of an art now deceased.[69]

But if portrait miniatures were constructed as relics of a lost art, they were also understood as the triumphant reminders of a specifically British art form. Redgrave trumpets the skills of "a succession of eminent [British] 'painters in little'" over the course of three centuries, while John Lumsden Propert describes how "for nearly two centuries England stood alone among the nations in keeping up an unbroken chain of artists, who raised the English school of miniature to a higher level than has ever been subsequently attained, either at home or abroad."[70] The *Times*, in its

review of the South Kensington 1865 portrait exhibition, was still more explicit in linking the flourishing of the portrait miniature in Britain to the nation's political structure, noting that four centuries of peace had allowed the "continuous accumulation of these treasures such as has been possible in no other country."[71] British political stability, these writers posited, had allowed families to collect portrait miniatures over generations, building a record of their family that mirrored in miniature the history of the nation.[72]

Exhibition organizers hoped to emphasize their historical understanding of portrait miniatures by organizing the art in chronological displays that would educate the public about the art's evolution over time.[73] Prince Albert himself recommended that the 1857 Art Treasures Exhibition of Manchester "illustrate the history of Art in a chronological and systematic arrangement . . . enabl[ing], in a practical way, the most uneducated eye to gather the lessons which ages of thought and scientific research have attempted to abstract."[74] Propert echoes this sentiment in his description of the planning for the Burlington Arts Club exhibition of 1889, noting that the organizers hoped to arrange the portraits chronologically both to show a rational progression and to maintain a "high standard of scientific accuracy."[75]

This proposed organizational system would have been particularly radical as a means of presenting portrait miniatures because of the traditional intimacy of the form. Portrait miniatures were usually commissioned and viewed in private settings by lovers, family, or friends; as a result, they had long been understood in terms of their subjects. To this day, many catalogs of these miniatures discuss the identity of the sitter as much as the painter or style of the image. Arranging portrait miniatures chronologically in public intrinsically invited another type of viewing, in which the observer considered the historical evolution of the art apart from its subjects. Rather than tracing the resemblances of features between sitters of different generations, visitors to a chronological portrait miniature exhibition would be able to trace commonalities between portraits painted during a particular era, deemphasizing the individuality of sitter and family (subject) to understand the commonalities of artist and epoch (maker).

But these intended scientific organizational schemas were rendered impossible in practice by the sentimental insistence of loaning families that their collections of portrait miniatures be displayed together.[76] The portraits were displayed in cases and on the wall in groups that reflected an older form of decorative display, emphasizing the invisible ties of ownership over the visible progression of artistic styles over time. The lack of "rational" organization was particularly evident because of the size of portrait miniatures, which meant that a single case might hold a dozen or more objects from different eras and in different styles. One case at the Burlington Arts Club exhibition, in stark contrast to Propert's intent, housed a sixteenth-century portrait miniature of Sir Philip Sidney, a seventeenth-century miniature of William Cowper, and a third-century glass medallion portrait of a mother and child.[77] While chronological and historical indexes were supplied to interested visitors, these guides were subordinated to the familial and social ties that were made visible through the arrangement of objects.

Outside the context of the museum, attempts to preserve and present portrait miniatures similarly negotiated the dueling imperatives of scientific organization and sentimental feeling, increasingly bringing these twin imperatives together into a form of scientific sentimentalism. This blending of approaches is particularly evident in Queen Victoria's attempts to regularize the royal collections. When Victoria ascended to the throne in 1837, she inherited a "neglected, scattered and unquantified" collection of miniatures, which she hired J. G. Bridge of Rundell, Bridge & Rundell to inventory.[78] Over the course of twenty-five years, Victoria worked with John Glover, the Royal Librarian, to organize and arrange the collections chronologically, adding individual entries to the 1851 catalogue in her own hand. Revised catalogues followed in 1870 and 1881, eventually with photographs to accompany each record. Victoria also regularized the method of display for these images, commissioning a set of Hatfield frames in the 1850s to ornament the walls of the Audience Room at Windsor Castle.[79]

Victoria's investment in her portrait miniature collections complicatedly marked an attempt to regularize the collections in impersonal ways as well as a personal quest to honor and fulfill her responsibilities to the past. Foreign visitors remarked on the queen's personal involvement with the collection; the French scholar Henri Bordier recalled in 1867, that

"Elle s'en occupe et les range quelquefois elle-même, dit-on. Ils sont accumulés dans une série de cadres qui tapissent les murs d'un boudoir et dont les quatres plus précieux décorent la chambre même où couche Sa Majesté, en formant une sorte de panorama autour de son lit. Un catalogue, corrigé en divers endroits de la main même du prince Albert, porte à deux cent cinquante environ le nombre des pièces de la collection."[80]

Bordier was likely incorrect that the miniatures ornamented Victoria's bedchamber; he probably observed them in the Audience Room. But his emphasis on the intimacy of the space in which the objects were displayed underlines the physical and emotional proximity between the queen and her collections; in organizing her collection, Victoria crafted a space that seemingly reflected the innermost chamber of her self. The careful corrections to the catalogue, which Bordier notes were made in Prince Albert's hand, reveal how the project was deeply personal for Albert as well as the queen. Following Albert's death, Victoria described visiting the collection: "After a great effort, brought myself to go the Print Room, the favourite resort of my dearest Albert. When I went in first, I was much upset & could say nothing. There were all the miniatures."[81] The historical collection of miniatures recalled Albert for Victoria, not by reproducing his image, but by preserving his organizational touch.

While portrait miniatures were increasingly understood as examples of a historical form, collectors at the end of the century held out hope for a revival of the art. In the 1880s and 1890s, portrait miniaturists again began to show their work in the Royal Exhibition halls. Societies and journals dedicated to the genre appeared, and several art critics expressed certainty that portrait miniatures would rise again in popularity in Britain. This resurgence, of course, never restored them to their former position: portrait miniatures faded into obscurity during the first decades of the twentieth century. But the hope, held by critics and collectors, carried with it all the vividness of a fairy tale, with the portrait miniature imagined as Sleeping Beauty being awakened from her sleep. As Propert wrote in 1891, "[i]t is impossible to believe that the faulty results of a mechanical process can continue to satisfy the art aspirations of the future. . . . [I]t can but be a question of time when the fascinating art of miniature shall again flourish, awaking from its slumber, refreshed and renewed, striving always onward to greater and greater perfection."[82]

Propert's image of reawakening implicitly evokes a possibility of reenchantment. The portrait miniature, like Sleeping Beauty, lingered in the public imagination for the duration of the century, waiting for a kiss from her prince. Almost a half-century after it had been declared a moribund art, the fantasy of portrait miniature achieving "greater and greater perfection" endured.

CHAPTER TWO

PORTRAIT MINIATURES IN THE NOVEL
FROM JANE AUSTEN TO GEORGE ELIOT

The cultural history of portrait miniatures in the nineteenth century charts the decline and transformation of the form across the first half of the century, followed by its recategorization as a historical rather than a contemporary form. These changes fundamentally altered the position of portrait miniatures in the popular consciousness, but they did not remove them from the public eye. Indeed, the decline of the portrait miniature as a form of high art and its reemergence as a historical and national art in the halls of museums functioned to suspend these objects in time. Treated as a historical form of art even as the last great practitioners were producing new works, the portrait miniature was trapped between past and present. Dismissed as a form for hack artists even as the objects remained tokens of devoted attachment, portrait miniatures became suspended between the artifice of commerce and genuineness of feeling. Finally, ballooning in size and becoming artifacts for the public sphere even as these works of art predicated their claims to attention on their small size and private significance, the portrait miniature was suspended between public and private, between the performative and the real.

These tensions ensured that the portrait miniature appeared with great frequency in short fiction and in the novel through the 1850s and 1860s and into the 1870s, offering evidence of intimate ties that intrinsically raised questions and speculations about the relationship between owner and subject. By virtue of their scale and the intimacy of their representations, portrait miniatures seemed ever on the verge of spilling their own secrets—of divulging the distant love affair, the lost sibling, or the beloved future spouse. In this sense, they served as starting points for narratives that unfurled across time, suggesting past secret histories and projecting imagined futures. These connotations were often left partly unexplained by the fictional narrative: portrait miniatures maintained an elusive ambiguity about the object's particular significance to its possessor. In fiction, miniatures suffused the fabric of the narrative with a sense of imminent possibility and with an awareness of the partialness of any fictional account.

Portrait miniatures in Victorian fiction rarely function as static artifacts. They are, rather, objects perpetually in motion, concealed or displayed, deployed at key moments and used to prove particular truths. At times, they were kept away from view—hidden inside a drawer, in a pocket, or under a dress—as the physical manifestations of a secret love or a secret self. At other times, portrait miniatures were deployed publicly or semi-publicly to make a statement or to convey a message to another person, being worn openly around the wrist or the neck, shown in a display case on the desk, or displayed on the wall. In either case, the relationship between the portrait miniature's owner and its subject was always under observation by the surrounding community. Yet though portrait miniatures are constantly represented in Victorian fiction, they are rarely described at any length. During a literary epoch known for its descriptive powers, the objects themselves become tools of description rather than subjects of it.

While the impact of photography upon the novel has received extensive critical attention, the significance of portrait miniatures has not.[1] Far from reflecting their insignificance, I argue, the scant critical attention given them merely suggests that we, as modern readers and critics, underestimate the portrait miniature's cultural power and oversimplify its significance. Portrait miniatures can, after all, be understood as straightforward points of connection between absent and present persons. But they may equally be understood as part of a cultural discourse that was

contesting the sincerity or artificiality of portrait miniatures and that was fascinated by their enduring capacity to point beyond both the circumstances of the present and the narrative scope of the novel.

Fiction, of course, cannot be considered an accurate record of portrait miniature use. But it does draw out the potentiality that Victorian authors understood these objects to contain. Most readers of Victorian fiction will remember just a handful of portrait miniatures in literature of the period (likely Dorothea's encounter with the portrait miniature of Aunt Julia in *Middlemarch* and Amelia's cherished miniatures of the elder and younger George Sedley in *Vanity Fair*). This chapter explores the role of portrait miniatures in fortyseven novels by major authors. Many other novels and short stories of the period could just as well have been chosen for their representations of what I call portrait miniatures in motion. Portrait miniatures reverberate through the fiction with a sense of possibility that could be deployed, intentionally or unintentionally, to alter a character's position in or toward the world.

As portrait miniatures increasingly became associated with the historic past, the act of creating or treasuring them became understood as a nostalgic or sentimental attachment to the ways or events of the past. Portrait miniatures, which had long been associated with the inner thoughts and personal histories of their owners, became equally entwined with notions of narrative, of personal histories unfolding across time. While Elizabethan portrait miniatures, as Patricia Fumerton has argued, were associated with the sonnet in their jewel-like form and hidden, elliptical meanings, Victorian miniatures can be associated with the novel as objects containing personal narratives that may be unfurled before the observer or reader. Indeed, portrait miniatures often become vessels that contain characters' feelings and visions of both past and future, underlining the existence of worlds of imagined life that may be as or more vibrant than real life. Such portraits, indeed, highlight interior experience, suggesting through their miniature form the significance of experiences that lie beyond the realm of sight.

Jane Austen, Mary Shelley, and the Scale of Feminine Art

At the beginning of the nineteenth century, the portrait miniature was already a feminized and often underrated art. In a letter to her nephew written on December 16, 1816, Jane Austen compares her nephew's

"strong, manly, spirited Sketches, full of variety & Glow" to her own writing, "the little bit (two Inches wide) of Ivory on which I work with so fine a Brush, as produces little effect after much labor."[2] Austen's metaphor, of course, self-deprecatingly suggests the feminine modesty and the small scale of her novels, contrasting this with the masculine self-assertion of her nephew's now long-forgotten prose. This was not the only occasion on which Austen emphasized the limited sphere of her artistic focus; in an 1814 letter, she describes how "3 or 4 Families in a Country Village is the very thing to work on" in composing a novel.[3] Austen's deployment of this familiar metaphor also suggests the intensity and concentration of her work. In narrowing the focus, Austen draws her reader's attention to the significance of the minutiae of social intercourse.

Austen's deployment of portrait miniature painting on ivory as a metaphor for her writing draws upon an understanding of that pursuit as an appropriate occupation for amateur female artists. Watercolor painting on ivory, though popularized by male artists like Richard Cosway and Andrew Plimpton, called for a delicate, pastel palette that reflected a feminine aesthetic ideal. The size of portrait miniatures meant that they were easy to paint in domestic spaces, while the disproportionate amount of labor required for a work of this size (what Austen calls "little effect after much labor") meant that they were relatively economical, despite the expense of ivory.[4] A proliferating number of guides assured an amateur female aspirant that she might easily learn to paint portrait miniatures; such guides offered advice on all the stages of production, from the preparation of the ivory and the selection of a brush, to the placement of the figure, the selection of an appropriate color scheme, and the correct shades for each part of the body.[5] Such guides proceeded on the premise that the artist's work was certain be received favorably by its intended audience regardless of its quality, as the labor of its creation in itself signified feminine devotion and love.

Yet within the dry genre of the guide to portrait miniature painting emerges an implicit narrative in which its practice is entwined with feminine eligibility for matrimony.[6] Consider L. Mansion's popular and fictionalized epistolary guide, *Letters upon the Art of Miniature Painting* (1823). In this work, Mr. Deville, a portrait miniaturist, exchanges a series of letters and portraits with Ellen Howard, the daughter of his friend, on the art of por-

trait miniature painting. Each letter imparts practical information about the practice, and the volume includes a foldout color palette for the reader to use in her own endeavors. At the same time, the fictional lives of the letter writers hover at the edge of the text. As Ellen Howard completes her training, she decides to paint a miniature of her deceased mother for her father to keep with him always. This act of filial piety proves both the daughter's character and her talents; as Mr. Deville notes, "Not content to recall the memory of her mother by an imitation of her virtues, she also delights to multiply her image by a display of her talents."[7] Almost immediately following the production of this portrait, a new character, the eligible bachelor M. de Saint Rémi, appears and proposes marriage to the newly trained artist. In the last few pages of the book, the new Mme. de Saint Rémi paints a self-portrait miniature, using it as a symbol of her giving herself to her husband and as proof of the skill of her instructor. She presents her husband with the image, inscribed with the words "Pledge of my love for you, and of Mr. Deville's friendship for me."[8] Through the process of instruction by a male tutor and having proved her feminine capacity for both filial and romantic feeling, Mme. de Saint Rémi has rendered herself a suitable and attractive candidate for marriage.

The same association between portrait miniatures and matrimony surfaces throughout Austen's novels, where miniatures signify romantic intimacy in tangible, though not always enduring, forms. In *Sense and Sensibility* (1811), Margaret Dashwood looks for a portrait of Willoughby around her older sister Marianne's neck as confirmation of their engagement; later in the novel, Lucy Steele astonishes Elinor by producing a portrait miniature of Edward Ferrars from her pocket.[9] Portrait miniatures in both cases signify secret intimacy. Marianne's nonpossession of a miniature of Willoughby suggests the absence of any spoken promise to her, much as Lucy's ownership of a miniature of Edward Ferrars underlines his commitment, however much regretted. The titular heroine of *Emma* (1815) briefly considers depicting her faithful friend Harriet in miniature, before determining on a full-length watercolor format that elevates Harriet's imagined social station to a prominent position above an imagined mantelpiece.[10] Harriet, as perhaps even Emma recognizes, does not immediately invite intimate attachments. In *Persuasion* (1817), the portrait miniature highlights the limitations of romantic commitments; Captain

Benwick has a miniature of himself made for Fanny Harville, but after her death he goes to London to have the object reframed for Louisa Musgrove.[11] His affections, like the object itself, are transferrable. It is her observation of Captain Benwick's behavior that leads Anne Eliot famously to compare male and female constancy of affection. Herself lacking a portrait of her beloved Captain Wentworth, Anne needs no object to prove or to pledge her unwavering affection to him.

Austen complicates popular associations of portrait miniatures with romance by depicting them as objects that signify intimate affection but that cannot sustain it. Indeed, portrait miniatures, in their portability and potential for secrecy, often suggest a fleeting or fickle attachment, while full-sized portraits signify relationships that take shape with a greater awareness of the context of romantic affection. When Elizabeth Bennet visits Pemberley in *Pride and Prejudice* (1813), she finds miniatures of George Wickham alongside those of Mr. and Miss Darcy arranged as they were in the late Mr. Darcy's life. Mrs. Gardner, not realizing the shift in Elizabeth's affections, points to Wickham's miniature as an object of particular interest to her niece. Elizabeth finally realizes that she loves Mr. Darcy after leaving the miniatures, as she stands before his full-scale portrait in the portrait gallery and hears his praises sung by his loyal housemaid, Mrs. Reynolds.[12] In drawing this contrast, Austen suggests that true romantic affection derives, not from the private and furtive exchange of portrait miniatures, but rather from the public evaluation of a potential spouse.

Austen's subtle and complex deployment of portrait miniatures to reveal and critique romantic attachments responds to the conventional use of portrait miniatures throughout romantic and gothic fiction to signify romantic secrets and sensational revelations. Late eighteenth-century miniatures, as critics including Kamilla Elliott and Joe Bray have noted, possessed the power to evoke emotion, reveal lost family ties, and bring to the fore forgotten secrets.[13] Well into the nineteenth century, portrait miniatures remained a popular tool to reveal forbidden liaisons, discover lost relations, or uncover the secrets of the past.[14] The narratives attached to portrait miniatures meant that the objects could also be easily manipulated or abused. When the creature in Mary Shelley's *Frankenstein* (1818) kills Victor Frankenstein's brother William and finds a portrait miniature that Elizabeth had loaned to the child, he seems intuitively to grasp the object's

potential to create false narratives.[15] Planting the object in the innocent servant Justine's pocket, the creature crafts two narratives in the minds of his anticipated audience: for the public the object confirms Justine's responsibility for the murder; while for Dr. Frankenstein it proves the creature's malice and guilt. The fact that the portrait miniature is a token of intimate affection only worsens the crime; either affection has been abandoned for greed (if Justine stole the object) or the affectionate ties of kinship are violated (if the creature planted it on Justine and implicated her in the crime). Portrait miniatures, in other words, are manipulable in powerful and disturbing ways; the cultural belief in their legibility as tokens of affection and objects of value is belied by the actual flexibility of their possible uses.

Miniature Manipulation: Charles Dickens, William Makepeace Thackeray, and Portrait Miniatures in Motion

By the 1830s, portrait miniatures were an easy target for fictional satire. Throughout Charles Dickens's early novels, they appear as symbols of vanity and vice, more often representing self-admiration than genuine affection for the beloved. John Dounce in *Sketches by Boz* (1836) falls in love and immediately "bribe[s] a cheap miniature-painter to perpetrate a faint resemblance to [his] youthful face" as one of a series of self-indulgent follies.[16] Miss Ledrook, from Crummles's theatrical troupe in *Nicholas Nickleby* (1838–1839), arrives at a wedding wearing "in her breast the miniature of some field-officer unknown, which she had purchased, a great bargain, not very long before."[17] The portrait miniature, in this case, becomes part of a new theatrical performance, in which Miss Ledrook can lay claim to a mysterious romantic liaison while actually knowing nothing of the gentleman represented. The performance of intimacy through the possession of a portrait miniature is repeated in *The Old Curiosity Shop* (1840–1841), where a wax brigand in Mrs. Jarley's company is paraded around town admiring the miniature of a lady.[18] His positioning performs publicly the private reverie associated with love; with the portrait miniature clasped before him, he is perpetually caught in the action of admiring his beloved. In the accompanying illustration, the brigand looms large over the petite Nell, and the substantial portrait miniature he holds looks like a mirror that he might be holding up in order to better examine himself (Fig. 2.1).[19]

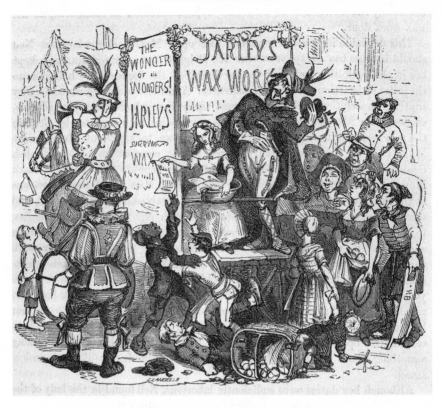

FIGURE. 2.1. The gentleman standing next to Little Nell holds an
open-cabinet miniature in his hand. Hablot Knight Browne, illustrator,
Producing a Sensation, in *Master Humphrey's Clock*, by Charles Dickens. London:
Chapman and Hall, 1861. Hathi Trust.

In *Nicholas Nickleby*, Dickens offers a more sustained critique of the
economy of portrait miniature painting through his representation of the
professional hack painter Miss La Creevy. Despite her quasi-professional
status, her economic stability is in constant jeopardy and her sales laugh-
ably low. In order to eke out enough income to pay the rent, Miss La
Creevy panders hopelessly to her audience. Her work consists of "[get-
ting] up early to put a fancy nose into a miniature of an ugly little boy,
destined for his grandmother in the country, who was expected to be-
queath him property if he was like the family."[20] Whether or not the boy
possesses such a nose is beside the point; Miss La Creevy understands

that the purpose of the portrait is not to represent the little boy's true features but rather to gratify his grandmother's desire that he look like herself and, in so doing, to secure the boy's fortune. Far from fostering an intimate connection between two persons, this portrait miniature permits an indulgent contemplation of the self, perpetuated (ostensibly) into the next generation. Indeed, Dickens repeatedly suggests that portrait miniatures must flatter if they are to succeed. As the elderly Mrs. Bedwin in *Oliver Twist* (1837–1839) remarks: "painters always make ladies out prettier than they are, or they wouldn't get any custom, child. The man that invented the machine for taking likenesses might have known *that* would never succeed; it's a deal too honest."[21] The distress of the portrait miniaturist's situation is emphasized in Dickens's novels by the fact that the sole portrait miniaturist is a female hack professional; this art form is the last resort of the desperate.[22]

Miss La Creevy's portraits are bad, not only because of her commercial motivations, but also because of her lack of talent. After her marriage to Tim Linkinwater, the former Miss La Creevy continues painting, now creating a set of portrait miniatures of herself and her husband to hang above the mantelpiece. Dickens observes: "Tim's head being powdered like a twelfth cake, and his spectacles copied with great nicety, strangers detected a close resemblance to him at the first glance, and this leading them to suspect that the other must be his wife, and emboldening them to say so without scruple, Mrs. Linkinwater grew very proud of these achievements in time, and considered them among the most successful likenesses she had ever painted."[23] If the purpose of the portrait miniature is to capture the effervescent essence of the sitter, these portraits fail completely. Observers identify Mr. and Mrs. Linkinwater by recognizing not their features but their accessories. Miss La Creevy's inability to represent her subjects accurately became a cultural touchstone of the period: a "'Miss La Creevy' miniature" was "a pale, washy thing on ivory, that generally bore about as much resemblance to your neighbour as yourself, if he happened to have the same coloured hair, the eyes, nose, and mouth being almost always done to one pattern."[24] By the late 1830s, even before photography replaced portrait miniature painting, Dickens was already representing portrait miniatures popularly understood as poor representations of their subjects.

But despite the scornful tone that Dickens's narrator often adopts toward portrait miniatures as artistic failures and self-indulgent follies, the objects function with surprising effectiveness as object-companions for the lonely. Consider, for example, the proprietor of M. Todgers's Commercial Boarding-House in Dickens's *Martin Chuzzlewit* (1843–1844). Mrs. Todgers keeps a portrait miniature of herself above the kettle holder, which she gazes upon with great satisfaction as a "speaking likeness" of herself as a young woman.[25] Her portrait miniature serves, most obviously, as a vanity piece that allows her to see herself frozen in time, maintaining a fantasy that her youthful and present selves are identical. Indeed, Mrs. Todgers invites her friends to affirm the indistinguishability of Mrs. Todgers in painted and physical forms. She claims that they observe, "If they could have met with it in the street, or seen it in a shop window, they would have cried 'Good gracious! Mrs. Todgers!'"[26] The portrait miniature, in this framing, might itself start into motion at any minute, walking the street like, or perhaps in company with, Mrs. Todgers herself. This does not, of course, match the early nineteenth-century presumption that portrait miniatures should sustain a connection with a beloved: Mrs. Todgers treasures, not an image of another person, but an image of herself. But while this object at first seems like a petty one used falsely to flatter Mrs. Todgers's vanity, its presence conceals the *absence* of Mrs. Todgers's husband, for whom the portrait was presumably painted. In his absence, she has only herself. Portrait miniatures, the novel suggests, function flexibly; an object intended as a reminder of a living spouse morphs seamlessly into the companion of an older women that connects the long years of her solitary life to the once-vivid hopes of her youth. The portrait miniature gives speaking life to the past as a consolation for the present.

The portrait miniature may not be an ideal companion, but it remains, in much of Dickens's fiction, a last symbol of connection for those who have lost hope. Miss Tox in *Dombey and Son* (1846–1848) possesses a "fishey old eye" enclosed in a locket and a portrait miniature of her ancestor as the only companion in her solitude, while the brokers in *Sketches by Boz* spare a portrait miniature of a deceased husband while seizing every other possession of a family in arrears.[27] And in "The Poor Relation's Story" (1852) the main character plans to leave nothing behind him upon his death save a miniature, which he hopes will be given some-

day to his son.[28] To possess a miniature, then, is to possess one final trace of the past.

Throughout early Victorian fiction, portrait miniatures are represented as objects in perpetual motion, functioning with surprising nimbleness as tools to navigate the public sphere. Consider, for example, the novels of William Makepeace Thackeray, where public assumptions about the significance of portrait miniatures are used to advance the interests of the portrait's possessor. While this function is implied in several of Dickens's novels—Miss Ledrook and Mrs. Jarley's wax brigand both pose as figures of romantic longing by wearing or holding such portraits—it becomes explicit in *The Book of Snobs* (1848), where Wiggle determines to possess himself of a portrait miniature as a prop to generate social caché. Wiggle, Thackeray notes, "made a considerable sensation by having on his table a morocco miniature-case locked by a gold key, which he always wore round his neck, and on which was stamped a serpent—emblem of eternity—with the letter M in the circle. Sometimes he laid this upon his little morocco writing-table, as if it were on an altar—generally he had flowers upon it—in the middle of a conversation he would start up and kiss it. He would call out from his bedroom to his valet, 'Hicks, bring me my casket!'"[29]

Wiggle's performance depends on generating curiosity among those who observe his behavior; he is aided by his friend Waggle who makes elusive references to a slew of possible subjects for the portrait, including an Italian princess, a countess, and the daughter of a Dissenting clergyman. "Who *does* know that fellow's intrigues!" Waggle rhetorically queries.[30] There is, of course, no indication of a real subject behind the performance of affection; the case, the key, the emblem, and the mysterious letter M all function to pique curiosity, even as Thackeray suggests that they are part of an elaborately staged act. Waggle's deployment of a symbol of intimacy and honest attachment for his own ends may appear dishonest, but his use of the artifact also taps in to a long tradition whereby the disclosure of concealment of a portrait miniature at strategic moments could be used for social advancement. Indeed, Waggle's strategic semi-reveal of the portrait might be considered as a nineteenth-century mimicry of Queen Elizabeth's strategic reveal of a portrait of Mary Queen of Scots, described in the previous chapter.

Portrait miniatures, indeed, became important tools of social naviga-
tion even when they failed to signify profound attachments. In *The Paris
Sketchbook of Mr. M. A. Titmarsh* (1840), they give the middle classes access
to what they perceived as more elevated realms of art. "The family,"
Thackeray notes, "goes to the Exhibition once a year ... there are
their own portraits, or the portraits of their friends, or the portraits of
public characters; and you will see them ... bustling and squeezing
among the miniatures, where lies the chief attraction of the Gallery."[31] In
Thackeray's text, portrait miniatures offer a means for the middle classes
to place themselves alongside celebrated figures, the differences in status
elided by the sameness of the representational scale and by necessarily
close groupings of portrait miniatures on the walls of the gallery. The as-
piring painter Clive Newcome in *The Newcomes* (1855) similarly gains rec-
ognition through a turn to miniature art. While his "great picture" is
refused by the National Exhibition, his "agreeable and spirited" portrait
miniatures are accepted as Nos. 1246 and 1272 at the exhibition.[32]
Newcome's decision to switch from one form to another almost precisely
follows the accusations of portrait miniature skeptics; he recognizes that
"to draw portraits of his friends, was a much easier task than that which
he had set himself formerly," and that he may be able to leverage his lim-
ited artistic abilities in painting portrait miniatures better than in any
other field.[33] Thackeray's satirical representation of Newcome and his
friends, who overeagerly celebrate his portraits by comparing them to the
works of Michelangelo, like his satirical description of the "bustling" and
"squeezing" middle classes at the gallery, belies the fact that the portrait
miniature authentically gave public recognition to a class striving to earn
it. That this public recognition took miniature form and necessitated its
shift into the public sphere made the portrait miniature an easy target of
satire, but this recognition had still been won. In portrait miniature gal-
leries, the middle classes saw themselves on display and conceived of
themselves as the proper subjects of art.[34]

The portrait miniature's capacity to be useful to its possessor is per-
haps nowhere more evident than in Thackeray's *Vanity Fair* (1848). Amelia
Sedley takes a near-obsessive interest in protecting and caring for her de-
ceased husband's portrait miniature, showing the object a physical devo-
tion that approximates the care she would have given to George Sedley

had he been alive. Thus she would "no more allow Mrs. Clapp or the domestic to dress or tend [her son] than she would have let them wash her husband's miniature."[35] In intimately washing the miniature every day, Amelia performs feminine devotion; although this ritual takes place in private space, she allows it to be known by servants and family alike. Her private devotions are equally laid bare before the reader. When Amelia retires to her chamber after Colonel Dobbin reveals George Sedley's past infidelities, Thackeray's omniscient narrator enters the private space with her, noting that the deceased George's "eyes seemed to look down on her with a reproach that deepened as she looked."[36] Here, the portrait miniature exacts perfect wifely devotion from beyond the grave; as an object, it seems to compel unrelenting obedience to a figure of the past.

Or does it? For while Amelia certainly responds to the portrait miniature as an object binding her to the past, her ties to George equally secure her independence in the present. Amelia's repeated retreats from public to private space function simultaneously to reinforce her appearance of wifely virtue and to protect her from social scrutiny. Thus when her mother presses her about Major Dobbin's affection for her, Amelia "turns red and begins to cry, and goes and sits upstairs with her miniature."[37] Physically retreating into the private sphere of her bedroom and a devoted reverie before the portrait miniature, Amelia evades questions about the present. Victorian social understandings of portrait miniatures require that Amelia's devotions before a representation of her deceased husband be understood as essentially equivalent to a wife's devotion to her living husband. But, unlike the living George Sedley, the portrait miniature of George will never be unfaithful to her, will never ask anything of her, and will never change. As such, it provides a perfect "pretext" for a woman who has "determined to be free" of all the complexities of a real relationship.[38] Although there is no official recognition of Amelia's deft manipulation of the portrait miniatures, Becky perceives, at least, that Amelia's portrait miniatures endow her with social stature and, "not to be behind in sentiment, had got a miniature too hanging up in her room," of Jos.[39] But while Becky employs the portrait miniature merely as a basic tool of social advancement, Amelia exploits the object's full potential as an instrument that a woman could deploy to obtain freedom from social and romantic control.

Charlotte Brontë, George Eliot, and the Unfolding Narratives of Portrait Miniatures

By mid-century, photography was rapidly replacing miniature painting as the preferred mode of capturing the beloved. While photography, as already described, captured the sitter's shadow and therefore functioned synecdochically like a lock of hair to make the beloved's body present, the portrait miniature sustained an ongoing relationship between sitter and owner even when one party was gone. In Elizabeth Gaskell's 1859 story, "My Lady Ludlow," an observant servant distinguishes between the effects of a lock of hair and a portrait miniature. She observes:

> in [Lady Ludlow's] bureau, were many other things, the value of which I could understand—locks of hair carefully ticketed, which my lady looked at very sadly; and lockets and bracelets with miniatures in them,—very small pictures to what they make now-a-days, and called miniatures: some of them had even to be looked at through a microscope before you could see the individual expression of the faces, or how beautifully they were painted. I don't think that looking at these made my lady seem so melancholy, as the seeing and touching of the hair did. But, to be sure, the hair was, as it were, a part of some beloved body which she might never touch and caress again, but which lay beneath the turf, all faded and disfigured, except perhaps the very hair, from which the lock she held had been dissevered; whereas the pictures were but pictures after all—likenesses, but not the very things themselves. This is only my own conjecture, mind. [40]

Lady Ludlow keeps locks of hair and portrait miniatures together in the same drawer; both connect her to her past. The lock of hair, in her servant's speculative explanation, reminds the observer of the body from which the lock was taken, calling to mind the disfigurement and decay the rest of the body must have undergone. The portrait miniature, in contrast, preserves the past in a miniature form that at once distances the image from the loss and pulls the observer physically close in order to see. Indeed, the servant's speculation that a microscope might be necessary to see all the details in the image emphasizes the image's transporting powers; the image takes the observer away from the temporal realm and into a space of representation. Gazing at the portrait, the viewer experiences a scalar displacement, a consoling shift from a world of physical

decay to one of representational exactitude. The comfort the portrait miniature offers derives, not from its ability to make an absent person present, but rather by allowing the observer to escape from the world of reality (the world of death and decay) into a preserved space of miniaturized representation.

Part of the portrait miniature's endurance in Victorian literature lay in its instant association with nostalgia, the summoning of a past, not with the vividness of a daguerreotype or a lock of hair, but rather with the dimmed emotion of feeling transmuted and contained in object form. In Gaskell's fiction, portrait miniatures are often an accoutrement of the maiden aunt: a symbol both of her capacity for real feeling and her distance from the individuals who inspired the same. Flocks of miniatures appear in Gaskell's *Cranford* (1851–1853), where the old maids of the town wear "any number of brooches, up and down and everywhere (some with dogs' eyes painted in them; some that were like small picture-frames with mausoleums and weeping-willows neatly executed in hair inside; some, again, with miniatures of ladies and gentlemen sweetly smiling out of a nest of stiff muslin)."[41] Worn, not singly, with purposeful significance, but in numbers that apparently render them into decorations, each portrait miniature nonetheless suggests a grief that lies beyond the sturdy habits of daily life that support these women. Gaskell's slim novella makes no attempt to unpack the stories behind each of these images; they hover just beyond the novel's view.

Miss Phoebe, in *Wives and Daughters* (1865) similarly develops a relationship to her portrait miniatures that depends upon their status as objects and not as surrogates for the beloved. Thus Miss Phoebe explains that she rarely wears the miniatures of her parents, "because they are so valuable," adding that her sister "always keeps them locked up with the best silver, and hides the box somewhere; she never will tell me where, because she says I've such weak nerves, and that if a burglar, with a loaded pistol at my head, were to ask me where we kept our plate and jewels, I should be sure to tell him; and she says, for her part, she would never think of revealing under any circumstances."[42] Miss Phoebe's absurd fear of burglary, like the similar fears of theft expressed by the ladies in *Cranford*, functions as a distraction from other, more serious forms of loss. Indeed, the large size of the portrait miniature allows it to function as a

kind of "shield to Miss Phoebe's breast."[43] Emotionally, as well as physically, the portrait miniatures protect her from acute grief at her loss by transmuting her parents into an object realm where theft is the danger most to be feared.

Even as daguerreotypes became exalted as a more accurate form of image capture for the present, portrait miniatures endured as symbols of emotional attachments that, often, had become buried or hidden with time. This contrast is, perhaps, nowhere so evident as in Nathaniel Hawthorne's *The House of the Seven Gables* (1851), where Hepzibah Pyncheon's portrait miniature of her brother Clifford is contrasted with the photographic miniature of Judge Pyncheon. The portrait miniature is an object clouded in secrecy, carrying with it the mysteries of Hepzibah's past. Upon revealing that the "strong passion of [Hepzibah's] life" lies in "a secret drawer in the escritoire," Hawthorne sets up a mystery in the minds of both readers and the youthful protagonist Phoebe, querying: "Can it have been an early lover of Miss Hepzibah? No; she never had a lover—poor thing, how could she? . . . And yet, her undying faith and trust, her fresh remembrance, and continual devotedness toward the original of that miniature, have been the only substance for her heart to feed upon."[44] The portrait miniature endows the apparently stolid figure of Hepzibah with a gauzy aura of mystery, alluding to secrets that lie just beyond the reader's knowledge and view. The daguerreotype, in contrast, functions not to suggest mysteries but to dispel them with the penetration of truth. The daguerreotypist Mr. Holgrave posits, "There is a wonderful insight in Heaven's broad and simple sunshine. While we give it credit only for depicting the merest surface, it actually brings out the secret character with a truth that no painter would ever venture upon, even could he detect it. There is, at least, no flattery in my humble line of art."[45] Holgrave subsequently presents Phoebe with an image of Judge Jaffrey Pyncheon, his dark character revealed for the first time by the photographic lens. Holgrave also questions Phoebe about the portrait miniature of Clifford Pyncheon, expressing his hope that, in photographing Clifford, he might learn the truth of Clifford's allegedly criminal past. But the novel embraces the asymmetry of portrait and daguerreotype, using it to develop the reader's sympathies and suspicions. Indeed, if the daguerreotype, in Hawthorne's novel, stands in for a future of definite

criminal knowledge (even as it recovers a resemblance to cruelties past), the portrait miniature becomes a symbol of an absolute devotion to the past in the absence of either modern or mystical knowledge.[46]

Seen thus, the portrait miniature endured as a symbol of affection that was equally indifferent to the appearance of the subject and to the quality of the portrait that represented the beloved's features. While elite portrait miniature painters experimented with scale and dimensions in ways that marked the form's aspirations to cultural recognition, the unfashionable-ness of the small-scale portrait miniature and its failure to capture the features of the sitter with photographic accuracy opened up a gap between the object and its original that had to be filled by the capacious love of its possessor. So although the portrait miniature could be deployed and ma-nipulated to social effect in ways suggested by Dickens and Thackeray, it still remained a symbol of uncritical affection, which gained in poignancy, for later Victorian writers, by virtue of its association with the past.

Portrait miniatures mark a departure from modes of strict realism and chronological time in that they make the hidden histories and the longed-for futures of individuals physically present in the text. In *Adam Bede* (1859), George Eliot contrasts Dutch realist paintings to portrait miniatures. Realist portraiture, Eliot notes, offers "faithful pictures of a monotonous homely existence," which may foster sympathy among those who see them-selves in these humble representations.[47] The portrait miniature models an affection that far exceeds this measured sympathy and that beautifies, not just the humbleness of those represented, but also the humble features of the observer. "I am not at all sure," Eliot writes,

> that the majority of the human race have not been ugly, and even among those "lords of their kind," the British, squat figures, ill-shapen nostrils, and dingy complexions are not startling exceptions. . . . [Y]et to my certain knowledge tender hearts have beaten for them, and their miniatures—flattering, but still not lovely—are kissed in secret by motherly lips. . . . Yes! thank God; human feeling is like the mighty rivers that bless the earth: it does not wait for beauty—it flows with resistless force and brings beauty with it.[48]

The beauty of the portrait miniature, then, lies not in the object, but in the response it inspires; its beauty derives from the tactile encounter

between the inviting small-scale object and the eager lips of the possessor who kisses the object with the same fervency with which she would kiss its subject. Portrait miniatures flatter; but the point, for Eliot, is not that the sitter has been made beautiful, but rather that the response of observers to them generates beauty out of a thoroughly ordinary materiality. This effect stands outside of time: British mothers of all periods are united in their affection for these imperfect images of unhandsome men. Eliot is not alone in conceiving of the miniature as a symbol of hidden tenderness. For instance, in *The Uncommercial Traveller*, Dickens cites the evidence of hidden portrait miniatures of women on shipwrecked passengers as proof that "rough men" possessed a "hidden tenderness."[49] To observe a portrait miniature properly was to see beyond the dingy characteristics of the owner and to perceive a narrative of rich attachment no less compelling for the frequency with which it appears.

The fervent emotion that was closely associated with the portrait miniature became a locus of narrative insofar as it signaled an affection or an untold story lying just out of sight. Portrait miniatures function not as ends in themselves but as loose strands of narrative thread that the author might or might not choose to unravel. Portrait miniatures, indeed, suggest wells of life and experience that have been almost entirely erased from view by the passage of time. The nineteenth-century portrait miniature functions, as Stewart writes of the dollhouse, as "the secret recesses of the heart: center within center, within within within."[50] This effect of the narrative unfolding of interior space clearly shapes the opening of George Eliot's 1857 novella "Mr. Gilful's Love Story," which appeared in *Scenes of Clerical Life*. The narrator of the novella discovers a pair of portrait miniatures hidden away in a locked room in Mr. Gilful's house and posits that these objects function as "a sort of visible symbol of the secret chamber in his heart, where he had long turned the key on early hopes and early sorrows, shutting up for ever all the passion and the poetry of his life."[51] The portrait miniature here becomes associated both with the closed-off spaces of domestic life and with the hidden interior life of a person's heart. The size of the portrait miniature aligns the object with the secret worlds of an inner self. The proceeding narrative, of course, opens up this secret chamber and narrates the story that is allusively suggested, though not actually revealed, by the portrait miniature itself. Similar examples appear in

Charlotte Brontë's *The Professor* (1845), Wilkie Collins's *After Dark* (1856), and George Meredith's *The Ordeal of Richard Feverel* (1859); Mary Elizabeth Braddon's *Lady Audley's Secret* (1862) comments upon this tradition by fostering the incorrect assumption among readers that her secret must be contained in a portrait miniature and not, as is actually the case, in writing.[52]

Mr. Gilful's story, as revealed by the subsequent narrative, unfolds in not altogether surprising ways. Once rejected by Caterina Sarti, the woman he loves, he eventually wins her hand in marriage after she is abandoned by her former lover. But the ordinary trajectory of this love story is given unexpected vividness by its mediation through the objects included in it. The narrative reveals that Caterina possessed a portrait miniature of her own, an image of her first lover that he had specially commissioned for her. When she discovers that he has left her, she throws his portrait to the ground, smashing it to pieces. Moments later, "when she saw the little treasure she had cherished so fondly, so often smothered with kisses, so often laid under her pillow, and remembered with the first return of consciousness in the morning—when she saw this one visible relic of the too happy past lying with the glass shivered, the hair fallen out, the thin ivory cracked, there was a revulsion of the overstrained feeling: relenting came, and she burst into tears."[53]

Caterina's tears come, not in thinking about the lover whom she lost, but in recalling her own history with the object, reviewing the emotions and actions inspired by the object-surrogate. The object encapsulates her own love story, both recalling memories of her past self and representing her shattered self in the present. But the object also allows her to achieve distance from its representational subject; she recognizes that what she mourns is not the loss of her lover but the loss of her past self. The object's failure to stand in for its represented subject, a failure that in other Victorian fiction promotes self-indulgence, here allows Caterina to move on: a few minutes later, "[u]nselfish tears began to flow, and sorrowful gratitude . . . helped to awaken her sensibility to Mr. Gilfil's tenderness and generosity."[54] It is fitting, then, that Mr. Gilful treasures the portrait miniature pair of Caterina and himself long after her death. In both cases, the portrait miniature represents a lost history, a secret past filled with happiness and love. But the portrait miniatures in the frame narrative are preserved; they represent a love that endures.

Victorian sensationalist fiction follows eighteenth-century gothic fiction in exploiting the open-endedness of the portrait miniature and its capacity for narrative for the purposes of plot. Portrait miniatures function in diverse but formulaic ways: they cause individuals to fall in love with unknown persons (Wilkie Collins's *Armadale*, George Meredith's *Celt and Saxon*); allow them to uncover the identities or the intertwined pasts of others (Collins's *Armadale*, Mary Elizabeth Braddon's *Phantom Fortune*, Thomas Hardy's *Desperate Remedies*); deter them from certain actions (Collins's *The Woman in White*, *The Evil Genius*, *The Legacy of Cain*); open up mysteries of the past (Braddon's *Birds of Prey*); and foreshadow the future (Collins's *Armadale*, Braddon's *London Pride*).[55] The miniature often gives characters a sense of destiny, of forces that connect persons in the past, present, and future, and that mark the interwoven nature of their fates across time.

As in the earlier novels of Dickens and Thackeray, portrait miniatures in mid-Victorian fiction are often depicted as objects in motion, being actively employed to communicate with others or to correct the self. The destruction of a portrait miniature in the presence of others, in particular, might be employed to convey either contempt or indifference to the subject it portrays. In Anne Brontë's novel *The Tenant of Wildfell Hall* (1848), Helen Lawrence impetuously burns a carefully colored portrait miniature that she has painted of Arthur Huntington when he discovers it in order to show that she has no particular feelings for him, an action that anticipates the disastrousness of their subsequent marriage. In Wilkie Collins's *Basil* (1852), the titular character's father rips Basil's portrait miniature from the family book to indicate his displeasure, an action he regrets in private with many tears.[56]

Portrait miniatures, indeed, were both tools of communication within relationships and devices to discipline the self. In Charlotte Brontë's *Jane Eyre* (1847), the heroine aims to shape her expectations for the future by painting portrait miniatures. Midway through the novel, Jane examines, through "Reason," her growing affection for Mr. Rochester and sentences herself to draw two portraits: one a rough crayon sketch of herself that she produces in an hour; the other a portrait miniature of Blanche in ivory that she creates in just under a fortnight. Jane's purpose is to cure herself of her fantasy that Rochester might hold any affection for her by depicting the physical contrast between the "Portrait of a Governess, dis-

connected, poor, and plain," and Blanche Ingham, with her "august yet harmonious lineaments, [her] Grecian neck and bust . . . the round and dazzling arm . . . and the delicate hand."[57] The differences in artistic form accentuate those of physical appearance. The portrait miniature of Blanche would possess all the alluring characteristics of the form; its possessor might cradle the small-scale object in the hand or bring it close to the face to scrutinize the features. Blanche's miniature, as Jane creates it, invites physical intimacy, just as, Jane imagines, the woman herself invites matrimonial proposals. Jane's crayon sketch of herself, by contrast, invites no physical intimacy; the object could not easily be held, kissed, or kept on the body, and the crayon (probably a lithographic crayon, since Jane also describes it as a chalk) might smudge or smear if someone else picked up or touched the drawing. Her choice of medium does not just underscore the contrast in the two women's appearances, it also formally suggests Jane's unsuitability for marriage itself.

Whereas Jane seeks to discipline her own thoughts with her first pair of portraits, she paints a second portrait miniature in an attempt to influence the actions of St. John Rivers. After noticing St. John's reciprocated affection for Rosamund Oliver, she paints a portrait miniature of Rosamund and sets it out for St. John to see, using the form, again, to accentuate her beauty and eminent suitability for matrimony. The portrait miniature succeeds in absorbing St. John, as Jane imagined it might; for a precisely measured fifteen minutes, he abandons his missionary dream in favor of a new vision. "Fancy me yielding and melting, as I am doing," he instructs Jane, adding, "now I see myself stretched on an ottoman in the drawing-room at Vale Hall at my bride Rosamond Oliver's feet: she is talking to me with her sweet voice—gazing down on me with those eyes your skilful hand has copied so well—smiling at me with these coral lips. She is mine—I am hers—this present life and passing world suffice to me. Hush! say nothing—my heart is full of delight—my senses are entranced—let the time I marked pass in peace."[58] The portrait miniature evokes, however briefly, the fantasy of another life, of an alternate world that St. John could, by his own action, bring into being. But however tempted he is by the portrait, he remains firm in his intent. Twice he puts the portrait down; and finally he covers it with a piece of paper, obscuring the image from view and setting himself on his determined path to martyrdom.

In crafting portrait miniatures of both Blanche and Rosamund, Jane aims to script the future; these acts stand in striking parallel to her later decision to compose this novel as a record of the past. But the futures Jane imagines through portrait miniatures are not the ones that comes to be: Rochester loves Jane despite the fact that she finds herself unworthy of a portrait miniature; and St. John resists Rosamund despite the allure of her miniature image. Each miniature, then, represents an alternative fiction, suggesting a possible narrative in which Rochester marries Blanche or St. John proposes to Rosamund. Indeed, the "what if" possibility of these fictions heightens the reader's awareness of the uncertainties of authorship. If Jane Eyre is so unreliable as a writer of imagined futures, should we trust her when she narrates the past? How, for example, does she know about the tablet marked "Resurgam," laid for Helen Burns fifteen years after the girl's death, unless she herself erected it?[59] If, as Jane suggests in the final chapter of the novel, "All my confidence is bestowed on [Mr. Rochester]," why does she make "no disclosure in return" when Mr. Rochester confesses having cried out for her and heard her voice answer?[60] Perhaps, portrait miniatures suggest, narration is always contingent, always dependent on perspective, always reflecting the biases and partialness of vision.

Jane Eyre is not alone in using portrait miniatures to envision the future. In George Eliot's *The Mill on the Floss* (1860), Philip Wakem draws two portraits of Maggie, the first a miniature watercolor sketch drawn from memory after their first youthful parting, and the second a large oil painting, painted from life after their later reunion. The first sketch is done in a flush of youthful intimacy, when Maggie promises that she will not forget Philip. It is "of real merit as a portrait" and sustains Philip's love over many years, bristling with a sense of possibility that hovers around a fantasy of life together in the youthful Philip's mind.[61] The second portrait, in contrast, functions less to envision the future than to announce the present; Philip uses the painting of the portrait as an excuse to get close to Maggie and intends to use the image to confess his love to his father. But this second portrait contains little of real life; it is "not quite so good a likeness" as the first, despite Philip's years of training, and it depicts Maggie, not as Philip knows her, but as "a tall Hamadryad, dark and strong and noble, just issued from one of the fir-trees."[62] Philip's

change in format suggests both that he has lost his former flush of intimacy with Maggie and that the promise of their early courtship has faded. Whereas in the Georgian age, Elizabeth Bennet's admiration of Darcy's full-scale image in *Pride and Prejudice* signals the social acceptability of her choice, Philip's attempt to represent Maggie in full scale signals his inability to see her as a woman and his attempt to aggrandize her through mythological references.

In creating spaces of connection across time, portrait miniatures function as portals to imagined worlds not just of the future but also of the past. George Eliot's *Middlemarch* (1871–1872) depicts them as a means to conjure an imagined space of feminine sympathy. Set in 1829–1832, Eliot's representations of portrait miniatures both situate the novel in the past and reflect the increasingly historic understanding of miniatures later in the century. Dorothea's encounters with the portrait miniature of Casaubon's aunt Julia (Will Ladislaw's grandmother) gradually dissolve the boundary between past and present, creating a new space of intimate encounter through the object's power. At the beginning of the novel, Dorothea considers portrait miniatures as historical relics, useful only for understanding Mr. Casaubon's family past. Indeed, she seems as indifferent to these objects as to her sister's cameos, regarding them both as forms of sentimental materialism. But as the novel proceeds, she first develops an emotional connection to the miniature of Aunt Julia, next finds herself compelled by the portrait to action, and finally discovers in it a place of emotional release from the claustrophobia of first her marriage and then her widowhood.

At times, the portrait miniature of Aunt Julia spurs Dorothea to act. Midway through the novel, Dorothea reflects that the boudoir containing the miniatures seems filled with "those memories of an inward life," while the portrait miniatures seem transformed into "an audience as of beings no longer disturbed about their own earthly lot, but still humanly interested."[63] The bare physical space of the boudoir reflects Dorothea's internal reality, even as the miniatures, especially that of Aunt Julia, concentrate her feelings. Impelled by her encounter with the miniatures, Dorothea makes a disastrous plea to Casaubon to bequeath his fortune to Will Ladislaw, not to her. What Dorothea fails to understand in this case is that portrait miniatures cannot transform the external world; they can only transform the inner self.

In Eliot's novel the portrait miniature achieves its highest function, not when it spurs action, but rather when it gives relief by connecting Dorothea to other women across time. When Dorothea returns to the room after the honeymoon, the objects therein contain the memory of her lost hopes, now considered "transient and departed things." Eliot observes that "[e]ach remembered thing in the room was disenchanted," except the miniatures, which "gathered new breath and meaning" from Dorothea's brief marriage.[64] In particular, the features of Casaubon's Aunt Julia are transformed in Dorothea's eyes. Once having described the features of a woman "peculiar rather than pretty," Dorothea now sees in Aunt Julia's face an echo of her own experience.[65] Eliot writes: "Dorothea could fancy that it was alive now—the delicate woman's face which yet had a headstrong look, a peculiarity difficult to interpret. Was it only her friends who thought her marriage unfortunate? or did she herself find it out to be a mistake, and taste the salt bitterness of her tears in the merciful silence of the night? What breadths of experience Dorothea seemed to have passed over since she first looked at this miniature! She felt a new companionship with it, as if it had an ear for her and could see how she was looking at it. . . . [Dorothea] felt herself smiling, and turning from the miniature sat down and looked up as if she were again talking to a figure in front of her."[66] In her grief, Dorothea brings the image to life, asking questions of the sitter that she might equally ask of herself. The companionship is palpable; as she fancies, queries, sits, smiles, she does so to an imagined sympathetic presence, a woman who might understand her emotions.

Dorothea's encounter with the portrait miniature allows Eliot to illuminate the limitations of her realist narrative. She famously uses the metaphor of a microscope to describe her study of human character, noting that even after magnifying the features of an individual, interpretations may "turn out to be rather coarse."[67] Turning her microscope on the town of Middlemarch, Eliot exposes only a tiny slice of life to view. In encountering the portrait miniature of Aunt Julia, Dorothea finds herself connected to worlds that exist temporally outside the limited scope of the microscopic stage of Eliot's novel.

When Dorothea finally comes into physical contact with the portrait miniature, the effect of the encounter is transformative. Toward the end

of the novel, Dorothea again goes upstairs to the boudoir in despair over the imagined loss of Will, whom she has just seen in company with Rosamund. There, "[f]or the first time she took down the miniature from the wall and kept it before her, liking to blend the woman who had been too hardly judged with the grandson whom her own heart and judgment defended."[68] The identification between Will's grandmother and him becomes complete in this moment, as Dorothea allows herself to express feeling for both. Like St. John Rivers, who for fifteen minutes indulges in a fantasy of life with Rosamund Oliver, or like Caterina, who weeps over the broken miniature of her beloved in *Scenes*, Dorothea allows herself to admit and to imagine "without inward check" the happiness she believes is lost to her. "Can any one," Eliot asks, "who has rejoiced in woman's tenderness think it a reproach to her that she took the little oval picture in her palm and made a bed for it there, and leaned her cheek upon it, as if that would soothe the creatures who had suffered unjust condemnation?"[69] Cradling the portrait in her hand, holding it against her cheek, Dorothea enters the space of her internal experience, what she describes as a "shadowed silent chamber," which remains in the wake of her former hope and happiness. In this moment of physical intimacy, she achieves a new form of sympathy through an object that at once represents her dream of a future with Will, which she now presumes is impossible, and offers an imagined community of fellow female sufferers, whose ranks she has joined. In the structure of the novel the scene serves as a fulcrum. Henceforth, Dorothea does not indulge in self-pity, but rather reconceives of herself as part of a female community united in suffering. Indeed, one of her first actions is to reach out to Rosamund, no longer viewing the other woman as a rival but seeing her as another woman in need of sympathetic understanding. Far from being simply identified with Will himself, the portrait miniature of Casaubon's Aunt Julia has transformed Dorothea's understanding of herself and her purpose in the present.

The portrait miniature's significance, then, must be understood in terms of its capacity to contain both past histories and future hopes. Victorian novels are, of course, peppered with objects that bring descriptive and imaginative richness to scenes. But portrait miniatures also carry stories with them, whether narratives of past affection or of future intention, which demand narrative unfolding. Sometimes, miniatures open

backward, pulling narrative and reader into a past whose only trace lies in the object that remains. At other times, they project forward, offering future scenarios that pose alternatives to the fictional narrative the author has written. And at certain times, as in *Middlemarch*, the portrait miniature offers an imagined space of solidarity, stretching across time and space, which transforms the protagonist by reshaping her understanding of her position within the world. This sense of narrative possibility accompanying the portrait miniature rends the fabric of realism by pointing to the limitations of narrative. Beyond a narrative's set trajectory lie other possibilities of how events might have proceeded; beyond the limited scope of the narrative itself lie innumerable lives whose stories remain untold.

Henry James and the Speaking Image

Literary references to portrait miniatures notably diminish in the last decades of the nineteenth century, as they increasingly came to signify the attachments, not of the previous generation, but of several generations back. Indeed, as photographs grew more accepted as the major form of representation in small, the distinct characteristics of portrait miniatures vis-à-vis photographs eroded, and the two began to be used almost interchangeably. This erosion almost certainly reflected the blurring of the distinction between the two in practice, as portrait miniaturists regularly took on new careers as photographic colorists, modifying as well as adding color to the photographic print. Thus while portrait miniatures appear frequently in the literature of the 1850s and 1860s, and regularly in fiction of the 1870s, such representations are much scarcer in the 1880s and 1890s.

When Henry James uses the portrait miniature in his 1888 novella *The Aspern Papers*, he draws on a rich tradition of literary representations, using the object both to suggest its capacity to summon a vivid reality, suggested by its alternate scale, and to underline the failure of such a representation to substitute for its represented subject in a satisfactory way. The unnamed protagonist spends the entire novella attempting to obtain the papers of the deceased poet Jeffrey Aspern, first from the elderly Miss Bordereau and later from her niece, Miss Tita. Miss Bordereau never shows the protagonist the papers, but she does reveal

her possession of a small, oval portrait miniature, under the pretense of an interest in selling it. The narrator describes it as "a careful but not a supreme work of art, larger than the ordinary miniature ... [with] a valuable quality of resemblance."[70] Locating the work's value in its relation to the sitter rather than in its properties as a work of art, the protagonist equally deemphasizes the object's format, only this once referring to it as a "miniature," with all the outmoded connotations that the term by 1888 possessed.

Yet the dimensions exert an incontrovertible hold over the protagonist, pulling him into a relationship with Aspern's miniature that closes off any possibility of romance. Toward the end of the novella, Miss Tita hands the portrait over to the narrator, divulging at the same time that she prevented her aunt from burning the letters prior to her death. In this moment of intimate encounter, the protagonist turns to the portrait, as if the unspeaking image were more real than the woman: "I looked at Jeffrey Aspern's face in the little picture, partly in order not to look at that of my interlocutress, which had begun to trouble me, even to frighten me a little—it was so self-conscious, so unnatural. I made no answer to this last declaration; I only privately consulted Jeffrey Aspern's delightful eyes with my own (they were so young and brilliant, and yet so wise, so full of vision); I asked him what on earth was the matter with Miss Tita. He seemed to smile at me with friendly mockery, as if he were amused at my case. I had got into a pickle for him—as if he needed it! He was unsatisfactory, for the only moment since I had known him. Nevertheless, now that I held the little picture in my hand I felt that it would be a precious possession."[71] Here, the portrait possesses all the characteristics of sentience, with its "delightful" eyes full of wisdom and vision and a smile of friendly mockery, that suggest the animation of the image on the ivory. With his image nestled in the narrator's hand, Aspern seems, for the first time in the novella, graspable. The narrator has found an imagined companion whose knowing gaze provides companionship even as it sparks his desire for possession of the object.

But whereas Dorothea's encounter with the miniature of Aunt Julia impels her to reach out to living persons in the present, the narrator's experience with Aspern inspires an unease with and even a fear of the woman who could give him access to the portrait. In this moment, the

outmoded form of the portrait miniature becomes more real and more important to the protagonist than the woman standing before him. As Miss Tita tentatively proposes that the narrator might become a kind of relation, he reports that "a light came into my mind. It was embarrassing, and I bent my head over Jeffrey Aspern's portrait. What an odd expression was in his face! 'Get out of it as you can, my dear fellow!'"[72] Repulsed by Miss Tita's suggestion, the protagonist engages in dialogue, not with the woman who has just proposed marriage, but with the static image of a man long deceased. Putting the portrait miniature in his pocket with the (false) promise to sell it, the narrator chooses a permanent relationship with the portrait miniature over a marriage to the real person of Miss Tita. Miss Tita burns the letters, but she leaves the portrait with the narrator, who, rather than selling it as promised, hangs it above his writing table. It remains as a perpetual reminder of the papers that he failed to obtain, with Aspern forever laughing at the narrator from across the gap of representational distance.

The speaking image of Jeffrey Aspern in *The Aspern Papers* offers a reminder of the potency of the portrait miniature to elicit responses from the viewer long after the displacement of the form by photography. But even as the portrait bridges the gap between past and present and brings the sitter into imaginative contact with the observer, the object's deficiencies as a companion are clear. To be obsessively engaged with a portrait miniature, by the end of the 1880s, was to be disconnected from reality, caught instead in a past that is destined to vanish into smoke. The resurgence of the portrait miniature in exhibitions and in a brief flurry of associations in the 1890s did little to bring the form cultural and literary credibility. Instead, like the portrait miniature of Jeffrey Aspern, the objects lingered on, making occasional reappearances that offered little hope for the future but permitted a sentimental immersion in the past.

Part Two
Miniatures and Science

CHAPTER THREE

MICROSCOPIC EMPIRICISM AND
ENCHANTMENT

In her preface to *Drops of Water: Their Marvellous and Beautiful Inhabitants Displayed by the Microscope* (1851), Agnes Catlow describes the experience of microscopic observation as an experience of spiritual transportation. She writes:

> My readers must fancy themselves spirits, capable of living in a medium different from our atmosphere, and so pass with me through a wonderful brazen tunnel, with crystal doors at the entrance. These doors are bright, circular, and thick, of very peculiar construction, having taken much time and labour to bring to perfection. A spirit named Science opens them to all who seek her, and feel induced to enter her domains. At the end of the tunnel we find other portals, much smaller, and more carefully constructed, and two or three in number; when these are opened, we are in the new world spoken of. And now I see your astonishment: your minds are bewildered with the variety of new beings and forms you behold, all gliding and moving about without noise and at perfect ease. . . . You exclaim, "This is not a living creature, but a miniature globe, rolling in this new world into which you have introduced us."[1]

Catlow's account curiously mingles the language of spirits with the precise delineation of mechanical parts. In it, the microscope functions like Aladdin's lamp, transporting its user into another world with the guidance of the genie-like spirit of Science. In looking through the microscope's lens, the user is physically guided through mysterious portals into a place that she characterizes, not as belonging to our world, but as a "miniature globe" and a "new world." Despite its fanciful language, Catlow's description remains tethered to the precise physical parts of the scientific instrument; she narrates the reader's progress through the crystal ocular lens, the bronze tube, and the objective lenses. Her narration is simultaneously an embroidered description of the physical parts of the instrument and a mystical tale of spiritual transformation. Scientific edification and spiritual enchantment, Catlow suggests, go intimately hand in hand.

During the nineteenth century, the microscope fostered a sense of wonder at the natural world by revealing the existence of a proximate world of enchantment hidden from the naked eye by reason of its scale. Scholars typically place the microscope alongside other tools of vision, including the spectroscope, camera, kaleidoscope, and telescope, which expanded or transformed Victorian visual perception of the world. The microscope bore a particular kinship to the telescope in that both expanded the scales of vision. Unlike the telescope, of course, it unveiled wonders, not in the far reaches of space, but in the immediate proximity of the user. The microscope forever transformed the user's understanding of her surroundings; having once looked through the lens at a sample of pond scum and seen dozens of miniscule creatures living there, the viewer might look at any body of water and imagine the billions of microscopic creatures within. The microscopic world could not be detected by any of the other senses—microscopic organisms could not be heard, tasted, or touched. As a result, microscopic forms of life possessed an illusory quality, as if they belonged to a dream or to fairyland.

The microscope offered a solitary experience of enchanting discovery in which objective and subjective modes of observation were intimately intertwined. Following Max Weber's famous claim about the disenchantment of the world in the nineteenth century, twentieth-century critics traced a growing separation between scientific and artistic understandings of the world, in which, as Lorraine Daston and Peter Galison put it,

"[a]rtists were exhorted to express, even flaunt, their subjectivity, at the same time that scientists were admonished to restrain theirs."[2] Recent scholars have challenged the sturdiness of the distinction between science and art, objectivity and subjectivity, pointing to the ways in which ideas of the scientific were in the process of being constructed and debated in the nineteenth century. Benjamin Morgan, for example, argues that both literature and science offered flexible rhetorics, which might be employed by the same individuals in different contexts and with different purposes, and Philipp Erchinger describes how literature and science developed in tandem as mutually imbricated processes of experimentation.[3]

The microscope offers a particularly illuminating example of the entanglement of imagination and science in the nineteenth century because microscopic observations were both deeply personal and frequently discussed. The experience of gazing through its lens was typically a solitary one; the nature of the microscope meant that observations of living organisms in particular were difficult either to conduct in tandem or to duplicate. At the same time, individuals sought to share their observations through publication, at club meetings, and even through the mail. The rapid development and increasing availability of reliable microscopic instruments in the nineteenth century meant that the science itself expanded to include amateurs in the process of scientific discovery. Two approaches governed the methods used to direct amateur participation in microscopic science. In one, scientists emphasized that scientific tools like the micrometer and the camera lucida allowed users to capture their observations objectively. This approach prioritized advancing scientific knowledge through careful, gradual, and duplicable research. In the other, microscopists contended that these tools fundamentally failed to capture the immersive experience of gazing upon a moving field of life. The emphasis on the experience of microscopic observation encouraged microscope users to produce what Cynthia Sundberg Wall describes as "*experiential* description[s] of something not just seen but imaginatively inhabited."[4] Wonder, in this approach, was not just incidental but essential to the progress of microscopy, insofar as it both attracted lay individuals to microscopic study and highlighted the stakes of this often painstaking work. Books and periodicals aimed at popular audiences placed particular emphasis upon the wonders of the microscope, promising that anyone

who gazed through the microscope's lens could and should see the world transformed as if by magic.

None of this, of course, came without controversy. But debates about the appropriateness of wonder and the proper mode of description took place within the field of microscopic science, not outside of it. While wonder was regarded with suspicion by some scientists who saw it as a threat to objective analysis, it was embraced by many who suggested it as the proper end for scientific study.[5] These differing positions were held by individuals within the same communities, sometimes appearing in the pages of the same journals or in the writings of a single author. Science became a tool used to reveal in nature a repository of enchantment that far exceeded the enchanting fancies of fiction. The microscope in particular seemed to expand space itself. During the same period that artists expanded the size of portrait miniatures to insist upon their importance, scientists used microscopes to reveal and magnify the intricate forms of tiny creatures in the natural world. Indeed, the microscope increasingly provided the dominant lens through which to think about alternative scales during the Victorian period, presenting a scale of life that was made visible through the microscopist's artificially extended gaze but that remained unknowable in its strangeness and in its endlessly unfolding expanse.

Thus, while the microscope gave its users the power to penetrate beyond the limitations of human sight, it also reminded them of how much remained unknown. Popular demonstrations used this sense of unknowing to generate a fear of the microscopic world and its impact on human life. More unsettlingly (though less sensationally), scientists began to postulate the existence of microorganisms that lay beyond the microscope's powers of magnification but that shaped human health and illness. In this sense, the microscope simultaneously helped users uncover the secrets of the natural world and directed their attention to worlds that lay beyond scientific explanation and human control.

How to Use a Microscope: Microscopic Instruction

The history of microscopy, as it is usually told by historians of science, is the story of the microscope's evolution as an instrument of reliable empirical observation.[6] When it was first developed in the seventeenth cen-

tury, the microscope provided revolutionary insights into the organic structures of both plants and animals. Early microscopists such as Robert Hooke and Antonie Philips van Leeuwenhoek focused on making visible anatomical details and forms that were invisible to the naked eye, using the instrument to penetrate as far as possible past the reach of the human eye. Because these observations were highly dependent on the skill of the microscopist, it was difficult to replicate and therefore to verify discoveries. In response to this problem, van Leeuwenhoek bequeathed twenty-six of his handcrafted silver microscopes to the Royal Society after his death; he attached samples to each one so that the receiving body could observe them as van Leeuwenhoek himself had. However, without a clear record of his methods in constructing microscopes or making observations, members of the Royal Society lacked the ability to duplicate them.[7]

During the seventeenth century, difficulties with the reliability and communicability of observations were further augmented by flaws in the compound microscope, including the distortions caused by the shape of the lens and the indistinctness of the microscopic image. Eighteenth-century microscopists responded to these difficulties by turning their attention to questions of methodology, working to develop proper methods of microscopic operation, which included precise observation, measurement, and nomenclature.[8] In order to standardize both observational techniques and means of description, eighteenth-century microscopists chose larger samples that were readily visible to the naked eye.[9] This period of standardization prepared the field for new discoveries around the turn of the nineteenth century, when a new generation of microscopists began to develop instruments with sharper resolution and fewer distortions from the shape of the lens. In 1830, Joseph Jackson Lister wrote a paper describing an arrangement of lenses that minimized visual distortions, thereby inaugurating what historians of science call the era of modern microscopy.[10]

From the 1850s to 1870s, the microscope underwent a second set of changes, expanding into mainstream use and shifting its place in the popular imagination from an object of elite study into a tool for mass education. Major microscope manufacturers like Field and names such as "The Child's Microscope," "The School Microscope," and the "Universal

Household Microscope" that emphasized their affordability.[11] The Society of Arts even offered a monetary prize for the manufacturer of the best student and teacher microscopes, defined as instruments costing less than 3*l.* 3*d.* and 10*s.* 6 *d.* respectively.[12] At the same time, amateur microscopists organized themselves into societies to promote microscopic use, founding the Microscopical Society in London in 1839 (later renamed the Royal Microscopical Society) and the Quekett Club in 1865, among others. These organizations held regular meetings at which members read academic papers, shared samples, and organized occasional soirées to include the broader public in their discoveries. Microscopic societies experienced rapid growth in their early years; membership in the Quekett Club, for example, increased from 155 members in 1866 to 273 in 1867 and 382 in 1868. By 1869, the club had 512 members, possessed a collection of 1,242 slides, and hosted an annual soirée that drew more than 1,400 members and friends.[13]

Information about microscopic study was also disseminated by a range of journals, including *The Journal of the Quekett Microscopical Club* (1868), *Transactions of the Royal Microscopical Society* (1867, later renamed the *Monthly Microscopical Journal*), *Quarterly Journal of Microscopical Science* (1863), and *Hardwicke's Science-Gossip* (1865). Each of these periodicals created a forum for questions, discussions, and dissemination of research within and beyond London. Postal societies furthered the exchange of information by allowing individuals to exchange slides and observations without the pressure of publication. While interested individuals might be trained in the operation of the microscope at universities, they might also learn to use a microscope through personal reading, study, and exchange.

Cultivating members of the public to be microscopic researchers was understood as a scientific and nationalistic priority. "It is a singular fact, but it is not the less a true one," opines one author in *Scientific Opinion* in 1869, "that there is no country in the world where excellent microscopes can be had cheaper, and yet where there is less good work done with them than England."[14] The emergence of new instruments opened up possibilities for scientific discovery in a range of fields—botany, entomology, anatomy, physiology, and histology, among others—but did nothing to develop qualified individuals to conduct research in these fields. As popular interest in microscopy grew, amateur microscopists were increas-

ingly understood as important in their potential to contribute in real ways to the advancement of microscopic science.

The popularization of the microscope and the growing inclusion of amateurs in the process of microscopic research exposed controversies within the scientific community about the proper place of the imagination and of wonder in the process of scientific discovery. Many scientists advocated for the necessity of strict methodology for lay users, insisting on precision and verification in order to distance themselves from past disputes that had called the microscope's reliability into question. The microscope seemed to extend the user's sight, giving the human eye the ability to discern otherwise imperceptible particles. But as nineteenth-century microscopists were keenly aware, it also distorted the user's vision, especially if the microscopist made technical errors in his or her operation of the instrument. Several major scientific disputes arose as a result that were embarrassingly founded upon contradictory observations or "facts."[15] Consequently, when scientists produced hefty textbooks for lay users—including John Quekett's pioneering work *A Practical Treatise on the Use of the Microscope* (1848), *The Microscope: and its Revelations* (1856) by William Carpenter, and *How to Work with the Microscope* (1857) by Lionel S. Beale, president of the Royal Microscopical Society—they emphasized the importance of rigorous empirical techniques, even for amateurs. Carpenter and Quekett spent 261 and 329 pages respectively detailing the technical aspects of the microscope's operation; they evaluated the comparative merits of various kinds of microscopes, catalogued the tools required to enhance the microscope's function, described the proper technique for manipulating the instrument, debated the appropriate lighting for the sample, and detailed the various possible preparations of slides and their effects.[16] Each edition grew larger than the last; when Beale reissued his 1854 guide in 1857, he added 100 pages and 157 illustrations.[17]

These works operated under the assumption, which Carpenter articulates explicitly, that anyone might make a real contribution to the advancement of science if she ceased to "spend their time in desultory observation" and chose instead to "concentrate their attention upon some particular species or group, and work out its entire history with patience and determination."[18] In the background of this positive injunction lay a warning: if the amateur microscopist did *not* work with patience, focus,

and proper technique, she fundamentally undermined the validity of her observations. Without proper technique, the microscope ceased to be a scientific instrument and became an optical toy.

Amateur microscopists were understood to require training not just in the mechanical operation of the instrument but also in the proper way to see through the lens. As Beale observed, "[The student's] eye and mind will require much careful education before he can hope to be able to form a correct opinion" on any microscopic sample.[19] The microscope flattened a three-dimensional field of vision into two dimensions, making it difficult to get a proper view and understanding of the sample's size, shape, and mechanisms of movement.[20] In order to train his students' vision, Beale included an appendix of eight tables, each of which guides the amateur microscopist through the process of examining common samples; at each step, Beale instructed his readers in what they should be seeing.[21] In his lectures at the Royal College of Surgeons, Carpenter prepared a series of microscopes with lamp and slides on a tray and passed them from student to student to allow them to observe samples individually.[22] These exercises framed microscopic study as a process not of discovery but of replication, as students successfully reproduced prior observations in order to standardize their observations and guard against future faulty assumptions or misinterpretations. In order to ensure the duplicability of observations, individuals were asked to use a micrometer and a camera lucida to measure and illustrate each sample and were urged to note in each case the make and model of the instrument and the magnification of the lens.

Even users who operated the microscope with technical precision, experts warned, might be tempted to fill in gaps or expand upon direct observation using their imaginations, and to present their extrapolative suppositions as empirical facts. By its very nature, the microscope gave only partial information to its user; its limitations in focus, magnification, and field of view meant that the user frequently caught tantalizing glimpses of creatures or structures that they could not see in full. The microscope seemed to invite users to embellish on their observations and to report, as Carpenter puts it, "what they *believe* and *infer*, rather than what they actually *witness*." But microscopists who allowed their conclusions to be "completed by the imagination," like users who failed to follow proper

technique, compromised the scientific integrity of all their observations.[23] Because of this, scientists like Carpenter saw it as their duty to guard rigorously against the imaginative wonder that microscopy often inspired.

Microscopists were particularly concerned that amateurs might be distracted and might have their vision distorted by the alluring possibility that they might discover a new species. "It is a strange thing," opined one author writing in *Hardwicke's Science-Gossip* in 1869, "that many people who term themselves naturalists, will run hundreds of miles over a country, and waste weeks and weeks for the possession of *rare* species. The chief object of the microscopists, I presume, is to resolve our most difficult problems in histology, and to lessen the number of our already too abundant species. What credit does it reflect upon any man because . . . he has discovered a species that nobody else has—Smithii, Brownii, Jonesii, Robinsonii? None, in my opinion. If there is any honour to be gained, it is in the reduction of species, and for the working out of such problems, brains, patience, and untiring perseverance are required to any extent."[24]

It is not, of course, at all surprising that the public would prefer the discovery of rare and unnamed species to the unglamorous work of scrutinizing familiar species or of understanding the structure of tissues. The proposed reduction in the number of species suggested limitations to the diversity of the microscopic world at a moment when the public hungered to find, in the world of the small, an endless unfurling of species and of space. The discovery of a new species, in contrast, permitted the naturalist to inscribe her name on the microscopic world, claiming a sliver of the microscopic world imperialistically as her own.

In the process of guarding against imaginative extrapolation, the scientific community developed severe consequences for those who were perceived to overstate or misrepresent their research. The embryologist and histologist Martin Barry, for example, permanently destroyed his scientific credibility after prematurely claiming, in the 1840s and 1850s, to discover a double spiral structure in animal tissues. Barry's mistake, as L. S. Jacyna has shown, was understood not just as an error of interpretation but also as the revelation of his flawed moral character.[25] In the words of one of his contemporaries, he had been "led wrong by an inordinately ambitious desire to *discover;* he is a fearful spectacle of morbid

craving for scientific distinction."[26] Implicit in this colleague's strict judg-
ment is a moral condemnation of the search for scientific distinction, as
if ambition for discovery were dangerous in itself. What the scientific
world needed in order to advance scientific knowledge were not
Odyssean explorers of exotic realms but patient workers in the unglamor-
ous trenches of the field.

How to Look Through a Microscope: Microscopic Enchantment

Even as many scientists guarded against the imagination and the thrill
of discovery as threats to the progress of microscopic science, others em-
braced the effects of microscopic observation on the imagination of the
user and purposefully promoted the concept of the amateur microscopist
as explorer. A set of popular plain language guides to microscopy, includ-
ing Catlow's *Drops of Water,* Philip Henry Gosse's *Evenings at the Microscope*
(1859), Edwin Lankester's *Half-Hours with the Microscope* (1859), John
Wood's *Common Objects of the Microscope* (1861), Henry Slack's *Marvels of
Pond Life* (1861), and Mary Ward's *Microscope Teachings* (1864), appeared
shortly after the first wave of serious laboratory manuals to microscopic
use. These introductory tutorials or "Guide Book[s]"[27] trained the reader,
not for the careful empirical work of the laboratory, but rather for the
imprecise, imaginatively stimulating exploration of the natural world.
Deemphasizing the difficulties of microscopic observation, these works
encourage the reader to put everything and anything they choose under
the microscope's lens. Lankester advises readers to spend just half an
hour familiarizing themselves with the microscopic instrument before
embarking on explorations of the nearby garden, country, pond side, and
seaside. Seen through the microscope, Lankester assures his reader, even
the most ordinary objects will be transformed. "What eyes would be to
the man who is born blind, the Microscope is to the man who has eyes,"
he declares. "It opens a new world to him, and thousands of objects
whose form and shape, and even existence, he could only imagine, can
now be observed with accuracy."[28] The microscope, in Lankester's fram-
ing, is not an extension of sight but rather a sixth sensory faculty that
adds a new layer of richness to the user's apprehension of the surround-
ing world.

Many naturalists adopted a populist approach to teaching about microscopy, insisting that anyone and everyone had a right to discover the riches of the microscopic world. Those who gazed through the microscope's lens became, in the words of the Quekett Microscopical Club, "fellow explorers in the new world of little things, . . . who would discover more of the hidden mysteries of life."[29] This work of exploration was understood as worthwhile even if the world being discovered was not entirely new. At one meeting of the Geological Society, a vial containing zoophytes was passed around the room. Initially, half the observers failed to see anything through the microscope's lens. But when the specific attributes of the zoophytes were pointed out to them, "our understandings began to co-operate with our eyesight in peopling the fluid which, up to that moment, had seemed perfectly uninhabited."[30] Learning to see felt like learning to do magic; the mechanical process of focusing the lens properly slid imaginatively into an act of creation, "peopling the fluid," as the creatures came into focus. These wonders were accessible to all. Though expensive microscopes provided higher resolution and held a greater capacity for scientific contributions, Wood assured his reader that "even a pocket-microscope of the most limited powers" would open up wonders everywhere for the amateur microscopist.[31]

Discussions of microscopy exploration and discovery frequently represented the microscope as a gateway to a new and separate world. The idea of a microscopic world contradicted the scientific taxonomies of the plant and animal kingdoms. The categorization of microscopic creatures had been the subject of debate in the eighteenth century. In his 1752 book *An History of Animals,* John Hill proposed an "Animalcule kingdom," which included "animals so minute in their size, as not to be the immediate objects of our senses, and are only seen by the assistance of microscopes."[32] His categorical scheme was soundly rejected; Peter Simon Pallas, Carl Linneas, and Otto-Frederik Müller, among others, incorporated microorganisms into existing kingdoms, organizing them according to their morphological characteristics rather than their (in)visibility to the naked eye.[33] Despite this scientific consensus, nineteenth-century naturalists and writers frequently referred to a microscopic world beyond vision, describing "the world of the small" or the "invisible world."[34] Microscopic guides often dedicated entire sections to the observation of animalcules, with the

idea that observers needed to employ specific techniques in order to find invisible creatures and bring them into focus under the lens. Naturalists rarely sought to dispel the fantasy of a separate and parallel world of microscopic life, nor did they emphasize the entwinement of microscopic and full-scale forms of life.

Natural scientists' belief that microscopic observation innately and rightly stimulates the imagination seeped into the language used to describe microscopic life. In some cases, writers seem to be playing a game of resemblance, finding familiar analogues for each unfamiliar thing. An article from *Hardwicke's Science-Gossip* reels off a list of species, using their elevated Latinate names and then matching each one to a familiar object: *Surirella constricta* reminds the author of "a lady's needle-case," *Surirella plicata* takes after "a lemon in outline," *Gallionela sulcata* resembles "highly-carved ivory bones stuck end to end," *Symphonema geminatum* is akin to "a number of folded fans attached to a branched stalk by the end held in the hand," and *Pleurosigma hippocampus* (sea horse) looks like "Hogarth's lines of beauty of different curvature joining at their ends."[35] Such descriptions not only familiarized microscopic organisms but also aestheticized them, likening them to artistic shapes and artisanal forms. In other texts, dry, objective descriptions of microscopic creatures yielded unexpectedly to metaphors and elaborate explanations that drew upon mythology, anthropology, astronomy, and literature. Gosse describes underwater creatures "gazing, as it were, after [the *Sabella*] as he retreats into his castle," noting that "it seems to require no very vivid fancy to imagine them so many guardian demons . . . the *Lares* of old Roman mythology."[36] Wood, only slightly more tempered in his analogies, observes that the serration on the chaff of wheat is "like the obsidian swords of the ancient Mexicans" and describes a throng of moving creatures in muddy water "running restlessly in all directions, like Vathek and his companions in the Hall of Eblis."[37]

These analogies model a new type of scientific observation in which the writer strives to convey the experience of microscopic observation in all its subjective vividness. It is unlikely that anyone but Wood would look at a swarming population of microbes in muddied water and see a microscopic enactment of William Beckford's Gothic novel *Vathek* (1786), but his use of the analogy gives a dramatic structure and a literary interest to

the scene that captures his own investment in the microbial action. Although descriptions like this one do not lend themselves to scientific duplication and confirmation, they are not for this reason inaccurate. Rather they propose a different standard of accuracy, implicitly positing that the meticulous recording of instrumental manipulation and sample measurements communicates less than the precise rendering of experi-ence. As Gosse notes concerning another extravagant description, "Though a stranger might think I had drawn copiously on my fancy for this description, I am sure, with your eye upon what is on the stage of the microscope at this moment, you will acknowledge that the resemblances are not at all forced or unnatural."[38] Gosse aims, not to escape the subjec-tivity of his own point of view, but rather to invite the reader into this subjectivity, allowing the reader to see through his eyes. He emphasizes that all descriptions, including those made with the micrometer and the camera lucida, tax the observer by requiring a particular mode of vision; he theatrically claims that he experienced "so much perplexity and diffi-culty" in reproducing the steps of another's experiments precisely, that he "was thrown back upon himself and nature, compelled to observe *de novo*, and to set down simply what he himself could see."[39] Didactic injunctions to measure and to duplicate, in this framing, artificially impose an exter-nal system that interferes with the simple act of seeing. Without disputing the dangers of distorted vision or of misinterpreted observation that so alarmed many scientists, Gosse suggests that the greater danger lies in the overmanagement of vision, which drains the observer of her capacity to see the world under the microscope's lens clearly.

In embracing the idiosyncrasies of descriptions, Gosse and others en-couraged readers to conceive of themselves as explorers, journeying de novo into worlds of life on an alternative scale, witnessing the habits and behaviors of the species they encountered, and then recording what they saw. This skill of observation and its corollary openness to wonder, they posited, reflects more truly a scientific approach; to be a scientist is not merely to measure but to see and respond to the observable world. In his essay on "How to Study Natural History" (1893), Charles Kingsley makes the imperative claim that microscopists not just can but *should* view the contents of each microscopic stage as a world unto itself, full of sufficient wonders for a lifetime. "[G]o to the water-but [*sic*] in the nearest yard,"

Kingsley advises, "and there, in one pinch of green scum, in one spoonful of water, behold a whole 'Divina Commedia' of living forms, more fantastic a thousand times than those with which Dante peopled his unseen world."[40] Kingsley's analogy not only likens the microscopic observer to the Dante pilgrim voyaging through a world of unbelievable forms, but also suggests that the richness of the natural world should be understood not with a micrometer but rather with the imagination. By borrowing a vocabulary from literature, Kingsley does not abandon his scientific training but rather gains the ability to render his observations accurately by capturing as precisely as possible the experience of what he sees.

Both trained scientists and amateur observers often give narrative sequence to the activities that unfold on the microscopic slide before their wondering eyes: they record struggles between different species; processions of microscopic soldiers seeming to prepare for war; and coquettish courtship rituals complete with jousts.[41] Observers found themselves absorbed into the action they saw unfolding. As one writer observed, "Transposing the well-worn quotation that the 'world is a stage,' may he [the microscopic student] not justly say of this instrument, that its 'stage is a world'?"[42]

The act of looking through the microscope consistently severed observers from the lived experience of daily reality. Most Victorian microscopes had a variety of lens magnifications, but there was no simple way to "zoom in" or "zoom out" on the sample—the microscopist gazed either at the familiar world of full-sized reality or at the fantastic world of microscopic life. Microscopists often described feeling disconnected from all ordinary thoughts and sensations and transported out of time and space. Wood, for example, noted that "There is something so entrancing in the manner in which Nature gives up her wondrous secrets that the mind seems to be entirely taken out of the world, the hours fly past as in a dream," and the body forgets all "time, place, hunger, and cold."[43] This forgetfulness of self was often experienced as a form of magical transportation. The microscope, as Gosse observed, was "[l]ike . . . some mighty genie of Oriental fable . . . which unlocks a world of wonder and beauty before invisible, which one who has gazed upon it can never forget, and never cease to admire."[44]

The microscopist who imagined herself being carried to an otherworldly realm, however, was in for a shock when she realized anew that

the microscopic world existed in the same physical space as daily life. The microscope did not transport the viewer anywhere; it simply made it possible to see creatures so small that they could not be seen with the naked eye. In *The Romance of Natural History* (1860), Gosse vividly captures the wonder that accompanied this realization, writing, "Scarcely anything more strikes the mind with wonder than . . . suddenly to remove the eye from the instrument, and taking the cell from the stage, look at it with the naked eye. Is this what we have been looking at? This quarter-inch of specks, is this the field full of busy life? are here the scores of active creatures feeding, watching, preying, escaping, swimming, creeping, dancing, revolving, breeding? Are they here? Where? Here is nothing, absolutely nothing, but two or three minutest dots which the straining sight but just catches now and then in one particular light."[45] As he emphasizes, observations made with the microscope could not be confirmed by the user's ordinary senses. Indeed, the evidence of the microscope and of the naked eye often contradict one another: the microscope shows the user a field of swarming microscopic life where the user sees with her own eyes, and therefore "knows" in an intuitive sense, that there is none. In acknowledging the reliability of microscopic observations, the observer must give credence to the scientific instrument (with all of its flaws and failings) over the evidence of her own senses. This leap of trust should, Gosse suggests, fill the observer with a sense of tingling wonder at the real existence of microscopic life.

As Gosse's description makes clear, the microscopist witnesses something that is beyond the mind's capacity to comprehend: an invisible, undetectable world of miniscule life hidden among mundane and familiar objects. By allowing his imagination to grapple with the truth of microscopic observation, Gosse revels in the experience of incomprehensible disjunction and gains a tremulous sense of wonder. Microscopic creatures were, as J. B. Reade, the president of the Royal Microscopical Society dubbed them, "Nature's *invisibilia*," a stratum of natural life lying beyond the veil of human perception but present everywhere in the natural world.[46] For microscopists like Gosse and Reade, the microscopic world could not be assimilated into the world of full-scale life merely through systems of measurement and naming, though these systems might purport to regularize and manage microscopic observations. Rather, microscopic

observations could and should rupture the observer's orderly sense of self, turning the mind outward (to borrow Benjamin Morgan's phrase) in the contemplation of an animate world of microscopic nature.[47] Such a rupture required that the observer reevaluate the relationship between the human and the microscopic, acknowledging the porousness of the human body and its vulnerability to forces and forms of life beyond scientific observation and human control.

"Our Invisible Friends and Foes": Knowledge and Its Microscopic Limits

Disagreements about the proper place of imagination and exploration in microscopic science responded to a broader tradition of popular microscopic demonstration that fanned public interest in the wonders and horrors of microscopic life in water. Johann Nathanael Lieberkühn introduced the solar microscope in 1739, and the instrument quickly became a means to project microscopic samples as live entertainment for an audience. These demonstrations reached their height in the late eighteenth century, when manufacturers began to produce glass that lessened the distortions of the creatures on display, though the new methods were too unreliable for scientific use.[48]

By the 1820s, the oxyhydrogen microscope began to replace the solar microscope and took its place as one of the most technically difficult and spectacular of the magic-lantern displays at the Adelaide Gallery and the Royal Polytechnic Institution.[49] Oxyhydrogen displays made visible wonders and horrors from the natural world; but, like magic lantern displays, these performances were carefully and artificially engineered for maximum effect. Early displays revealed parts of plants and insects, demonstrated magnetic currents, and showed the decomposition of water.[50] But the most spectacular displays were those of animal life. A little sour paste diluted with water, one writer claimed, presented to the audience's view "tens of thousands of living animalculae resembling eels, . . . struggling and twining in masses so densely congregated, that it appears as if they alone constituted the paste!"[51] Behind the scenes, it was not quite so easy to achieve such spectacular effects; demonstrators more typically steeped hay and leaves in water for several weeks prior to the performance.

Cloudy to the naked eye and full of swarms of life when magnified by the microscope's lens, these samples were, in the words of John Wood, prepared purposefully "to discompose the public mind."[52]

Audiences responded viscerally to these displays. In an 1833 letter to Emily Tennyson, Arthur Hallam describes "the great [solar] Microscope and all the horrible lions & tigers which lie 'perdus' in a drop of spring water."[53] Another observer narrates how the solar microscope prompted the entire loss of his appetite, observing in 1829 that "since my unlucky visit to that diabolical contrivances [*sic*], I have not had a mouthful of wholesome food, nor enjoyed a sound appetite, nor a healthful digestion. If I lift the most delicate morsel to my lips, I fancy it alive with delicate monsters; teeming with invisible aligators, minute elephants, and impalpable tortoises. If I walk the streets, I tremble lest some unlucky drayman should drive down my throat. I dare not drink, for fear of swallowing steam boats, and being blown up by the bursting of a boiler. As for a fig, it is horrible to think of it! Going *a whole hog*, is nothing; the man who eats a fig must swallow a million of living beings."[54]

Projected to a large scale, microscopic organisms morph into monsters of horrifying proportions that teem, careen, and steam through the earth, air, and water with every bite of food, every sip of water, every breath of air. This observer draws not just on images of foreign animals, but also on characteristic elements of industrial urban life: draymen, steamboats, and boilers. At one and the same time, the horrors of the microscope were gigantic (projected on the wall) and minute (invisible on the slide), exotic (in their forms) and familiar (in their activity). What's more, spectators watched microscopic dramas unfolding in real time; as Meegan Kennedy has shown, spectators experienced a mixture of identification and alienation that led them to narrativize the struggles of microscopic creatures who were present with them, dwelling in the live-box in the same room.[55] The experience of observing microscopic life projected on the wall united groups around the excitement of microscopic observation. One speaker recalled giving a lecture on pond life with a projecting lantern microscope during which a Hydra seized a water flea; the entire room gazed transfixed at the struggle between two organisms, and when the water flea escaped, "every man in the room sprang to his feet and joined in a deafening cheer."[56]

The thrill and horror of solar microscope displays were so well known that they became subject to parodies, including William Heath's 1828 illustration of a woman dropping her teacup in "Monster Soup" (see Fig. I.1) and an equally satirical 1838 lithograph of an old woman staring back at the observer in horror after having gazed through the microscope at the "wonderful inhabitants" of a drop of water. This lithograph, printed by William Spooner as part of a series of "Transformations," itself enacted the dramatic and ghastly expansion of vision: when held up to the light, the lithograph reveals the "wondrous inhabitants" of a drop of water as seen through the microscope and projected as if by a solar microscope for view. The ghoulish features of the creatures suggest a comic malice that matches the old woman's fear.

These fears became more pressingly real in 1850, when the botanist Arthur Hill Hassall turned to microscopy to examine the concentration of contaminants in Thames water and uncovered what he understood to be a major crisis of public health. Hassall's illustrated volume, entitled *Microscopical Examination of the Water supplied to the Inhabitants of London and Suburban Districts* (1850), crystallized earlier fears of the water of the Thames by using plates to illustrate how the water provided by each of the Metropolitan Companies "swarms with living productions."[57] Hassall makes no explicit claims about the dangers posed by the presence of specific creatures to drinkers of Thames water. Instead, he relies upon his readers' intuitive fears of contamination by noting that "all living matter contained in water used for drink . . . is to be regarded as so much contamination and impurity—is therefore more or less injurious, and is consequently to be avoided."[58] Hassall's plates visually amplify the threat posed by microscopic life by representing the creatures observed in each sample of water crowded inside a single circle, as if each image were a precise rendering of a single observation (Fig. 3.1). In reality, microscopic life in the Thames was far less dense than these illustrations suggested; Hassall had chosen to compress the results of numerous observations into a single image to maximize visual effect. His illustrations and enumeration of the number of the contaminants in Thames water were highly effective in promoting much needed water reforms. But in his method of presentation, Hassall relied upon a visual syntax that corresponded closely to sensational solar microscope displays.[59]

Plate 1

THAMES AT BRENTFORD.

THAMES AT HUNGERFORD.

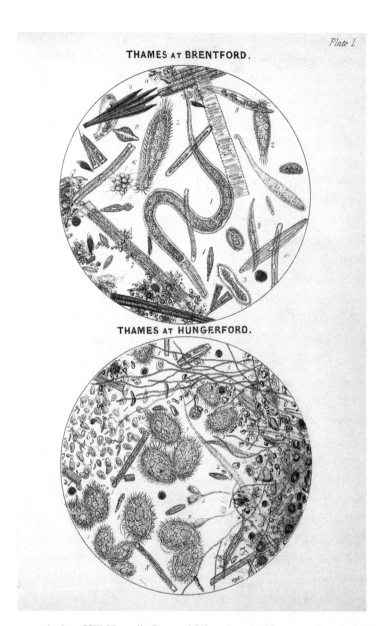

FIGURE. 3.1. Arthur Hill Hassall, *Drops of Water from the Thames at Brentford and the Thames at Hungerford*, in *A Microscopical Examination of the Water supplied to the Inhabitants of London and the Suburban Districts*. London: S. Highley, 1850. Wellcome Collection. CC BY.

Hassall's work implicitly accentuated the permeability of the human body, which blurred the distinction between humans and microorganisms. To gaze through the microscope was to observe human identity enmeshed in and amidst microscopic forms of life, which, popular audiences imagined, were consumed with every bite of food, sip of water, or breath of air. An 1850 *Punch* cartoon of "A Drop of London Water" represents a microscopic stage upon which the identities of humans and microorganisms blur together (Fig. 3.2). In the illustration, the microscopist, complete with his Victorian waistcoat, floats amidst grotesque microscopic "pests," who have human hands and feet. The observer's nose, his natural sensory faculty, has been replaced by the microscope, and he has gained a tail, which furthers his resemblance to the creatures he observes. Even as the cartoon represents the microscopist surrounded by microorganisms, it also implies that such creatures dwell inside him, entering his body with every sip of water that he takes. In the text accompanying the *Punch* cartoon, the writer describes "a little drop of water—of that water which Londoners drink, swallowing daily, myriads and myriads of worlds, whole universes instinct with life, or life in death! . . . Creatures—who shall name them? Things in human shape—in all appearance London citizens . . .—are seen disporting in the liquid dirt as in their native element."[60] The language of the author underlines the disturbing resemblance between humans and microorganisms. Perhaps, the author suggests, the reader should be afraid less because pests are entering human bodies and more because pests reveal the true character of urban Londoners.

The fear generated by popular microscopic displays and examinations of water produced a backlash in which authors and popular audiences criticized the microscope for destroying the innocent enchantment of the natural world and rendering it a place of monstrosity. One author, full of nostalgia for a past of fairy belief, observed: "We used, in our ignorance, to drink water as the purest and simplest beverage; we know now that it is— faugh! A mass of horror, and that, with every glassful we swallow, we convert our stomachs into nurseries for embryo crocodiles, alligators,—in fact for 'All monstrous, all prodigious things / Abominable, unutterable, and worse.'"[61] Positing that science in general and the solar microscope in particular destroys innocence, here figured as the purity of water, the author nonetheless endows science with the imaginative power to unveil a Miltonic

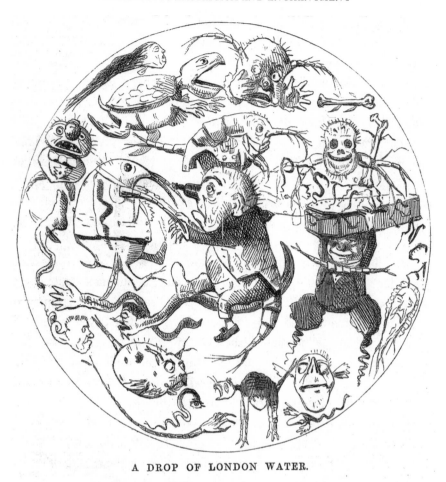

A DROP OF LONDON WATER.

FIGURE. 3.2. John Leech, *A Drop of London Water, Punch* 18 (1850), 188. World
Digital Library. Wellcome Collection. CC BY.

hell in the natural world. Far from being opposed to the imagination, then,
scientific instruments were credited with invigorating ghastly scalar fantasies.

From this point of view, knowledge itself became undesirable insofar
as it brought seemingly senseless disillusionment. In one popular mid-
nineteenth-century story, a missionary to India (or, in other versions of
the tale, the Prussian microscopist Ehrenberg) shows a Brahmin the con-
tents of a drop of stagnant water through a microscope. In Edwin Paxton
Hood's version of the account, the Brahmin sees "myriads of creeping
things in it, a world swarming with life, and was told that he had both

drunken such water, and was in the habit of drinking it."[62] But instead of allowing himself to be discomposed by the knowledge, the Brahmin purchases the instrument and then smashes it to the ground. In destroying the agent of illumination, he rejects the revelations of the microscope as scalar fantasies, visions of horror that fail to bring practical wisdom while considerably disturbing the minds of those who view them.

While sensational microscopic displays both thrilled and frightened audiences, popular scientific writers reassured readers by emphasizing that the dangers posed by microorganisms had been much overstated. Agnes Catlow calmly explains in her book *Drops of Water:* "Many people are disgusted after viewing water through a microscope, and suppose that all water abounds in living creatures, and that, consequently, we drink them in myriads. This is an error: there are none, or very few, in spring water, and, as no one would think of drinking from a ditch, or stagnant pool, where plants abound, there is little to fear."[63] While Hassall insists that spring water became contaminated as it flowed toward London by merging with "unclean and weedy" feeding ditches, Catlow reasserts the agency of her middle-class readers, insisting that their instinctual avoidance of unclean spaces would protect them from drinking contaminated water.[64]

Mary Ward frames the popular horror at the idea of microscopic organisms in drinking water as an alluring but childish fear. Her own study with the microscope, she reports, taught her by "slow degrees" that microorganisms only swarm in stagnant waters. Ward adds, with the tone of a schoolteacher educating her youthful pupils, "I hope you will simply feel pleasure, and not a shade of regret at the loss of a long-believed horror, when you hear that animalcules do NOT inhabit spring-water."[65] In allaying the fears of their readers, both Catlow and Ward suggest that the dangers posed by microorganisms in spring water satisfied a widespread (if unacknowledged) popular desire for the tingling fear of the dangerous and proximate unknown.

Yet even as popular authors like Catlow and Ward used the microscope to dispel their readers' fears, Victorian scientists also realized that the instrument had limitations, which raised the possibility of further life existing beyond its penetrating power. As early as 1830, the German scientist Wilhelm Weber argued that the microscope had literally penetrated as far as possible given the nature of light; it was scientifically impossible, he

suggested, to see what lay in submicroscopic realms of space. In 1873, Ernest Abbé developed a formula that defined the limits of this vision based on the wavelength of light. For the public, this meant that the only way to "see" the smallest particles was to imagine them. Naturalists and writers intuitively reached the same conclusion. In his 1862 *Studies in Animal Life,* George Henry Lewes ponders that "deep as the microscope can penetrate, it detects life within life, generation within generation."[66] Describing the microscope as a kind of peeler that continually unveils new layers, Lewes contemplates a vortex of discovery, an endless sequence of worlds fitted like nesting dolls one inside of the other. He concludes his musings with the question: "In your astonishment you will ask, Where is this to end?"[67] Implicit in his question was an equally thrilling and disturbing possibility: perhaps there was no end to be found.

In the last quarter of the century, the field of microscopic research shifted in ways that excluded amateurs from participation and from the thrill of proximate discovery. Scientists employed ever more sophisticated techniques to detect minute particles—charting, for example, the refraction of light. The fears of microorganisms in water gave rise to new research into the existence of germs, inspired by Louis Pasteur's groundbreaking work, from the 1860s to the 1880s, on fermentation and infection. While Pasteur's work on animate contagion did not reach acceptance until the 1890s, his research inspired others, allowing Joseph Lister to develop aseptic surgical techniques in the 1870s and Robert Koch to identify the specific pathogens that cause tuberculosis and other diseases in the 1880s.[68]

While the microscope in the mid-nineteenth century allowed amateurs to explore and make discoveries in an unseen world, the microscope toward the end of the century disclosed the insufficiency of the tools of science to reveal everything in the natural world. At this juncture, the imagination took on a new significance, not as a means of speculation, but rather as a tool with which to confront the inexplicable. In his essay "Scientific Use of the Imagination" (1872), John Tyndall explains, "I would simply draw attention to the fact that in the atmosphere we have particles which defy both the microscope and the balance, which do not darken the air, and which exist, nevertheless, in multitudes sufficient to reduce to insignificance the Israelitish hyperbole regarding the sands upon

the seashore."[69] Tyndall's assessment is framed in the language of moderation ("I would simply draw attention to the fact"), but his claim boldly uses the imagination to suggest the narrow scope of scientific measurement and the need for imaginative extrapolation in order to conceive of the minutest forms of animal life. Indeed, in an 1876 lecture on fermentation, Tyndall posits that humans are surrounded by myriad other forms, which he terms, "our invisible friends and foes."[70] The microscopist, Tyndall suggests, does not voyage into a separate world, but rather becomes aware of the microscopic organisms all around her, both in and out of her body.

By the 1880s, amateur participation in microscopic research was on the wane. Microscopic societies diminished in size and number, and though popular guides to microscopy continued to be reprinted, fewer guides were written, especially for adults. But the effects of popular microscopic observation endured, establishing the scientific reality of invisible forms of life and expanding general perception of space itself. The microscope had established that the natural world was not a finite domain for exploration, but rather an endlessly unfolding expanse of nestled forms of life. The world of daily life, the microscope showed, was more than it seemed; each leaf, drop of water, and speck of dust became full of potential insofar as it might contain worlds of life and activity. Even as the discovery of germ theory limited the possibility of popular participation in scientific research, it reinvigorated this powerful sense of invisible enchantment, tinged with horror at the limits of human knowledge and control. The wonder generated by microscopic observations was so powerful that it made everything seem possible, even the far-fetched idea of fairyland.

CHAPTER FOUR

FAIRIES THROUGH THE MICROSCOPE

In 1858, the Irish author Fitz-James O'Brien published a short story entitled "The Diamond Lens." In it, a half-mad scientist, Linley, develops a super-powerful microscope whose lens is a massive diamond of 140 carats. Gazing through his new instrument, Linley discovers an exquisite female creature, whom he names Animula. Animula is never called a fairy, but she clearly is one. Her signature characteristics, including the extreme delicacy of her features, the supple grace of her motions, and the sexual coyness of her manner, all point to her fairy nature, and Linley repeatedly refers to her as a "Sylph."[1] Completely infatuated, Linley becomes disillusioned with the world of full-sized life and repelled by all human women (including a renowned ballerina playing a fairy at the ballet). He begins to spend all his time gazing at Animula, but is unable to tell her of his love. One day, he sees her suddenly writhing in agony and, as he watches her die, he realizes that the water on the slide has dried up. Animula has been killed by his scientific instrument and by his lustful self-preoccupation.

O'Brien's idiosyncratic fable, which is commonly described as a work of science fiction but can also be read as a dramatization of a delusion in

the mind of the protagonist, illuminates the surprising imaginative inter-relationship between the microscope and the fairy in O'Brien's native Great Britain. This tale illustrates how the microscope was used both to dispute and to promote the idea of fairyland in the nineteenth century. On the one hand, Linley's experience with the instrument highlights how it only functions properly if used with a rigorous adherence to emerging norms of microscopic use. The scientist's task (in which Linley fails) is to measure and describe the sample with as much detachment as possible. On the other hand, the microscope functions in this tale as the naturalist's instrument of exploration. Gazing through its lens, many natural scientists and amateur users, like Linley, perceived this miniature world as a fairyland of science. Linley's microscope functions both as an agent of enchantment, bringing Animula into view, and as an instrument of destruction, killing the fairy who falls under scientific scrutiny. Linley despairs of encountering Animula through a sense other than sight: if he were gazing upon another planet through a telescope, she could not seem more distant from him. Yet her death occurs as a direct consequence of Linley's carelessness precisely because she lives in his immediate surroundings.

During the nineteenth century, microscopic research was both mirrored and transformed in emerging forms of fairy enchantment. The microscope, understood as an instrument of scientific progress, might be supposed to dispel the superstitions of the past. But, as discussed in the previous chapter, the microscope in the nineteenth century also expanded the natural world, opening up spaces of enchantment and demonstrating the limits, as well as the power, of scientific research and vision. The accepted truth of microscopic observation, which pointed to the possibility of other wonders as yet unseen and unknown, lent fairies a new plausibility. Fairies, most Victorian adults believed, were relics of a superstitious and rural past. But the microscope revealed a sliver of lustrous possibility: What if fairies were real?

Although nineteenth-century fairies are now often regarded as the trivialized offspring of past superstitions, they continued to inspire Victorian artists and writers with a restored sense of enchantment and innocence. The burgeoning interest in fairies related in part to a shift in their imagined size and cultural function. While fairies in previous centuries were conceived of as powerful creatures of folkloric belief, nineteenth-century

fairies were imagined as the miniature, winged denizens of flower buds and nursery illustrations. Believing in fairies, or, more frequently, imagining believing in them, expanded the world by filling it with the proximate possibilities of minute wonders. Indeed, fairy belief functioned like the microscope as a means of expanding the natural world by giving the believer new eyes with which to see it. Just as the microscope showed minute forms of life in the crevices of nature, so too fairy texts, paintings, and illustrations populated mushroom gardens and flower buds with fairies.

Despite the seeming incongruity of the connection, a surprisingly substantial body of texts—both fairy art and literature and popular scientific texts—connect microscopes and fairies. Writers of imaginative literature frequently used scientific discoveries to give credence to their fanciful inventions, while naturalists and lay users readily used a vocabulary drawn from fairy literature to explain the strangeness of the microscopic world. Scientific discoveries and fairy fictions each reinforced the other's imaginative appeal, fostering a half-belief in the existence of creatures—whether microorganisms or fairies—that dwelt just out of human sight. In the process, many Victorians saw fairies through their microscopes and espied natural wonders through their fairy lenses. The obvious difference between empirical science and fairy fancies was, for many Victorians, less significant than their mutual engagement with fantasies of possibility and scale. As fairy texts increasingly blended scientific observation with fanciful imagination, they created a new genre of what I call "fairy science" in which belief in fairies became a natural step toward scientific understanding.

Nineteenth-century fairy authors, artists, and readers suspended their belief in the fictionality of fairies in order to extend the enchanting supposition of their reality. John Ruskin makes this distinction between belief and fancy in his essay on "Fairy Land," where he notes that both adult and child "can always *fancy* what you like," but they "can[not] fancy what you like, to the degree of receiving it for truth."[2] Fancy, for Ruskin, was innocent insofar as it neither promotes false beliefs nor impedes true knowledge. Cultivating a sense of fancy, in his view, not only made the natural world a richer and more enchanted place, but also developed children's capacities of thought and feeling.

This chapter describes the convergence of fairy fancies and microscopic descriptions, which prompted many Victorians to imagine the natural

world and fairyland in tandem, as parallel, and perhaps even as interconnected realms of enchantment. Both the microscope and the fairy generated a sense of wonder by suggesting the possibility of miniature worlds, present in nature but visible only through the physical lens of the microscope or the metaphorical lens of fairy belief. The enchantment of these visions, however, was open only to those who looked for it. The convergence of fairy representations and microscopic observations encouraged a suspension of disbelief and an open embrace of fancy as part of a child's developing understanding of the natural world. Under a license of microscopic fact, fairies enchanted the Victorian world.

Naturalizing the Fairy in Victorian Art

By the mid-nineteenth century, true belief in fairies had essentially disappeared in England after thriving in rural regions of the country for hundreds of years. The fairies of superstition possessed diverse physical forms, but most were described as being about the size of a small child. Victorian folklorists like Thomas Keightley observe that the fairies of England, Ireland, and Scotland "rarely exceed[ed] two feet in height,"[3] while the contemporary critic Carole Silver confirms that the fairies seen by superstitious observers were small but not miniature, estimating their size somewhat more generously as "three and a half feet."[4] The fairies of superstition allegedly trod on the borders of human dwellings and expected regular offerings or gifts from their human neighbors. Sometimes malicious and sometimes indifferent to humans, the fairy was a symbol of humans' vulnerability to powers beyond their control. All this changed in the early nineteenth century, as industrialization and urbanization radically altered the landscape of England. As the population shifted from rural to urban centers, science, not folklore, became the primary means of explaining odd phenomena and experiences. Fairies became the subject, not of tales told by the fireside, but rather of folkloric and anthropological accounts of the possible origins of fairy belief. One group of anthropologists argued that fairies were simply the mythologized memories of other, more primitive peoples, while others postulated that fairies were the faded memory of a diminutive and primitive race of pygmies that had existed at one point in the past. Linguists speculated that fairies evolved out of a mis-

construction of metaphorical language about the gods, while other scholars considered the possibility that belief in fairies might have originated from hallucinations caused by sunstroke or heat.[5] The fairy had become a symbol of naive superstitions and inherited beliefs, contemplated with a sense of detached scientific and cultural superiority.

Victorian writers crafted nostalgic narratives about the end of fairy belief, often blaming empirical science, as the emblem of unimaginative reason, for the "death" of the fairy as the symbol of imaginative fancy. The world, for many writers, was fundamentally impoverished by this shift toward mechanistic explanations for the world. One writer for *Household Words* decried, "What have I done that all the gold and jewels and flowers of Fairyland should have been ground in a base mechanical mill and kneaded by you—ruthless unimaginative philosophers—into Household Bread of Universal Knowledge administered to me in tough slices at lectures and forced down my throat by convincing experiments?"[6] Laboratory scientists were described as the particular enemies of fairy belief because they prioritized the accrual of knowledge over any sense of reverence for the mysteries of the world; they used their microscopes for "looking into things as they are not meant to be looked at and seeing them as they were never intended to be seen."[7]

At the same time, scientific discoveries brought with them their revelations about proximate forms of invisible life, presented not as beliefs but as empirical facts. In his posthumously published memoir, *Early Reminiscences, 1834–1864* (1924), Sabine Baring-Gould describes: "For untold ages our ancestors had believed in a fairy world . . . but, almost suddenly, that is to say, in my lifetime, belief in the existence of pixies, elves, gnomes, has melted away; and in its place a door has been opened, disclosing to our astonished eyes a whole bacterial world, swarming with microbes, living, making love, fighting; some beneficial and others noxious—an entirely new world to us. . . . We have cast aside Oberon, Titania, Robin Goodfellow, . . . [and] [t]heir place has been usurped by the Bacilli, by Schizophyta, . . . and Spiro bacteria. . . . Scientifically we have gained much. Imaginatively we have lost a great deal."[8] Marking the cultural movement from superstitious belief to scientific sight, Baring-Gould emphasizes the rapid dissolution of tradition in the face of microscopic discoveries. With the end of fairy belief, he notes, comes the loss of a rich cultural and literary imaginary for

which the microscopic world offers no replacement. As he rhetorically queries, "What Shakespeare of the future will think of giving us a Bacteriological Midsummer's [*sic*] Night's Dream?"[9]

While Baring-Gould nostalgically mourns the disappearance of belief in the child-sized fairy of superstition, he also describes microscopic creatures possessing the same characteristics that he formerly ascribed to the fairy. In his account, bacteria exhibit personified behaviors ("living, making love, fighting"), possess exotic names (Bacilli, Schizophyta, Spiro bacteria), and relate ambivalently to humans ("some beneficial and other noxious"). Far from differentiating microscopic particles from their fairy predecessors, Baring-Gould describes the creatures found under the microscope as fairies on the bacterial scale. Implicitly, his reminiscences suggest that the same scientific discoveries that eliminated belief in the child-sized fairies of superstition also opened up the scientific possibility of fairies on a microscopic scale. The miniaturization of the fairy around the turn of the nineteenth century extended the fairy's imaginative life by tying fairy imaginings to microscopic discoveries.

Miniature fairies attained cultural prominence in the nineteenth century, but they had originated several centuries earlier as a literary device that figured the poet's fanciful imagination. William Shakespeare first conceived of miniature fairies in Mercutio's Queen Mab speech in *Romeo and Juliet* (1597), where he conjures a vivid image of Mab's minute size: "In shape no bigger than an agot-stone / On the forefinger of an alderman."[10] Three years later, in *A Midsummer Night's Dream* (1600), Shakespeare used full-sized actors onstage to play fairy roles even as he described fairies poetically as miniature denizens of the natural world—his fairies use acorn cups as hiding places, bat wings as coats, butterfly wings as fans, and bumblebee thighs as torches.[11] Shakespeare's poetic vision of the miniature fairy captured the imaginations of his contemporary poets and fostered an enduring association between the fairy and the poet's internal imaginative faculty.[12] As Margaret Cavendish speculated in 1653, "Who knowes, but in the *Braine* may dwel [*sic*] / Little small *Fairies*; who can tell?"[13] In the eighteenth century, Alexander Pope added the concrete feature of "insect-wings" to his fairies or "Sylphs" in *The Rape of the Lock* (1717).[14] This detail captivated the imagination of artists, prompting Henry Fuseli to depict the titular subject of *Robin Goodfellow-Puck* (1787–1790) with bat-wings.[15] A few years later,

Thomas Stothard first represented fairies with butterfly wings in his 1797 illustrations for Pope's poem. Stothard's illustrations gave vivid visual form to the heretofore abstract conceit of the miniature fairy and established the fairy in the public's imagination as a figure halfway between miniature human and personified insect.

Stothard's image of the butterfly-winged fairy aligned the miniature fairy with the burgeoning disciplines of scientific naturalism in general and entomology in particular. According to an often reprinted story (first recorded by Stothard's daughter-in-law in her 1851 biography of Stothard), it was a friend who first suggested to Stothard that he paint Pope's sylphs with butterfly wings. "'That I will,' exclaimed Stothard; 'and to be correct, I will paint the wing from the butterfly itself.' He immediately sallied forth, extended his walk to the fields some miles distant, and caught one of those beautiful insects."[16] Stothard's concern with being "correct" to nature while painting an imaginary fairy highlights a paradox that would become crucial to popular conceptions of the miniature fairy throughout the nineteenth century: even though the Victorians knew that miniature fairies did not exist, they nonetheless imagined them as a spur to naturalist inquiry, situated amidst a fully realized natural world. Stothard's own experience studying butterflies for his fairy illustrations led him to become an avid naturalist and an amateur expert on butterflies.

Following Stothard's lead, artists blended naturalistic observation and fanciful imagination to represent the fairy as a symbol of the wonders of the natural world. During the golden age of fairy painting, from 1840 and 1870, fairies were portrayed amidst realistic depictions of nature that were filled with scientifically exact renderings of plants, flowers, and insects.[17] John Anster Fitzgerald (sometimes dubbed "Fairy Fitzgerald") painted fairies throughout the 1850s and 1860s in primitive, almost animalistic, conflict with the natural world. Some of his fairies are shown cruelly tormenting robins (*The Captive Robin* [1864]), bats (*Fairy Hordes Attacking a Bat* [date unknown; Fig. 4.1]), and mice (*Chase of the White Mice* [1864]), while others peacefully coexist with larger creatures, including rabbits (*A Rabbit Among the Fairies* [date unknown]) and squirrels (*The Wounded Squirrel* [date unknown]). In *Fairies in a Bird's Nest* (ca. 1860), Fitzgerald doubly locates his fairy subjects in the familiar natural world, first by painting three fairies nestled in a bird's nest, and second by surrounding the painting with a

FIGURE. 4.1. John Anster Fitzgerald, *Fairy Hordes Attacking a Bat,* n.d., oil on canvas. Private Collection, n.p. *The Athenaeum.* Web.

twiggy frame, as if to suggest that the observer herself must enter into the bird's home to see the fairies there. In John G. Naish's *Elves and Fairies: A Midsummer Night's Dream* (1856), butterfly-winged fairies flock around blooms that are readily recognizable from Victorian gardens, while an elf rides atop a minutely depicted moth.

The scale of fairies and their proximate otherness often led authors and artists to represent them as insect-like both in their ubiquity and in the diverse strangeness of their forms. Seeing them required a microscopic attentiveness not just to the fairies themselves but also to the natural world. In Richard Dadd's late fairy paintings, for example, the density of fairies and of foliage renders some figures nearly impossible to distinguish with the naked eye. Beneath the feet of the titular fairies in Dadd's painting *Contradiction: Oberon and Titania* (1854–1858), tiny fairies fight and dance almost invisibly against a monochromatic color palate of leaves, flowers, and insects. His second masterpiece, *The Fairy Feller's Master Stroke* (1855–1864), bewilders the observer with its mass of detail, as figures on various scales compete for attention (Fig. 4.2). Tangled grasses cover the

FIGURE. 4.2. Richard Dadd, *The Fairy Feller's Master Stroke*, 1855–1864, oil on canvas, support 54 × 39.4 cm. Tate. Photo © Tate.

painting and obscure the figures, giving the observer the impression of snatching a glimpse of a forbidden realm, where fairies swarm like insects in the undergrowth. Dadd's microscopic precision in painting, like the microscope itself, reveals enchanting and disturbing secrets hidden within the natural world.[18]

At times, fairy paintings paid more attention to the details of nature than to the fairies themselves. Early critics of John Everett Millais's painting *Ferdinand Lured by Ariel* (1849–1850) marveled, not at the fairies in the scene, but rather at the twenty varieties of grass the artist painted with "a microscopic elaboration."[19] Fairies offered a pretext for such close scrutiny, changing the scale on which artist and viewer considered the natural world. John Ruskin speculated of Sir Joel Noel Paton's Shakespearean fairy paintings that "the artist intended rather to obtain leave by the closeness of ocular distance to display the exquisite power of minute delineation . . . than to arrest, either in his own mind or the spectator's, even a momentary credence in the enchantment of fairy-wand and fairy-ring."[20] Fairy painting, in Ruskin's framework, counterintuitively allows an accurate rendering of the details of the natural world, despite the fictionality of its main subject.

Other audiences responded to the profusion of fairy life in these paintings with a quasi-scientific attempt to grapple with the strangeness of these forms by enumerating them. On September 12, 1857, Lewis Carroll famously counted 165 fairies in Joel Noel Paton's painting *The Quarrel of Oberon and Titania* (1849).[21] In calculating the density of fairy life in the painting, Carroll mimicked the action of those microscopists who sought to calculate the number of microscopic organisms in a square inch; it is easy to imagine Carroll, with his mathematical nature and his sense of whimsy, multiplying outward to calculate the population of fairyland in England.

Fairy paintings were understood by many artists as a testament to the vividness of the poetic and visual imagination; painting fairies with the same level of detail as the plants and animals that surrounded them offered proof of the artist's visionary skill.[22] In *The Artist's Dream* (1857), John Anster Fitzgerald depicted both the sleeping figure of the artist in the real world and the artist's imagined self asleep. In his dream, the artist is painting a butterfly-winged fairy queen as ghoulish elves or goblins crown him with laurels and fill his pockets with gold; in the real world, the same

creatures hover around the sleeping artist. Fitzgerald's painting clearly figures his ambitions of winning praise and a fortune as a fairy artist, but his work also suggests that artists are always surrounded by fairies as figures of the artistic imaginary. Despite the widespread articulation of artistic loss at the decline of belief in fairies, fairy painting reached its height after this decline, not before. Thus even when the enchantment of fairyland was "half-dispelled" by a loss of true belief, as one writer for *Household Words* observed, "elfin lore still grace the poet's lay, / And his heart's home be still in Fairyland!"[23] Disbelief in the reality of fairies paradoxically renewed artistic engagement by allowing them to be imagined in an infinite number of ways. In the active space of fancy between belief and disbelief, artists discovered proliferating possibilities for conceiving of fairyland in ways that gave artists new eyes to see the natural world as well.

Popular illustrations in children's books lack the exquisite detail and painterly skill of more famous works, but the attention to botanical and entomological features remains. Artists often represent fairies mimicking human behaviors with the peculiar natural resources appropriate to their scale; in Richard Doyle's fanciful illustrations for *In Fairyland* (1870), fairies ride in butterfly coaches through the sky (Fig. 4.3), move in long processions atop snails, and joust with beetles as their steeds.[24] The texts accompanying these illustrations emphasize the shift in scale; an 1867 poem by E.S.A. describes one fairy feast as consisting of

> A roasted ant that's nicely done,
> By one small atom of the sun;
> These are flies' eggs in moonshine poach'd
> This a flea's thigh in collops scotched . . .
> This is a dish entirely new,
> Butterflies' brains dissolved in dew;
> These lover's vows, these courtiers hopes,
> Things to eat by microscopes.[25]

E.S.A.'s invocation of the microscope at the close of this passage suggests a transformation of vision and scale that allows the reader to experience nature as an otherworldly place of fairy enchantment; once transported through the instrument's lens, the reader might join the fairies at a feast of delicate morsels prepared by the sun and moon.

The Fairy Queen takes an airy drive in a light carriage, a twelve-in-hand, drawn by thoroughbred butterflies.

FIGURE. 4.3. Richard Doyle, illustrator. *The Fairy Queen Takes an Airy Drive in a Light Carriage, a Twelve-in-hand, drawn by Thoroughbred Butterflies*, in *In Fairy Land. A Series of Pictures from the Elf-World*, by William Allingham. London: Longmans, 1870. Courtesy Huntington Library, San Marino, California.

The placement of fairies in the natural world also distanced them from the adult experience of Britain's rapid industrialization and urbanization, associating them instead with an imagined rural space of nursery fantasies and past beliefs. The fairy's loss of stature was widely understood to align the fairy with the child herself. This alignment was, of course, a cultural association rather than a natural one: children are not small-scale winged versions of adults. But it was sustained by the fact that fairies and children both were separated by their scale from the world of adult life.[26] By the same logic of scale, parents and educators alike understood fairy faith as a harmless belief for infants, one that would naturally pass away as the child grew in age and size. Just as English civilization, it was imagined, had "matured" beyond belief in fairies and could look back with nostalgia, so too the individual child would progress naturally

into a state of rational adulthood, none the worse for having cherished a childish faith in miniature creatures with wings who lived in flower blossoms.[27] Whereas Edwardian adults like Sir Arthur Conan Doyle fervently and vocally defended the reality of the flower fairy, Victorian adults more moderately dwelt on the idea of the fairy as a known fantasy that nonetheless added an element of enchantment to the natural world.[28]

Preserving a belief in fairies in children became a symbolic means to preserve childhood itself as a period of perceived innocence. Victorian adults cherished the fairy beliefs of their children as symbols of nostalgia both for their own childhoods and for their cultural past. Fairy belief was, in the words of one writer for *The Living Age*, "the exclusive prerogative, the divine gift of childhood, wholly to enjoy and half to believe these delightful fictions." To deprive a child of the fanciful fairy fictions of childhood would be a "presumptuous rebellion against nature," by which the overreaching adult attempted to sever the child from innocence itself.[29] This rhetoric nostalgically recalls Romantic visions of childhood as a period of simplicity and idyllic innocence.

Even as Victorian adults became increasingly engaged in defending children's belief in fairies, fairies themselves were seen as guarding the moral uprightness of the nation. They were thought to serve as exemplars, teaching children kindness to animals and refinement of manners and doling out rewards and punishments in the form of dreams.[30] In *The Fairies' Favourite, or the Story of Queen Victoria told for Children*, written by T. Mullett Ellis for Commemoration Day in 1897, a group of fairies protect Queen Victoria through every trial of her life, first thwarting an assassination attempt using orange peels by the evil "Grumble-land" (an obvious caricature of Victoria's uncle, the Duke of Cumberland), and then finding her a worthy partner and husband in the form of Prince Albert.[31] By commemorating Queen Victoria's Diamond Jubilee as an occasion marked by the fairies' blessing, Ellis reframes national history through a lens of enchantment, crowning the queen's long reign with the blessing of her fairy protectors. Her fairy protectors confirm the purity and justice of her reign, aligning it with the order of the natural world. While the fairies add a layer of enchantment to a familiar history, they also, more importantly, substantiate a claim that Victoria's reign is a real fairy story more wonderful than any tale of a distant fairyland.

The absence of any evidence for the existence of fairies permitted a range of artistic approaches. Victorian fairy paintings and illustrations typically represent fairies as being at odds with the increasingly industrialized world of Great Britain. Believers in the fairies of superstition had previously explained the increasing infrequency of sightings by supposing that these fairies dwelt in hidden groves and remote dells, which of course became increasingly scarce as rural spaces became populated. Some Victorian authors and artists, especially toward the end of the century, continued this tradition, often representing a single fairy with the nostalgic title "the last of the fairies."[32] For other authors and artists, however, the very fictionality of fairies opened up the imaginative possibility of their ubiquity. Because the fairy was an acknowledged fantasy, it became possible to claim, as the children's author J. F. Charles put it, that fairies were "everywhere and nowhere in the world around you"—present everywhere in the imagination and nowhere in fact.[33]

The Invisible World of Fairyland

Victorian fairy texts simultaneously imagine fairies nestled within every minute crevice of the natural world and acknowledge the reality that no person, however observant, will ever find a fairy in his or her flower garden. Fairy literature addresses this paradox by envisioning a veil, which is alternately conceptualized as the limitations of human vision or as the insufficiency of the human imagination, separating fairyland from the human world. Once a person passes through the veil by embracing the possibility of fairies, the entire world becomes enchanted, infused with the glow of fairy life and activity. Children's picture books and fairy illustrations transport the reader imaginatively into the fairy's miniature world. From the moment the child opens a fairy book, she sees the familiar natural world on a different scale through the lens of fairy experience. The changing seasons mark the fairy's maturation; fairies peek out from new blooms in the spring and tumble from falling leaves in the autumn. Plants and trees become the materials from which fairies craft clothing and tools; fairies dress themselves in woven leaves, wear inverted blooms on their heads, and use nutshells as carriages. Insects, birds, and rodents all gain personalities that must be harmonized by the fairies' influence; glowworms and fireflies are rewarded for faithfully

lighting the night air, while spiders are forced to relinquish their captured prey.[34] The plots of these tales are highly conventionalized, but they delighted child readers by making the natural world a space of enchantment.

Just as fairy art used the scale of fairies to magnify the proportions of the natural world, putting insects, leaves, and grasses on view alongside fairies, fairy literature used the shift in scale to promote an expansion of the imagination. In shorter, illustrated works, this expansion was often marked by the visual experience of transportation; the child who gazed at the rich illustrations in these tales tumbled imaginatively into fairyland. Longer works marked this expansion by showing the protagonist on a journey through a new realm that had opened up. In Jean Ingelow's novella "Mopsa the Fairy," the young "Captain Jack" enters fairyland atop an albatross with three miniature fairies in his pocket and sails in a boat, watching the fairy Mopsa grow until she becomes large enough to be a queen. Vane, the protagonist of George MacDonald's fantasy novel *Lilith* (1895), meets a sexton upon passing into fairyland, who teaches him that the human world and fairyland coexist in the same space. The thought bewilders Vane, who reflects: "I was lost in a space larger than imagination; for if here two things, or any parts of them, could occupy the same space, why not twenty or ten thousand?—But I dared not think further in that direction."[35] Vane's logic mirrors the fears raised by microscopic observation; in delving into another world, whether on the microscopic scale or in the fairy plane, the explorer extrapolates to imagine innumerable other layers of beings and life. Where, Vane seems to ask, is it all to end?

Fairyland is often represented as a place that is difficult to enter and still more difficult to remember clearly upon leaving. Indeed, the forgetfulness of the protagonists of fairy stories and novels emphasizes that human limitations (whether of sight, memory, or belief) create a veil separating fairyland from the human world. At the end of "Mopsa the Fairy," Captain Jack is ejected from fairy court and wakes up in his bed at home, where he rapidly forgets his journey and the heroism he showed there.[36] Similarly, the titular fairy in Kipling's fairy novel *Puck of Pook's Hill* (1906) repeatedly takes the child protagonists on adventures, but erases their memories at the end of each one. The children's forgetfulness draws a veil over fairyland that protects its enchanted borders even as it impoverishes the children's lives.

Fairy texts with adult protagonists depict their lead characters actively struggling to distinguish between reality and fantasy after returning from fairyland. In *Sylvie and Bruno* (1889), Lewis Carroll shows an elderly protagonist increasingly confused about the distinction between the real world and fairyland, while H. G. Wells depicts a man forever dulled after a brief stay with the fairies in "Mr. Skelmersdale in Fairyland" (1903).[37] The uncertainty about memory and about reality itself that runs through these tales serves not to dim the seeming reality of fairies, but rather to challenge the cultural certainty that fairies do not exist with the tingling possibility that the Victorians had merely forgotten them. Such forgetfulness, some authors imagined, made humans vulnerable by playing to a hubristic belief in their rational understanding of their surroundings; disbelief in fairies impoverishes their understanding of the world. In *Puck of Pook's Hill*, Rudyard Kipling describes fairies (or "Pharisees" as the teller pronounces it) gathering in hordes in a marsh by the shores of England, trapped by the peripheries of urban Britain but unable to leave the land that no longer believes in them. The fairies in Kipling's tale function like germs, bringing disease to the human inhabitants of the region, who neither see nor believe in them. Only when an elderly woman allows her deaf and blind sons to take the fairies across the shore to the continent does she feel, around her feet, a massive wave of invisible "liddle feet patterin' by the thousand" down to the shore.[38] Remembering fairies, not forgetting them, restores health and tranquility to the region.

Fairy stories and novellas have never been taken very seriously as literature, but this subgenre thrived throughout the Victorian period precisely because it created a space of wonder where the facts of science and the fancies of the imagination existed side by side. Critics often decry the butterfly-winged miniature fairy as an uninteresting figure of rote repetition; they note that the sanitized sentimentality of the miniature fairy palls in comparison with the primal power of the fairy of superstition.[39] The best critical accounts of the nineteenth-century fairy attempt to show that it embodied deeply held anxieties, either about urban life, as Carole Silver suggests, or about man's place in the natural world, as Nicola Bown argues. But while the fairy certainly reflects these anxieties, standard fairy literature overwhelmingly harmonizes discordant elements of Victorian culture in ways that critics have overlooked.

The Victorian fairy bridges cultural divisions between science and fantasy, past and present, adult and child, to foster a sense of imaginative possibility. The fairy was a creature of frivolous fancy, which was ostensibly being eliminated by the rise of empirical science; but it was also a symbol of scientific wonder, which fostered an interest and engagement in the natural world. Fairy literature typically espoused a form of natural theology, using the wonders of the natural and fairy world to promote Christian belief in the power of God; but later Victorian representations of the fairy also reflected Darwin's influence by breaking down the separation between humans and lower animals, including both insects and microorganisms, and by representing the violent struggle for life. Fairies were figures of nostalgia tied to the folk beliefs of England's past, but they were also figures of disenchantment, marking the end of true superstition and the repackaging of these past beliefs as childhood fancies. Representations of the fairy were typically directed at children, but the fairy facilitated children's transition into adulthood by developing their appreciation of the natural world. The fairy was typically represented as a singular figure of innocent reassurance, reinforcing Victorians' belief in the beauty and magic of the world. But fairies also appeared en masse as figures of dark foreboding, recalling the masses of microscopic particles and germs that Victorians were increasingly coming to fear as "far more real messengers of evil than poet or painter ever imagined."[40] The fairy thus simultaneously emblemized naive belief *and* natural science, human supremacy over insects *and* the harmonious mingling of higher and lower orders of creation, remembering past beliefs and superstitions *and* forgetting them in favor of current discoveries, remaining a child forever *and* maturing into an adult. Fairy stories did not answer or resolve these contradictions, but created a minute and fantastic space of fantasy where the contradictions did not matter.

The fairy fostered a sense of wonder in Victorian readers and viewers because it offered a sense of immanent possibility in a world that seemed increasingly governed by fixed laws of science and reason. The diverse connotations around the figure of the fairy can make much of fairy literature seem scattered and at times incoherent. But these varied connotations also signal how fairy literature relies not on a narrow understanding of facts but rather on an expansive belief in possibilities. By mingling natural science and imaginative fancy, the fairy allowed the reader or viewer

to conceive of worlds of wonder, hidden within the mundane realities of daily life.

Fairy Science

Victorian lay audiences imagined microscopic creatures and miniature fairies in strikingly analogous ways. Both types of creatures were minute in size, fantastic in appearance, profuse in number, and invisible to the naked eye. Looking through the physical lens of the microscope or the metaphorical lens of fairy belief, the observer had her conception of the world broadened from a limited set of physical realities to an unlimited set of imaginative possibilities. Both microscopes and fairy texts (including both printed and visual) offered partial glimpses into an alternative world existing on another scale; the mechanical limitations of the microscope allowed the user to see only so far, while the subjectivity of fairy fancies meant that anything might happen or exist outside the depicted region. In the imaginations of many Victorians, these worlds stretched out beyond the bounds of representation. From the observation of a single speck of dust, the amateur microscopist envisioned billions of microorganisms populating the air she breathed; and from the description of a fairy banquet, the child imagined all the social rituals of the fairy world.

To the present-day reader or critic, the microscopic world and fairyland seem fundamentally divided by the nature of their claims: microscopic slides demonstrate scientific facts, while fairy stories or illustrations fabricate imaginative fictions. For many Victorians, however, the distinction between science and fantasy was less significant than their mutual investment in imaginatively conceiving a world beyond natural vision. While some scientists opposed the use of wonder or fantasy as unreliable and even antiscientific, many naturalists and popular scientific writers conceived of science as a tool that opened up vast imaginative frontiers. Far from being a force of plain fact that dispelled mystery and beauty, science could enhance an individual's appreciation for the marvels of the natural world by authorizing the user to imagine minute marvels throughout it.

For many Victorians, then, the microscope offered an enchanting lens; it was, as one author put it, "that fairy gift, which at once multiplies, almost indefinitely, our powers of vision."[41] Popular awe gave the instru-

ment an otherworldly aura and obscured its real limitations of focus and magnification. Vision, after all, had increased exponentially. After an extended discussion with a working-class man about the microscopic world, Mary Ward describes her interlocutor querying, "It is beautiful—but, *is it true?*" "Yes my friend," she imagines replying, "'it is true; it is itself a truth and a reality.' And in this consists the charm of microscopic research."[42] Even as she emphasizes the veracity of microscopic observation, Ward implies its peripheral importance in her pitch for lay users: she is teaching her audience to use the microscope in order to endow them with a sense of wonder at the minute world of microscopic life. For Ward, the essential purpose of microscopic research is not truth but beauty.

Popular microscopic texts often invoked fairyland in order to underline the kinship between the wonders of science and those of fantasy and to distance popular science from the stereotype of dry empiricism. Microorganisms and Victorian fairies bore no physical resemblance to one another, and fairy literature and art never attempted to imagine fairies literally as microscopic organisms. Yet again and again, science writers urged their readers to look through the microscope's lens and see fairies. Henry Slack, a president of the Royal Microscopical Society, described how microscopic fauna resembled "a tree from fairy-land, in which every leaf has a sentient life," while Mary Treat, a naturalist and correspondent of Darwin, characterized tree vorticella as "marvelous, beautiful, fairy creatures."[43] Whereas some scientific texts urged the amateur to take and record numerical observations that were understood to be objective, a substantial body of works emphasized the importance of capturing the user's subjective experience of wonder and awe. An objective description would fail, by this measure, to transmit the sheer weirdness of the spectacle being observed. In his speech "How to Study the Natural World," Kingsley observes, "in the tiniest piece of mould on a decayed fruit, the tiniest animalcule from the stagnant pool, will imagination find inexhaustible wonders, and fancy a fairy-land."[44] Although Kingsley states that the microscopic world is fairyland as if it were an accepted fact, he is really instructing the reader on how she *should* see the natural world. For Kingsley, the observation of microscopic realities offers only a starting point; from these observations, the observer's imagination might sprawl outward to conceive of an entire, fantastic world of fairyland.

Comparing microorganisms to fairies involved, not just seeing similarly strange and enchanting features, but also observing the creatures' ability to change inexplicably in size and shape. Part of the appeal of both the microscopic world and of fairyland lay in their mutability; to gaze at the world was not to see a static landscape but an ever-changing field of life. Treat, for example, first asserts that the microorganisms are "far more beautiful than those [fairies] you read of in fairy-tales," and then adds that "our fairies in this real world pass through as many forms or transformations as the most approved fairy of the imagination could desire."[45]

Even as popular scientific texts analogized microorganisms and fairies, fairy texts insisted on the compatibility of fairy fancies and true scientific principles, although not common scientific practices. While fairy believers were frequently accused of seeing things that didn't exist, fairy texts reversed the accusation and claimed that scientists often *failed* to see what lay right before their eyes, usually because of their overreliance on the alleged "facts" of science. In May Kendall and Andrew Lang's novel *That Very Mab* (1885), a scientist captures the titular queen of the fairies, but is unable to recognize her as a fairy. Against the urging of his son, who grasps that Mab is very much alive, the scientist prepares to impale her in order to examine her with his microscope, and Mab barely escapes with her life. Even after seeing Mab at close range, the scientist remains unenlightened and stuck in his own narrowly scientific presuppositions.[46] Virtually the same scene is played out more famously in Charles Kingsley's fairy novel *The Water-Babies* (1863), where an empirically minded professor catches the water-baby Tom in his fishnet. Having previously told his granddaughter that water-babies do not exist, the naturalist half-intentionally drops Tom back into the water and denies ever having seen him.[47] In an almost precise refutation of Mary Ward's claims about the beautiful truth of microscopical research, the professor "had not the least notion of allowing that things were true, merely because people thought them beautiful."[48] Both texts suggest that empirical science has eradicated the ostensibly groundless superstition of belief in fairies only to replace it with an equally tenuous conviction in scientific principles that overrides the evidence of the senses. In one illustration for Kingsley's novel, Linley Sambourne depicts the scientists Richard Owen and Thomas Henry Huxley peering into a sealed bottle with a water-baby inside, the flexibility of both scientists being tested by the inexplicable figure before their eyes (Fig. 4.4).

FIGURE. 4.4. Linley Sambourne, *Richard Owen and Thomas Henry Huxley Examining a Water Baby,* in *The Water Babies,* by Charles Kingsley, 80. London: Macmillan and Co., 1885. Courtesy Huntington Library, San Marino, California.

The opposition between fairy belief and scientific rationalism crucially does not signify an opposition between fairies and science, but rather a diverse range of approaches within science itself. Several prominent popularizers, including Kingsley, noted that the principles of science required the scientist to keep his or her mind open to every possibility—even those that at first seemed completely absurd. As Kingsley observed, "no one has a right to say that no water-babies exist, till they have seen no water-babies existing; which is quite a different thing, mind, from not seeing water-babies; and a thing which nobody ever did, or perhaps ever will do."[49] Mary Everest Boole, in *The Preparation of the Child for Science* (1904), took the argument one step further by describing the process of scientific reasoning itself as akin to the fantasy-making impulse behind fairy stories. She observed, "every scientific man worthy of the name . . . spends a good part of his time in that grown-up sort of fairyland, the world of scientific hypothesis. . . . We have each a private domain of our own in that Unseen World; and no mortal has the right to deny the truth of what another says he sees there."[50]

Popular scientific literature in the second half of the nineteenth century drew on the association between the microscope and the fairy to construct

a powerful alternative model for gazing at the natural world through the enchanting lens of what Alfred Lord Tennyson first dubbed "the fairy-tales of science" in "Locksley Hall" (1835), which I call, more simply, fairy science.[51] The world could be examined scientifically in different ways, either with the closely calibrated measurements of the micrometer or through the richly imaginative lens of the fairy. Scientific authors of fairy-science texts promoted the possibility that the entire full-sized world of nature would be transformed into a fairyland if the reader chose to gaze upon it through the metaphorical "lens" of fairy stories and fairy belief. In her popular and widely reprinted book, *The Fairy-Land of Science* (1879), Arabella Buckley describes how the wonders of the natural world resemble the wonders of fairyland both in their narrative unfolding and in the suddenness and proximity of magical transformations. Buckley retells scientific occurrences with a narrative flair, recounting, for example, the scientific processes of the crystallization and melting of ice as a scientific version of the tale of Sleeping Beauty and her enchanted court. The instruments of science, including the microscope, suddenly unveil wonders before the observer, proving that the titular fairyland of science "is not some distant country to which *we* can never hope to travel. It is here in the midst of us, only our eyes must be opened or we cannot see it." Citing the naturalistic accounts of fairyland given by Shakespeare's Puck and Ariel, Buckley suggests that the traditions of fairyland actually converge with the wonders of science. Science does not supplant fancies; instead, the wonders of science prove themselves to be "as real as our old friends"—the fairies of fairy tales.[52]

In order to see the fairyland of science, Buckley insists, an individual must undergo a complete transformation of vision. She instructs her reader that she might "enter the fairyland of science" on one condition: that, "[l]ike the knight or peasant in the fairy tales, you must open your eyes . . . everything around you will tell some history if touched with the fairy wand of imagination."[53] Like the microscope, the "fairy wand of imagination" distanced the user from his or her ordinary perceptions of the natural world; just as the microscope opened up a field of view on a new scale, so too the fairy wand of imagination permitted the observer to see nature as a fantastic realm filled with real-world fairy tales. Fantasy emerges, in this model, not by rejecting scientific facts, but rather by viewing them through the lens of the imagination.

Buckley's emphasis notably falls upon the would-be explorer. The writer or scientist may explain the wonders of the natural world, but it is up to the individual child to see them for what they are: as evidence of the fairyland of science. Tools of vision, like the microscope, unveiled the enchantment of other worlds through both a shift in vision and an understanding of the instrument. As the naturalist J.P. urged in 1866, "it is not enough that we are placed in possession of [the microscope]. Like the magic lamp of Aladdin, it is useless unless we understand its properties, and are in possession of the magic spell which can call them forth."[54] Of course, the "magic spell" that unlocked the instrument's powers was not as thrilling as it sounded; the child who wished to learn the proper incantations needed to study the intricacies of the microscope's operation contained in volumes of dry instruction like those written by Quekett and Carpenter and described in the previous chapter. But Buckley posits that technical knowledge goes hand in hand with imaginative understanding to unveil the secrets of nature.

Fairy-science texts do not distinguish between fairy belief and scientific knowledge, but rather depict the child's seamless transition from one to another. A large group of fairy-science texts follow the same plot: a bored and resistant child develops an appreciation for the wonders of the natural world by learning to "look closer" (sometimes with the naked eye and sometimes with the microscope) and to see a fairyland in the natural world. The child's guide in this process is sometimes a miniature fairy, as in the case of *Fairy Know-a-bit; or, a Nutshell or Knowledge* (1866; Fig. 4.5) and *Fairy Frisket: or, Peeps at Insect Life* (1874), both by Charlotte Tucker, and sometimes by a human tutor, as occurs in *Etta's Fairies: A Little Story for Little Folks* (1879) by Crona Temple, *Where Is Fairyland?: Tales of Everywhere and Nowhere* (1892) by J. F. Charles, and *Princess and Fairy; or the Wonders of Nature* (1899) by Lily Martyn.[55] The existence of fairies, importantly, doesn't actually matter; the didactic message of these tales remains the same either way. The important point is that the fairy directs the child's attention to the details of the natural world, where she discovers natural wonders that exceed the promised wonders of fairyland. As George E. Roberts puts it, "whether the tiny creatures have any existence or not, they can be our teachers."[56] Science, in these tales, does not dispute the child's faith in fairies (which most authors assume will disappear with age

FIGURE. 4.5. *The Fairy Mirror,* in
*Fairy Know-a-bit; or, a Nutshell of
Knowledge.* London: Nelson, 1866.
Hathi Trust.

anyway), but rather shows how the marvels of the real world are greater than any fairy marvels the child could imagine. The marvels of nature do not differ from the marvels of fairyland in kind but only in truth.

Indeed, the central premise of fairy-science texts is not that fairies offer a suitable analogy for natural wonders, but rather that natural wonders *are* a form of fairy stories. Thus when Etta exclaims to her Aunt Rachel that the growth of a chestnut tree "is *exactly* like a Fairy story!" her aunt corrects her, "It *is* a Fairy story; but it is a fact nevertheless."[57] Such wonders exceeded any tricks that humans might produce. In his 1869 book, *Madam How and Lady Why,* Charles Kingsley rejects artificial for natural wonders, urging his young readers to "wonder at the right thing, not at the wrong; at the real miracles and prodigies, not at the sham. . . . Wonder at the works of God." Nature, in Kingsley's view, offers a dynamic spectacle exceeding anything that might be staged; as he adds, "The theatre last night was the fairy land of man; but this [Nature] is the fairy land of God."[58]

While the conjunction of the microscope and the fairy initially appears to be no more than an odd happenstance, it in fact demonstrates a star-

tling fact: Victorian popular science and fantasy were mutually engaged in fostering a renewed sense of wonder in an age of scientific enlightenment. This has several important consequences for our understanding of fantasy and science in the Victorian age. First, it highlights that while some scientists saw the imagination as a danger, many regarded it as a critical part of true scientific curiosity. Second, it suggests the importance of fairy art and literature, which has often been critically disparaged as frivolous and trivial, in forming and reflecting Victorian popular responses to scientific discoveries. Finally, it suggests that science and fantasy drew on one another to enhance the appeal of each. Scientists invoked the fantastic in order to capture the imaginative power of their observations, while fairy fictions immersed themselves in a scientific vision of the world to endow their fictions with a sense of reality.

This would no longer be the case by the early twentieth century. In 1904, J. M. Barrie placed Tinkerbell onstage as a bobbing light reflected from a mirror with a bicycle bell for a voice and asked his viewers to clap if they believed in fairies (to save her life).[59] In so doing, he changed the focus of discussions around fairies from observation and imagination to nostalgia and belief. While the Victorian fairy was always accompanied by the adult urging the child to "look closer" at the natural world in order to see it, Tinkerbell was a theatrical trick of lighting that would be revealed as a fraud if the child approached nearer. Nonetheless, Tinkerbell so captured the public imagination that she overshadowed the Victorian fairies who had preceded her. But for the brief half-century before her first appearance, fairy fiction and microscopic truth mingled to produce a unique body of literature suffused with a half-believing, half-doubting wonder at the possibility of invisible worlds of microscopic and fairy life.

Part Three
Miniatures and Childhood

CHAPTER FIVE

IMPERFECT MINIATURIZATION

Toys in the Victorian Nursery

The process by which human creators miniaturize objects has long been governed by a strong sense of proportion and form. From the extraordinarily intricate boxwood miniatures of the Netherlands in the sixteenth century to the contemporary masterpieces produced by members of the International Guild of Miniature Artisans, miniatures are often crafted to mimic precisely the appearance of full-scale objects. Dollhouses rank among some of the most extraordinary of these miniature marvels. Queen Mary's Dolls' House, manufactured from 1921 to 1924, featured thousands of individual objects, including not only furniture, silver, ceramics, and textiles but also around a thousand works of art, seven model cars, a bicycle, circa two hundred books handwritten by the writers themselves, and even a Fabergé mouse. Upon the completion of the house, A. C. Benson stated, "[i]t is a serious attempt to express our age and to show forth in dwarf proportions the limbs of our present world."[1] Whereas the microscope and the fairy opened up new worlds to view, the dollhouse possessed the capacity to represent the entire known world in small. And unlike microorganisms or fairies, each marvelous part of a dollhouse might be held and touched.

As creators of miniatures all know, achieving the effect of a "perfect" miniaturization requires key alterations. Objects reduced to a miniature scale look different. When furniture, for example, is scaled down according to the precise dimensions of full-scale pieces, the pieces do not look right to the human eye; certain parts and proportions must be adjusted in order to attain the *appearance* of a perfect miniature.[2] Contemporary artisans pay careful attention to disguising these traces of difference. The International Guild of Miniature Artisans insists that both the size *and* appearance of miniature furniture should be on miniature scale, usually 1:12, but sometimes 1:48 (quarter-scale) or 1:144. Artisans are enjoined to make their works both realistic and accurate by painting a miniature grain on the wood, creating artificial knot holes in miniature, crafting hardware for the furniture that matches the object's scale, and even scaling the thickness of the finish on the wood.[3] These guidelines suggest an understanding that miniaturization is not just an act of making smaller, but also a form of trickery that acts upon the eye and the mind by erasing the physical demands of creation and obscuring the physical differences between objects on different scales.[4] Photographers make use of the same principles in tilt-shift photography for the opposite purpose, capturing images of full-scale objects or scenes in such a way as to make their photographs *look* like the images of miniature models and not of full-scale life at all. What both examples tell us is that the human eye perceives full-sized and miniature objects differently. To create a "perfect" miniature, craftsmen must at some point trust their instincts and their eyes. As one museum guide to miniature objects notes, "Miniaturization is a process that begins and ends with thinking small. To appreciate such tiny wonders, it is essential to visualize the finished product not as a reduced version of something big, but as something small in its own right and by its own nature."[5] Dollhouse miniatures are based on an essential contradiction; they both *require* a full-scale counterpart (they are defined by their identification with a larger thing) and *refuse* to mimic their full-sized equivalents perfectly.

Prior to the nineteenth century, most dollhouses were constructed for adult women and strove to achieve a form of visually perfect miniaturization that represented domestic spaces and labor. By the end of the nineteenth century in Britain, these precise dollhouses had diminished in number but had also became a rhetorical trope associated with female

confinement in the home, most prominently in Henrik Ibsen's influential 1879 play, "A Doll's House."[6] To live in a dollhouse, for the Victorian woman, was to be treated and seen as a doll—a beautiful object, the passive subject of the male gaze.[7]

The advent of dollhouses designed explicitly for children introduced a new set of rules in which perfect miniaturization ceased to be the goal. Intricate and delicate dollhouses required adults carefully to supervise children's play. In contrast, children might be granted complete access to dollhouses that featured sturdy but out-of-proportion furnishings or homemade parts. Indeed, Victorian observers noted that children seemed to relish playing with unfinished or mismatched dollhouse toys precisely because these playthings encouraged the child to bridge the gap between the imperfect physical reality of the object and its imagined perfection in play. John Ruskin, for example, describes in his essay on fairyland how the child's imaginative capacity is reflected in her preference for toys not too close to life. He writes, "One of the most curious proofs of the need to children of this exercise of the inventive and believing power,—the *besoin de croire*, which precedes the *besoin d'aimer*,—you will find in the way you destroy the vitality of a toy to them, by bringing it too near the imitation of life."[8] Toys, like fairies, were supposed to be key to the child's development precisely because she was involved in the process of animating them. This process of animation involved creating additional elements to fill or adorn the dollhouse or dollhouse doll and of interacting with the space itself. Children could fill their dollhouses with a combination of homemade and manufactured objects and people them with dolls of various sizes, some of which might be small and awkward to pose, others of which might be too large to fit inside the house.

A nineteenth-century child's relationship to her toys was defined less by the realism of the toys than by her scalar relationship to them. The child loomed over her dollhouse in ways that allowed her to manipulate the toy world that she imaginatively set into life and motion. In contrast, a child who played with her proportionally larger dolls often blurred the boundaries of identity between herself and her toy. The equivocal position of the doll was reinforced by its scale; the doll existed neither on the scale of the miniature nor on the scale of the child, but rather occupied an uncertain middle ground that marked the doll as being both like and unlike the

child herself. The indeterminacy of doll play made dolls themselves apt starting points, not for singular narratives, but rather for a range of branching and often contradictory narrative possibilities. Indeed, the instability of doll play allowed the child to engage with her dolls in flexible ways that supported her creativity and curiosity about the world.

It is of course difficult to state with any degree of certainty how Victorian children played with their toys, due partly to the diversity of play practices and partly to a lack of documentation. Some toys, especially dollhouses, were played with primarily in the private space of the nursery, leading Frances Armstrong to speculate that play practices may have followed family traditions rather than contemporary trends.[9] Few records of this play exist. Children, with the Brontë siblings as a notable exception, rarely recorded their games in literary form, and most accounts of children's play are written by adults who may have silently regulated and regularized such play. Memoirs offer windows into remembered practices, although these may be distorted by memory and time, and children's letters to newspapers offer glimpses into contemporary practices, even though these letters were chosen and edited by adults. Fiction also gives suggestions about the nature of Victorian play, as authors crafted accounts that were meant be believable for readers, though these too must be understood as fiction. The difficulty of reconstructing children's play practices is augmented by the fact that Victorian adults were invested in the child's fantasy of doll sentience and in the moral and practical principles they imagined that children would derive from this belief. Adults often, I argue, worked to uphold play practices that supported a fantasy of stable control over children's exploratory practices of play that used the scale and vibrancy of the doll to resist adult-given narratives of the world. Adults were most troubled not by acts of violence against their toys but by children who defied expectations of their innocence by manifesting skepticism of their toys' animation altogether.

This chapter traces the instabilities in children's play with dolls and dollhouses, which hinged upon the child's ability to accept seemingly incompatible possibilities. The child's play with her dollhouse and her doll hinged upon her experience of power by virtue of her relative size and the object's passivity. Through her imagination, the child set the dollhouse into motion and brought the doll to life, entering into forms of

play with both of them that eradicated the differences of scale. As the child became invested in the reality of her play, her own identity became entangled with those of her possessions. The experience of unadulterated power in play, therefore, also became an experience of disintegration and fragility that ultimately required the child to reformulate her understanding of herself.

How to Play with a Dollhouse: Domestic Stasis and Fluid Play

Didactic rhetoric surrounding miniature toys like dollhouses and toy soldiers frequently suggests that these toys prepared children for their adult responsibilities. Miniature toys, writers claimed, taught children neatness and carefulness, skills that could easily translate into domestic responsibilities. Yet in each case the toy marks a shift in perspective from within to above: the girl takes on tasks of domestic management, not from within the home, as her mother would, but rather looking *down* on the dollhouse; the boy wages military actions, not by directing men of his own size, but rather by manipulating posed miniature figures. In both cases, the child is a giant in comparison to the toys with which she plays; she gains pleasure from complete and arbitrary control over a miniature world. "The cleverer I am at miniaturizing the world," Gaston Bachelard posits, "the better I possess it."[10] While adult dollhouse owners often reveled in the experience of possessing a perfect or "clever" miniature, Victorian children reveled in the imperfections of their toys, which opened up possibilities for play.

Dollhouses descend from a long tradition of miniature rooms that stretches back to Egyptian burial rooms. The earliest modern dollhouses, which emerged on the Continent in the sixteenth century, were large wooden cabinets partitioned into rooms and kept by adult women. Furniture and domestic accoutrements filled carefully arranged rooms that represented the spaces of everyday life. In the seventeenth century, cabinet houses emerged across Germany and the Netherlands as objects displayed to signify the owners' wealth. In the Netherlands, dollhouses offered tableaux that represented female space and suggested the fleetingness of life. Dollhouses were envisioned as objects of vice if they became sources of pride, but could also be tools to teach virtue if children learned proper modesty and care for the object.[11] These dollhouses emphasized

rooms associated with female labor: the dollhouses of Petronella Dunois and Petronella Oortman, for example, include kitchens, dining rooms, cellars, linen rooms, "best rooms," lying-in rooms, nurseries, and even pantries, but no bedrooms or studies (associated with masculine activity).[12] The arrangement of these rooms without halls or stairs between them functioned, as Michelle Moseley-Christian has argued, like a series of panels to map out the stages of a woman's life, from childhood, to marriage, through housekeeping and childbearing.[13]

Dollhouses crossed over the channel to England in the eighteenth century. Early British dollhouses, like their Dutch counterparts, were typically constructed for upper-class British women, and sported exquisite details from hand-painted landscapes on the walls to gilded panels, Chippendale furniture, and tiny china and silver.[14] These dollhouses emphasized the home's intimate domestic spaces but occupied prominent public positions in the real home, often at the top of the main staircase. While they were miniature in scale, they were massive in size, far outstripping the proportions of the architectural miniatures of the period. Thus, while the scale model for Uppark house is two feet tall, the Uppark Baby House measures seven meters tall, including a two-foot-high arcade.[15] Intricate, large-scale dollhouses were envisioned, not as tools for play, but as objects for display, showcasing the wealth and taste of their owners and putting female domesticity on view for visitors without actually permitting them to enter domestic spaces.

While dollhouses continued to connote the wealth and status of their adult owners through the end of the eighteenth century, they began to be used as instruments of instruction for children as early as the sixteenth. Wealthy children in the sixteenth and seventeenth centuries were given dollhouses to teach them domestic responsibilities by requiring them to take care of their miniature homes. In 1572, when Anna Electress of Saxony gave her three daughters a baby house, it was the girls' responsibility to keep the home clean and organized and to polish each pewter object in the kitchen, including 71 bowls, 106 plates, eggcups, and spoons.[16] In 1631, the German widow Anna Köferlin purchased a baby house and opened it up to visitors as a didactic tool. On a broadsheet advertising her model home, she urged potential visitors, "look you then at this Baby House, ye babes, inside and out. Look at it and learn well

ahead how you shall live in days to come. See how all is arranged in kitchen, parlour, and bedchamber, and yet is also well adorned."[17] The scale of the baby house made it possible to see in one view all of the tasks set out for the female housekeeper, even as it manifested the confinement of female space and the smallness of female labor. Children had limited access to these dollhouses; they were not expected to play with the houses but to showcase their domestic skills by keeping them orderly and neat.

For many children, even in the nineteenth century, play with dollhouses was so seriously restricted as to render imaginative engagement difficult. Milly Acland recalls how, during her childhood in the 1880s, she and her siblings possessed a large old dollhouse that "always seemed to promise a good spell of play," but failed to live up to this promise. As she explains, "One of us would say: 'Hurrah, it's a real wet day. Let's play the whole morning with the dolls' house.' There had to be a definite decision, because the windowed front of the house was kept locked, and a grown-up had to come and unlock it and latch it back against the wall and tell us to mind and not go breaking the glass. Then, somehow, when we had straightened up the fallen bits of furniture, and tidied up the beds, and had a roll-call of the doll inhabitants, we failed to develop any really amusing game."[18] Acland's account captures a central problem posed by the "perfect" dollhouse. Insofar as the didactic aim of dollhouse play was to maintain a static state of ordered perfection, there was little room for creativity. Children who fulfilled their imagined responsibilities toward the dollhouse had little room for creative play. The first literary representation of children playing with a dollhouse exemplifies this trend. In Eleanor Fenn's *Cobwebs to Catch Flies* (1783), two little girls systematically catalogue and compare the objects in their dollhouses without entering into any sort of imaginative exploration of the same.

When children were given greater access to their dollhouses, they rarely maintained their dollhouses in such strict and perfect order. The earliest known British dollhouse owned by a child belonged to Ann Sharp, who was born in 1691. Unlike Köferlin's baby house, Sharp's dollhouse was not an object of display; some of the furniture was clearly made by Sharp herself, and a piece of paper labeling the house as hers remains pinned to the exterior. When the dollhouse was rediscovered in the twentieth century, several objects were in unusual places; a boy and a

monkey, for example, had been placed together in an adult's dressing room.[19] Other early dollhouses with which children were allowed to play show similar oddities suggestive of children's unknown games; in one, a doll was found under the mattress, while in Mary Shelley's childhood dollhouse, a doll was found in men's pants wearing an apron and lying in a four-poster bed.[20]

Incomplete dollhouses invited children to participate in completing the dollhouse (by creating objects whose proportions might not quite match the scale of the rooms) and to dispel any perceived gap between the dollhouse's actual form and its imagined properties through play. Manufactured dollhouses, which began to rise in popularity around 1850, took a smaller and simpler form than earlier examples, typically featuring a set of rooms on two levels contained within a simple free-standing box.[21] The creation of mass-produced dollhouses, of course, reflected improvements in mechanical production and the development of a manufacturing industry for toys that responded to the growth of the middle class, who possessed income to spend on luxuries like toys. These sturdy and more affordable dollhouses required much less supervision than the handcrafted examples of previous centuries.

More importantly, dollhouses in the latter half of the nineteenth century were increasingly understood less as static spaces for the child to maintain than as dynamic domains through which the child might guide her miniature toys. Late eighteenth-century theories of play, which emphasized the importance of tactile engagement for child development, supported this practice by suggesting that such interactivity fostered the child's growth into a productive adult.[22] By the nineteenth century, children were expected to engage both physically and imaginatively with their playthings. Miniature toys, put simply, were understood to be transfixing to children, not because of the qualities they possessed, but rather because of the details they lacked and that the child therefore was obliged to imagine. As one writer for *Chambers's Journal of Popular Literature, Science, and Art* explained in 1888, "There is not a doubt that the more a child needs to exercise its imaginative faculty with regard to its playthings, the happier it is, and the more chance does it get of bringing its ingenuity and originality into play in its future life."[23] A complete dollhouse gave the child fewer opportunities to exercise her ingenuity and imagination;

an incomplete dollhouse, by contrast, invited her into a form of active play that was considered as preparation for future action.

Indeed, records of nineteenth-century children's play with dollhouses suggest that these toys were animated by perpetual, imagined motion. As previously noted, didactic materials encouraged little girls to create domestic routines for their dollhouse dolls that precisely mirrored their own daily schedules. Dollhouses, in this way, might inculcate their owners with a sense of the importance of routine, care, and neatness. Practically, this meant that the child engaged perpetually in moving objects in an orderly way through the dollhouse space. An article in *The Young Lady's Book* in 1888 describes the "sensible" daily play of one child who kept up a daily routine for the dolls in her dollhouse that mirrored her own schedule: she dressed her dolls each morning, laid breakfast for them, seated the children for lessons (while she undertook her own studies), took them on a walk, seated them for dinner, gave them tea, and put them to bed.[24] Once a year, the little girl even took the dolls to a seaside residence, changing the furniture and filling a basin with water to suggest the sea. "Thus she played," the author opines, "and her little household was as regular as that of her mother's [*sic*]."[25] In this case, play involved the child's enacting with her toys the tasks she also undertook in daily life; miniature and full-scale worlds ran parallel to one another. But the motion of dollhouse life differed crucially from that of the child's real life in its disjointedness: dolls remained stationary (except in cases of falling over) when the child was inattentive or away. In other words, the child's actions were necessary to maintain the fiction and to ensure, for example, that her dollhouse dolls stayed dedicated to their studies while the child completed hers, even though, in her imagination (like the microscopist's imagination extrapolating from individual samples), she saw them as being in perpetual motion even in her absence.

Nineteenth-century didactic texts often encouraged children to spend their efforts in constructing new objects for the interior of a dollhouse, or even in improving its structure. An incomplete or empty dollhouse was an invitation for children to create objects to fill the room. Boys as well as girls became involved in this project; while the dollhouse might appear to be a toy just for girls, the *construction* of the dollhouse could both entertain and enlighten both sexes by teaching them industry and dedication.

Didactic texts like Jane Mill's "How we Finished our Dollhouse" (1876), describe how three children constructed furniture, cups, and saucers from peas, wove carpets from papers, and sewed clothing for dolls. Constructing objects transformed the child into a miniaturist, attentive to the details of an object and transfixed by the static landscape a finished dollhouse represented. Such stasis was, however, in tension with the improvisational motion of children's play. In Juliana Horatia Ewing's *Dolls Housekeeping,* a brother attempts to "improve" his sister's dollhouse by adding a second floor and replacing painted windows with real glass. But his improvements fail to have their intended effect, instead requiring his sister to keep her dollhouse doll in a drawer. "I don't know when I shall be able to play at dolls again" the narrator observes, adding, "I almost wish I had kept the house as it was before. We managed very well with a painted window and without a front door."[26] "We," used here to name the child and her dolls, did not need real windows or another floor; such contributions to the realism of the space might in fact detract from the child's ability to play. Ewing's narrator was perfectly capable of turning a painted window into a glass one and imagining a door without her brother's efforts.

The dollhouse's small scale required children who sought to follow the scripts of didactic play to imagine imperfections away. Dollhouses were not large enough to make rearranging figures inside them easy. In order to manipulate tools in the kitchen, for example, the child had to remove the doll who was ostensibly the one cooking.[27] Because of their small size, dollhouse dolls were also typically identical in features and stiff in form; they were notoriously unable to sit down properly and tended to slide out of their seats onto the floor at unexpected (and often inopportune) moments.[28] To imagine that these dolls looked like real people required the transformative power of the child's mind. Imaginatively enacting a daily routine in miniature therefore required the child to imagine dolls entering spaces into which they did not fit, to ignore disproportions of scale, and to overlook improprieties or incapacities in dollhouse doll behavior.

Children not only imaginatively animated their dollhouse dolls but also conceived of their identities as being fluid. Material evidence shows that the legs of male dolls often got broken, in which case the doll owner often changed the doll's gender, using a long skirt to hide the missing

parts.[29] While didactic accounts of dollhouse play emphasis the desire to reach a static state (or a series of static, repeating tableaux), either by keeping the dollhouse neat or by completing it through decoration, contemporary and retrospective accounts of children's play explain how children imagined their dolls not just moving but also growing older. One dollhouse owner collected a range of dolls of different sizes, which the owner imagined to correspond to different ages: age two, age four, age six, and so on. When the child imagined that her dolls had grown older, she switched their bodies. "Annie," who at age two occupied the smallest doll's body, occupied the second smallest body at age four, and continued to increase in size and age up to adulthood. At this point, the child staged a wedding and started a new dollhouse doll household.[30] While on the one hand this practice suggests a mimicry of the child's own future growth, it also suggests her creative investment in the sentience of her unmoving, miniature toys. If her dolls were supposed to be real, this child realized, they must grow older. To solve this problem, she detached each doll's identity from a single, material form and instead imagined it as passing fluidly (albeit in disjointed bursts of growth) through a series of forms.

This fluidity extended to the child herself, inviting her to enter into the space of dollhouse life despite her physical size that rendered this an impossibility. Nineteenth-century illustrations of dollhouse play typically represent the dollhouse with its rooms exposed to view and with one or two children in front of it. These visual conventions evince the disproportions intrinsic to dollhouse play—a comparatively gigantic child reaches into small rooms. For a child, however, these disproportions were erased through the activity of play. In one illustration for Juliana Horatia Ewing's *Dolls Housekeeping*, the child sits on the floor in front of the dollhouse while her oversized doll lies atop the roof. Both are reaching into the dollhouse that they cannot fit inside (Fig. 5.1). Ewing's protagonist remarks that she is glad the house doesn't have a front door (or a front closure at all), observing, "If there were, I couldn't play with anything, for I should'nt [sic] know how to get inside."[31] Implicit in this statement is the idea that, in the act of reaching into the house, the child "get[s] inside," imaginatively becoming one of the dollhouse's inhabitants as she rearranges effects inside. Another fictional child still more clearly observes, on the completion of her doll-

ELEVATION
PLAN
NEW WING.

We—that is I and Jemima, my doll. (For it's a Doll's House,
Though some of the things are real, like the nutmeg-grater,
but not the wooden plates that stand in a row. You Know,

FIGURE. 5.1. R. André, illustrator. *Jemima and I*, in *Dolls Housekeeping*, by Juliana
Horatia Ewing. London: Society for Promoting Christian Knowledge, 1884.

house, that she and her siblings "feel as though we could almost walk into
it ourselves."[32] The physical impossibility doesn't block the imaginative
leap. Rather, as the child cranes her neck into the space, she not only
bridges the difference of scale but also enters a dollhouse that, however in-
complete in reality, thrums with life and activity in the child's mind.

The dollhouse invited the child not just to observe it from above but
also to enter it, with none of the help that the transporting lens of the mi-
croscope provided. While the dollhouse initially appears to have grounded
the child's thinking in concrete material realities that prepared her for do-
mestic stasis, it also opened her up to fluid possibilities that were initiated
by the objects' failures to live up to her imagination. The child exerted her
imaginative power, not just to make the dollhouse a space of active do-
mestic life (continued imaginatively after the child had moved on to other

things), but also to render life itself malleable. From the outside, a doll's party was less likely to result in the neat arrangement of figures in interior spaces than in dolls splayed across dollhouses, chairs, and tables, with their bodies often failing to conform to the child's will. But the child herself often felt that her power was unlimited. Godlike, the child could make her dollhouse dolls deathly ill and then well again, could plunge the home into topsy-turvy turmoil, could age her dollhouse dolls and then bring back their youth, could recast the identities of individual dolls (and even change their genders)—could, in other words, exert her will over the laws of doll nature and doll life. Far from representing the child's understanding of her miniature toys as mere objects, these practices reflected the child's investment in maintaining a fantasy of her toys' sentience on another scale. Malleability and motion therefore exemplified the Victorian child's engagement in the practices of miniature play.

Durability and Play: Victorian Dolls

While the Victorian child consistently related to her dollhouse from a position of scalar power, she might relate to her doll in a wider variety of ways. First, a child might regard her doll (especially a fashionable French porcelain doll) as an adult, and even as an aspirational vision of the child's future self. British writers often decried fashion dolls as being unsuitable for play; a commentator on the Paris Universal Exhibition of 1867, for example, averred the "total unfitness of most of those [dolls] exhibited in the French portion of the Exhibition to be classed as toys at all."[33] Yet such dolls also represented the pinnacle of doll beauty; dolls with their complete trousseaux of clothing were status symbols both for children and for their parents. Second, a child might consider a doll as her child and subordinate. While adult dolls had long been treated as the children of their owners, the baby doll was developed in the early nineteenth century with the particular intent of allowing the child to cultivate her maternal instinct. Indeed, the creation of baby dolls further diversified the child's ability to mimic adult life in the nursery, by encouraging her to nurse and to put to sleep children of her own. Third, the child might relate to her doll as a peer and friend, taking it with her to lessons, tea parties, social visits, and playtimes.

A child's conception of her doll was often scripted by the doll's partic-ular physical characteristics: her size, the materials from which she was made, and her clothing. Oftentimes, a single doll played multiple roles for the child, sometimes alternating and sometimes simultaneous. Charlotte Mary Yonge describes her sixteen dolls, including "large wooden, small wax, and tiny Dutch," as "my children and my sisters."[34] Yonge was not alone in playing with dolls of disparate sizes at the same time. Because a middle-class child was unlikely to have many large dolls, children who wished their dolls to have friends and companions got creative, imagining that their dolls befriended not just smaller and cheaper dolls but also other toys, animals, and even younger siblings. Poor children were even more creative in crafting dolls for themselves out of rags, sticks, bundles of straw, broken crockery, or even mud.[35]

The Victorians conceived of dolls both as universal playthings and as reflections of the culture in their country of origin. Dolls, many Victorian authors insisted, represented a kind of primal instinct of girls' play. Just as the Victorians conceived of belief in fairies as a vestige of primitive faiths, so too they understood play with dolls to be part of a historical tra-dition of a performance of womanhood that could be traced back to an-cient Egypt and could still be found in the so-called primitive cultures of the present day.[36] Within Western Europe, different nationalities were imagined to specialize in dolls of different types: French dolls were known for being the height of delicacy, beauty, and fashion, while German dolls were known for their craftsmanship, particularly in the medium of wood. Individual doll parts were sent across Europe, and indeed the world, in order to be assembled at their place of sale; papier-mâché heads covered in wax were imported from Germany and sewn to leather bodies in England; glass dolls' eyes, painted black rather than the blue color fash-ionable in England, were exported from Britain to Spanish territories in the Americas.[37] British authors often described how British children pre-ferred dolls from their own country because French fashion dolls were too fragile to endure rough play and German wood carvings were too rigid for easy manipulation. The active—some might say rough—play of British children was considered as a form of national superiority. An au-thor writing for *Household Words* in 1853 explains to a mother who is dis-content with her son's disinterest in a new and expensive German toy,

"[your son] is no German, he cannot sit before a toy, and look at it. In this country, at any rate, children are active things, and a child's toys are only proper toys when they provide materials for action."[38] In order to ensure the child's activity, the toy needed to be one that spurred or scripted action.

Nineteenth-century toy manufacturers, led by French toymakers, produced dolls with extraordinary features that made it increasingly possible to imagine the doll simply starting to life. In 1824, a Parisian mechanic developed the "Pa-and-Ma" doll as a modification of the emerging baby-doll type; when the child raised the toy's arm, she activated an internal set of bellows that caused the doll to "speak."[39] By 1851, the French exhibition of dolls at the Great Exhibition astonished judges and visitors by the startling realism of the toys on display. In his exhibit, Pierre François Jumeau showcased dolls with individual painted eyelashes, eyes that opened and closed, and ball-and-socket joints for smooth movements. Madame Montani's display was celebrated for the care and taste with which her dolls were constructed; the hair, eyelashes, and eyelids, for example, were all separately inserted into the wax, creating an effect of "life-like truthfulness."[40] Meanwhile, German manufacturers took the lead in crafting dolls with powers of mobility. In 1862, Enoch Morrison had patented a walking doll called "the Autoperipatetikos Walking Doll," which moved by means of gears under the doll's skirt. Thirteen years later, in 1875, Louis Schmetzer invented the crawling doll.[41] By 1889, an author in *St. Nicholas* queried: "Are the dolls of this nineteenth century now to talk in earnest, laugh in earnest, cry in earnest, and, for aught I know, cough and sneeze in earnest when they catch cold? And they are not to do all this with little squeaking sounds, such as have disgraced intelligent dolls up to the present date, but with real, human *child* voices, every shade of sound complete?" Answering his own questions, the author replies, "This is wonderful, and very hard to believe; yet it is *true.*"[42] Wonderful, yet true—the formula used to celebrate the wonders of microscopic life (recall Mary Ward)—are used here to suggest the doll's realness.

Such marvelously realistic dolls were well beyond the means of middle-class British children and their families. Madame Montani's dolls at the Great Exhibition in 1851 cost between ten shillings and ten-and-a-half pounds unclothed, and much more in complete dress.[43] Middle-class children in Britain

were most likely to own dolls with papier-mâché heads covered in wax and a sawdust-stuffed canvas body; in 1856, such a doll might cost anywhere between two shillings and eight pence for a dozen to three pounds for a single doll.[44] Wooden dolls remained common, but were no longer crafted individually; while eighteenth-century wooden dolls were typically hand carved, the torsos of nineteenth-century wooden dolls were usually produced on a lathe, which made the doll's front and back identical.[45]

More expensive dolls that mimicked the features and sometimes even the movement and the voice of living persons were also particularly vulnerable to the effects of rough play. Indeed, the very features for which these dolls made them celebrated also made them the frequent victims of intentional or unintentional acts of violence. The noses of wax dolls were easily melted off in front of a fire; a doll made entirely of wax might be cut in half unintentionally by her owner's attempt to tie a ribbon tightly around her waist.[46] Rather than representing a particularly violent impulse on the part of children, as critics like Sharon Marcus have suggested, the abuses of children's play, both intentional and accidental, were widely imagined by Victorian authors to be a natural part of play.[47] If a doll was fragile, it meant that she was unlikely to last long; as Frances Hodgson Burnett observed, many dolls quickly "wore out and only lasted from one birthday to another."[48]

The damage sustained by dolls through play, indeed, was understood not as a fault in the child but as a flaw in the manufacture, which stripped the doll of her capacity to develop an identity and a relationship with her child owner. "The doll of commerce," Alice Meynell notes, "is very heartlessly made so that she often goes to pieces on the very day of presentation. Her brief arm comes off first; it had been ineffectually glued on. Piecemeal she comes apart. She does not preserve such poor individuality as she had, long enough to get a name."[49] Meynell's critique of the "heartless[ness]" of toy makers hinges on a conception of the importance of the relationship between child and toy. To have an enduring identity and a name, Meynell posits, dolls do not require closing eyes or moving limbs, but rather a sturdy physique that can withstand inevitable abuse. Roland Barthes, in his essay on "Toys," similarly marks a preference for wooden toys both for their sturdiness and for their connection to the natural world; manufactured toys, he notes, "die in fact very quickly, and once dead, they have no posthumous life for the child."[50]

Wooden dolls, in this framework, are praised for their capacity to endure and to live on for the child, even if they became disfigured with time. Like the unfinished dollhouses of the nineteenth century, wooden dolls had a capacity to absorb the child's unruly behavior in ways that fostered unbounded forms of play. Consider the following 1856 article outlining the advantages of a wooden doll through a listing of the calamities to which it might be exposed: "The [wooden doll's] eyes, being painted, cannot be probed out; the body being a solid block cannot be broken; therefore, when the once-curled tresses have been frizzled or ruthlessly torn away, when the varnish has been chipped and the nose snubbed by repeated bangings against the floor, or even seared by an unlawful thrust into the bars of the nursery grate, the wooden doll, tattooed and scarred, often survives as prime favourite after the destruction of inert babies of more gorgeous construction."[51] These claims about durability implicitly normalize the violence that the wooden doll survives. Behaviors that we might consider as abusive—poking out eyes, breaking the body, tearing the hair, banging the nose, searing the face in the fire— were fundamentally part of imagining the doll as being full of life and motion; a doll that was incapable of enduring such abuse was "inert."

Children often received wooden or more durable dolls first and then progressed to dolls that required more care. Charlotte Mary Yonge describes how, at age seven, she was given a doll with a leather body and papier-mâché head to replace her former favorite, the large wooden Eliza. Yonge bequeaths her former favorite to a poor family in the neighborhood; almost twenty years later, she espies Eliza in the arms of a young child, who is "hugging the stump of Miss Eliza, without a rag upon her, paintless, hairless, eyeless, noseless, the last wreck of doll-anity, but still caressed!"[52] Borrowing the term "doll-anity" as a play on "humanity" from Louisa May Alcott's *Little Women*, Yonge points out that the deformity of the doll and her utter failure to resemble a person does not strip her of her essence. The "doll-anity" of the doll—with all the sentience that this phrase implies—stretches beyond the doll's semblance of realism, enduring for as long as her child owner has the power to imaginatively transform her. What defines the doll's "doll-anity" is not resemblance to an objective norm, but rather the caresses and care of her young owner.

Real or Not Real?: Identity, Consciousness, and Doll Play

The essence of the child–doll bond in the nineteenth century lay not only in the child's physical relationship to the body of her doll, but also in her conception of the doll's identity and essence. The child was encouraged to imagine her doll as her friend, her child, and her peer. In the process, she imagined the doll as possessing sentience, much like the child herself. Yet the doll was also a very particular kind of friend—a friend who, unlike real boys or girls, never differed from the child, fought with the child, or parted from the child of her own accord. These beliefs produced a paradox in the child–doll bond: *if* the doll was a sentient being like the child, capable of returning the child's affections and possessing an inner life of her own, she *must* differ from the child occasionally, protesting against the punishments the child arbitrarily dealt out or seeking the child's love after the child had wearied of the doll. The ideal doll, for most Victorian children, was *both* sentient *and* fully in compliance with the child's desires (insentient), despite the fact that these two things are fundamentally at odds with one another.[53]

Victorian writers often commented on this paradox in children's understanding of their dolls, noting that, to varying degrees, the child's belief in her doll's sentience could be unwavering *even as* she understood that her doll was inanimate. The belief in living dolls was, in this regard, like belief in fairies or even in Santa Claus; all three might be "half believed to be alive."[54] Another author observes, "it would be hard to define the distinction made in the child's mind, when a willing imagination has worked habitual self-delusion."[55] What most intrigued Victorian writers about the child's suspension of belief and disbelief was the fact that the two contradictory positions directly coexisted in the mind of the child. Believing and pretending were simply not distinguished in the child's play. As one periodical writer explained: "A little girl playing with her doll knows quite as well as her mother that it can neither speak nor hear; that the face she so fondly gazes on is executed in wax or porcelain; that its limbs are stuffed with sawdust, and that when she lays her darling down to rest, those beady eyes would never close but for a mechanical contrivance which can be more easily guessed than described. Of all this the child is perfectly aware, and yet she continues day by day to treat the

puppet as if it were flesh and blood,—to kiss it, to talk to it, to lavish upon it in her childish way, but with perfect sincerity, the same endearing expressions and maternal caresses which experience has taught herself to prize. This, we repeat, is not the result of delusion, but of active fancy."[56] Put in terms of active fancy, the child's play was framed as an exploratory instinct, an active orientation to her world as a place rich with enchantment. Whether the child's belief in the doll's sentience was a half-belief, a lack of distinction drawn between belief and disbelief, or a simultaneous belief *and* disbelief, Victorian writers celebrated it as a sign that the child was imaginatively engaged with the world.

The perceived contradiction within Victorian doll play can be understood in terms of D. W. Winnicott's theories of play. The infant child, Winnicott posits, must transition from a belief in her omnipotent control over the world to an understanding of the independent existence of others. During this transitional stage the infant lives with one essential question unasked and unanswered: Is the child omnipotent and living in a world structured to meet its needs? Or is the child a small, vulnerable part of a larger world outside of her control? In order to negotiate this ambiguity, Winnicott suggests that the child relies upon transitional objects, which at once represent an extension of the child's self (perpetually present for child) and exist *outside* the child's control (physically exterior to the child's body). He writes, "[o]f the transitional object it can be said that it is a matter of agreement between us and the baby that we will never ask the question: 'Did you conceive of this or was it presented to you from without?' The important point is that no decision on this point is expected. The question is not to be formulated." This suspension of definition, for Winnicott, opens up "the magic of imaginative and creative living."[57]

Victorian children similarly suspended certain essential queries into their dolls' nature; a doll, like Winnicott's transitional objects, functioned at once as an extension of the child (with no will of her own) and as an animate being (with independent desires and needs). A child who understood her doll as fully inanimate was unlikely to engage in imaginative play and might even be distressed by social pressure to treat an inanimate thing as real. A child who believed her doll was fully sentient had only a limited number of options for relating to her doll who, in fact, would

never respond back. But for the child who embraced the doubleness of the doll—real and not real, "me" and "not me"—the doll functioned as a tool of exploration, imagination, and trial, who opened up the child's world. This, in Winnicott's terms, is the "intermediate area of *experiencing*, to which inner reality and external life both contribute."[58]

Consider two famous depictions of doll play in Victorian novels. In *The Mill on the Floss*, Maggie Tulliver famously keeps a large "fetish" doll in the attic, into whose wooden head she drives nails in moments of rage. While driving in a third nail with particular vengefulness, she simultaneously imagines that she is Jael pounding a nail in Sisera's head in the Bible and that she herself is punishing her Aunt Glegg. "But immediately afterwards," Eliot notes, "Maggie had reflected that if she drove many nails in, she would not be so well able to fancy that the head was hurt when she knocked it against the wall, nor to comfort it, and make believe to poultice it, when her fury was abated."[59] Maggie realizes that her pleasure in alternately enacting violence and showing sympathy to the doll is limited by the desire to continue imagining the doll's sentience; if she destroys the object utterly, she will lose the ability to abuse Aunt Glegg at all. Her cruelty depends upon the doll simultaneously being *both* Aunt Glegg (who feels every stroke of Maggie's rage) *and* an object (upon whom abuse can be heaped again and again without consequences, as long as the object is not destroyed altogether). When Maggie modifies her play, she turns, not to compassion, but to a new form of violence that leaves fewer marks on the doll, "grinding and beating the wooden head against the rough brick of the great chimneys."[60] Doll play does not teach Maggie compassion; it teaches her how to express her violent aggression in ways that perpetuate the doll's in-betweenness.

In *Bleak House*, by contrast, Esther Summerson treasures her doll as an intimate companion to whom she confides her most intimate secrets. Following her birthday, when her godmother tells her it would have been better if she had not been born, Esther describes "how often I repeated to the doll the story of my birthday, and confided to her that I would try as hard as ever I could to repair the fault I had been born with (of which I confessedly felt guilty and yet innocent)," drawing her doll close to her as her godmother pushes her away.[61] Yet after her godmother's death and burial, when Esther leaves her childhood home, she "wrapped the dear

old doll in her own shawl, and quietly laid her—I am half ashamed to tell it—in the garden-earth, under the tree that shaded my old window."[62] As a fourteen-year-old girl, Esther is acting responsibly in putting aside her childish toy. But instead of passing the doll on to another child, as ideal codes of Victorian conduct might dictate, Esther chooses to bury it. The doll burial at once stands in for the burial of Esther's godmother (much as Maggie's doll stands in for Aunt Glegg) and represents a burial of Esther herself—a concealment of her secrets, her confessions, and her youthful self in the dirt. The doll is Esther and not Esther—an inanimate thing that can be buried in a child's mimicry of adult rituals and a sentient being who carries all of Esther's youthful confessions with her into the earth.[63] Esther's shame in burying her doll indicates that she understands her actions to be irrational: the insentient doll could never tell Esther's secrets. To bury it anyway suggests her lingering sense that the doll is more than just a doll; it is the container of her youthful self.

Retrospective accounts of real dolls similarly describe forms of play that depended on both the doll's sentience and her insentience. For example, in her childhood, Jane Welsh Carlyle (later the wife of Thomas Carlyle) determined at the age of ten to use her doll to reenact Dido's death. "On her tenth birthday," as her friend Geraldine Jewsbury recounts, "she built a funeral pile of lead pencils and sticks of cinnamon, and poured some sort of perfume over all, to represent a funeral pile. She then recited the speech of Dido, stabbed her doll and let out all the sawdust; after which she consumed her to ashes, and then burst into a passion of tears."[64] In this scene, Carlyle and her doll play the role of Dido together. Carlyle speaks Dido's final words and stabs her with the sword, while the doll, like Dido, dies by the blow of the sword and the flames of the pyre. The death can only be considered a suicide insofar as the child and the doll are one. Later commentators ascribe Carlyle's tears to regret at the fact that she has just destroyed her beloved doll,[65] but this initial account does not give any reason for her tears. Indeed, Carlyle's tears may have stemmed from the fact that she had just (imaginatively) stabbed herself to death.

For some children, the blurring of identity between child and doll manifested itself in a more predictable projection of the owner's personality onto her possession. "[C]uriously enough," a writer for *Chambers's Journal*

observed, "a child's doll always seems to bear a strong resemblance to the child in constitution and disposition, if not in appearance."[66] Selfish children, the author posited, have selfish dolls; children who love to eat ginger have dolls with a mysterious penchant for the same.[67] Such correspondences, of course, allow the child to use the doll as an excuse and a companion in indulging her own preferences. Contemporary texts used the doll's appearance to pass judgment on the character of the child. A plain but neatly cared-for doll reflected the child's modesty and industry; a richly dressed doll might reflect the owner's vanity or her spoiled character.

Belief in doll sentience was not just a treasured faith of childhood but also a belief strongly encouraged by adults who wished to see their children or other young relations engage with the enchantment of doll play. Children who did *not* experience dolls as enchanting objects, therefore, sometimes experienced this as a moral failing. Edith Nesbit begins an autobiographical account of obtaining her favorite doll with "a confession" that "I had never really loved a doll."[68] When Nesbit obtains a new doll, she performs a series of loving actions, dressing and undressing her, and keeping her by her side even in sleep. But at the end of the account, Nesbit admits, "I never loved her. I have never been able to love a doll in my life."[69] Nesbit's "confession" is troubling precisely because it dissolves the favored fantasy of childish innocence; not only is Nesbit failing to demonstrate an early maternal instinct, she is also resting in the world of reality without embarking on fantasies of miniature play.

Frances Ann Kemble goes one step further in describing the doll, not just as an object of indifference, but as one of actual repulsion. In her memoirs, Kemble recalls how dolls "always affected me with a grim sense of being a mockery of the humanity they were supposed to represent; there was something uncanny, not to say ghastly, in the doll existence and its mimicry of babyhood to me, and I had a nervous dislike, not unmixed with fear, of the smiling simulacra that girls are all supposed to love with a species of prophetic maternal instinct."[70] For Kemble, the "ghastly" effect of the doll is linked to the Victorian cultural insistence that the doll resemble a real child, despite the lack of real resemblance between the two. Kemble's unwillingness to participate in the double play of dolls, the believing disbelief in the doll's sentience, puts her on the outside of a society that understands this performance as an essential part of childhood.

Kemble's horror therefore highlights the strangeness of what adults and children alike largely accept: that the doll actively "mimic[s]" babyhood, just as the child mimics maternity during the period of her own infancy. To propose that the same relationship might exist between child and doll as between mother and child is to suggest that relative scale is the *only* thing that matters; if a child can carry a doll in her arms, it *must* be her baby and the child must be enacting her mother's role "in miniature." Kemble is repelled precisely by the in-between status of the object; it aspires toward a perfect mimicry of human life, but falls short of this ideal. Uncanny in Freud's sense of the term, the doll represents home and not-home in its imperfect reproduction of the child's own life and self.

The child's indifference to or repulsion toward doll play was chilling to adults not just because it failed to conform to adult expectations for the child's early emerging maternal impulses, but also because it undercut the adult fantasy of innocent childhood enchantment. Writers consistently show less concern about a child's violent behavior toward her doll— beating it, tying it up in the snow, or even bludgeoning it with nails—than they do when a child expresses complete detachment from her toys. The French author Julie Gourand, for example, speculates that such indifference must disenchant the experience of play and propel the child to disembowel her toys to understand the mechanical functioning of their inner parts. She writes, "Fear the results of such a mournful disenchantment! What are our illusions, but the *bran* from which our life takes its tone, its joys, and its pleasures? The veil torn, the illusions vanish. What remains? an empty doll-case."[71] To open up the doll in a spirit of scientific inquiry, Gourand hyperbolically posits, would prematurely destroy the innocent enchantment of childhood itself.

Gourand was not alone in seeing childhood curiosity about the mechanics of a doll as a failure to maintain the enchanted aura that adults insisted characterized the child–doll bond. If the doll did not train the child in maternal behaviors, then it might instead be a tool within the child's own agenda—whether that was an imaginative enactment of the child's global fantasies of exploration or a quasi-scientific inquiry into the nature of a doll's constitution. Indeed, the child who undertook experiments in a spirit of empirical inquiry, opening up her doll in order to understand the mechanical workings of the doll as an object, violated

adults' conception of her maternal instincts and her delicate constitution. Charles Campbell, in his essay on "Doll Philosophy," inquires: "How is it that the little people who are not credulous about Doll-life, are still not impressed by the human semblance of the toy, when they attack Dolly with the penknife or scissors, to discover, like boy and girl Frankensteins, the secrets of her vitality as regards inward squeaks or shutting eyes? How is it that even the callous schoolboy can extract the eyes of that flaxen-haired creature, without being startled by a sense of atrocity?"[72] Campbell does not offer any answers to the questions he raises. Rather, he categorizes them as "awful and unanswerable queries" that recall "so strongly our childish—imaginary—introduction to the secret chamber of Bluebeard, that we flee from it in horror."[73] Such language is certainly hyperbolic, but it suggests a fear that enchantment itself is in peril at the hands of the curious child.[74] For adults who had passed beyond the age of doll fancies and doll play, the preservation of children's supposed fancies was important as a means to protect adult constructions of childhood innocence and enchantment.

Prescriptive accounts of doll play in the nineteenth century have obscured the variety and vibrancy of uses to which dolls might be put. The child's believing disbelief in the doll's sentience invited forms of play that look like abuse and encouraged unauthorized games, from doll burials and doll burnings to doll adventures in domestic space, that liberated the child's imagination from the limited actions normally permitted her. These actions, indeed, were not just allowed but often encouraged because of a widespread adult desire to see the enchantment of doll play endure in a scientific age. But for the children who resisted adult recommendations for play altogether, cutting apart dolls' heads and bodies with penknives to see what lay inside, the doll similarly represented a tool for agency. Whereas children with faith in doll sentience used their dolls for adventures beyond the child's ordinary field of view, children who took their dolls apart more fundamentally resisted adult scripts, using their toys to claim for themselves a world of play run by their own rules. In this sense, the destruction of the doll, too, formed an imaginative engagement that envisioned a world where children could be, not just glossy-eyed innocents, but aggressive explorers delving into the unknown mysteries of the world.

Disintegration and Doll Narratives

Doll narratives, which retell the story of an individual toy's journey from creation or "birth" to disintegration, discarding, or "death," encouraged the child's belief in the doll's sentience even as they admitted that such belief would fade with time. These narratives emerged out of a much longer tradition, begun in the eighteenth century, of "it-narratives," in which inanimate objects or (later) animals tell their stories. Shillings or guineas, shoes, sofas, waistcoats, thimbles, needles, pug dogs, and others all describe passing through the hands of various owners, thereby highlighting modes of circulation through the British economy, including those that transgress social norms.[75] Nineteenth-century it-narratives, in contrast to their eighteenth-century predecessors, tended to take on narrators whose feelings could be more easily imagined, usually animals or dolls. The didactic purpose of these narratives lay in their attempt to expand the child's capacity for sympathy. Works like Mary Mister's *The Adventures of a Doll* (1816), Richard H. Horne's *Memoirs of a London Doll* (1846), Julia Charlotte Maitland's *The Doll and Her Friends, or Memoirs of the Lady Seraphina* (1852), *The Adventures of a Doll in Ainslie Place and Blackfriars Wynd* (1853), Julia Pardoe's *Lady Arabella, or, The Adventures of a Doll* (1856), and Julie Gourand's *Memoirs of a Doll: Written by Herself* (1856) charted the progress of their doll protagonists from their birth in the toy shop through numerous owners to their end, usually either as the worn but treasured possession of a virtuous child or as detritus for the dustheap.

Crafting narratives about the circulation of objects with the doll at their center put a strain on Victorian understandings of the enduring all-importance of the child–doll bond. While a sofa (to choose one eighteenth-century example) might be exchanged or sold without any judgment on the seller, every parting in a doll narrative required that the child either abandon her responsibilities to the doll or outgrow its usefulness. Often the parting was the result of a child's vice: she lost interest in the doll as its beauty diminished or actually lost the doll in a moment of carelessness. But at other times a virtuous child relinquished her doll because she understood that another child needed it more than she did. Doll narratives often went to great lengths to uphold the idea of a lasting child–doll bond, staging reunions of the doll with a favorite former

owner at the end of the narrative to suggest that their relationship had shaped the child's life.[76] But the structure of these narratives disconcertingly undercut the notion of a singular doll–child bond, supplanting this idea with the suggestion of multiplying possibilities for the relationship between girl and doll that yielded a seemingly endless sequence of scripts for play. Paradoxically, dolls in these narratives teach the child the skills that allow her to assume a place in the adult world even as this process of maturation also breaks up the all-important child–doll bond. Just as a child's belief in fairies evolved into wonder at the marvels of the natural world, so a child who believed in the reality of dolls grew into a social maturity that allowed her to relinquish her former best friend.

Doll narratives attach moral virtue to the child's belief in her doll's sentience, which they show as crucial to allowing her to take her place in the adult world. The child who believes—or half-believes—in her doll's sentience is rewarded by learning a range of moral lessons: the stories variously propose that a child must respect the feelings of other persons, especially other children (*The Doll and Her Friends*); that vanity is essentially folly (*Lady Arabella*); and that children can and should help the suffering but out-of-sight children at the other end of the social spectrum (*The Doll of Ainslie Place*). In other words, the child who imagines doll consciousness is socialized into adult norms of thought and action, all under the auspices of play.

The child who considers her doll purely as an object, by contrast, demonstrates callousness of character. The selfish first owner of Lady Arabella reveals her true nature when she scorns "to play with her [as] the object she is!" while Geoffrey, a young cousin of the doll owner in *The Doll and Her Friends,* insists on his right to beat his cousin's doll, claiming, "A doll is nothing but wood or bran, or some stupid stuff; it can't feel."[77] The reiterated denial of a doll's feelings accentuates the central assumption of these narratives, which is that dolls should be treated as if they *can* feel. The child reader is encouraged, along with the doll herself, to feel "ashamed" of this child's violent behavior and to judge the "Ignorant child!" who thinks thus about her toys.[78] Crucially, these narratives are not concerned about the act of physical abuse per se, but rather about the violence done to the doll by conceiving of her as insentient—a thing and not a being. It is this belief that is emotionally damaging both to the doll and to the child who espouses it; physical violence merely follows as an afterthought.

Doll narratives make it extremely clear which doll owners should be judged morally upright and which morally lacking, locating these judgments in the point of view of the insentient doll. If the reader sets aside these moral judgments (made, of course, by an unfeeling toy), doll narratives offer dozens of scripts for creative ways to play with toys—some of which wear out the doll's body sooner than others, but all of which show the child either engaging in or testing the fantasy of doll sentience. Thus, for example, while both author and doll-narrator make it clear that Marianna Sedley's forms of play in *The Adventures of a Doll* transgress norms by crossing boundaries of gender, race, and class, and by imperiling the physical body of the doll, the doll-narrator nonetheless cherishes Marianna, attracted by the vibrancy of her imagination.[79]

While the child's and doll's personalities are imagined to be inextricably entwined, the doll's fate uncomfortably jars with the child's future; for as the child matures into strength and beauty, her doll, which began existence in her most beautiful and perfect form, decays and disintegrates through the process of use and play. Indeed, while doll narratives follow a picaresque narrative structure in which the doll travels from place to place and learns moral lessons that broaden her understanding of the world, they all end in the same way—with the doll's disintegration. In some cases, the doll-narrator expresses contentment with her lot, having fulfilled her purpose on earth. In others, she expresses despair at being neglected, shoved in a drawer, or tossed on a trash-heap after so many years of service. The child's progression beyond a belief in doll sentience necessitates these endings. Yet the fantasy of doll sentience cannot easily be set aside.

Indeed, even as the human characters in doll narratives set aside their fantasies of doll sentience, sometimes literally coming to the realization that the doll's speech was a dream, the reader is left with lingering images of doll sentience and suffering. At the end of *Lady Arabella*, for example, the child Mary wakes up after listening to the titular doll's tale. The doll lies atop a dust heap, bemoaning the fact that she has been brought low as children's play—and their periodic abuse—gradually destroyed her body (Fig. 5.2). As the doll finishes recounting her last adventure, during which a dying man supposed her to be his newborn human child, Mary "awoke with a start, and had scarcely done rubbing her eyes to dispel the fancies of her dream, when she saw a huge iron shovel plunged deep into

FIGURE. 5.2. George Cruikshank, *Lady Arabella lying in a dust heap,* frontispiece of *Lady Arabella, or, The Adventures of a Doll,* by Julia Pardoe. London: Kerby and Son, 1856. Courtesy Huntington Library, San Marino, California.

the pile of rubbish beside which she had fallen asleep, and the mutilated doll, after flying high into the air, fall back into the unsavoury garbage with which the cart was laden. 'Good gracious me!' murmured Mary to herself; 'so it wasn't true after all that a doll could talk, and see, and feel pain when her arms were torn off, and her eyes put out! It was nothing but a foolish dream; and now I am too late for school, and I shall have a bad mark in the afternoon; and all because I did not do as I was bid, and go on when I was told to do so. I'll take very good care not to be so disobedient again; though, to be sure, it was very droll after all!'"[80]

Mary's condescending characterization of the tale she has just heard as "droll," bracketed by the brutal destruction of the doll's body parts, dismisses the entire narrative. But the violence of this last scene overshadows the child's pat moral meditations. While Mary pushes aside the brief interval in which she heard and believed the doll's tale, dubiously understanding the destruction of the doll's body as proof that her tale "wasn't true," Lady Arabella's sentience is not so easily created and dismissed by the reader, who experiences Lady Arabella and Mary equally as persons. Lady Arabella's narrative does not become less powerful or immediate when Mary, the less compelling character of the two, abruptly claims the whole previous narrative as her dream. Could such an unimaginative child as Mary, the reader may well wonder, have imagined such a life? The destruction of Arabella's body amplifies rather than diminishes the memory of the doll who is now lost.

What the narrative of *Lady Arabella* brings to the fore is the possibility that the child reader may choose to trust the reality of Arabella's tale more than the frame narrative of Mary's dream. In this sense, doll narratives raise the epistemologically disconcerting possibility that the reality of toys is more enduring than the reality of their child owners. This reverberating sense of possibility became a source of inspiration for many major works of imaginative literature in the nineteenth century. In imagining the world of the doll, both the child reader and her fictional surrogate grappled with the possibility that her own experience of daily life was a dream and a fiction.

CHAPTER SIX

SPECULATIVE FICTIONS

World Making in Glass Town and Wonderland

Victorian dolls and dollhouses encouraged play by requiring the child to complete the object with her imagination. These toys were appealing to children precisely insofar as a child suspended questions of belief and disbelief and allowed the doll's identity to intermingle with her own. This ambiguity about the reality of the doll lent itself to fantasies that spiraled outward to envision a world that the toy might inhabit. From the physical reality of the toy the child's imagination turned to world making, summoning diverse possibilities.

These forms of play were intimately tied to fiction. Often children drew on stories they had read or poems they had memorized as inspiration for their play. Frances Hodgson Burnett later observed that she had had little interest in dolls until literature "assisted imagination and gave them character," making an object "stuffed with sawdust" into "a Heroine."[1] Burnett describes how her doll became "Bloody Mary" of England, faced pirates in shark-infested waters, participated in Aztec ceremonies and rites, and played "chief" and "squaw" in a wigwam.[2] Certain dolls scripted particular forms of play; dolls that were modeled after the

Prince and Princess Royal, for example, encouraged child owners to imagine them as Queen Victoria and her children ruling over the British Empire. Individual novels had a direct impact on the doll trade; as an 1853 article observed, for example, the publication of *Uncle Tom's Cabin* "has done something for the doll-shops; for, although neither Tom, nor Legree, nor Haley, nor the Quaker, would look very nice in the doll form, yet there are Tom's two little boys, and Eva, and Eliza's child, and Topsy—they are all to be met with among the costlier varieties in the doll-maker's store at the present time."[3] Children might fancy that their porcelain dolls were, in fact, Eva on the verge of her death. Or they might, as Burnett did, tie a gutta-percha doll to the post of a staircase to re-create Simon Legree's infamous beatings of Uncle Tom (Fig. 6.1).[4] Other children enacted different stories; a pair of twins, for example, strapped their doll to the back of an uncooperative cat to reenact Mazeppa's torturous journey through the desert in Byron's poem.[5] The violence that these forms of play enacted upon the doll's body did not impair the child's belief in the doll's sentience; if anything, it amplified it.

These beliefs were at once exhilarating and precarious, standing as they did, not on the evidence of the child's senses, but on the extrapolative and imaginative power of her mind. Just as the microscope offered material grounding for a fairy imaginary, authorizing a literature in which the fancy of fairies in the garden gave way to an interest in the natural world, so too toys inspired speculative fictions in which a single toy could transport the child into new worlds and exotic spaces. Like the world of the microscope too, the world of toys was filled with experiences of both power and terror. As the child became more invested in imagining her toys' reality, her power over them became more thrilling. But if the toys' reality was imagined too vividly or convincingly, then the child's understanding of her own world might be destabilized. After all, if the toy was real, what made the child different? And if toys had a world of their own, what did that mean about the reality of the child's own experience?

The thrill and terror of such imaginative possibilities lay partly in the fact that the Victorian child occupied a position in which she was constantly made aware of size. In the nursery, furniture and other objects were often scaled to the child's proportions; these reduced-in-scale objects were not miniature, but they were smaller than objects in the rest of the

At the end of the entrance hall of the house in which she lived was a tall stand for a candelabra. It was of worked iron and its standard was ornamented with certain decorative supports to the upper part. What were the emotions of the

Small Person's Mamma, who was the gentlest and kindest of her sex, on coming upon her offspring one day, on descending the staircase, to find her apparently furious with insensate rage, muttering to herself as she brutally lashed, with

FIGURE. 6.1. Francis Hodgson Burnett, *The One I Knew the Best of All: A Memory of the Mind of a Child*, by Frances Hodgson Burnett, 45, 50. New York: Charles Scribner, 1893.

house.[6] In relation to her dollhouse and toy soldiers, the child was massive and possessed of a godlike power that allowed her to manipulate miniature worlds from above. But once she stepped out of the nursery, she entered a world in which she was proportionately small. The child's vulnerability in the outside world was perhaps epitomized by the expectation of submission to her parents' will, a submission that mirrored the toy's expected obedience to the child.

A child's smallness was only compounded by a sense of the even greater scale of the British city and the empire. The population of England and Wales was rapidly increasing, reaching 9 million in 1801, 16 million in 1841, and 36 million by 1911.[7] As the British Empire expanded over the course of the century, its size was almost unfathomable, stretching across some 9.5 million square miles in 1860 and extending to 12.7 million in 1909.[8] The processes of industrialization and globalization shifted attention to the gigantic, as machines, buildings, cities, and even novels expanded to grapple with the new scale of life. In a world of such massive proportions, the child appeared tiny and powerless to effect change.

As the child negotiated these two dynamics, her size and power in the nursery and her smallness and vulnerability in the outside world, she encountered the persistent equation of size with power. The adult possessed scalar power over the child just as the child possessed the same power over her toys. The child's size itself was, of course, changeable, as each year she grew. But this growth also paradoxically meant that the child would soon be asked to relinquish her authority over miniature toys as belonging to a childish past. Growth, then, meant not just the acquisition of power but also the relinquishment of imaginative possibilities.

While contemporary and retrospective accounts of doll play typically focus on the child–doll bond, imaginative fiction, whether written by children or adults, extrapolates outward, using toys as the building blocks for fictions of world creation, in which the imagined world rivaled the full-scale world in its vibrancy. These speculative fictions represented dynamics of size that resonated with the child's daily experience, offering fantasies about power and nightmares of powerlessness. As the child immersed herself in imagined worlds of shifting scale and expanding proportions, she might find herself challenging her assumptions about the world and about her own reality. While the fantastic elements of these

fictions, in particular the strange disproportions and shifts in scale, bracketed them as "mere" children's fantasies, these speculative fictions of scale stretched the child's imagination to the limits. How far was the child willing to go in imagining the implications of doll sentience and doll life? How durable was the child's conception of her own reality when envisioning the equally alluring and disturbing possibilities of doll sentience and doll life? To explore at the limits of size and scale was to question the nature of reality and, potentially, to grapple with enduring questions about the nature of the child's world.

Godlike or Childlike?: The Nursery, the Globe, and the Brontë's Glass Town

As already described, the Victorian child possessed a godlike power over her dolls. Her imagination summoned the toy into life, bridging the gap between the doll's faulty materiality and its imagined realness. The child could also impose her will on the toy freely, either by imagining the doll's will as precisely matching her own desires or by imposing obedience through physical force. However, the child's unchecked power over her toys was complicated by her own experience of vulnerability in the adult world. She might reject her helplessness and embrace the feeling of power and grandeur in relation to her toys, but she might also identify with the toy's position of vulnerability, recognizing it as her own. The child's impulse both to rule over her toys and to identify with them produced struggles between godlike power and childlike vulnerability, between distant mastery and intimate identification.[9]

While the child who exerted her power over a world of toys might experience the intoxicating thrill of imperial dominion, the child who immersed herself in that world had the opportunity, through her imagination, to expand it almost endlessly in size and complexity. "Large issues from small," Bachelard explains, "not through the logical law of a dialectics of contraries, but thanks to a liberation from all obligations of dimensions, a liberation that is a special characteristic of the activity of the imagination."[10] The liberation from the obligations of dimensions meant that the Victorian child no longer had to experience the nursery as a confined space. Instead she could regard the miniature objects of the nursery as starting points

that, like the microscope, gave her entrance to a new world. The toy, in this case, functioned as material evidence of an imagined world lying just beyond sight.

The toy itself also played a fundamental role in charting a path toward imaginative expansiveness. Kendall L. Walton theorizes that toys facilitate imagination insofar as they *"prompt* imaginings; they are *objects* of imaginings; and they *generate fictional truths,"* while Susan Stewart, discussing the impact of scale in particular, posits that "[t]he toy is the physical embodiment of the fiction: it is a device for fantasy, a point of beginning for narrative.""[11] The tactile properties of the toy, in particular the diminutiveness of miniature figures, gave the child a vertiginous sense of power over her new acquisition.

The process through which toys prompted childish imaginings can be seen in the extraordinary childhood record of the Brontë children's early games. In an 1829 journal entry, Charlotte recalls the morning, likely in 1826, when Patrick Brontë brought his son Branwell a set of toy soldiers. Charlotte writes, "Branwell came to our door with a box of soldiers. Emily and I jumped out of bed and I snatched one up and exclaimed, 'This is the Duke of Wellington! It shall be mine!' When I said this Emily likewise took one and said it should be hers. When Anne came down she took one also. ... Branwell chose 'Bonaparte.'"[12] As the children snatched and named the soldiers, they asserted their ownership and power over them. Charlotte's and Branwell's decisions to name their soldiers the Duke of Wellington and Bonaparte respectively indicates the boldness of their imperial ambitions. By their choices they became, in a single moment, the arbiters over the fates of the two most prominent military commanders of recent history.

From this moment on, the toy soldiers became the physical points of genesis from which the Brontës imaginatively waged imperial wars and enacted imperial expansion in the kingdom of Glass Town. Branwell's toy soldiers, dubbed the "Twelve Adventurers" by the children, engaged in wars against the Ashantee peoples, initially represented by a set of ninepins given to Charlotte Brontë by her father at the same time that Branwell received his soldiers. In 1830 or 1831, Branwell drew a map of Glass Town and its environs that seems to be inspired either by an 1826 article on the "Geography of Central Africa" in *Blackwood's Edinburgh*

Magazine, to which the children's father subscribed, or by a map from Goldsmith's *Grammar of General Geography* (1823) owned by the Brontë children.[13] Inscribing their imaginative inventions over the known world, the children use the miniature to reimagine global history. Frenchyland appears in Branwell's map just off the coast of West Africa, along with a series of other kingdoms: Wellington's Land, Parry's Land, Sneaky's Land, Stumpy's Land, and Monkey's Land, among others, are located on the West African mainland or just off the coast. In one of the earliest tales, Wellington returns to Western Europe to defeat Napoleon there, but, in a departure from the annals of history, he returns to Glass Town to rule over the kingdom. The growth of Glass Town itself and the ongoing battles of its citizens against the Ashantee are presided over by the gigantic and all-powerful "Genii" of Glass Town: Tallii, Brannii, Anii, and Emii, named for Charlotte, Branwell, Anne, and Emily Brontë. The use of the map suggestively indicates that the fiction of Glass Town is not purely a fiction of toys living their lives in miniature at Haworth (it is not a doll narrative); their world rather represents a parallel or even rival reality to our own.[14]

In early records of the exploits of the Twelve Adventurers, the children revel in their comparatively gigantic statures in relation to their soldiers. In 1829, mere months after composing her first record of the incident, Charlotte Brontë retells the scene in which the children named the soldiers from one soldier's point of view. In the process, she raises the stakes of the episode from a childish game of naming to a magical scene of anointing. After arriving in West Africa, the twelve soldiers are led by the powerful "Genius of the Storm" to a hall of sapphire with four "Princes of the Genii" sitting on golden thrones.[15] One of the soldiers narrates: "As soon as [the Princes of the Genii] saw us they sprang up from their thrones, and one of them seizing A[rthur] W[ellesley] and exclaiming, 'This is the Duke of Wellington!' A[rthur] W[ellesley] asked her why she called him the D[uke] of W[ellington]. The Genius answered, 'A prince will arise who shall be as a thorn in the side of England and the desolator of Europe. Terrible shall be the struggle between that chieftain and you! It will last many years, and the conqueror shall gain eternal honour and glory. . . . The renown of the victor shall reach to the ends of the earth. Kings and emperors shall honour him, and Europe shall rejoice in its deliverer. . . . At his death renown shall cover him and his name shall be

everlasting!'"[16] In reimagining the scene, Charlotte Brontë becomes an exotic Genius who announces Charles Wellesley's destiny in pseudo-messianic language ("A prince will arrive") and predicts the future of all Europe (a future that was already history when the Brontës were children). The comparative relation between Charlotte and her favorite soldier remains the same, but in Charlotte's fantastic rewriting of the scene, both characters are scaled upward in size and power, the toy becoming the greatest general of Europe, and the child a being of godlike power.

Such godlike power came with its consequences. As the cycle of stories progressed, both Charlotte and Branwell began to imagine the Genii's rule as a form of tyranny that was resented by the inhabitants of Glass Town. Branwell in particular relished descriptions of the Genii's cruelty. In June 1829, the Genius "Bany" unreasonably demands £500,000,000 in cash under the "Rascally" threat of "LIGHTNING."[17] Three years later, Branwell becomes a thunder God prone to tormenting his subjects; he is "Awful Brannii gloomy giant / Shaking o'er earth his blazing air, / Brooding on blood with drear and vengeful soul / He sits enthroned in clouds to hear his thunders roll."[18] Branwell's imagined threats provided an impetus for the inhabitants of Glass Town to mount heroic resistance to the genius's unjust dominion. Thus, one unnamed Glass Town citizen writes to the Glass Town journal: "Sir—it is well known that the Genii have declared that unless they 'perform certain arduous duties every year, of a mysterious nature, all the worlds in the firmament will be burnt up . . .' I think, sir, that the horrible wickedness of this needs no remark."[19] Mimicking the language of Lockean contract theory, Charlotte and Branwell Brontë imagine the resistance of Glass Town's soldiers and citizenry in terms that frame their own power as tyranny. In so doing, the children abnegate an imagined identification with their Genii surrogates and identify themselves instead with the heroic cause of resistance.

Throughout the Brontë juvenilia, Charlotte and Branwell Brontë vacillate between these two positions: the godlike ones of Tallii and Branii, the Genii of Glass Town; and the vulnerable positions of the town's inhabitants, dominated by the Genii but also nobly resisting their unjust demands. If the first position represents the child's fantasy of complete power, the second represents children's real vulnerability in a world in which they actually had very little power. The inhabitants of Glass Town, of course,

could respond to the tyranny of the Genii in ways that the Brontë children could not respond to their father. In identifying with their toys, Charlotte and Branwell Brontë claim an agency for themselves that was fundamentally grounded in their imaginative and literary abilities to imagine new worlds and create literary texts. Under their literary personae, the Brontës protested against the injustice of the Genii and invoked both philosophical principles and military strength to support their points.

As the Brontës shifted their focus from play practices that emphasized their own scalar relation to their toys to those that represented an immersion in their fictional world, the size of their writings shrank and they began to "publish" their fictions in miniature books that imitated contemporary periodicals in small. While the earliest Brontë manuscripts measure around 10 by 6 cm, in August 1829 their manuscripts suddenly assumed the form of magazines measuring around 5 by 3.4 cm (Fig. I.1).[20] The tiny size of these volumes likely kept the children's writings secret from their father's eyes. More crucially, they matched the scale of their toy soldiers, physically reinforcing the fiction that it was the soldiers, not the children, who composed the contents of each volume. The periodical, entitled *Blackwood's Young Men's Magazine* in a clear gesture to *Blackwood's Edinburgh Magazine,* features a series of distinctive elements that evinces the children's skill as artisans. Each volume includes title pages with visual dividers, tables of contents, regular features (including "Military Conversations," modeled after *Blackwood's* "Noctes Ambrosianae"), poems, reviews, advertisements, and even a copyright. The precision with which the children mimicked the original periodical in miniature signals their investment in maintaining the seeming reality of their fiction; in one issue, for example, Charlotte Brontë surrounds her initials with an elaborate colophon on the title page in the exact place and in a similar style to the portrait of the sixteenth-century Scottish historian George Buchanan framed by a colophon on the cover of *Blackwood's* (Fig. 6.2).

In choosing the form of a periodical for their fictions, the Brontës embraced a literary genre that is incomplete, partial, open-ended, and referential: each individual issue gestures toward characters, objects, and documents that lie beyond the scope of the text itself. A single September 1829 issue of the Brontës' periodical, for example, features advertisements for cinnamon and artificial roses from the comically named Captain Knownothing and Sergeant Thumphimself, neither of whom appears again, and descriptions

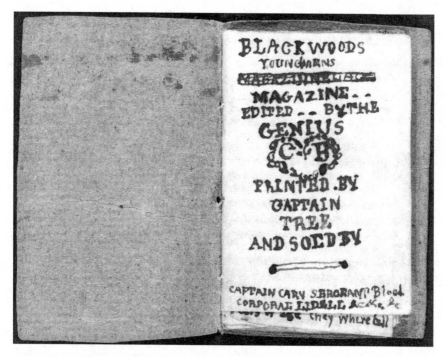

FIGURE. 6.2. Charlotte Brontë, 1816–1855. *Blackwoods young mens magazine . . . Edited by the Genius C. B.* AMsS, Haworth, Aug. 1829; 5.3 × 3.4 cm. MS Lowell 1 (6). Houghton Library, Harvard University.

of books, including a fifty-volume set on *The Law* written by Sergeant Bud, a Guide to Glass Town by Ned Laury, "one who knows every corner of that great city," and a Royal Atlas.[21] In each case, the existence of the object poses more questions than it answers. How do Glass Town laws differ from those in Britain? Does Ned Laury know corners of Glass Town that the children do not? Does the Royal Atlas include a map of Britain as it was in 1829, or does Britain look different in the world where Glass Town exists? Passing references in the periodicals bear an unclear relation to the familiar world of Great Britain: Is an advertisement for *Tales of Captain Lemuel Gulliver in Houynhmhm Land,* for example, an advertisement for *Gulliver's Travels,* or for a slightly skewed version of the same?[22]

In this sense, the Brontë periodicals are crafted to heighten the imaginatively broad and expansive effects of the shift in scale. While an individual volume might make passing references to a dozen characters including soldiers, ladies, and ruffians, the form of the periodical implies a still

larger population that includes the printers, distributors, and readers of the magazine. An 1830 title page of the renamed *Young Men's Magazine* notes that the volume will be "SOLD BY SERGEANT TREE, ETC. / AND ALL OTHER / Booksellers in the Chief Glass Town, / Duke of Wellington's Glass Town, / Paris, Ross's Glass Town, Parry's / Glass Town, etc., etc., etc."[23] The existence of unnamed booksellers in at least five cities, coupled with the implied existence of the readers who purchase and read the periodicals they sell, creates a fictitious version of what Benedict Anderson has termed an imagined community. The periodical implies the existence of readers whose lives and reading habits are not explicitly known. In creating and in rereading their own works, the Brontës placed themselves among thousands of imagined readers who similarly perused the magazine's features. No longer occupying the privileged position of creators, they subsumed themselves into the world they created.

The Brontë juvenilia expands its imaginative scope through the partialness of its own literary record; each periodical offers a glimpse into the life of Glass Town, but also points to persons, objects, and events beyond its view. In this sense, the periodicals are as limited in scope as the observation of a single sample under the microscope's penetrating lens. Just as Victorian writers posited that the unfinishedness of a dollhouse best engaged the child's mind, so the unfinished quality of the Glass Town world allowed the children to keep creating, inventing, and reinventing its dimensions. Moreover, the texts contain contradictions that point to the indeterminacy of the imagined world; characters change personalities and ages and deceased characters abruptly return to life in ways that suggest a vibrant potentiality that breaks the bounds of ordinary experience.

The Brontës, of course, cannot be taken as typical; even as children their considerable creative powers are evident. But their extraordinary record of play suggests how the child's fantasies could sprawl outward, not just transporting her to positions of power in distant locations and climes, but also allowing her to experience her own vulnerability. For while the Brontës initially relished their godlike power over Glass Town, their play quickly shifted as they entered into the world of their fictions and became human once again. To be a soldier or citizen of Glass Town, of course, was not the same as being a child in Haworth, but the common experiences, first of vulnerability, and then of literary aspirations, united the

two. The experience of play placed the child in a new world whose rules and boundaries were determined, not by the fixed laws of adult reality, but by the flexible principles of childhood imaginings.

Narratives of Shifting Scale: Disorientation in Wonderland and Doll Country

Children's miniatures opened up imagined worlds for the child to explore even as they fostered a sense of uncertainty about the nature of the world the child had entered. Miniatures both reflected the real-world vulnerability of the child, based on her comparative size, and challenged her equation of size with power. As adult authors of children's literature were keenly aware, the child's size was not a constant but changed with time. However stagnant the child's place might seem to her, she was constantly growing, physically and emotionally, toward adulthood. As J. M. Barrie observed, "All children, except one, grow up."[24]

Growing up, for middle- and upper-class children, meant losing the scalar difference that set them apart from the world of adult life and kept them free from certain constraints of adult life and its attendant "facts" (to use Mr. Gradgrind's term from Dickens's *Hard Times*). Scalar difference, indeed, marked out imaginative freedom. Fiction written by adults for children drew upon this principle, using scalar difference to conceive both of the instability and of the freedom in the child's imaginative world. In three fictional texts from the second half of the nineteenth century—Lewis Carroll's *Alice's Adventures in Wonderland* (1865), Clara Bradford's *Ethel's Adventures in Doll Country* (1880), and George MacDonald's *At the Back of the North Wind* (1871)—fluctuations in size convey both the richness and the instability of the child's imagination. In all three texts, a stabilization of size would also mean a stagnation of imagination.

Speculative fictions of scale are importantly still governed by rules, even if and when these rules differ from the scientific laws of ordinary life. Creating a world grounded in child's play means taking license to imagine an alternate reality while still incorporating elements of the known world.[25] The worlds that the child enters imperfectly mirror reality: a rabbit carries a pocket watch (*Adventures in Wonderland*); a set of chess pieces walk of their own accord in the cinders of a fire (*Through the*

Looking-Glass); a Robinson Crusoe doll rides on a goat (*Ethel's Adventures*); and the North Wind blows a cork out of a hole in the wall three times in succession, imperiously claiming the hole as "my window" (*At the Back of the North Wind*).[26] Despite their fantastic elements, these fictions remain intimate parts of the child's experience; the questions they raise and the topsy-turvy suggestions they offer linger after the fantasy fades from view. Rather than posing direct alternatives to the child's life, then, these fantasies offer "what if?" visions of what the world might be.

In *Alice's Adventures in Wonderland,* the titular heroine famously learns to manipulate and to adjust her size as circumstances require. Yet the need to adjust her size also accentuates the fact that size is relative; Alice's size only matters based on her ability to engage with or to relate to the spaces and creatures around her. And she is rarely the right scale to begin with: she is too big to go through a door, then too small to remain safe in the remaining flood of her tears; too big for the house, then too small to face the puppy; too big for the jury-box; and finally, too small for her dreams to be taken seriously in the world into which she awakes. Indeed, Alice's scalar difference always places her at odds with her surroundings. At times, her relatively large size gives her power. For example, she can overturn the jury-box and defy the queen's orders to have her beheaded because she is so much larger than the inhabitants of Wonderland. Yet this power by virtue of size comes with its consequences: her shaking the Red Queen clutched in her hand dispels the fiction of Wonderland and causes Alice to wake up. It is no wonder, then, that she fails to experience her changes in size as empowering, complaining that "It was much pleasanter at home . . . when one wasn't always growing larger and smaller, and being ordered about by mice and rabbits."[27] Syntactically, Alice equates "growing" with "being ordered about"; changes in size are less a matter of empowerment than a response to coercive forces.

These shifts in size not only alter Alice's scalar relations to others but also fundamentally change her relationship to her own body. When she drinks from the "Drink Me" bottle, she remarks, "What a curious feeling! . . . I must be shutting up like a telescope!"[28] By choosing a metaphor with significant size-based implications (telescopes, after all, visually enlarge small and distant objects), she refers only to the object's mechanical operation and not to its function. Alice seems intuitively to have grasped

(in ways that film adaptations of the novel rarely do) Galileo's insight about how any reduction in scale has consequences for bodily form and weight: she envisions herself, not just shrinking, but changing in shape, collapsing into herself. A few pages later, when she eats the cake and begins to grow, she again likens herself to a telescope in its mechanical operation, while disregarding its functional power to bring distant objects visually close. She observes, "'I'm opening out like the largest telescope there ever was! Good-bye, feet!' (for when she looked down at her feet, they seemed to be almost out of sight, they were getting so far off.) 'Oh, my poor little feet, I wonder who will put on your shoes and stockings for you now, dears? I'm sure *I* shan't be able! I shall be a great deal too far off to trouble myself about you: you must manage the best way you can.'" She goes on to imagine addressing a parcel containing a boot at Christmas to her right foot, sending it to the hearth rug near the fender.[29] Alice's growth alienates her from her own body, making her not a whole person but rather an assemblage of parts that might be espied through a telescope or contacted through the mail, but that cannot be experienced as part of a coherent self.

The changes to Alice's body not only fragment her physical self but also fracture her understanding of her identity. When the Caterpillar asks who she is, she confusedly replies: "I—I hardly know, sir, just at present— at least I know who I *was* when I got up this morning, but I think I must have been changed several times since then. . . . [B]eing so many different sizes in a day is very confusing." Alice clearly believes that the changes to her physical form have changed her inner self as well. "I'm not myself, you see," she politely explains.[30] While this confusion of identity might be marked as another fantastic element of Wonderland, Carroll is careful to associate it instead with natural patterns of growth and transformation. Alice asks the Caterpillar "when you have to turn into a chrysalis—you will some day, you know—and then after that into a butterfly, I should think you'll feel it a little queer, won't you?"[31] Although the Caterpillar is unmoved by Alice's attempt at connection, her remarks implicitly suggest how fantasies of scalar change reflect the real bodily changes that she will undergo in her natural growth into adulthood, which might indeed make her feel "a little queer." Growth into human adulthood, of course, does not take place overnight and thus may not be felt as so acute a change.

What Wonderland forces Alice to confront, however, is the very real truth that her self is *not* immutable. She is a child destined to grow into something else—an adult.

The titular protagonist of Clara Bradford's novel *Ethel's Adventures in Doll Country* mistreats her dolls precisely because she embraces the notion of size as power without grappling with the ethical or personal consequences of such a belief. *Ethel's Adventures* combines *Alice's* adventure narrative with the doll-narrative formula; the titular protagonist travels into doll country in pursuit of her one of her dolls. The doll, when Ethel finds her, recounts to the queen of the dolls and her court the tale of her suffering at Ethel's hands. Ethel is found deficient as a caretaker, not just because she has abused her doll, but also because she has failed to care for her dolls and dollhouses in a way that reflects a belief in her dolls' sentience. Objects in her dollhouse are "all topsy turvy—chairs, tables, pans, and tea-cups scattered on the kitchen floor." Even Ethel recognizes her failure to maintain order in the miniature domain over which she rules: "'How untidy it looks,' she thought with shame."[32] Ethel's dolls scorn her caretaking ability, responding with contempt to her inability to keep things neat. Given unlimited, godlike power over her toys, Ethel misuses it, justifying her actions through her belief that "It's only to be done to a doll, and dolls can't feel."[33]

In the fictional world of doll country, of course, dolls *can* feel. Yet Ethel remains surprisingly phlegmatic when confronted with her doll's narrative of past mistreatment. The only thing that moves Ethel, an unimaginative and stolid child, to experience fear or regret is a series of encounters with an oversized birch rod, who constantly threatens to beat Ethel for her former and current misbehavior. The existence of a gigantic and sentient rod inverts Ethel's position of scalar power; whereas before she loomed over her toys, now the birch rod looms tall over her. Firm in her belief that size can be equated with power, Ethel feels a fearful respect for the cruel and vindictive birch rod even as she fails to muster the same respect for the wise and ethical (but small) Queen of the Doll Country.

Bradford's choice of a birch rod as the self-proclaimed avenger of doll injuries sits uneasily with the reader, precisely because Victorian children were in fact beaten by their parents (most likely their mothers) in everyday life.[34] Ethel's desire to escape the rod and its gaze suggestively figures

a very real childish fear of corporal punishment. The rod is a nightmar-ish version of a parent, possessing an inescapable, all-seeing gaze that makes any escape impossible. When Ethel gains wings and begins to fly, the rod grows and remains next to her; and when Ethel hopes that her re-turn to the ground will render her comparatively small, the rod assures her that "We always see little girls, however insignificant they may be."[35] No diminishment in size and concomitant relinquishment of power will allow Ethel to escape the rod's disciplining gaze. Nor does the rod show any inclination toward mercy. In the final moments before Ethel wakes up, he assures her, "You are in my power at last!"[36] Like Alice, Ethel fi-nally escapes doll country by waking up. When she does, the rod's "un-sparing" injunction to "Get up" turns into the nurse's almost identical, but decidedly more polite, urging, "You really must get up, Miss Ethel."[37] This softening of discipline as Ethel wakes up suggests that her nightmar-ish vision of the rod does not reflect her real experiences, but rather an internal reckoning with what she fears she deserves.

Ethel's Adventures locates the fear and instability of a child's life not in the external authority of parent figures but rather in the world of the child's dream. The appearance of the birch rod and his nightmarish assertion of schoolroom discipline suggests the imaginative precariousness of the child's authority over her toys. Ethel retains her power only insofar as she sees her dolls as just objects; as soon as her dreaming mind opens up the possibility of toy life, her own regime over her dolls turns into a crime that might be punished in some frightening way left unstated in the text. Even then, Ethel remains impervious to the suggestion that the aliveness of her toys impacts her own identity in any way. Unlike Alice, she does not find herself questioning the stability of her body or her self. When the rod re-bukes Ethel, querying, "How would you like to be whipped because some one had broken your nose, and you tried to forget your troubles by going out an enjoying yourself a little?" Ethel resists the implication of his re-mark, stubbornly reasserting her humanity and her difference by stating, "*I* am not a doll!"[38] Even at the end of the novel, Ethel remains resistant to tutelage. Though she is reminded of the limitations of her power, she continues to insist upon using what power she has. Ethel stolidly expresses security: her final wish is to possess (and presumably mistreat) a doll ver-sion of the fairy doll queen she has seen in doll country.

While *Alice's Adventures in Wonderland* and *Ethel's Adventures in Doll Country* embrace the significance of size for children, *At the Back of the North Wind* calls into question the child's fixation with scale, arguing that size has little to do with identity or worth. The North Wind appears in a variety of forms over the course of the novel, sometimes appearing as vast as the sky, sometimes in the comfortable, largeish size of Diamond's mother, and occasionally in the tiny form of a fairylike creature. As a child who has learned to understand size as a marker of identity and power, Diamond finds the changes in his mysterious friend's size utterly disorienting.

For Diamond, size intrinsically suggests power or powerlessness. So when the North Wind appears to him in the shape of a young girl, he assumes that "you are not big enough to take care of me," and when she reappears in an even smaller form as "a lovely little toy-woman," he cannot help but exclaim, "You darling!"[39] The North Wind seeks to teach Diamond that her essence is immutable; whether she appears as small and helpless as an insect or as large and terrifying as a vengeful storm, she is one and the same being. "If there's one thing makes me more angry than another, it is the way you humans judge things by their size," the North Wind explains. "I am quite as respectable now [at the size of a dragonfly] as I shall be six hours after this, when I take an East Indiaman [boat] by the royals, twist her round, and push her under."[40] Her message is at once deeply disorienting and profoundly reassuring; she asks Diamond to trust in the continuity of her being despite the evidence of his senses and the instincts of his mind. She promises not sameness but rather constancy amidst the physical transformations that take place. In Diamond's world of human uncertainty, which includes his father's illness, the family's poverty, Sal's abuse of Nanny, and Diamond's own illness and approaching death, the North Wind serves as a figure of stability precisely because she undergoes physical changes that alter her appearance without altering her essence. Power and authority, she claims, are not tethered to size, but rather inhere in a person's self. As a result, physical and perspectival changes are not to be feared. As she puts it, "Do you think I care about how big or how little I am?"[41]

But Diamond *does* care what size the North Wind is, just as Alice cares about her morphing dimensions and Ethel wishes to change her size in order to disappear from the birch rod's view. Scale matters to the child

whose life has been defined by his own smallness. MacDonald introduces Diamond as "little Diamond" (using the name twice in the first sentence in which he is introduced), and Diamond himself uses the same title to distinguish himself from "big Diamond," the family's horse.[42] When Diamond meets Nanny in Chapter 4, he calls her "little girl" until Chapter 21, when she is renamed, at last, "Sal's Nanny."[43] The word "little," indeed, is used 387 times in the novel as a whole. Diamond's use of size to define and name the persons in his world means that he struggles to recognize the North Wind when she appears in her various forms. "Must you see me every size that can be measured before you know me, Diamond?"[44] the North Wind asks. The answer, for a child in a world of uncertain proportions, may be yes.

Together, Alice, Ethel, and Diamond suggest how a rising interest in the generativity of Victorian children's play with their toys gave rise to fictions in which these fluctuations in size challenged the child's understanding of herself and of the world. Although these fluctuations mark all three of the discussed narratives as "fantastic" in genre, this categorization minimizes the potentially lasting impacts of such fantasies on child readers themselves. For fantasies of other scales bring lingering questions with them. The child who doubts the durability of her reality in Wonderland may also query what is real in daily life. Fluctuations in size, therefore, became a means for authors both to identify their works as fantasies and to give young readers a chill of possible, lasting truth. Indeed, fantasies of changing size not only challenge the child's notion of the stability of identity but also require her to question what she knows to be real. By conjuring worlds out of childish fancy and belief, children destabilized their sense of the cohesion and stability of their daily existence.

Am I Real?: Challenges to Epistemic Reality

In James Sully's 1897 volume *Children's Ways*, he describes a little girl who, shutting her eyes, tells her mother, "Mother, you can't see me now." When the mother corrects her daughter, the daughter replies, "Oh, yes, I know you can see *my body*, mother, but you can't see *me*."[45] Sully surmises that the little girl here is associating her self with her soul, which is invisible to the eyes. But the little girl's claim also cuts to the core of questions

of material existence: Is a child's material body the same thing as her self? If so, what distinguishes the unmoving but materially existent doll from the child? In Sully's account, the child, on a different occasion, poses precisely this question, asking her mother, "Mother, am *I* real or only a pretend like my dolls?"[46]

While a young child might uncomplicatedly imagine her miniature toys as being alive, for the older or more reflective child this possibility raised questions about the fundamental nature of consciousness and about what separated the doll's world from the world of the child. In play, the child imagines reality as conforming to her will; as D. W. Winnicott observes, when a child plays, she "manipulates external phenomena [e.g., toys] in the service of the dream and invests chosen external phenomena with dream meaning and feeling."[47] The perceived dream quality of toys coming to life is evident in all three books discussed in the previous section; Alice, Ethel, and Diamond all either discover or wonder if the realms they explore are dreams. Yet in endowing their imagined worlds, their "dreams," with such vividness, Victorian children actually diminished their ability to distinguish between the real and the fantastic. Their fantasies, humming with life and throbbing with a vitality that seemed to exist apart from the child herself, called into question the reality of the child's everyday world by positing an equally or even more vibrant world of imagined beings. Here the oft-invoked question of dream versus reality carries a real sense of urgency: the child's essential indecision about this question gave a new lustrous quality of wonder both to speculative fictions and to real life.

The indecision about the reality of the dream is powerfully present in the writings of the Brontë siblings, whose early fictions comprise a rare representation of Victorian childhood play by children unfiltered through the observation of adults. In her early fictions, Charlotte maintains an extraordinary double consciousness, writing from dual positions both within and above the world of her imaginative creation. A single tale might be signed "By Lord Charles Wellesley" and "By Charlotte Brontë," not as a form of collaborative authorship, but as a type of simultaneous writing; the work was composed in the Great Glass Town in Africa by one author and in Yorkshire, England, by another.[48] In another case, two prefaces offer alternative accounts of a tale's genesis. In Glass Town, Charles Wellesley explains that "My motive for publishing this book is that people

may not forget that I am still alive, though a good way from Ashantee," while Charlotte Brontë more simply explains that the composition of the book took five and a half hours over the course of two days.[49] Both prefaces are signed with the same date, February 22, 1830.[50] The two prefaces work almost precisely at odds against one another: in one, Wellesley asserts his continuing existence (despite his physical absence from view) and erases the role of the child creator; in the other, Charlotte precisely delimits the time the imagined Charles Wellesley's tale occupied her mind. Yet rather than understanding the two worlds as being at odds with one another, she presents them equally on the page as simultaneous and not dueling accounts. The child's imagination capaciously presents both her own and her imagined characters' realities rather than creating a hierarchy between them.

In order to remain absorbed in the possibilities of toy play, the child suspended disbelief. To acknowledge the fictionality of the toy, after all, was to lose the precious vibrancy of speculative worlds. In an 1881 article on "Doll Philosophy," Charles H. Campbell describes the avidness with which children at times clung to the fantasies of sentient toys. He describes in particular one unnamed illustration that shows "a little girl begging her mamma not to let remarks be made about the Doll when the Doll is there, because she has been trying all her life to keep that Doll from knowing she was not alive. This suggests the utmost degree of delusion, and the child's plea inverts the real state of the case; she had been trying all her life to keep *herself* from realising that the Doll was not alive."[51] Campbell's framing suggests that the child who claims to protect her doll's feelings may actually be protecting the imaginative aura surrounding her doll, an aura of possibility in which the doll's imagined sentience opens up the possibility for speculation and fantasy. What the child fears, in this imagined case, is that the fragile "what if" belief will be shattered, and life will be restored to its ordinary conditions and dimensions.

The child who insisted on the toy's reality, however, risked destabilizing her own existence. Annie Besant recalls, "to me in my childhood, elves and fairies of all sorts were very real things, and my dolls were as really children as I was myself a child."[52] Her phrasing importantly emphasizes how the identification between child and doll made the doll *as real as* the child herself. Her recollections raise the question: If in fact her dolls are

not her children, is she *not* a child? In defining her doll's reality in terms of her own, Besant invests in the possibilities of imaginatively vibrant play while also opening up the possibility that her own reality was no more stable and durable than the doll's.

For the child who invested fully in the principles of play, the reality of the toy destabilized her perception of her own reality. In August 1830, Charlotte Brontë wrote a story entitled "Strange Events" in which her favorite narrator and surrogate, Charles Wellesley, becomes oddly conscious of his own imaginary nature. "It seemed," he writes, "as if I was a non-existent shadow, that I neither spoke, eat, imagined or lived of myself, but I was the mere idea of some other creature's brain. The Glass Town seemed so likewise."[53] Charles Wellesley's meditation is, of course, quite true. But its truth does not diminish its unsettling qualities. In imagining Charles Wellesley realizing his own fictionality, Charlotte Brontë also imagines what it would be like to realize that her own daily reality is just a dream. Put simply, she identifies with the experience of being fictional. Still in his dream, Charles finds himself raised by a giant hand to gaze at "two immense sparkling, bright blue globes," before being set on the ground, where "I saw a huge personification of myself—hundreds of feet high."[54] From the imagined perspective of Charles Wellesley, Charlotte Brontë exists, first as dismembered eyes, described as worlds unto themselves rather than as body parts, and next as a "personification," a projection who is herself as unreal, though much larger, than the Glass Town character she has imagined. What if? What if, in the child's words from the beginning of this section, Charlotte Brontë was "pretend like [her] dolls"? What if, when Charles Wellesley woke up, she disappeared?

This question represents the ultimate uncertainty of doll play: Can the toy's sentience be imagined in a world that coexists with the child's reality, or does the toy's reality actively displace the child's own? Through encounters with miniature toys, the real possibility of worlds beyond is contemplated with an intensity that had the potential to displace the child's immediate experience of the world.

Adult authors of speculative fictions represent this uncertainty as central to the child's experience. Lewis Carroll, for example, uses the infectious unreality of scale-based play as a means to represent the child's experimental approach to testing the limits of her own reality. When

Alice first sips from the "Drink me" bottle and begins to shrink, she worries that "'it might end, you know, . . . in my going out altogether, like a candle. I wonder what I should be like then?' And she tried to fancy what the flame of a candle is like after the candle is blown out, for she could not remember ever having seen such a thing."[55] Even as Alice's metaphor figures an absolute extinction ("going out altogether"), her imagination leads her beyond this, trying to remember seeing an extinguished flame. As amateur microscopy had made immediately apparent to many Victorians (Carroll included), the limits of vision were not the limits of existence; creatures lived not only beyond the penetrating power of ordinary sight, but even beyond the reach of microscopic life. If Alice "shrinks away altogether," then, does she still exist beyond the reach of ordinary sight? Does an extinguished candle still have its flame?

In entering Wonderland, whether by falling down the rabbit hole or by stepping through the looking glass, Alice enters a world that is governed by rules she does not understand and turns to the methods of scientific experimentation to test the limits of reality and fiction. Alice drinks from a bottle because "I know *something* interesting is sure to happen" and eats a cake because "it's sure to make *some* change in my size."[56] Alice's experiments rarely illuminate the rules of the world around her, but they do test the transformative limits of her body and her self.

Alice's experimentation, though, has its limits. When she encounters Tweedledee and Tweedledum in *Through the Looking-Glass*, she confronts a more direct challenge to her epistemological reality. Tweedledum insists to her, "Why, you're only a sort of thing in [the Red King's] dream! . . . You know very well you're not real."[57] Tweedledum's suggestion violates our sense of the fictional narrative; the reader of *Looking-Glass* knows that Alice is not real, but Tweedledum's accusation nonetheless seems to impeach the reality of any child who has ever had a vibrant dream. And while Alice later declares, "I do hope it's *my* dream, and not the Red King's! I don't like belonging to another person's dream . . . I've a great mind to go and wake him, and see what happens!"[58] she leaves the Red King sleeping, the reality of Tweedledum's suggestion untested. Indeed, though she wakes up at the end of both *Alice's Adventures* and *Looking-Glass*, dissolving the fantasy of Wonderland into the waking reality of daily life, Alice herself does not take this wakening as clear evidence of her reality.

For instance, at the end of *Looking-Glass,* Alice presses her kitty to tell her whether the Red King appeared in her dream or if she appeared in his.

Fictions that do not pose direct challenges to reality still adopt an experimental attitude, exploring possibilities with the power to unsettle readers in lingering ways. Consider, for example, Ethel's bizarre stream-of-consciousness meditations on what would happen if people, like some dolls, could not close their eyes of their own accord. She muses: "How funny people would look lying in bed *asleep,* with wide-open eyes! just like great big dolls! Suppose no one could close their eyes without help! and that there were funny sort of little men, like I have seen in pictures, with long noses and pointed toes, who did nothing else but shut people's eyes! or—suppose, we all closed each other's eyes!—but then, who would close the eyes of the person going to bed last? Somebody must be last!"[59] Her exclamatory imaginings make the real world uncanny; they suggest a fantastic unreality in which some of the rules of the "real world" still apply. In the process of taking her fancies seriously, Ethel poses a series of questions: Who would shut the last person's eyes? Would her brothers beg to have their eyes shut? Would she oblige them? In querying the nature of toy reality, Ethel blends real-world experience with childish whimsy to suggest a dynamic view of reality. However far-fetched her ideas may be from the perspective of an adult reader, she follows them to their logical conclusion, recognizing a certain arbitrariness in the way things are. This imaginative energy disrupts her experience of the real.

While Lewis Carroll and Clara Bradford allow Alice and Ethel to grapple with the weirdness of their imaginings without offering answers, George MacDonald suggests to both his child protagonist and his child reader that the unanswered questions and possibilities raised by their imaginings can ultimately offer reassurance. The North Wind's fluctuating size and ability to predict the future endow her with a tremulous unreality. Indeed, the idea of wind as a character in itself suggests an impossibility, as wind is in its essence fleeting, unpredictable, and invisible. When Diamond raises the idea that the North Wind might be a figure in his dream, MacDonald does not reject that possibility; rather, the North Wind herself expresses uncertainty about whether or not she is objectively real. What she suggests is that Diamond relinquish any attempt to rationally determine her reality, setting aside a scientific or experimental

approach to understanding reality and embracing emotion and intuition as ways to understand the world. "I think," the North Wind notes to the silent Diamond, "that if I were only a dream, you would not have been able to love me so."[60] The child's internal experience, the North Wind proposes, matters more than any objective truth. Like the Victorian children who chose not to come to a conclusion about their dolls' sentience, Diamond suspends the question of the North Wind's reality. His love is enough. Indeed, the whimsical logic that structures *At the Back of the North Wind*, with its cryptic rhymes and its embedded fairy tales, suggests that the child's belief in the North Wind not only opens up worlds of speculative possibility but also speaks directly to the suffering of the world that adult logic fails to understand or to explain.

With the exception of the Brontë juvenilia, of course, most speculative fictions are created by adults to mimic, and sometimes to sentimentalize, the nature of the child's world-making fancies. This authorship shines through: the preoccupation, in *At the Back of the North Wind*, with defending epistemological uncertainty speaks as much to adult readers as to children. Still, these fictions of fluctuating scale demonstrate the possibilities that came with the idea of toy sentience and that echoed in the child's mind long after the book was closed. As microscopy introduced a spirit of genuine inquiry into the realms of miniatures, toys offered material prompts that opened up enchanting worlds beyond perception. Drawing on a cultural association of children with the miniature scale, authors challenged the given realities of the world and reimagined it through a lens of topsy-turvy, logically illogical possibility. Bracketed by the adult's conviction of their unreality, these fictions nonetheless retained a force of imaginative suggestion that paralleled the suggestiveness of the objects themselves.

Part Four
Miniatures and the Book

CHAPTER SEVEN

MULTUM IN PARVO

Miniature Books

At first glance, *The English Bijou Almanac of 1838* scarcely appears to be a book at all. Measuring 3/4 by 9/16 of an inch, the entire volume is slightly smaller than a thumbnail (Fig. 7.1).[1] An arabesque design on the front and back of the volume suggests the preciousness of the object, while the slipcover offers protection for the volume's brown morocco spine and gilt-stamped covers. More ornate and expensive editions feature hard binding in morocco or vellum, elaborate cases of velvet or tortoiseshell, and matching magnifying glasses that fit into the case. The almanac was crafted to live up to its name as a bijou; it indeed resembles a jewel in the richness of its appearance. The contents of this tiny volume are printed in a miniscule script that is only just legible to the naked eye. Readers who wish to read it unassisted must strain their eyes to see the mostly italicized font, while also grappling with the considerable mechanical challenge of turning thin miniature pages and keeping the tightly bound volume open without blocking part of the text with their fingers. Indeed, a reader's hands and fingers feel massive in relation to the book, like clumsy instruments barely capable of manipulating its pages. The

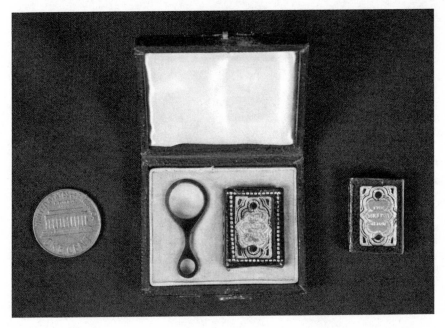

FIGURE. 7.1. Slipcase and cover of *The English Bijou Almanac of 1838*, by Letitia
Elizabeth Landon. London: Schloss, 1837; volume measures 3/4 × 9/16 inch.
Courtesy Lilly Library, Indiana University, Bloomington, Indiana.

publisher Albert Schloss had produced a book-shaped jewel of crafts-
manship in the guise of an almanac, bringing the artful decorative in-
stincts of early modern portrait miniatures into book production.

Inside, *The English Bijou Almanac* includes some of the charts that typi-
cally appear in nineteenth-century almanacs, including a calendar mark-
ing important dates for the year, a table of the eclipses, and a list of the
royal heads of Europe. These tables are interspersed with and overshad-
owed by a series of striking pen illustrations of famous persons, including
Queen Victoria, Sir Walter Scott, Mozart, and Giulia Grisi, each of
which is accompanied by an elegant poem written by the popular poet
L.E.L. (Letitia Elizabeth Landon). While almanacs of the period often in-
clude amusing poems and tidbits, *The English Bijou Almanac* puts a dispro-
portional emphasis on the elements of entertainment; only ten of the
volume's thirty pages include information that might be construed as
practical.

The English Bijou Almanac was an immediate critical and commercial success. Albert Schloss created new editions every year from 1835 to 1843, employing Landon to provide poetry for the first six years of its publications. Early critics praised it as a triumph of beauty over utility, dubbing it a *"veritable Bijou,"* a "Lilliputian pigmy among annuals," and a "butterfly of the annuals."[2] The royal family lent their support to the publication. Queen Adelaide allowed the 1837 almanac to appear "under [her] immediate patronage," and Queen Victoria took up her aunt's patronage after her coronation in 1838.[3] In 1840, Schloss enclosed a portrait of Prince Albert in honor of the impending royal nuptials, with the queen's permission. At the same time, admiring and skeptical critics alike described the uselessness of the book as a reference tool. *The Metropolitan* noted, "Mr. Schloss should have printed a larger almanack to accompany this, for the sake of those who would require some use in this unique and very diminutive affair."[4]

Despite the critical consensus about its impracticality, Schloss declared that his miniature almanac was equally suitable for pleasure and use. In a typical advertisement for the volume, he bragged, "The useful and agreeable in Literature were never confined within so tiny a compass before."[5] Schloss's assessment, of course, exhibits a publisher's bravado. Yet the *possibility* that his works might be read was an essential part of their appeal, regardless of whether or not they were actually used. Indeed, his work reflects an emerging ideal of *multum in parvo*, or much in little, in which the miniature book became a perfect embodiment of beauty and knowledge condensed into a minute sphere.

By combining the artisanal beauty of miniaturization with the compression of knowledge in space, miniature books like *The English Bijou Almanac* became objects of pure enchantment. Whereas fairies and toys were understood as the particular domain of children, and the microscope showcased wonders in nature beyond human understanding, the enchantment of miniature books, like that of portrait miniatures, came from the ingenuity of its human creators. Far from claiming a significance proportionate to their size, miniature books aimed for a degree of miniaturization that represented a kind of infinity of knowledge. In the particular case of *The English Bijou Almanac*, its scale rendered it otherworldly. *The Mirror of Literature, Amusement and Instruction* announced the 1839 volume by querying "From the land of Lilliput, or whence came this

tiny thing . . . ?" while the *New Monthly Magazine* characterized it as "a fitting present for Titania."[6] Its chief poet, Letitia Elizabeth Landon, similarly characterized the almanac as "Our fairy volume" and "My little fairy chronicle," in the 1838 and 1839 editions respectively, and observed in the 1837 edition that "our little book seems planned / By elfin touch in elfin land, / And sent by Oberon, I ween, / An offering to our English Queen."[7] The scale of both text and illustrations requires the reader's complete concentration, inviting immersion in the alternative scale of the text. Indeed, the dedication page of the 1838 volume left a blank space upon which the giver might inscribe the recipient's name in a participatory act of micrographia, inviting the reader to engage with the volume on its own scale. Like the twenty-first century iPhone, the nineteenth-century miniature book transfixed and transported its user, proffering the promise of infinite knowledge to one who embraced its alternative scale.

In the twentieth century, the study of miniature books belonged to the realm of the collector. Miniature book collectors, societies, and periodicals produced comprehensive bibliographic surveys of the genre, including Ruth Adomeit's *Three Centuries of Thumb Bibles* (1980) and Doris V. Welsh's *Bibliography of Miniature Books, 1470–1965* (1988).[8] Scholars, by contrast, have largely ignored these miniatures. Those scholars who do discuss miniature books describe them in largely ahistorical terms, emphasizing their physical qualities (Susan Stewart characterizes "the [miniature] book as talisman to the body and emblem of the self") or its endearingly odd appeal for collectors (Judith Pascoe notes the "childish whimsy" and nostalgia of miniature books and their collectors).[9] The miniature book's appeal for its nineteenth-century owners and publishers, however, hinged upon the relationship between expansive content and diminutive form. In this chapter, I use the methods of the collector, describing the idiosyncrasies of individual volumes, in order to trace how the nineteenth-century fascination with miniature books led to a growing interest in the volume's promise of infinite knowledge, condensed into a physical form that fit into a pocket. While the microscope, for many Victorians, proved God's power in having created microscopic forms with infinite intricacies, miniature-book publishers offered a human answer, striving to craft miniature books that reached the limits of human and mechanical capabilities.

Both the form and the content of miniature books suggested that global knowledge itself had been condensed and contained within the diminutive bounds of the volume. This fantasy, however, played out in different ways. Miniature alphabets or word books giganticized the few letters or words contained inside, rendering the letters of the alphabet into symbols that both represented and contained the world of animals, objects, and things. Thumb Bibles abridged the Christian scripture, claiming for themselves the ability to distill biblical truth into its most concentrated form. Miniature reference volumes, including almanacs, gazetteers, and dictionaries, sought to condense information about the globe into a compact and portable form. Finally, curiosities produced with microscopic type represented a quest to craft books as gems of knowledge. As publishers worked to produce the smallest book in the world, they strove for a kind of divine omniscience, achieved through print.

The miniature book's exquisite qualities as an object meant that the knowledge it contained seemingly inhered in its form; the act of reading became less significant than the fact of possession. As miniature books were produced in greater numbers and on a smaller scale than ever before, they reinvigorated the form of the book as an enchanted gateway to literary wisdom and power.

Defining Miniature Books

What is a miniature book? Miniature books are defined by their external proportions; most collectors agree that a miniature book should measure three inches (77 mm) at most. Despite its widespread acceptance, this definition-by-external-proportions invites exceptions and quibbles. Many collectors include volumes measuring up to four inches or even a bit more, often with the caveat that such slightly-too-large books should be "extraordinary" in some way (whatever this means). Other collectors *exclude* miniature works that cannot be read with the naked eye, claiming that a miniature volume is not really a book if it is not, as the miniature-book collector H. T. Sheringham put it, "both readable and read."[10] Rare books librarians and curators are often disconcerted by miniature book collections, finding it difficult to take seriously a literary form frequently donated in shoeboxes in which miniature alphabets, Shakespeares, and

Bibles, most with carefully hand-set type, mingle alongside book-shaped erasers, pencil sharpeners, and matchboxes.

Collectors and critics often describe the nineteenth century as "the supreme age of the miniature book," both due to the number and the quality of works being produced at this time.[11] Printed miniature books first appeared in the fifteenth century, shortly after the invention of the printing press, and their number grew rapidly in the centuries that followed, first rising gradually from an estimated 100 unique books in the fifteenth century, to 400 in the seventeenth and 650 in the eighteenth, and then expanding exponentially to 3,000 in the nineteenth century.[12] As the number of miniature books increased, the number of genres also expanded. In the early centuries of miniature book production, the majority were religious or devotional works: abridgements of the Bible alone accounted for 23 percent of all sixteenth-century miniature books.[13] This percentage rose slightly to 24.5 percent in the seventeenth century, but shrank to 14.3 percent in the eighteenth and 7.7 percent in the nineteenth century.[14] The diminished number of miniature Bibles in later years reflects the proliferation of genres. Nineteenth-century printers produced miniature almanacs, alphabets, etiquette books, songsters, travel books and fold-out maps, encyclopedias, histories, even photographic albums and embroidery samplers.

Despite their small size, most miniature books aim to be legible without a magnifying glass. This means that, in most cases, a miniature book's type is disproportionately large in relation to the page. Printers chose larger type partly out of consideration for the reader and partly for practical reasons: larger type was easier to read and easier to set by hand. Small type requires both manual dexterity to set and technical precision to cut in order to leave a clear impression on the page. Printers also faced the challenge of maintaining the quality of printing at this size. Miniature books are often described as 64 mo (64 pages printed on a single sheet) because of their dimensions (2 to 3 inches). But in order to print miniature books in this way, a full-sized sheet would need to be folded six times. With this number of folds, even the smallest error in lining up pages and lines is magnified exponentially. To avoid the difficulties produced by this method, printers typically cut full-sized sheets into smaller sizes for folding.[15] An uncut version of *The Fairy Annual* (1838) reveals that it was printed with eight pages per side on a partial sheet, while the microminiature 11/16 by 1/2 inch

Galileo a Madama Cristina di Lorena from 1896 was printed with 32 pages per side.[16] The careful use of paper was a necessity, since, according to William Sale's estimate, paper constituted three-fifths of the cost of printing during the late eighteenth century.[17] If well planned, however, miniature books required only a small amount of paper.

Early miniature books were sold as portable volumes for the wealthy and devout. The majority of these are either prayer books or classics. Anne Boleyn carried a miniature book with her to the guillotine, while Sir Francis Bacon, Sir Edward Gibbon, and Napoleon Buonaparte all traveled with portable, albeit substantial, libraries of miniature classics, typically housed in sizable wooden cases.[18] Miniature books were not, however, widely accessible to the middle classes. Around 1800, several innovations in book production made it cheaper and easier than ever before to print impressive miniature volumes. The introduction of the cast-iron press by Charles Stanhope produced crisper impressions on the page due to the greater power of the machine, which made it easier to print with smaller type. Mechanical improvements in the process of type casting, including the improvement of the hand mold, also made it easier to cast smaller pieces of type. Lithography, introduced at the end of the eighteenth century, made it possible to include words and images together on the page and to produce clearer illustrations, thereby increasing the visual appeal of the miniature book, particularly for child readers.

At the beginning of the nineteenth century, new purchasing patterns established alternative markets for miniature books. The emergence of children's book production in the eighteenth century had prompted publishers to reconceive of miniature books as objects ideally scaled "to fit the hands and pockets of children."[19] Around the same time, the growth of the middle class provided a second new market. In order to maximize the number of potential buyers, publishers sold single volumes in a wide range of formats and price points, from simple paper-bound copies to elaborately gilt versions with padded cases and magnifying glasses. This meant that the middle classes could afford miniature books but elite buyers could still purchase deluxe editions. As the cost of printing miniature books decreased toward the end of the century, inexpensive miniature almanacs began to be distributed for free as advertisements to women in particular; for example, almanacs were used to advertise such products as Colgate & Co.'s toilet

soap and Piso's Remedy for Catarrh.[20] The attention that had gone into miniature-book design in earlier parts of the century dissolved as mass-produced miniature books became marketed as souvenirs rather than as tokens of literary power.

Gigantic Children and Miniature Books:
Alphabets and Word Books

My Tiny Alphabet Book, published in 1900, measures only one and one-eighth by seven-eighths of an inch, making it approximately the size of a human fingernail.[21] The cover of the volume depicts a young blond girl, seated on a stool contained within a circle, holding a book. The image suggests the child reader who would hold *My Tiny Alphabet Book*, yet the proportions are dramatically different: the book in the image is full-sized or even a bit over-sized in relation to the young girl who reads it. Its back cover is emblazoned with an advertisement for "Mellon's Food" that takes up almost the entire space. Below, in minute script illegible without a microscope, are the words "Ora et Labora" (Pray and Work).

My Tiny Alphabet Book was sold in a silver metal-hinged case that could be worn as a necklace if the owner ran a chain through the small metal loop atop the case. On one side of the case was a magnifying glass, suggestively promising to help the reader who might wish to read the print inside the volume. Inside, however, the book is entirely printed in an easily legible font. The magnifying glass thus draws attention to the small size of the volume without serving any practical function. On the other side, the case bears a worn, imprinted description: "Midget-Book with Magnifying Glass," accompanied by the image of a globe on top of a stack of books. The globe functions to present the alphabet inside the book as a form of global knowledge. The round shape of the globe echoes both the circle surrounding the young female reader on the cover and the circular shape of the magnifying glass, as if to suggest that the young girl is either being viewed through the magnifying lens or, in her person, has come to stand in for the globe. Micro and macro scales meet in the iconography of the object, which position *My Tiny Alphabet Book* as a tome of worldly knowledge.

Victorian alphabets operated based upon the central principle of elevating the building blocks of language. As in full-sized alphabets, minia-

ture alphabets use single objects, animals, or plants to represent the letter pictorially. Miniature books, however, are uniquely characterized by their disproportions. The child reader is gigantic in relation to the miniature book, while the letters on the page are massive in relation to the page they occupy. In the pages of *My Tiny Alphabet Book*, simple alphabet inscriptions fill the pages. Each letter is written twice, once in red uppercase lettering and a second time in black lowercase lettering. "E e for elephant" accompanies a lithographed full color picture of an elephant on the facing page. This illustration miniaturizes the elephant (which measures only 1 by 5/8 of an inch and does not even fill the page) while comparatively giganticizing the letter "E." A few pages later, the words "M m for mouse" accompany a colored picture of a mouse, the small rodent possessing virtually the same proportions on the page as the gigantic elephant. This scalar equivalency matters here precisely because the form of miniature books draws attention to questions of scale. Rendered in the same size on miniature pages (next to oversized letters), elephant and mouse are equally made subject to the child's alphabetic will and mastery. The alphabetic parade of animals in *My Tiny Alphabet Book* includes not only large and small creatures but also foreign and domestic ones. Familiar animals, including a cat, a horse, and a rabbit, are intermingled with exotic creatures like an Urson (a North American porcupine), a Quagga (a South African plains zebra) and a Nylghau (an Asiatic antelope). All become accessible within the rubric of alphabetic logic, and all are compressed into a form that might easily be slipped into a child's pocket.

Publishers first began printing miniature books for children in the eighteenth century, claiming that they were intrinsically suitable for the diminutive proportions of young readers. Thomas Boreman produced the first notable small-scale volumes for children in the early 1740s, ironically titling his diminutive (though not quite miniature, as they measured six to seven inches) set of ten books the *Gigantick Histories*. According to the record of the original subscription list, 75 percent of Boreman's reader-subscribers were between four and eleven years of age, and 12.5 percent lived within 250 yards of Guildhall.[22] For these young readers, the first volume, which tells the history of a giant at Guildhall, sought to defamiliarize a familiar landmark to child readers through a double displacement in size: this work shows London through the eyes of a giant

and in the form of a miniature book. In 1744, John Newbery published a miniature volume of his own, entitled *A Little Pretty Pocket-Book*, to emphasize both its portability and its suitability for a "little pretty" child. The unusual size of miniature books required children to physically manipulate them in a manner that resembled child's play. Newbery even sold his *A Little Pretty Pocket-Book* with "a Ball and a Pincushion, the use of which will infallibly make Tommy a good Boy and Polly a good Girl" for an extra two pence.[23] Miniature books, it seems, developed both the child's mind and her character.

Late eighteenth- and nineteenth-century publishers often claimed that miniature books were appropriate for child readers because they were scaled to the child. This is quite simply not true. Miniature books, which measure less than three inches in height, are one-third or less the size of an ordinary eight-to-ten-inch octavo volume. Most children, by contrast, reach approximately half their adult height at just eighteen months (for girls) or two years of age (for boys). Many miniature books, like *My Tiny Alphabet*, are considerably smaller than three inches. Miniature volumes also pose special challenges for children. The small size of the pages and the thin paper used in them mean they often require a manual dexterity that children typically lack; perhaps for this reason, contemporary children's books are usually oversized and printed on thick paper. The obviousness and falsehood of the claim that small books are suitable for small readers, then, marked a strategic attempt by publishers to redefine the imagined audience for chapbooks. While chapbooks had previously been associated with the lower classes because of their inexpensiveness, they were now imagined as appropriate for middle-class children because of their size.[24]

At the same time, the association of small books with small readers functioned as a spur to the creativity of publishers, who began to produce miniature libraries for children that both mimetically represented their parents' libraries and implicitly modeled the process of language acquisition. *The Infant's Library* (1800), for example, contains twelve individual volumes in a bookcase-box measuring less than 4 by 6 inches in size.[25] Its front cover is elaborately painted so that the top resembles a glass-fronted bookshelf, while the bottom mimics a cabinet with drawers. A decorative carving on the top made the object easy to open and easy to break; the child might

grasp the carving to slide the lid open, but was also likely to break off the decoration while transporting or playing with it (copies of the set today are rarely fully intact). Each volume moves in a progression from letters to full literacy: volumes one, two, and three showcase single letters, short words, and easy sentences respectively, as if the child might progress through the stages of literacy acquisition simply by turning the pages.

The Book-Case of Knowledge, produced in the same year, similarly includes a sliding lid (measuring 6 3/4 by 4 inches) decorated to imitate an adult bookcase. Instead of reproducing the stages of literacy, this set offers a broad survey of key subjects.[26] Taken together, its volumes on Mythology, Botany, Geography and Astronomy, Birds and Beasts, Arithmatick, Grammar, the Lives of British Heroes, the History of England, Moral Tales, and Scripture History promise a compact yet comprehensive means of understanding and mastering the world. Yet another similarly sized decorated bookcase, *A Miniature Library in 8 Volumes,* brings chronological and geographical information to the child's fingertips with its illustrated volumes that place English, Roman, and Grecian history next to a minia-ture Bible, a guide to London, and a survey of traditional forms of dress around the globe.[27] Each of these libraries strains toward its own form of comprehensiveness, aspiring to be not just a miniature bookcase but a full library condensed into a single case. Decorated miniature libraries reached their peak at the beginning of the century, but continued to be produced until its end. A French bookcase from the 1890s is covered with brocade and features a beveled glass door with a floral handle that shows the actual miniature books inside.[28]

Nineteenth-century miniature children's books often untether them-selves from the rules of reality by foregrounding disproportions of size and scale that make a volume's entire contents subject to the child's imaginative mastery. From page to page, the scale of the illustrations vacillates widely: an empty chair on which the child might sit occupies one full page, while a hot-air balloon, with barely discernable miniscule human figures inside, fills the next. The comparative size of objects ceases to matter; the child reader is already gigantic in relation to anything and everything repre-sented in the volumes.

The scalar disproportions of miniature books gave the child new per-spectives on her body and its relation to the surrounding space. *Kate*

Greenaway's Alphabet, published around 1885 and measuring two and three-fourths inches in height, imaginatively conflates alphabetic letters with the world that letters are used to describe.[29] Her wordless volume shows children playing on and around each individual letter. The children's actions make the letters on the page resemble familiar things: for instance, the letter *F* becomes a tree upon which the child perches; *T* becomes a Maypole around which children dance; and *U* becomes a jump rope. Unlike many alphabet books, in which letters clearly stand for the object represented (as with "e is for elephant," "m is for mouse"), these letters do not clearly signify anything: when a girl plays shuttlecock over the letter *V* or peers through a window *P,* there is no obvious word that matches the action. Instead, the children respond to the shapes of the letters themselves, as if they were physical structures for play.

These illustrations, which show the letters of the alphabet looming over the pictured child, effectively suggest that the letters of the alphabet are not merely the elements of language but the constitutive elements of life itself: each letter both abstractly suggests and physically represents the world. But these gigantic letters exist within a tiny book that the child reader can carry in her pocket, like a guidebook to life itself. At one and the same time, then, the child dwarfs the alphabet and the alphabet dwarfs the child. Both child and alphabet are elevated in importance through the encounter: the child masters the alphabet, while the alphabet structures the world.

Miniature alphabet books or libraries for children claimed to represent a kind of complete account of the world. The letters of the alphabet, the child learned, constituted all the building blocks for language, just as the smattering of books in a miniature library stood in for all the books the child's parents might possess. In this sense, these miniature books were governed by a central disproportion: the small collection of letters, animals, or facts they contained was taken to represent a vast body of knowledge. All became the pocket possession of the child, who was elevated into a position of authority even as that authority was bracketed or qualified by the representation of children within the pages. Alphabet books and children's libraries were limited in the information they actually imparted, but under a rubric of alphabetic completion they offered a fantasy of complete knowledge about the whole globe.

Condensed Truth: Thumb Bibles

The Bible in Miniature, or a Concise History of Both Testaments measures one and seven-eighths by one and one-fourth inches. Published in 1802 in London, this edition is elegantly bound in maroon leather, with the initials IHS for Jesus Christ on the front, surrounding a cross with rays emanating outward. "It is not a very pleasant reflection," the preface begins, "that in a country where all may have the Bible in their hands, that so many should neglect to read it."[30] While this prefatory statement seems to promise that this work places the entire Bible in the reader's hands, the author goes on to explain that it aims instead "to give the reader a taste" of the Bible by abridging and reorganizing its contents.[31] An average thumb Bible, according to Sheringham's estimates, contains about 7,000 words in total, whereas the King James Bible has a total of 783,137 words.[32] As a result, only a tiny fraction (typically less than 1 percent) of the Bible's contents are included.

The effect of these limitations was to produce a volume that offered a neat and digestible encapsulation of spiritual truth. The first "book" of this Bible is not Genesis, but rather an editorial description of God's nature: "Treating of God And of his Attributes."[33] The rest of the Old Testament is presented as a series of stories that tell the history of God's chosen people in ninety-two pages. Beautifully printed illustrations render the key moments even more legible: "Adam & Eve," "Cain & Abel," "Noah's Ark," "Jacobs Dream [*sic*]," "Finding of Moses," "David & Goliath," "Death of Absalom," "Haman Hanged," and "Daniel and the Lions." Each of these is related simply in the editor's own language. In the New Testament, fifty-eight of the seventy-four pages describing the life of Christ are used to reproduce a slightly abridged version of the Sermon on the Mount from the King James Bible (Matthew 5–7). While a few scenes from the life of Christ and from his parables are illustrated ("Birth of Christ," "Flight to Egypt," "In the Temple," "Little Children &c.," "Good Samaritan," "The Crucifixion"), Jesus's words are presented as the best summary. Indeed, as *The Bible in Miniature* explains, the Sermon on the Mount itself serves as "an emphatic compendium of [Christ's] doctrine"—a perfect distillation of spiritual truth.[34]

The 1802 *Bible in Miniature* is a relatively typical example of the genre. The nineteenth-century thumb Bible was tied, more deeply than any other

form of miniature book, to its historic past. Thumb Bibles first emerged in the seventeenth century as miniature verse abridgements of the Bible for children. Limitations in the size of type and the thickness of paper, indeed, meant that the first full-text miniature Bible was not printed until 1896. John Weever's *An Agnes Dei*, published in 1601, bears the distinction of being the first known thumb Bible, but John Taylor's *Verbum Sempiternae* (later *Verbum Sempiternum*), published in 1614, offers the first great example of the genre. Taylor's text became a popular standard for thumb Bibles for the next three centuries; it was reprinted almost verbatim by Longmans in the nineteenth century in 1849, 1850, and 1851 and served as the basis for other editions in England, America, and the Netherlands.[35] Illustrated thumb Bibles, usually using woodcuts, began to be produced in the eighteenth century. William Harris's 1771 *The Bible in Miniature* and Elizabeth Newbery's rival 1774 *Bible in Miniature, or a Concise History of the Old & New Testaments* both merged text and illustration in editions ostensibly designed for children with great success: from 1800 to 1870, the two works were reprinted twenty-eight times.[36] Nineteenth-century Bibles on both sides of the Atlantic frequently cribbed illustrations or texts from earlier editions to meet rising needs, often streamlining the eighteenth-century originals in the process. As printing methods improved with the introduction of stereotype plates and iron printing presses, illustrations became notably finer in quality even as the text remained the same.

Thumb Bibles from the seventeenth to nineteenth centuries articulate a single, shared goal: namely, to condense the Bible into its most compact and essential form. One 1793 edition of the *Verbum Sempiternum* begins with a dedicatory epistle to Queen Mary, reading, "Most mighty Princess, to your hands I give / The sum of all that ever makes us live."[37] A complementary epistle to King William at the beginning of the New Testament adds, "And though the Volume and the work be small, / Yet it containes the sum of All in All."[38] These verses suggest that the reduction in size has not resulted in a loss of content; the "sum" or entirety of the Bible has simply been reduced to a form that fits into the reader's palm, giving a newly literal meaning to the phrase "into thy hands." This formulation endured through the centuries; a popular 1805 American Bible in verse, *An History of the Bible and Apocraphy Versified*, shifted the address from the monarchy ("Most mighty Princess") to a democratic public

("Dear Christian friends"), but printed these verses otherwise unchanged.[39] Handwritten inscriptions indicate the importance of passing thumb Bibles from the hands of one believer to another. One 1693 copy of *Verbum Sempiternum* includes two signatures: one, likely from the mid-eighteenth century, identifies the volume as a gift to Eliza Pigot from her mother; the other, likely from the early nineteenth century, claims the book for Bridgett Lee as a gift from her brother. In both cases, a young female reader received the thumb Bible as a means of giving her spiritual understanding. These inscriptions suggest that gift giver joins with publisher in telling the child, "with great reverence have I cull'd from thence, / All things that are of Greatest consequence."[40]

Nineteenth-century publishers continued to claim that abridgement distilled the essence of the Bible into compact form, but they also emphasized that the thumb Bible intrinsically suited a child's mental and physical proportions. In an address to "The Parents of Little Children," *The Pocket Bible, For Little Masters and Misses* explains that "the Bible, as appointed to be read in Churches, is too copious and mysterious a volume for the comprehension of young children: therefore, to obviate this difficulty, the following Compendium of the HOLY BIBLE has been compiled . . . [which] will convey to children as clear and perfect ideas of the contents of the Holy Bible at large as their apprehensions can possibly receive."[41] The use of a size-based term ("large") to allude to the limits of children's understandings stresses the appropriateness of the physical dimensions; the reduction in the volume's physical proportions implies a reduction in length and difficulty that renders it well-suited for small children. The term "thumb Bible" first appeared in 1849, when Longman and Company decided to reprint *Verbum Sempiternum* under this title. It refers, not to the body part, but to the legendary little person General Tom Thumb, the "perfect man in miniature" who toured Britain in 1844.[42] The term "thumb Bible," therefore, emphasizes that the book that was not just small (thumb-sized), but also miniature (perfectly reduced in proportions, length, and difficulty).

In practice, these abridgements simplified the Bible according to clear didactic principles. A few thumb Bibles retained the traditional book structure of the regular Bible, often shortening entire books into single couplets. *An History of the Bible and Apocraphy with Cuts* sums up each book

of the Bible in lilting, sometimes comical verses; the book of Ecclesiastes is briefly summed up thus: "Health, strength, wit, valour, wisdom, worldly pelf, / All's naught and worse than vanity itself."[43] More commonly, children's thumb Bibles dismantled the traditional structure of the Bible in favor of loose summaries. Scenes of sexual lust, such as King David spying on the naked Bathsheba, are almost universally omitted, while tales featuring children—such as Samuel being called by God, Mary holding the child Jesus, and Timothy learning the scriptures—are often prominently featured.[44] The tale of the children who tormented the prophet Elisha and were devoured by bears was considered so essential as a didactic warning to children—and, perhaps, so marketable to adult purchasers—that *The Child's Bible* featured, not only a full-page illustration of "Bears tearing children,"[45] but also a frontispiece image of children gazing at this illustration and exclaiming: "There are the Bears tearing the children. Oh what wicked children they were!"[46] This frontispiece emphasizes the volume's concrete didactic benefits: potential purchasers are promised that their children will be schooled in the dangers of mocking their elders. Yet the frontispiece also directs the child reader to the corresponding gory illustration. In this way, publishers both claimed the moral high ground of a didactic cautionary tale and appealed to the child reader who was captivated by images of violent destruction. This scene of children being mauled by bears appeared again and again in thumb Bibles throughout the nineteenth century.

As the child reader of a thumb Bible grew in age and size, these publishers suggested, she would naturally progress to larger editions of the Bible. The thumb Bible, as *The Juvenile Bible* notes, serves as "a valuable step to the ladder of inspiration," which will inculcate children with a belief in "the necessity of applying to the larger and more detailed manifestations of infinite wisdom."[47] The prefaces of thumb Bibles offer a narrative, appealing to parents, in which the purchase of a single book inculcates the child with a love of scripture for life. "After you have read this through," the author of *The Child's Bible* remarks, in an address ostensibly directed to the child reader, "you will wish to know more about the Bible. Your mamma will get you one, or let you take hers, and you will learn much more than we had room to tell you."[48] This prediction, framed in terms of certainty and not possibility, offered potential parental

purchasers a thinly veiled fantasy of the child's lifelong devotion to the Bible.

The widely made claim that thumb Bibles served to introduce young readers to scripture is undercut by the fact that many of them required prior familiarity with biblical stories in order to become legible. *Wood's Pictorial Bible,* for example, emphasizes visual over textual representation.[49] Full-page woodcuts and matching quotations from the King James Bible are printed in verso; illustrations face each other, and the matching quotations appear on the back of each image. This design relegates the text to secondary importance and eliminates narrative flow: images and captions follow one another without any explanation. Most illustrations represent well-known events ("Cain & Abel," "The universal Deluge," "David with the head of Goliath"), but some depict more obscure occurrences. An image of Manoah's pregnant wife (the official caption was cut off in the copy I examined by a printing error) requires a substantial knowledge of the Bible to recognize; its caption ("Judges XIII:3. And the angel of the LORD appeared unto the woman, and said unto her, Behold now, thou art barren, and bearest not: but thou shalt conceive, and bear a son") does not substantially clarify the placement of the scene in biblical history.[50]

While Wood's Bible is unusual in its choice not to narrate biblical events, it reveals a broader tendency among thumb Bibles to summarize or refer to biblical events without explanation. *A Miniature of the Holy Bible, being a brief of the Books of the Old and New Testament,* for example, describes the temptation of Eve, but neglects to tell of her creation.[51] This fragmentary representation of biblical narratives implies either prior familiarity or parental guidance, but it also invites invention: such illustrations and phrases might easily spiral into alternative narratives forming in the minds of young readers. On the other hand, some thumb Bibles deemphasize narrative altogether in favor of theology. In *The Bible in Miniature, Intended as a Present for Youth,* the author concludes the Old Testament by observing that "The whole of the Old Testament, as Dr. Hammon observes, 'is a mystical Virgin Mary, a kind of Mother of Christ, who, by the Holy Ghost, conceived him, Gen. iii. 55, and throughout Moses and the Prophets carried him in the womb; and in Malachi brought him unto his birth.'"[52] Such dense, referential writing hardly seems like a welcome gift for youth.

Thumb Bibles claimed to condense spiritual truth into portable form. Abridgement was necessary in order to reduce the Bible to pocket size and desirable in order to match the content of the volume to the comprehension of the imagined youthful reader. The thumb Bible's success in reaching its supposed audience is uncertain; existing copies of miniature Bibles often show little reading wear and few markings other than the occasional inscription of a child owner's name and age in the front free endpaper. Yet the proliferation of versions and the republication of early editions testify to the works' success in appealing to parental purchasers, who were promised that the thumb Bible would aid their child in developing an understanding of biblical truth. As the fairy might guide the child to an appreciation of the natural world as she grew older, so too the thumb Bible might lead the child to a sense of wonder at God's power and mercy. While publishers presented this progression as inevitable, the objects themselves suggest the possibility of other uses; child readers might treasure their Bible for its representations of violence or use its illustrations as starting points for invention. The enduring appeal of thumb Bibles, despite the impossibility of their stated goal, demonstrates the vitality of miniature books as objects that promised infinite things.

Miniaturized Knowledge: Reference Volumes

The Bijou Gazetteer of the World, published in London in 1871, measures 3 3/8 by 2 1/2 inches, with a thickness of 11/16 of an inch. Slightly exceeding the three-inch limit usually assigned to miniature books, this work fits into a separate category of the "macrominiature." The effect of its dimensions is to give the impression of substance despite the volume's diminutive format. Unlike *The English Bijou Almanac* with its jewel binding, the *Bijou Gazetteer* is bound in durable leather, with a strap closure to protect the gilt pages. The only words that appear on the outside of the volume are the title (associated with the publisher) and the author's name: "Warne's Bijou Gazetteer / Rosser." In the 636 closely printed pages that follow, the gazetteer offers information on "position, area, and population, every country and state, their subdivisions, provinces, counties, principal towns, villages, mountains, rivers, lakes, capes, etc."[53]

In its physical form and textual contents, *The Bijou Gazetteer* aims for comprehensiveness. The author, William Henry Rosser, emphasizes the juxtaposition between the volume's minute form and its massive contents

in his preface, writing, "This Work, though small in size, contains 30,000 distinct references; its aim and scope is to convey as much topographical knowledge of a country, province, county, town, ocean, river, mountain, &c., as can be embodied in a single line—to produce, in fact, an EPITOME OF GEOGRAPHY *useful to the* GENERAL READER." In service of his aim of condensing information as much as possible, the author crams 30,000 references into 8.96 cubic inches of space and "as much . . . knowledge" as possible "in a single line."[54] Abbreviations, both familiar and unfamiliar, aid the author in this aim: *A.* stands for "Asia"; *aff.* for "affluent, of a river"; *b.* for "by"; and *bo.* for "contributury parliamentary borough."[55] These abbreviations and omissions create entries that the reader must translate into more expansive descriptions. The entry for the city of London reads: "*cap.* of England and *metropolis* of the British Empire; 51°31′N; in Middlesex and Surrey; total P. 2,803,989; P. of *city & par. bo.* 113,247;—on Thames *r.*"[56] Whereas the term "bijou" habitually connotes a jewel, here it signifies a pure compression. Facts are transformed into jewels of knowledge under the pressure of miniaturization.

Miniature reference volumes became popular in the second half of the eighteenth century as a portable source of information. In England and America, miniature almanacs and calendars became a regular part of the literary marketplace; for example, *The London Almanac,* was published continuously for over two hundred years, from 1690 to 1912. While *The London Almanac* varied in its size and shape over the years, ranging from 1 1/2 to 3 inches in height, it consistently featured the same set of charts showing the days of the months, saints' days, monarchs of England, lord mayors and sheriffs of London, holidays of the year, and values of current coins. These works were sold either in sturdy leather cases with wraparound closures or in highly decorated slipcases that resembled jewels.

By the early nineteenth century, a wide range of macrominiature gazetteers, dictionaries, and grammars advertised themselves as useful objects that compressed huge amounts of useful information into a portable form. These works accentuate their paradoxical minuteness of form and expansiveness of content in their titles. *The Little Gazetteer or Universal Geographical Dictionary in Miniature* and *The Little Linguist; or, A Complete Guide to English Philology* pair "Little" with "Universal" or "Complete" to stress the idea of the comprehensiveness of the miniature.[57] Small and large are paired

together; the miniature yields an infinity on a different scale that matches the vastness of the universe itself. *The Little Linguist* aims to provide "more practical information relative to the laws of Grammatical Construction, and a greater number of Exercises on Syntax and Style, than are to be found in many bulky and elaborate Treatises," while *The Tom Thumb Pronouncing Dictionary* promises to show how to enunciate "in the concisest possible Form, All the Words of difficult Pronunciation and many Scientific Terms."[58] *The Diamond Gazetteer* similarly claims to be "so *complete*, and at the same time so *compressed*, that it may without the least inconvenience be made a constant companion to the pocket, even to the supplanting of a less instructive or useful occupant—the Snuff Box."[59] Here, the publishers contrast the snuff box as a symbol of unnecessary luxury with the *Gazetteer* as a token of its possessors' commercial shrewdness. Rather than narrowing their focus to suit their size, these works aim to become, as *The Little Linguist* puts it, "a Lilliputian giant—the true multum in parvo."[60]

Implicitly, these volumes sought to endow their owners with a sense of power and prestige. The frontispiece of *The Little Gazetteer or Geographical Dictionary in Miniature* shows an image of a helmeted Britannia, in the form of Athena standing atop a globe along with the allegorical figures of America, Asia, and Africa gathered at her feet (Fig. 7.2). In possessing this volume, this suggests, the gazetteer's owner became Athena, presiding over the world with the knowledge contained in his or her pocket. In a similar gesture, the cover of the *Tom Thumb Pronouncing Dictionary* depicts, not the diminutive figure of the title, but rather Atlas holding up the globe. Like Atlas, it implies, the owner of this volume carries all the knowledge of the world. Unlike him, the owner bears this knowledge, not as a heavy burden on the back, but as a light load in the pocket.

Despite their claims of utility, these miniature reference volumes present their readers with a variety of mechanical challenges. Tight bindings and small pages make it difficult to locate and read particular entries. Barely legible print strains the reader's eyes after only a few minutes, while abbreviations and occasional omissions slow the reader's progress. It is difficult to imagine that many of these volumes would have been more convenient, as their printers claim, than their full-scale counterparts; information on remote geographical regions, for example, is usually required at an office or at home where a larger volume might easily be housed. Yet the extravagant

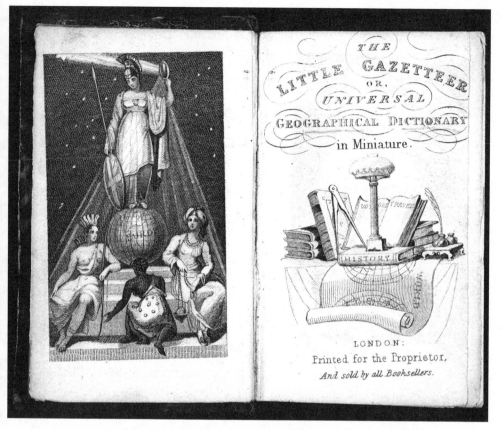

FIGURE. 7.2. Title page and frontispiece, *The Little Gazetteer or Geographical Dictionary in Miniature,* by William Henry Rosser. London: Warne, 1871; volume measures 3 3/8 × 2 1/2 inches. Courtesy Lilly Library, Indiana University, Bloomington, Indiana.

promises offered by publishers indicate that they were selling a fantasy of complete knowledge as much as a reality of portable facts. By embracing the *multum in parvo* ideal, these works promise to contain knowledge itself in a portable form that will not encumber the reader who carries it.

Beyond the Limits of the Senses: Curiosities

Nineteenth-century miniature books strove to convey a sense of infinite knowledge, compacted into miniature form. Whether by emphasizing the disproportions of language (alphabets), condensing the truth of

holy texts (thumb Bibles), or compacting the size of knowledge (reference volumes), their goal was to create the impression, if not the reality, of un-bridled possibility in print. Through the necessary exertion of two senses (the straining of the eyes, the careful turning of the pages), readers gained entry into a minute world of knowledge. Some miniature works, however, sought to extend the reader's thoughts and perceptions beyond the limits of visual and tactile perception into a world of aural and imagi-native possibility.

Critics and collectors have long attempted to draw a distinction be-tween books in miniature and precious trinkets in the form of miniature books. Charles Lamb first suggested a distinction between *biblia* and *abiblia*, or books and not books, in 1822.[61] Eighty years later, in 1902, Sheringham codified this distinction by clearly articulating a difference between *biblia*, or "books proper" which "have or have had any claim to utility" and *abib-lia*, or books "whose existence is a freak, and whose only claim to consider-ation is their beauty or oddity."[62]

While this distinction is appealing, it also immediately excludes minia-ture books whose function defied practical purpose. Consider the follow-ing account by a reviewer of receiving *The English Bijou Almanac* through the post: "Our first and natural supposition was that some antiquarian friend had sent Sylvanus Urban an antient seal . . . in a small wooden box. Our next, on discovering the morocco jeweler's case, that some pi-ous relative of a deceased person of eminence had complimented him with a ring . . . On opening the satin-lined case, still we were somewhat at a loss, but we perceived a little ribbon, by the help of which we at length drew from its innermost receptacle of vari-coloured and gilded leather, the tiny volume whose extreme dimensions are here represented."[63] The sheer length of this description (which takes up almost half of the entire, brief review) indicates that the first and most obviously pressing question about this volume is the most basic one: What is it? A bejewelled book? A book-shaped jewel? Or something else entirely? By virtue of its size, a miniature book seems to contain a secret, to embody interiority, like the small portrait miniature. Yet as this description suggests, the nature of the object itself forms part of the secret for an unsuspecting audience as it is gradually unveiled through a process of speculation and discovery. Instead of being a *container* for micrographic secrets, the book itself be-

comes the secret, the gem and the treasure. Form takes precedence over content, making the material reality of the book, normally a medium for knowledge, itself the subject of its possessor's curiosity.

Publishers experimented with printing in unusual small-scale formats that underlined the global and encyclopedic claims made more implicitly by miniature books as a whole. *The Earth and Its Inhabitants,* for example, made in Nuremberg around 1850, consists of a pastel-blue cardboard measuring just over two inches cubed.[64] As the owner opens the box, she uncovers a pocket globe, which sits on top of a book of accordion-folded pages. When unfolded, the pages reveal peoples of the world in their traditional dress. Citizens of major European nations, including the "English," "Frankh,'" Italien,' and "Swiss," mingle alongside inhabitants of remote and sometimes extinct cultures, the "Siamese," "Hindoe," "Illirian" (ancient Balkans), "Hottentotte," and "Tscherkesse" (northern Turks). To further emphasize the global ambitions of the object, each drawing is labeled in German, French, and English, sometimes with idiosyncratic spellings.

By pairing the compactness of the globe with the diminutiveness of the miniature book, *The Earth and Its Inhabitants* formally combines two forms of global encounters: the pocket globe implies mastery (through education and possession), while the unfolding miniature book suggests the endlessly unfolding expanse of global space. Pocket globes were popular throughout the late eighteenth and early nineteenth centuries, especially in England. These globes served primarily as educational tools for children, though they may also have functioned as geographical reference tools and novelty toys for adults.[65] The child owner of *The Earth* could hold the miniature globe, measuring 1.7 inches in diameter, between two fingers. The same child could unfold the accompanying accordion-folded miniature book to a length of over four feet (52 inches), winding it entirely around her body. By having the booklet affixed to the bottom of the box, the object encourages the child to return both globe and booklet to their places and to contain them again within the unassuming six sides of the case. The same object, then, scripts the child's immersion in the endlessly unfurling expansiveness of global space and her subsequent control over the globe and its populations in the form of a pocket possession.

Other miniature books allow the child to experience an unfurling of both knowledge and power that at once grants the reader's mastery and

suggests a chaos of infinity. *The Infant's Cabinet of the Cries of London,* published in 1807, combines the forms of a miniature library and a deck of cards, allowing the child to discover and explore the aural and visual panoply of the city of London. A wooden box, measuring about 2 1/2 by 3 1/2 inches, contains two miniature volumes and twenty-eight cards, each of which represents a unique "Crier" or hawker of the London streets.[66] Inscriptions running under the illustrations record hawkers' cries: "Ripe Strawberries," "Rare Mackeral," "Buy a Mat a Door Mat," or "Buy a Duck a Live Duck." The watchman simply tells the time: "Past Ten O'Clock."

The implied voices of the sellers build to an imagined cacophony, allowing the child alternatively to summon the streets of London and to shut London's populations neatly up inside the box. The concept of representing the "Cries" of a city dates back to broadsheets published in Paris in 1500. Examples of the genre appeared throughout the next three centuries in England and Paris, assuming the varied forms of broadsheets, sets of illustrations, and, beginning in the eighteenth century, illustrated volumes for children. By framing the cries as a series of cards, *The Infant's Cabinet* both offers a fantasy of regulation and control over the voices and hints at the unmasterable chaos of the city itself. The cards might, indeed, be engaged in a wide variety of ways. The cards showing the sellers might be ordered to match the cries in the accompanying miniature volumes; but they might equally be spread out in a large square, splayed across a table in overlapping chaos, or compacted randomly into a single deck. The city itself recedes into the background of a landscape defined by the diverse persons and voices within it; these perspectives, normally relegated to the background as noises of the city, are both familiar and unfamiliar. In this sense, *The Infant's Cabinet* functions like a microscope, permitting the close examination of overlooked forms, but also, in its partial views, hinting at the infinite ungovernability of the city space. The colors and sounds of London are contained and made manageable by the box even as the miniature scale and format suggest their unfurling, disorienting expansiveness.

Like *The Earth and Its Inhabitants* and *The Infant's Cabinet, La Lanterne Magique* engages the reader's senses, this time in order to suggest the insufficiency of vision. Published in 1825 in France, *La Lanterne Magique* contains twelve booklets of four pages each with insert illustrations. When

the illustration is held in front of a light, an additional image appears. Each booklet explains the second image in a unique way, alternately invoking man-made technology and supernatural vision to give significance to the display. The titular volume, "La Lanterne Magique" shows a magical lantern projecting the image of a proud soldier on horseback to the awe of the spectators. In the text of the booklet, the projector announces: "Approchez, messieurs et dames, approchez; vous allez voir des étoiles en plei midi, des rivières sans eau, des femmes sans tête, des danseurs sans jambes, des avocats sans langue, des Hercules sans bras."[67] Impossible things become visible through the magic lantern's lens. Other booklets also represent man-made illusions: a marionette play appears in profile on a stage in "Les Marionnettes," and a bust of Napoleon appears behind a screen in "La Silhouette." Still others explore the possibilities of the supernatural: in "L'Ours Magicien," a bear-magician, dressed as a man, shows a young girl the image of her family as a demonstration that he holds them in his power. Meanwhile, a sorcerer shows a young man his future wife in "Le Sorcier," a psychic summons a vision of a young lady's lover in "La Psyché," and a genie tricks a young man into thinking that he has been transported to the bedside of his ladylove in "Le Talisman." *La Lanterne Magique* remains agnostic about the possibility of magic in the real world; it describes magicians and sorcerers as belonging to a distant past of magicians and genies, yet the advances of technology ambiguously bring these supernatural visions into the technological present. A final group of booklets reveal invisible specters: "Le Solitaire" represents a monk at prayer, while the light reveals demons swarming around him; and "Le Cauchemar" represents a sleeping woman upon whose breast a demon sits in the precise pose of the ghoul in Henry Fuseli's painting *The Nightmare* (1781). In some cases, the apparitions are evoked by the subject's mind; in "Le Songe," a sleeping soldier conjures an image of his heroism being rewarded while he lies asleep.

In equating human spectacles and supernatural marvels, *La Lanterne Magique* fosters the conception of a world that is both within and beyond human control. In each case—the technological deception, the supernatural vision, the imagined presence, and the soldier's dream—the reader becomes a literary magician as she holds the insert up to the light and makes the second image appear. This technology of print mimics other

visual technologies (such as the microscope, telescope, and kaleidoscope) to enlarge vision and reveal what was previously hidden. Using the same technology as William Spooner's lithograph of "The Microscope," discussed in Chapter 3, *La Lanterne Magique* places the reader in a position of agency in summoning the vision, even as she grapples with the possibility that the spectacles she reveals belong to worlds beyond her control. By virtue of its scale and hidden image, the book invites the reader to briefly entertain the possibility that magic is real.

These miniature books—*The Earth and Its Inhabitants, The Infant's Cabinet of the Cries of London,* and *La Lanterne Magique*—give the child reader an experience of unlimited power. Whether holding the globe between her fingers, containing the voices of the city in a box, or summoning spirits and forces from beyond the realm of vision, the child reader has an experience that is less about reading (engaging with the volume's contents) than about ownership (engaging with it as an object).

Printers and publishers of miniature books throughout the nineteenth century aspired to reach an unknown limit of minuteness in printing, straining against the boundaries created by the physical limitations of typesetters and binders, and working to refine technologies that would permit still more perfect examples of the form. In the quest to create the smallest book in the world, they forged partnerships and rivalries across France, Italy, Germany, and Great Britain. This quest was guided less by the spirit of possibility that often accompanied miniatures than by a concrete and competitive belief in an end point that, though unknown, could be reached. One crucial question remained: how small was the smallest book that could be made?

In 1490 the smallest type (according to our modern scales) was a six-point type popularly called "nonpareil," or "without equal." By 1627 printers were using a five-point type called "Pearl"; and in 1700 a four-and-a-half-point type titled "Diamond" was cut for the first time in Amsterdam. Nineteenth-century printers added to these a four-point "Brilliant" type and a three-point "Excelsior" type.[68] The names of these increasingly diminutive types serve to convey the printers' conviction that they were creating gems of the printed world. In 1827, Henri Didot printed Rochefoucauld's *Maximes et Réflexions Morales* in what he called "les caractères microscopiques," a two-and-a-half-point "Microscopic" type

that exceeded in size and beauty all moveable type that had come before. In the preface to the volume, Didot framed his accomplishment in nationalistic terms, writing, "je l'avouerai, si je dois m'applaudir d'avoir dépassé dans la gravure des petits caractères le terme de réduction que les typographes anglais n'ont point osé franchir, ce qui me paraît d'un plus grand intérêt dans cet effort de l'art, c'est d'y avoir trouvé l'occasion de constater, par une production qui sort des règles ordinaires, tous les avantages d'une découverte qui appartient exclusivement à la France (la fonderie polyamatype), et dont j'oserai croire qu'elle peut s'honorer en raison de son incontestable supériorité sur tous les procédés connu."[69] Didot was correct in assessing the superiority of his type over anything previously produced; his miniscule type remained the premier standard in France and Great Britain until 1873, when Miller and Richard produced a pristine three-point type that exceeded Didot's in clarity, though it was also slightly larger in size.[70]

While Didot excelled in creating type that was notable for its clarity and beauty, other printers worked to make the smallest type regardless of legibility. In 1834, Antonio Farina in Milan cut the first examples of what he called "occhio di mosca" or "fly's eye type." The size of this typeface made it nearly impossible to use in practice; it was not until 1867 that the brothers Salmin of Padua began an edition of Dante's *Divina commedia* with this type, and it took them over a year to complete it.[71] According to an account passed down in the Grolier Club, the strenuous task of type-setting this volume required one month to print thirty pages, necessitated new type for every form, and damaged the eyesight of both compositor and corrector in the process of production.[72] In 1897, the Salmin brothers produced a second volume with their fly's eye type: *Galileo a Madama Cristina di Lorena (1615)*, which measures a mere 11/16 by 1/2 of an inch (Fig. 7.3). The choice of text demonstrates the ambition intrinsic in the act of miniaturization. In choosing to print Galileo's letter defending the Copernican theory in miniature, the Salmin brothers reproduced his theories about the nature of universe in a book that is half the size of a postage stamp. Indeed, this volume is widely believed to be the smallest book printed with moveable type.[73] The infinitesimal size of the volume emphasizes the paradoxical scale of Galileo's own writing: just as the brevity of Galileo's letter accentuates its significance, so the scale of this

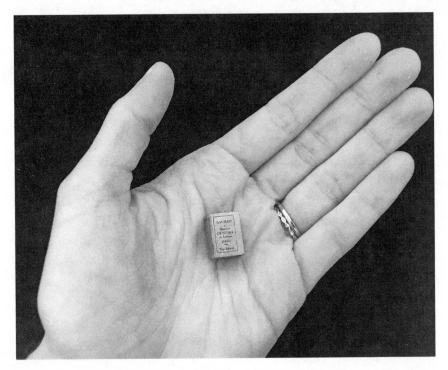

FIGURE. 7.3. *Galileo a Madama Cristina di Lorena (1615)*. Padua: Tipogr. Salmin, 1896; volume measures 11/16 × 1/2 inch. Courtesy Huntington Library, San Marino, California.

printing posits an equivalence between the vastness of miniature space and the vastness of the universe itself.

Not to be outdone, Ernest A. Robinson published a volume in 1891 that measures just 13/16 by 11/16 of an inch, making it the smallest book printed in English with moveable type. Robinson titled this work *The Mite*, selecting a word that at once connotes a minute insect, a small sum of money, and even a tiny child. In its name, *The Mite* claims to embody minutiae, less as a jewel (the volume is simply bound in red cloth), than as the smallest iota of the natural, commercial, and human worlds. Unlike *Galileo*, *The Mite* prioritizes form over content. Instead of miniaturizing an important literary or scientific text, Robinson printed twenty-eight pages of useless information, including the amount of wire used annually for making pins, the height of the Eiffel Tower, the number of colors obtained from coal tar, and the date of Lord Salisbury's birth.[74] The com-

mercial success of *The Mite*, which Robinson declared was "issued as a curiosity,"[75] suggests the transition of the miniature book at the end of the century toward the status of a collectible.

Two major technological innovations, indeed, were fundamentally altering the nature of miniature book production in the last quarter of the century. First, Oxford University Press introduced an ultrathin but strong and opaque paper called India paper in 1875, which made it feasible to produce longer volumes with less bulk. For miniature-book printers, this meant that the Bible could be printed in miniature with its full text for the first time. Second, the introduction of photolithography, in which full-sized pages could be decreased in size through the reduction of larger-scale images, made it possible to create miniature books with unprecedentedly small dimensions. Typesetters no longer had to strain to set miniature type; printers could produce smaller volumes with less technical skill at a lower cost. This also meant that works printed in miniature no longer needed to be designed explicitly for the miniature format. For example, the Glasgow University Press reprinted a 560-page volume entitled *The Miniature New Testament* as a volume measuring 3/4 by 5/8 of an inch simply by shrinking an Oxford pica sixteenmo.[76]

These changes permitted miniature-book production to become a large-scale commercial enterprise. David Bryce of Glasgow was the first to capitalize in earnest upon these commercial possibilities. He stumbled into the field of miniature-book production after a run of twenty thousand copies of a small (but not miniature) dictionary took years to sell out. Rather than reprinting the dictionary directly, Bryce determined to cut the size of the volume in half and market it as a "Thumb Edition." The first edition of *Bryce's Thumb English Dictionary* (1890) sold twenty thousand copies in six months; from 1890 to 1928, Bryce estimated that he sold over two million copies of the volume.[77] In view of this success, Bryce created even smaller works. He describes, "Instead of developing works of a larger kind, I descended to the miniature, mite and midget size, producing a little dictionary, the smallest in the world, in a locket accompanied by a magnifying glass. I had many a scoff and jeer as to the absurdity of the production, nevertheless it appealed to Mr. Pearson of the notable weekly, who gave me my first order of 3,000 copies, and its sales are now over 100,000."[78] Bryce's books are considered artistic and

commercial triumphs, both at first printing and today. They are also disproportionately represented in contemporary collections, an indication that their print runs were much larger than any that came before, numbering at times above a hundred thousand.[79]

Even as technological innovations permitted a new brilliancy in miniature printing, they also created an industry of "souvenir" miniature books, which clearly prioritized size over quality. The ease of reduction meant that printers no longer needed to think small, and the crucial difference between crafted miniatures and their full-scale inspirations evolved into a precise and mechanical form of reproduction on a small scale. Bryce's *The Smallest English Dictionary in the World* (1900) measures just one and seven-sixteenths by one inch, but includes thirty-nine lines of definitions on each of 384 pages.[80] Sold with a magnifying glass for the relatively inexpensive price of 1s. 3d., this work was illegible even under magnification due to a lack of definition in the letters.[81] The dictionary, complete with a tiny image of Samuel Johnson as the frontispiece, suggests the logical culmination of a century-long fascination with the seemingly infinite space of miniaturization: this dictionary is compressed into impossible dimensions. Bryce's self-titled "souvenir" editions of the Bible similarly make no claim to be useful; each presents itself as a novelty. One features a metallic medallion with a photograph portrait of King Edward VII and Queen Alexandra; another is attached by a chain to a miniature lectern; and a third simply declares itself a "Souvenir of the Glasgow Exhibition" on the cover.[82] No longer triumphs of the printer's art, these works were trinkets of the commercial sphere.

Throughout the nineteenth century, publishers and printers had sought to capture the enchantment of the miniature in the form of books. The ingenuity of these works derived precisely from their creators' response to the limitations posed by the use of moveable type: a miniature book was not simply a technological trick but an intense labor of artisanal craftsmanship. The last prominent set of miniature books produced through artisanal labor was a set of volumes handwritten and illustrated expressly for Queen Mary's dollhouse in 1924.[83] With the production of this new library, miniature books ceased to be the province of either the adult or the child in the public imagination and became the accepted property of the doll.

CODA

MINIATURES AFTER THE VICTORIAN AGE

In the early 1920s, Queen Mary received a five-foot-tall dollhouse as a gift from the British people that showcased Britain's technological and artisanal capabilities. Constructed from 1921 to 1924 entirely on a one-to-twelve-inch scale (or one inch to one foot) and designed by the renowned architect Sir Edwin Lutyens, the building included not just bedrooms, drawing rooms, and a kitchen, but also staff rooms, a garage, a cellar, and an elaborate library. The house also contained 750 works of art by leading artists of the period, hand-embroidered bed drapery over horsehair mattresses on beds with hot-water bottles under the sheets, a working gramophone that played "God Save the King," replicas of the Crown jewels, running hot and cold water, working elevators, loadable guns, motorcars from the five major British manufacturers (Daimler, Lanchester, Rolls-Royce, Sunbeam, and Vauxhall), botanically accurate flowers and trees, a Hoover vacuum cleaner, a tin of Colman's mustard powder, bottles of Mumm champagne, and barrels of Glenlivet and Jameson's whiskeys, among many other items.[1] More than 1,500 craftsmen manufacturers, decorators, artists, and writers contributed to the project, making it, as one writer put it, "a work of art—in fact

hundreds of works of art—and a beacon of national importance."[2] When the dollhouse was put on display at Wembley for six months, it was seen by 1,617,556 people. *The Times* declared it "A Miracle in Miniature" and "a dangerous sight for half-believers in magic."[3]

Queen Mary's Dolls' House is a spectacular feat of miniaturization. By incorporating unique works by current artists and writers alongside reduced versions of popular manufactured objects, it offered a complete world into which the observer might imaginatively step. Yet the very completeness of this fantasy—its running water, electric lights, and untouched room arrangements—marks the gap between Victorian miniatures and this early twentieth-century masterpiece. This remarkable dollhouse does not invite the imagination to complete it, but rather defies the imagination to conceive of anything that has been left out. Toothpaste sits next to washbasins; pillowcases in the servants' quarters have miniature buttons; linens on the beds are hand-embroidered with a monogram; even the mousetraps are equipped with miniature mice.

Queen Mary's Dolls' House marked a new height of artisanal labor in miniaturization, but it also placed this labor behind glass, away from the prying hands and imaginations of curious onlookers. Queen Mary herself, who called it "My house," had to make a special request in order to play with it alone with the king for four hours.[4] Immense labor went into constructing objects that were never seen fully. This was particularly true of the library, which included works by such prominent writers as A. A. Milne, J. M. Barrie, Arthur Conan Doyle, Vita Sackville-West, Thomas Hardy, and Edith Wharton. Each author had been sent a blank miniature book and asked to inscribe a new tale inside it; these volumes were accessible to public view (at a distance), but not to public perusal.[5] The books offered no pretense of portability or use (as nineteenth-century miniature books typically did); they were, rather, part of a meticulously created tableau of life—a tableau so static that not even dolls were permitted to occupy the chambers lest they, in their imperfect mimesis of human life, jeopardize the semblance of reality maintained by the whole. Here, fairy magic becomes secondary to the wonders of the modern metropolis. In one book, the cartoonist Fougasse (Cyril Kenneth Bird) wrote the tale of a fairy blown to London who adopts the dull name of James Smith and whose talents as a dancer, singer, and painter are decried by professional

artists in the city.[6] Elsewhere in the palace, a toy theater was arranged to show scenes from *Peter Pan*, a play that, as previously discussed, employed electricity to represent the fairy Tinkerbell. Technology, not fairies, brought the sense of magic to this dollhouse.

I linger over Queen Mary's Dolls' House precisely because it both unites many of the forms of miniaturization discussed in this book and suggests the trajectory miniatures took in the twentieth and twenty-first centuries. The house features miniature paintings that serve as decorations for imagined doll inhabitants, objects crafted with microscopic precision, doll furnishings that are perfect in the degree of their completeness, and miniature books containing stories that are inaccessible to the observer. In its perfection, it marks a shift toward a technological reproduction in small, which reduces the role played by the observer's imagination even as it marks new heights of technical achievement. While the Victorian miniatures described in this book point beyond themselves to worlds and ways of being that lie just out of view, miniatures in the early twentieth century and after have striven for perfection of detail, reducing the role of guesswork, extrapolation, and exploration in observing them.

In the 1970s, the development of an International Guild of Miniature Artisans epitomized a new seriousness about the production of miniatures. To become an artisan or fellow in the guild, an artist must produce a series of miniatures that meet the guild's standards for "overall impression, degree of difficulty, workmanship, adherence to scale, and creativity." Miniaturists who specialize in animals, for example, are enjoined, not only to attend to the shape and scale of an animal's muscular structure and its covering (whether skin, scales, fur, or feathers), but also to ensure that each miniature animal has a light in the eyes that gives "an essence of being alive."[7]

This is not, of course, the only story to be told about miniatures in the twentieth and twenty-first centuries. Children's dolls and dollhouses, for example, endure both in intricate and in imperfect forms, engaging the imaginations of children and adults alike. But nineteenth-century miniatures bore both the weight of nostalgia for a past of cultural and childhood innocence (understood through a reduction in scale) and the excitement of discovering a microscopic world in the present (associated with the scale of miniatures). Both of these associations have faded in the twentieth and

twenty-first centuries as technological innovations have come to define our understandings of miniature space. Technology, indeed, has opened up production on a scale of unprecedented minutiae. While the smallest book printed with handset type, *Galileo a Madama Cristina di Lorena (1615)* (1896), measures 11/16 by 1/2 inch, the smallest book in the world now, *Teeny Ted from Turnip Town* (2007), was printed in a laboratory with a gallion-ion beam and measures 0.07 mm by 0.10 mm (0.003 by 0.004 inches); it can only be read with a scanning electron microscope.

Today we are in the grip of another form of miniaturization: the digital miniaturization of the smartphone. As of early 2019, 81 percent of Americans possessed a smartphone, which ostensibly brings the world's knowledge and resources to their fingertips.[8] Yet while the smartphone, and particularly the iPhone, have become symbols of infinity—of "everything"— this, like earlier conceptions of miniatures, is a cultural fiction. Like the miniature books that preceded them, smartphones do not always carry through on the ease of use they promised. These systems remain characterized by technological imperfections (malfunctioning applications and confusing navigation), factual unreliability (misdiagnoses from Dr. Google), information overload (preemptive answers to users' questions), and attention-grabbing distractions (advertising banners and pop-ups). While, as I have argued in this book, nineteenth-century miniatures promoted and permitted an open-ended engagement with indeterminacy and possibility, twenty-first-century smartphones promote a different kind of diffusion by offering an experience of complete immersion from which it is (intentionally on the part of program designers) difficult for the user to extricate herself.

What unites twenty-first-century smartphone users and nineteenth-century owners of miniatures is a common sense of the wonder of miniatures and of their capacity to contain what seems like infinity in a form that can be held in the palm of the hand. In this book, I have argued for a periodization of miniatures, positing that they held unique cultural significance for, approximately, the period of Queen Victoria's reign. In making this argument, I hope to suggest that this wonder in itself contains a kind of infinity, morphing into different forms and assuming different significances from age and age. In this sense, my book is an open invitation to my readers to explore the many miniature worlds still waiting to be discovered and described.

NOTES

Introduction

1. Gaskell, *The Life of Charlotte Brontë*, 62.

2. See, for example, John Plotz's seminal study *Portable Property: Victorian Culture on the Move*, in which he outlines how material objects accrued sentimental meaning over time even as they remained fungible and therefore engaged with commodity culture.

3. In making this claim, I join a growing community of scholars across disciplines who seek to dispute the notion that global and singular narratives intrinsically possess more importance and power than local narratives or, in the case of this book, than miniatures. As J. K. Gibson-Graham notes, in contemporary discourse "[t]he global is represented as sufficient, whole, powerful, and transformative, in relation to which the local is deficient, fragmented, weak, and acted upon." They add, "[t]he judgment that size and extensiveness are coincident with power is not simply a rational calculation in our view but also a discursive choice and an emotional commitment." Exploring miniatures means acknowledging that the forces we associate with power—including globalization, capitalism, and empiricism—have placed disproportionate emphasis on certain aspects of human identity and experience; Gibson-Graham, "Beyond Global vs. Local," 30, 51. This bias toward the global and the large-scale is equally evident in critical literature. As Michael Tavel Clarke and David Wittenberg noted in their recent edited volume, "dominant contemporary discourses of scale, particularly concerning globalization and the Anthropocene, privilege the large," in part because of a discursive association of size

with political power and global change"; Clarke and Wittenberg, Introduction to *Scale in Literature and Culture*, 24.

4. This fallacy derives its force in part from the ease with which images and models may be scaled up or down both in digital forms and in the imagination. For an astute overview of why the fallacy of scalability continues to hold sway and how this fallacy reveals a failure to grasp the real implications of scale, see Clarke and Wittenberg, Introduction to *Scale in Literature and Culture*, 1–4.

5. See Cooper-Hewitt Museum, *Miniatures*, 10.

6. This similarity-and-difference has much in common with Freud's definition of the uncanny, which he defines as being both *heimlich* and *unheimlich*, home and not-home. Sigmund Freud, "The Uncanny," 219–226.

7. For an astute account of the ways in which the boundary that critics sometimes posit between science and fiction was consistently blurred during the period, see Erchinger, *Artful Experiments*. Erchinger is not alone in positing a breakdown in the distinction between science and the arts; see also Luckhurst and McDonagh, "Introduction: 'Encounter Science,'" and Morgan, *The Outward Mind*, esp. 16–19. For accounts of the ways in which science itself served as an agent of enchantment in nineteenth-century culture, see Levine, *Darwin Loves You*, xiv–xvii; Josephson-Storm, *The Myth of Disenchantment*, 17–18.

8. Walton, *Mimesis as Make-Believe*, 22.

9. See Chapter 4 and Doyle, *The Coming of the Fairies*.

10. Saler, *As If*, 7.

11. For examples of each, see *The Fairy Annual*; "Portraits, Busts and Statues," 703; Whitelock, *Fly-Away Fairies*.

12. Bachelard, *The Poetics of Space*, 154–155.

13. Ibid., 155.

14. Stewart, *On Longing*, 65.

15. Mack, *The Art of Small Things*, 5, 169.

16. To my knowledge, no comprehensive account of early modern miniatures exists. Patricia Fumerton's chapter on "Secret Arts: Elizabethan Miniatures and Sonnets" outlines how portrait miniatures fit into a larger pattern during the period of rhetorical and material ornamentation, used in social settings as part of a performance of the self. Fumerton, *Cultural Aesthetics*, 67–110.

17. Rabb, *Miniature and the English Imagination*, 9.

18. Ibid., 98–102.

19. Miniatures therefore reflect the emergence of the British middle class and the development of nineteenth-century consumer culture. For a discussion of both transformations, see Cohen, *Household Gods*, 1–31.

20. For a discussion of how Gulliver's comparative size raised philosophical and moral questions about the relation of the part to the whole, see Rabb, "Johnson, Lilliput, and the Eighteenth-Century Miniature," 290–291.

21. See ibid., 287–288.

22. Rands, *Lilliput Levee*, 4. See also *Lilliput Revels* (1871), *Lilliput Lectures* (1871), and *Lilliput Legends* (1872).

23. Mary Mister, *The Adventures of a Doll*, 143.

24. Ibid., 144–145.

25. Ibid., 146.

26. Landon, *The English Bijou Almanack for 1837*, n.p.

27. Hooke, *Micrographia*, n.p.

28. Ibid., 210.

29. This period of standardization has often been characterized as one of dormancy for microscopic discovery, but, as Marc J. Ratcliffe has shown, it also involved the creation of a vocabulary, technique, and system of categorization for microscopic organisms that laid the groundwork for the discoveries of the following century. Ratcliffe, *The Quest for the Invisible*, esp. 125–147.

30. Macleod of Skye, "Microscopical Research," 230.

31. See Iwan Rhys Morus, "Worlds of Wonder," and Bernard Lightman, "The Microscopic World."

32. See Dick, *The Atmosphere and Atmospherical Phenomenon*, 132.

33. *The Cabinet of Curiosities*, 102.

34. West, "On Some Microscopic Tracings," 41.

35. See Benjamin, "Sliding Scales," 99–122.

36. "Painting Microscopic Slides," 108.

37. Mantell, *Thoughts on Animalcules*, 7.

38. Simmel, *The Philosophy of Money*, 475.

39. Clark, "Scale," 72.

40. This logic recurs throughout scientific literature of the period. Thomas Rymer Jones, for example, calculates the size of the *Monas termo*, a type of bacteria, as being 1/22,000 of an inch. From this, he reasons, "We may, therefore, safely say, that, swimming at ordinary distances apart, 10,000 of them would be contained in a linear space one inch in length, and consequently a cubic inch of such water will thus contain more living and active organized beings than there are human inhabitants upon the whole surface of this globe!" Jones, *The Natural History of Animals*, 100.

41. Such imagery recalls Darwin's memorable final description of the entangled bank thick with life that, as he posits, emerged from a single or select group of ancestors. Darwin's image works to suggest how the physical entanglement of plants, birds, and insects reflects a deeper evolutionary connection between them; cartoons like this one suggest that the entanglement is not just located in the distant past. Darwin, *On the Origin of Species*, 489–490.

42. Carroll, *Sylvie and Bruno*, 298.

43. Ibid., 299.

44. Ibid., 302.

45. Brown, "Thing Theory," 4.

46. This concept represents an expansion of anthropological insights into the ways in which objects possess agency in their influence over the structure of community norms and interactions. See Appadurai, "Introduction," esp. 12–29.

47. Other critics, taking up Freedgood's model, have powerfully implemented these ideas. See, for example, Susannah Daly's *The Empire Inside* and Julie Fromer's *A Necessary Luxury*. Perhaps most influentially for my own work, Isobel Armstrong illuminates a Victorian glass culture that must be understood through the historical particularities of Victorian glass blowing, glass displays, and glass manufacture, even as it engages with transhistorical questions of aesthetics and visual culture. Armstrong, *Victorian Glassworlds*, esp. pp. 1–16.

48. Stewart, 47.

49. Ibid., 52.

50. Bernstein, *Racial Innocence*, 8.

51. By contrast, miniatures appear only infrequently with Victorian poetry, which, even in its lengthy narrative forms, tends to aim for aesthetic suggestiveness over world-making completion. During historical epochs when miniatures were understood less in terms of narrative or world-making terms, they were also represented in poetry more frequently. Patricia Fumerton, for example, has argued that the form of the miniature in the early modern period is conceptually analogous to the sonnet. Stephen C. Behrendt extends this claim to Romantic poetry, emphasizing that both Romantic sonnets and portrait miniatures require technical virtuosity to compress the meaning that they carry. Fumerton, 85–104; Behrendt, *British Women Poets*, 118.

52. Connor, "Thinking Things," 17. I also follow Connor in using the term "things" in a looser sense than Brown's precise definition allows.

53. In describing the effects of miniatures on their possessors, including the epistemological unsettling of a belief in human distinctness, I retain a distinction between humans and material things. In this sense, my approach is distinct from that of Jane Bennett and other critics who envision things as possessing a thrumming life that cannot be distinguished from the life of people themselves. It equally differs from that of Karen Barad, who posits in "Posthumanist Performativity" that what we term humans and material things are entwined in a state of becoming, and that neither can nor should be conceived of as distinct entities.

Chapter 1. Victorian Portrait Miniatures

1. Quoted in Bridget Wright and Susan Owens, "'Such wonderful method,'" 49.

2. RA VIC/MAIN/QVJ (W) March 3, 1850 (Princess Beatrice's copies)

3. Harvey, "Modern Miniature Painting," 296.

4. "Correct Likeness," 508.

5. Foskett, *British Portrait Miniatures*, 176. The nineteenth-century collector George Charles Williamson credits the decline of the art to the "increasing conventionality of the

portrait that was demanded" and to the rise of "a mechanical portraiture." In 1963, Daphne Foskett, in her influential history of the form, observed dismissively that early nineteenth-century miniaturists were "perhaps not of the same calibre" as the miniaturists in the generation before. Moreover, because early twentieth-century collectors, as Cory Korkow has observed, "did not value Victorian miniatures," samples of the art from this period are often omitted from collections dedicated to the form. Williamson, *Portrait Miniatures*, 83, 88; Foskett, 152; Korkow, 20.

6. Reynolds, *English Portrait Miniatures*, 142.

7. See Fumerton, *Cultural Aesthetics*, esp. 85–104.

8. Fumerton, 67–68.

9. Marcia Pointon underlines what she terms the "social economy of portraiture" in the eighteenth century, arguing that portrait miniatures represent an entwinement of economic and sentimental value. Pointon, "'Surrounded with Brilliants,'" 57.

10. The eye miniatures of the Prince Regent and Maria Fitzherbert are among the only examples whose subjects can be reliably identified. For a longer discussion of the intimacy of eighteenth-century eye miniatures and the power of an exchanged gaze, see Grootenboer, *Treasuring the Gaze*, esp. 5–7, and Holloway, *The Game of Love*, 72–78.

11. Duff, *Catalogue of the Portraits*, 4.

12. Elliot, *Portraiture and British Gothic Fiction*, 126–127.

13. "Richard Cosway," 38.

14. Reynolds, *British Portrait Miniatures*, 108, 122. Elsewhere, Reynolds estimates that there were over three dozen accomplished professional miniaturists working in England between 1760 and 1800. Reynolds, *English Portrait Miniatures*, 143.

15. Shee, *Rhymes on Art*, 33.

16. White, "Photography Popularly Explained," 53.

17. Robertson to John Ewen, January 25, 1802, in Robertson, *Letters and Papers*, 64.

18. Robertson, Memo, January 20, 1802, in Robertson, *Letters and Papers*, 61.

19. Robertson to John Ewen, June 1, 1803, in Robertson, *Letters and Papers*, 99.

20. Rochard, *Portrait of Miss Mary Wedderburn Stirling and Master Patrick Stirling*.

21. Catherine Georgiana Stirling to John Stirling, October 1841.

22. Reynolds, *English Portrait Miniatures*, 172.

23. "Miniature," *Arts and Sciences*, 669.

24. Stern and Thimme, *Eastern Port of Corinth*, 337.

25. Reynolds *English Portrait Miniatures*, 155. The body of the artisan here becomes an important but invisible part of the portrait miniature's materiality, just as the breath of the glassblower became a part of his finished product, as Isobel Armstrong has illuminatingly shown. Armstrong, *Victorian Glassworlds*, 3–5.

26. Johnson, *American Portrait Miniatures*, 36.

27. Robertson, "Treatise on Miniature Painting," *Letters and Papers*, 164.

28. Remington, *Victorian Portrait Miniatures*, 489.

29. See Joe Bray's description of portrait miniatures transported by letter in the late eighteenth and early nineteenth centuries in *The Portrait in Fiction of the Romantic Period*, esp. pp. 51–55.

30. Coltman, *Sojourning Scots*, 435–438.

31. Subjects of British miniature painting, of course, were not always British. In the late eighteenth century, miniaturists, including Ozias Humphry and John Smart, traveled from London to India with the East India Company, where they painted both British expatriates and locals. Humphry's trip to India ended prematurely after three years, not for lack of work, but from the difficulties he faced extracting his fees from his foreign-born sitters. His lack of long-term success did not deter followers. Thomas Hickey, Robert Home, and George Chinnery, among others, all made the trip.

32. Ross, *Victoria, Princess Royal.*

33. "The Royal Academy: The Eighty-Third Exhibition 1851," 161.

34. Robertson to William Robertson, May 1802, *Letters and Papers*, 69.

35. See, for example, "The Royal Academy: The Eightieth Exhibition 1848," 179; "The Royal Academy: The Eighty-Third Exhibition 1851," 161; Council of Four, *The Royal Academy Review*, 7.

36. Ross, *Margaret, the Duchess of Somerset.*

37. Hervé, *Rosamund Croker.*

38. Carrick, *Unknown Woman.*

39. "The Collection of Miniatures," 216.

40. Tidey, Alfred Tidey to Unknown.

41. Victoria and Albert Museum, *Review of the Principal Acquisitions*, 111.

42. Tidey, Alfred Tidey to Unknown.

43. Ibid.

44. Remington, *Victorian Portrait Miniatures*, 10.

45. Ibid., 395, 399, 572–573.

46. Ibid., 17.

47. Ibid., 16.

48. RA VIC/MAIN/QVJ (W) March 10, 1863 (Princess Beatrice's copies).

49. Remington, *Victorian Portrait Miniatures*, 143.

50. RA VIC/MAIN/QVJ (W) January 7, 1840 (Lord Esher's typescripts).

51. Remington, *Victorian Portrait Miniatures*, 3.

52. "The Photographic or Daguerreotype Miniatures."

53. "Foreign Correspondence," 69.

54. Clericus, "M. Daguerre's Discovery"; N., "Miniature Painting," 226.

55. Letter of December 7, 1843, in Barrett, *Elizabeth Barrett to Miss Mitford*, 209.

56. See Nancy Armstrong's contention that fiction took its ideas of realism from photography, in her *Fiction in the Age of Photography;* Novak's discussion of photographic manipulation and abstraction as essential to understandings of both photographic and literary realism in *Realism, Photography and Nineteenth-Century Fiction;* Green-Lewis's description of

how photography shaped contemporary memory and nostalgia in *Victorian Photography, Literature, and the Invention of Modern Memory;* and Groth's point that photography gave rise to a desire to arrest time in *Victorian Photography and Literary Nostalgia.*

57. The microscope and the camera were not infrequently associated as tools of scientific vision in the nineteenth century. Arabella Buckley, for example, described "five magic glasses—the magnifying-glass, the microscope, the telescope, the photographic camera, and the spectroscope" in *Through Magic Glasses,* 53.

58. Winter, "The Pencil of Nature," 288–289.

59. Photographers, of course, resented the understanding of the camera as a scientific rather than an artistic instrument. When photographs were displayed, not among the "Modern Fine Arts" but in the "Machinery Court" at the International Exhibition in London in 1862, *Punch* reacted in horror with a satirical cartoon showing a monkey-operated camera. The accompanying text railed against the organizers for "pass[ing] an insult upon Photographic Art, by classing its productions with railway plant and garden-tools, small arms and ships' tackle, big guns, and new omnibuses, donkey-carts and corn-extractors, and the thousand other articles of mechanical apparatus." "Fair Play for Photography," 221.

60. "The Collection of Miniatures at South Kensington," 216.

61. Reynolds, *English Portrait Miniatures,* 165.

62. Kilburn, "Photographic Miniatures," 298.

63. See Henisch and Henisch, *The Painted Photograph.*

64. Eastlake, "Photography," 467.

65. These numbers, which I calculated using Remington's volume, are of course approximate due to the lack of information of the source of every image and the difficulty of establishing definitive chronologies. These numbers are further qualified by the fact that the images were painted throughout the duration of Victoria's reign and therefore do not reflect changes across the century. Remington, *Victorian Miniatures.*

66. Ibid., 4.

67. Redgrave, "Introductory Notice," *Catalogue,* x.

68. Propert, "The English School of Miniature Art," 7.

69. Siegel, *Desire and Excess,* 7. See also Siegel's larger discussion of the museum as mortuary, 6–10.

70. Redgrave, vii; Propert, "Introduction," *Burlington Arts Club Exhibition of Portrait Miniatures* (London: Burlington Arts Club, 1889).

71. Quoted in Remington, *Victorian Miniatures,* 13–14. The 1,200 portrait miniatures shown at the Art Treasures Exhibition of Manchester, for example, almost all came from the exceptionally rich collections of the Dukes of Buccleuch and Portland. *Exhibition of Art Treasures,* 17.

72. This insistence on the political stability of England, of course, overlooked the English Civil War. This oversight was perhaps partly enabled by the fact that artists like Samuel Cooper navigated the political turmoil, painting both Oliver Cromwell and the restored monarch Charles II.

73. For a discussion of early museum culture and the trend toward historical and educational organizational schemes, see Whitehead, *The Public Art Museum,* esp. 3–8.

74. *Exhibition of Art Treasures,* 17.

75. Propert, "English School," 7.

76. The *Art Journal* notes of the South Kensington Exhibition that the impossibility of arranging the portrait miniatures chronologically was "a source of regret to the student." "The Collection of Miniatures at South Kensington," 216.

77. *Burlington Arts Club Exhibition,* 8–12.

78. Quoted in Remington, *Victorian Miniatures,* 21.

79. Ibid., 25.

80. "They say that sometimes she takes charge of and arranges them herself. They are gathered in a series of frames that cover the walls of a boudoir, and the four most precious of them decorate Her Majesty's very own bedchamber, forming a sort of panorama around her bed. A catalogue, corrected in several places in Prince Albert's own hand, lists about two hundred and fifty pieces in the collection." Quoted with translation in Remington, *Victorian Miniatures,* 26.

81. RA VIC/MAIN/QVJ (W) March 20, 1862 (Princess Beatrice's copies).

82. Propert, *A History of Miniature Art,* 131.

Chapter 2. Portrait Miniatures in the Novel from Jane Austen to George Eliot

1. See especially Armstrong, *Fiction in the Age of Photography;* Green-Lewis, *Framing the Victorians;* and Novak, *Realism, Photography, and Nineteenth-Century Fiction.*

2. Austen, *The Collected Letters,* 323.

3. Ibid., 275.

4. For a further discussion of the association of women with particularity and small-scale details, see Schor, *Reading in Detail,* 10–18.

5. See Kendrick, *Conversations on the Art of Miniature Painting* (1830); Parsey, *The Art of Miniature Painting on Ivory* (1831), *New Hints, by an old Professor, on Miniature Painting* (1837); Whittock, *The Miniature Painters' Manual* (1844); Day, *The Art of Miniature Painting* (1852); Russell, *The Art of Miniature Painting in Oil, on Ivory etc.* (1855); Templeton and Wall, *The Guide to Miniature Painting and Colouring Photographs* (1867); and Wagner, *Miniature Painting* (1876), among others.

6. See Kelly's discussion of "the heroine's progress as a painter, specifically as a miniaturist, unfolded apace with her progress as a young lady" and of the transatlantic racial, class, and gender dimensions of portrait miniature painting. Kelly, *Republic of Taste,* 110, 105–113.

7. Mansion, *Letters upon the Art of Miniature Painting,* 136.

8. Ibid., 179.

9. Austen, *Sense and Sensibility,* 94, 158.

10. Austen, *Emma,* 35–37.

11. Austen, *Persuasion*, 235–236.

12. Austen, *Pride and Prejudice*, 186–189.

13. See Elliott, *Portraiture and British Gothic Fiction*, 123–147, and Bray, *The Portrait in Fiction of the Romantic Period*, 47–76.

14. Consider, for example, the confusion caused by a portrait miniature in Maria Edgeworth's *Helen* (1834), and the titular heroine's hope in Mary Shelley's *Matilda* (1819) that her father might recognize her by the image of him she wears around her neck. Edgeworth, *Helen*, 2:64, 67, 78, 111; Shelley, "Matilda," 159.

15. Shelley, *Frankenstein*, 53, 59–63.

16. Dickens, *Sketches by Boz*, 288–289.

17. Dickens, *Nicholas Nickleby*, 315.

18. Dickens, *The Old Curiosity Shop*, 220.

19. For another example of the self-reflexive use of the miniature as mirror, see Thackeray's 1848 story "Our Street," where the character Bragg decorates his home and his wife with miniatures of himself in order to brag. He does not seem to possess any images of his wife. Thackeray, "Our Street," 50

20. Dickens, *Nicholas Nickleby*, 56.

21. Dickens, *Oliver Twist*, 90.

22. See also *The History of Samuel Titmarsh and the Great Hoggarty Diamond* (1841), where a painter's miniature is praised until an unpardonable flaw is noted: the painter has forgotten to include a soldier's sword belt upon the sitter's person. Without this accoutrement, all artistry counts for naught. Thackeray, *The History of Samuel Titmarsh*, 4–5.

23. Dickens, *Nicholas Nickleby*, 775.

24. White, "Photography Popularly Explained," 53. Elsewhere, Miss La Creevy's portraits are taken as an example of how portrait miniatures were "too often much more like manufacture than art," as in Cork, when pre-painted miniatures were individuated with only a few hastily added details during the Peninsular Wars. "Notes," 505.

25. Dickens, *Martin Chuzzlewit*, 116.

26. Ibid., 116.

27. Dickens, *Dombey and Son*, 17, 578–579; Dickens, *Sketches by Boz*, 50–51.

28. Dickens, "The Poor Relation's Story," 225–226.

29. Thackeray, *The Book of Snobs*, 155.

30. Ibid.

31. Thackeray, *The Paris Sketchbook*, 208.

32. Thackeray, *The Newcomes*, 70.

33. Ibid.

34. See Christopher Rovee's discussion of how the middle classes earlier in the century sought artistic representations of themselves in *Imagining the Gallery*, esp. pp. 5–6, 130–149.

35. Thackeray, *Vanity Fair*, 449.

36. Ibid., 781.

37. Ibid., 457.

38. Ibid., 784.

39. Ibid., 794.

40. Gaskell, "My Lady Ludlow," 68–69.

41. Gaskell, *Cranford*, 73.

42. Gaskell, *Wives and Daughters*, 284.

43. Ibid.

44. Hawthorne, *The House of Seven Gables*, 37–38.

45. Ibid., 101.

46. Alan Trachtenberg helpfully suggests that the daguerreotype itself straddles the boundary between realism and romance, being both an instrument of scientific modernity and an object with magical powers of penetration. I understand the portrait miniature as positing a third type of vision, which captures not the subject but the purity with which the subject is regarded. Trachtenberg, "Seeing and Believing," esp. 460, 465–468.

47. Eliot, *Adam Bede*, 195.

48. Ibid., 196.

49. Dickens, *The Uncommercial Traveller*, 19–20.

50. Stewart, *On Longing*, 61.

51. George Eliot, "Mr. Gilful's Love Story," 89.

52. In Charlotte Brontë's *The Professor* (1845; published 1857), Hunsden Yorke Hunsden shows William Crimsworth and Frances Henri the portrait miniature of Lucia in order to tell them about his lost love. In Wilkie Collins's *After Dark* (1856), Mlle. Clairfait is induced to tell the story of her history with "Sister Rose" after a student observes the portrait miniature lying over her bracelet clasp. George Meredith's *The Ordeal of Richard Feverel* (1859) uses a set of portrait miniatures to open a conversation about the disappearance of Lucy Desborough, Richard's love. In Mary Elizabeth Braddon's *Lady Audley's Secret* (1862), other characters speculate that Lady Audley wears a portrait miniature around her neck, when it fact she wears a slip of paper. Thackeray's "De Juventute" (1860) employs a portrait miniature as a means to meditate on the fleetingness of time, as a boy's first love, embodied by a portrait miniature, fades into a staid marriage, symbolized by the same image above the fire. Brontë, *The Professor*, 242–244; Collins, *After Dark*, 77–80; Meredith, *The Ordeal of Richard Feverel*, 139–141; Braddon, *Lady Audley's Secret*, 14, 17; Thackeray, "De Juventute," 64–66.

53. George Eliot, "Mr. Gilful's Love Story," 159.

54. Ibid.

55. For examples of falling in love, see Collins, *Armadale*, 30, 32; Meredith, *Celt and Saxon*, 59–73, 79–80, 111–113; for uncovering identifies, see Collins, *Armadale*, 109; Braddon, *Phantom Fortune*, 47–49; Hardy, *Desperate Remedies*, 68–69; for deterrence from action, see Collins, *The Woman in White*, 174, 209, *The Evil Genius*, 122–3, 144–5, and *The Legacy of Cain*, 148–149; for exposed mysteries, see Braddon, *Birds of Prey*, 4th ed., 2:105–107, 185–186, 263, 3:98; for foreshadowing of the future, see Collins, *Armadale*, 145–146; Braddon, *London Pride*, 410.

56. Anne Brontë, *The Tenant of Wildfell Hall*, 134; Collins, *Basil*, 199–202, 261–262.

57. Charlotte Brontë, *Jane Eyre*, 237–238

58. Ibid., 469–470.

59. Ibid., 148.

60. Ibid., 554, 551. Lisa Sternlieb makes the case that Jane Eyre's entire narrative is structured around concealing herself from her reader. Sternlieb, "Hazarding Confidences."

61. George Eliot, *The Mill on the Floss*, 312.

62. Ibid., 441, 339.

63. George Eliot, *Middlemarch*, 349.

64. Ibid., 258

65. Ibid., 70.

66. Ibid., 258.

67. Ibid., 55.

68. Ibid., 514.

69. Ibid., 514–515.

70. James, "The Aspern Papers," 90.

71. Ibid., 125.

72. Ibid., 128.

Chapter 3. Microscopic Empiricism and Enchantment

1. Catlow, *Drops of Water*, 2–3, 5.

2. Daston and Galison, *Objectivity*, 37. Gaston Bachelard, meanwhile, suggests the distinction actually lies within the field of science, arguing that the naturalist "takes the world as though it were quite new to him . . . [with] the enlarging gaze of a child," while the empiricist "has a discipline of objectivity that precludes all the daydreams of the imagination." Bachelard, *The Poetics of Space*, 155–156.

3. Morgan, *The Outward Mind*, 16–19; Erchinger, *Artful Experiments*, 1–13.

4. Wall, 74. For a more substantial discussion of subjectivity and scientific description, see Wall, 71–82.

5. See Lynn L. Merrill's description of the importance of the imagination in approaches in natural history. Merrill, *The Romance of Natural History*, 3–15.

6. These accounts typically focus on the evolution of the instrument and the correction of major flaws. See, for example, Bradbury, *The Evolution of the Microscope*, 104–115, 149; Clara Sue Ball, "The Early History of the Compound Microscope," 51–60; Brian J. Ford, "The Royal Society and the Microscope," 29–39; or William J. Croft, *Under the Microscope*, 7–8.

7. Ratcliffe, *The Quest for the Invisible*, 27–28.

8. See ibid., 2–9. Ratcliffe's description of the progress made by eighteenth-century scientists in developing a standardized language and methodology for microscopic research marks a departure from earlier understandings of the eighteenth century as a period of stagnation in microscopic research.

9. Ibid., 57.

10. See Schickore, *The Microscope and the Eye*, 105–132; Ratcliffe, *The Quest for the Invisible*, 184, 245–248.

11. Queen, *Priced and Illustrated Catalogue of Optical Instruments*, 30, 31, 35.

12. Henry Moseley, "Report for the Year 1854," 316.

13. "Echoes from the Club," *Hardwicke's Science-Gossip*, 220; "Annual Meeting: July 24th 1868," *Journal of the Quekett*, 115; *Fourth Report of the Quekett Club and List of Members* (London, July 1869), 6, 9.

14. "Microscopical Research," reprinted in *Hardwicke's Science-Gossip*, 177.

15. See Schickore, *The Microscope and the Eye*, esp. 39–67.

16. Carpenter, *The Microscope*, 1–261, and Quekett, *Practical Treatise*, 1–322, 447–454

17. Beale, *How to Work with the Microscope*, vii.

18. Carpenter, *The Microscope*, 25.

19. Beale, *How to Work with the Microscope*, 187.

20. See Carpenter, *Address*, 14.

21. Beale, viii. Later authors cite Beale's charts as a suitable starting point for beginners. Mordecai Cubitt Cooke's volume, *One Thousand Objects for the Microscope*, operates according to a similar principles, guiding the student through the examination of each microscopic sample.

22. Bradbury, *The Evolution of the Microscope*, 203–204.

23. Carpenter, *The Microscope*, 8.

24. Macleod of Skye, "Microscopical Research," 230.

25. Jacyna, "Moral Fibre," 40.

26. William Sharpey, letter to Allen Thompson, October 29, 1845. Quoted in Jacyna, "Moral Fibre," 40.

27. Ward, *Microscope Teachings*, viii.

28. Lankester, *Half-hours with the Microscope*, 1.

29. "Echoes from the Club," 232.

30. Hall, *Patchwork*, 14.

31. Wood, *Common Objects of the Microscope*, 3.

32. Hill, *An History of Animals*, 2, 1.

33. See Ratcliff, *The Quest for the Invisible*, 178–215.

34. Carpenter, *The Microscope*, 37; Hogg, *The Microscope*, 121.

35. Waine, "Diatoms," 10.

36. Gosse, *Evenings at the Microscope*, 422–423.

37. Wood, *Common Objects of the Microscope*, 49, 113.

38. Gosse, *Evenings at the Microscope*, 322–323.

39. Ibid., iv.

40. Kingsley, "How to Study Natural History," 303.

41. See R., "A Struggle for Life," 91; Hobson, "Baccillaria Paradoxa," 139; Holland, "Prehensile Antennae," 127–128.

42. R., 91.

43. Wood, *Common Objects of the Microscope*, 9.

44. Gosse, *Evenings at the Microscope*, iii.

45. Gosse, *The Romance of Natural History*, 171.

46. Reade, "Microscopic Test Objects," 140.

47. See Morgan, *The Outward Mind*, 19–23.

48. Stafford and Terpak, *Devices of Wonder*, 80–81.

49. Morus, "'More the Aspect of Magic Than Anything Natural,'" 346–347.

50. Clarke, *Direction for using Philosophical Apparatus*, 48–57.

51. Ibid., 59.

52. Wood, *Common Objects of the Microscope*, 112.

53. Quoted in Ricks, *Tennyson*, 106.

54. "Solar Microscope," 142.

55. Kennedy, "Throes and Struggles," 104–107.

56. Lewis Wright, *A Popular Handbook*, 164.

57. Hassall, *Microscopical Examination*, 5–6.

58. Quoted in "Water Supply," 101.

59. For further discussions about the pollution of the Thames and its relation to micros-copy, see Hamlin, *A Science of Impurity*, 114–121; Schülting, *Dirt in Victorian Literature and Culture*, 63–66; Seibold-Buitmann, "Monster Soup: The Microscope and Victorian Fantasy," 211–219.

60. "A Drop of London Water," 188.

61. "The Fairies," 254.

62. Hood, *Self-Formation*, 153.

63. Catlow, *Drops of Water*, 11–12.

64. Hassall, *Microscopical Examination*, 19.

65. Ward, *Microscopic Teachings*, 135.

66. Lewes, *Studies in Animal Life*, 27.

67. Ibid., 28.

68. The notion that Pasteur's research marked the starting point for this theory is sometimes disputed. See, for example, Catherine Wilson's persuasive discussion of how theories of animate contagion originated between the seventeenth and eighteenth centu-ries. Wilson, *The Invisible World*, 140–175.

69. Tyndall, "Scientific Use of the Imagination," 27.

70. Tyndall, *Our Invisible Friends and Foes*.

Chapter 4. Fairies Through the Microscope

1. O'Brien, "The Diamond Lens," 365, 366, 367.

2. Ruskin, "Fairy Land," 84–85.

3. Keightley, *The Fairy Mythology*, 363.

4. Silver, *Strange and Secret Peoples*, 210. For an extensive treatment of the size of fairies in the sixteenth to eighteenth centuries, see Latham, *The Elizabethan Fairies*, 1–11.

5. Key accounts include Muller, "Comparative Mythology," 1–146; Tylor, *Primitive Culture;* MacRitchie, *Fians, Fairies and Picts;* Lang, "Introduction," ix–lxv; and Baring-Gould, *A Book of Folk-Lore.* See also Silver's account of nineteenth-century scientific treatments of the fairy; Silver, *Strange and Secret Peoples,* 43–50.

6. Sala and Wills, "Fairyland in 'Fifty-Four," 313.

7. Kendall and Lang, *That Very Mab,* 23.

8. Baring-Gould, *Early Reminiscences,* 19–21.

9. Ibid., 20.

10. Shakespeare, "Romeo and Juliet," I.vi.4–5.

11. Shakespeare, "A Midsummer Night's Dream," II.i.31; II.ii.4–5; III.i.172–173; III.i.168–170.

12. For a full description of the effect of Shakespeare's imagery upon fairy poetry of the seventeenth and eighteenth centuries, see Latham, *Elizabethan Fairies,* esp. pp. 187–218.

13. Cavendish, "Of small Creatures," 162, lines 1–2.

14. Pope, *The Rape of the Lock,* 2.61; 2.75.

15. Fuseli, *Robin Goodfellow-Puck.*

16. Bray, *Life of Thomas Stothard,* 32. The same story is reprinted in "Mrs. Bray's Life of Stothard," 318. "The Artist and the Butterflies," 3396, and "Stothard the Artist," 508, among others.

17. These paintings also drew on folkloric traditions. See Gere, "In Fairyland," 67–71.

18. See Talairach-Vielmas, *Fairy Tales, Natural History and Victorian Culture,* 165–166, note 15.

19. "The Royal Academy: The Eighty-Second Exhibition—1850," *The Art-Journal* (June 1, 1850), 175.

20. Ruskin, "Fairy Land," 89.

21. Carroll, *Lewis Carroll's Diaries,* 102.

22. For a description of the poet's and painter's ability to compel belief not just in observed nature but in internal poetic and even fairy fancies, see Eagles, "The Natural in Art," esp. 435–436.

23. Watts, "A Lament for Fairies," 60.

24. Richard Doyle, illustrator, *In Fairy Land,* n.p.

25. E.S.A., *Fairyland and Fairies,* 11.

26. Stewart defends an association between miniatures and childhood, "not simply because the child is in some physical sense a miniature of the adult, but also because the world of childhood, limited in physical scope yet fantastic in its content, presents in some ways a miniature and fictive chapter in each life history." Stewart, *On Longing,* 44.

27. This alignment of primitive cultures with childhood drew upon a conception of other races as miniature. See Vallone, *Big and Small,* 130–140.

28. Silver has argued that real belief in fairies was far more prevalent than we have heretofore believed. While this may be the case, there was not an active debate in the public sphere about the falsehood or veracity of fairies. Most Victorian adults took it for

granted that fairies were not real, and they cherished fanciful representations of fairies accordingly. The debate about the actual reality of fairies was reignited during the Edwardian period.

29. "Books for Children," *The Living Age,* vol. 1 (1844), 301.

30. See, for example, Taylor, *Dot's Diary,* 30–32; Hood, "Queen Mab," 302.

31. Ellis, *The Fairies' Favourite,* 5–6, 33, 36–39.

32. Nicola Bown speculates that the profusion of representations of the last of the fairies at the end of the century represented an anxiety about the loss of memory of the past. Bown, *Fairies in Nineteenth-Century Art and Literature,* 180.

33. Charles, *Where Is Fairyland?,* 37.

34. For examples of each of the patterns listed, see Whitelock, *Fly-Away Fairies;* Bowley, "Fairy Flights"; Murray, *Merry Elves;* Wallace-Dunlap and Rivett-Carnac, *Fairies, Elves and Flower Babies.*

35. MacDonald, *Lilith,* 33.

36. Ingelow, *Mopsa the Fairy.*

37. Carroll, *Sylvie and Bruno,* 19, 56–57, 197, 263, 283, 348–350; Wells, "Mr. Skelmersdale in Fairyland," 109–111.

38. Kipling, *Puck of Pook's Hill,* 246.

39. Silver, for example, articulates a disappointment that "these once great powers were moralized and idealized, deprived of their ambiguity and capriciousness and often trivialized in literature designed for Victorian children"; Silver, 188. See also Diane Purkiss's discussion of "hideously" (256) cute fairies in *At The Bottom of the Garden,* 256; 253–262; and K. M. Briggs's description of fairy whimsy, which, she notes with concern, "reduced [fairies] to almost the status of insects," in *The Fairies in Tradition and Literature,* 198, 197–202.

40. McPherson, *The Fairyland Tales of Science,* 16.

41. J.P., "Microscopes and How to Use Them," 370.

42. Ward, *Microscope Teachings,* xii–ix.

43. Slack, *Marvels of Pond-Life,* 96; Mary Treat, "The Microscope," 116.

44. Kingsley, "How to Study," 299.

45. Treat, "The Microscope," 116.

46. Kendall and Lang, *That Very Mab,* 43–44.

47. Kingsley, *The Water-Babies,* 171–172, 176–182.

48. Ibid., 172.

49. Ibid., 77–78.

50. Boole, *The Preparation of the Child for Science,* 151.

51. Tennyson, *Locksley Hall,* n.p.

52. Buckley, *The Fairyland of Science,* 5. As Laurence Talairach-Vielmas argues, the language of fairies and fairyland is not just used in the context of microscopic discoveries but to describe a range of ways in which the study of natural history expands human vision and unveils marvels in the proximity of the observer. Talairach-Vielmas, *Fairy Tales,* 15–22.

53. Buckley, *The Fairyland of Science*, 12–13.

54. J.P., "Microscopes and How to Use Them," 370.

55. The earliest example of the genre, perhaps, appears as a tale within a tale, "Uncle David's Nonsensical Story about Giants and Fairies," in which Master No-Book must choose whether to laze about the castle of the fairy Do-nothing or to learn in the garden of the fairy Teach-all. Sinclair, "Uncle David's Nonsensical Story," 132–142.

56. Roberts, *Book for Fairies*, n.p.

57. Temple, *Etta's Fairies*, 49–50.

58. Kingsley, *Madam How and Lady Why*, 134, 135.

59. See Tracy C. Davis's discussion of the significance of this technology in "What Are Fairies For?," 33.

Chapter 5. Imperfect Miniaturization

1. Benson, *Everybody's Book of the Queen's Dolls' House*, 136.

2. Cooper-Hewitt, *Miniatures*, 11.

3. "Guidelines for Artisan Membership," 3.

4. In particular, a miniature that is 1/10 the size of its full-scale original will only weigh 1/1000 of the original, assuming the use of the same materials. See the discussion in the Introduction and in Clarke and Wittenberg, Introduction to *Scale in Literature and Culture*, 1–5.

5. Cooper-Hewitt, *Miniatures*, 7.

6. The association between the dollhouse and domestic oppression is not confined to Henrik Ibsen's 1879 play "A Doll's House." For a discussion of the constrictions and the possibilities of dolls and dollhouses, in Dickens's fiction in particular, see Armstrong, "Gender and Miniaturization," esp. 405–410.

7. See Sharon Marcus's description of how Estelle serves as Miss Havisham's doll in Dickens's *Great Expectations*. Marcus, *Between Women*, 192.

8. Ruskin, "Fairy Land," 83.

9. Armstrong, "The Dollhouse as Ludic Space," 25.

10. Bachelard, *The Poetics of Space*, 150

11. Moseley-Christian, "Seventeenth-Century *Pronk Poppenhuisen*," 347.

12. Ibid., 355.

13. For a further discussion of the dollhouse as an object through which Dutch women performed their domestic identities, see Moseley-Christian, "Seventeenth-Century *Pronk Poppenhuisen*," esp. 356–358.

14. Varat, "Family Life Writ Small," 156.

15. Ibid., 154.

16. Jaffé, *A History of Toys*, 159.

17. Cooper-Hewitt, *Miniatures*, 14.

18. Acland, *Good-bye for the Present*, 61.

19. Armstrong, "The Dollhouse as Ludic Space," 36.

20. Ibid.

21. Ibid., 24.

22. For a discussion of how John Locke's ideas informed John Newberry's ideas of the importance of physical touch in learning, see Klemann, "The Matter of Moral Education," esp. 228–232.

23. "Dolls," *Chambers's Journal,* 97.

24. "Dolls and Dollhouses," 325, 328–329.

25. Ibid., 329.

26. Ewing, *Dolls Housekeeping,* n.p.

27. See, for example, Ewing, n.p.; Mill, "How we Furnished our Dollhouse," 127.

28. See Armstrong, "The Dollhouse as Ludic Space," 43–45.

29. Ibid., 44.

30. "Dolls and Dollhouses," 326.

31. Ewing, *Dolls Housekeeping,* n.p.

32. Mill, "How we Furnished our Dollhouse," 142.

33. *Reports on the Paris Universal Exhibition,* 126

34. Coleridge, *Charlotte Mary Yonge,* 59.

35. "A Word on Toys," 615.

36. For an account tracing doll play back to Egypt, see "Children's Playthings," 261. Victorian children's doll play was most frequently compared to Native American women's doll play, but also to customs in India and in Africa among the Bechuana, Basuto, and Ostiyak peoples. See "Odd Notions and Old Ones," 420–421.

37. "Dolls," *Household Words,* 354.

38. "Playthings," 431.

39. Jaffé, *A History of Toys,* 133.

40. "Dolls," *Household Words,* 354.

41. Jaffé, *A History of Toys,* 133.

42. "Jack-in the Pulpit," 632.

43. "Dolls," *Household Words,* 354.

44. "Christmas Toys," 550.

45. "Dolls," *Household Words,* 352.

46. "Toys, Past and Present," *All the Year Round,* n.s.4 (October 1, 1870): 419.

47. See, for example, "A Word on Toys," 617.

48. Burnett, *The One I Knew,* 52.

49. Meynell, *Childhood,* 3.

50. Barthes, "Toys," 61.

51. "Christmas Toys," 550.

52. Coleridge, *Charlotte Mary Yonge,* 77.

53. Some texts, like Browne's *Live Dolls,* explore the problems arising from this paradox. The protagonist wishes that her doll might come to life and then, when her wish is granted by a miniature fairy, must come to terms with the fact that her living doll has

needs and wishes of her own. In the end, the doll joins the fairies as a spirit but lingers with the protagonist in her original, insentient doll form. Browne, *Live Dolls*, esp. pp. 6–12, 119–127.

54. "Some Christmas Pleasures," 801.

55. Campbell, "Doll Philosophy," 722.

56. "Popular Toys," 149–150.

57. Winnicott, *Playing and Reality*, 17, xvi.

58. Ibid., 3.

59. George Eliot, *The Mill on the Floss*, 31.

60. Ibid., 31.

61. Dickens, *Bleak House*, 31.

62. Ibid., 36.

63. Doll burials were not uncommon as a form of play in Victorian England. See Armstrong, "The Dollhouse as Ludic Space," 41.

64. Jewbury's recollections of her friend's stories were sent to her husband and printed in Carlyle, *Reminiscences*, 54–68.

65. See "Dolls," *Chambers's Journal*, 98, and Jackson, *Toys of Other Days*, 26–27.

66. "Dolls," *Chambers's Journal*, 98.

67. Ibid., 98.

68. Nesbit, "My School Days," 200.

69. Ibid., 201.

70. Kemble, *Records of a Girlhood*, 16.

71. Gourand, *Memoirs of a Doll*, vii.

72. Campbell, "Doll Philosophy," 723.

73. Ibid., 723.

74. Campbell's analogy, of course, also has the curious effect of suggesting that the child should be like an uncurious Bluebeard's wife oblivious to the horrors of his closet. In this case, perhaps, the realities of un-enchanted industrial London were the realities from which the child had to be protected.

75. See Liz Bellamy, "It-Narrators and Circulation," 121–122.

76. See, for example, Mister, *The Adventures of a Doll*, 189–191.

77. Pardoe, *Lady Arabella*, 19; Maitland, *The Doll and Her Friends*, 60.

78. Maitland, *The Doll and Her Friends*, 51, Bradford, *Ethel's Adventures*, 140.

79. Mister, *The Adventures of a Doll*, 143–146.

80. Pardoe, *Lady Arabella*, 87–88.

Chapter 6. Speculative Fictions

1. Burnett, *The One I Knew*, 44, 50.

2. Ibid., 61, 64, 68.

3. "Dolls," *Household Words*, 354.

4. Burnett, *The One I Knew*, 55–57.

5. "Juvenile Theatricals," 308.

6. Nursery furniture, indeed, is "technically . . . not miniature at all, since it is of adequate dimensions for a child's use and thus constitutes full-scale children's furniture." Cooper-Hewitt, *Miniatures*, 47.

7. Long, *Victorian Houses and Their Details*, 2

8. Ferguson, *Empire*, 201–202.

9. See Lois Kuznets's claim that toys "arouse feelings of affinity, as well as power and control, especially when the models are of creatures that in real life are proportionately bigger . . . than the person holding them." Kuznets, *When Toys Come Alive*, 80.

10. Bachelard, *The Poetics of Space*, 154–155.

11. Walton, *Mimesis as Make-Believe*, 21; Stewart, *On Longing*, 56

12. Charlotte Brontë, *An Edition of the Early Writings*, 5.

13. Alexander, *An Edition of the Early Writings*, by Charlotte Brontë, 11, note 8.

14. This tension seems to have existed, at least later in their lives, for the Brontës themselves. Charlotte Brontë, for example, describes how the inhabitants of Glass Town's successor, Angria, visit her in the schoolroom in full size, drawing her into a dream world that is rapidly dispelled by the entrance of pupils. Charlotte Brontë et al., *Tales from Glass Town*, 156–157.

15. Charlotte Brontë, *An Edition of the Early Writings*, 12, 14.

16. Ibid., 14.

17. Branwell Brontë, *The Works of Patrick Branwell Brontë*, 17.

18. Ibid., 326.

19. Charlotte Brontë, *An Edition of the Early Writings*, 39. As Christine Alexander observes, this letter is written in Charlotte's hand but signed "UT" ["us two"], a signature that suggests collaborative authorship with her brother.

20. For manuscripts from 1828 and 1829 that Alexander measures as about 10 × 6 cm, see Alexander, *An Edition of the Early Writings*, n.1, 4; n.1, 5; n.1, 21; n.1, 35; n.1, 36; n.1, 39; n.1, 40; n.1, 41; n.1, 42; n.1, 99. For manuscripts measuring around 5 × 3 or 3 1/2 cm, see n.1, 54; n.1, 62; n.1, 70; n.1, 78; n.1, 91; n.1, 113; n.1, 123.

21. Charlotte Brontë, *An Edition of the Early Writings*, 68–69.

22. Ibid., 61.

23. Ibid., 215.

24. Barrie, *Peter Pan*, 3.

25. Walton, in discussing the representational arts, notes the importance of the rules that govern make-believe and fictions and that consistently translate, for example, a tree stump into a bear; Walton, *Mimesis as Make-Believe*, 35–43. These speculative fictions resemble children's play in that the rules and the scale of the world are unveiled or created with time.

26. Carroll, *Alice's Adventures*, 4, 125; Bradford, *Ethel's Adventures*, 5; MacDonald, *At the Back of the North Wind*, 47.

27. Carroll, *Alice's Adventures*, 28.

28. Ibid., 8.

29. Ibid., 10–11.

30. Ibid., 35.

31. Ibid., 35, 37.

32. Bradford, *Ethel's Adventures*, 88.

33. Ibid., 139.

34. See Sharon Marcus's account of this dynamic in *Between Women*, esp. 135–148.

35. Bradford, *Ethel's Adventures*, 40.

36. Ibid., 181.

37. Ibid., 181, 182.

38. Ibid., 84.

39. MacDonald, *At the Back of the North Wind*, 66, 86.

40. Ibid., 86.

41. Ibid., 65.

42. Ibid., 45, 51. Horse Diamond and child Diamond are also called "old Diamond" and "young Diamond," suggesting an equation of size and age.

43. Ibid., 72, 186.

44. Ibid., 65, 84.

45. Sully, *Children's Ways*, 72.

46. Ibid.

47. Winnicott, *Playing and Reality*, 69.

48. Charlotte Brontë, *An Edition of the Early Writings*, 170.

49. Ibid., 134.

50. Ibid.

51. Campbell, "Doll Philosophy," 722.

52. Besant, in *Record of Girlhood*, ed. Sanders, 201.

53. Charlotte Brontë, *An Edition of the Early Writings*, 257

54. Ibid., 258.

55. Carroll, *Alice's Adventures*, 9.

56. Ibid., 27, 32.

57. Ibid., 162–163.

58. Ibid., 204.

59. Bradford, *Ethel's Adventures*, 3–4.

60. MacDonald, *At the Back of the North Wind*, 288.

Chapter 7. Multum in Parvo

1. Landon, *The English Bijou Almanac of 1838*; 3/4 × 9/16 inch. All measurements in this chapter are the author's own. Courtesy Huntington Library, Art Collections and Botanical Gardens. San Marino, California.

2. "The Bijou Almanac," *The Art-Union* 5 (January 1843): 23.

3. "The English Bijou Almanac," *Bent's*, 131.

4. "The English Bijou Almanack, 1837," *The Metropolitan* 45 (1837): 45.

5. "The English Bijou Almanac," *Bent's*, 131.

6. "The English Bijou Almanac," *The Mirror*, 95; "The Bijou Almanac," *New Monthly Magazine*, 103.

7. Landon, *The English Bijou Almanac of 1838*, n.p.; Landon, *The English Bijou Almanac of 1839*, n.p.; 3/4 × 9/16 inch; Bridwell Library Special Collections, Perkins School of Theology, Southern Methodist University. Landon, *The English Bijou Almanac for 1837*, n.p., 13/16 × 5/8 inch. Courtesy Huntington Library. The association of miniature books with fairy makers was not uncommon; in the epistle to an 1838 collection of stories called *The Fairy Annual*, the fairy Robin Goodfellow (Shakespeare's Puck) dedicates the volume to Queen Victoria, observing, "It was my intention to have dedicated this great and important work—the most splendid that has ever been produced in the dominions of Oberon—to my own Royal Mistress: but, by her express command, I lay the offering at the feet of your Majesty." Such a dedication claims the dexterity of fairy hands for the human makers of the book. *The Fairy Annual*, i–ii; 2 5/16 × 1 11/16 inches. Courtesy Huntington Library.

8. See, in particular, Adomeit, *Three Centuries of Thumb Bibles*, and Doris V. Welsh, *Bibliography of Miniature Books*.

9. Stewart, *On Longing*, 41; Pascoe, "Tiny Tomes," 137.

10. Sheringham, "A Library in Miniature," 223.

11. Bondy, *Miniature Books*, 57.

12. These numbers are estimates based on Welsh's extensive, but not totally exhaustive, bibliographic records of examples of the form. Doris V. Welsh, *A History of Miniature Books*, 35, 40, 44.

13. Ibid., 29.

14. Ibid., 36, 40, 44.

15. Reconstructing the printing methods used for an American *Verbum Sempiternum* (ca. 1794), George Parker Winshop describes cutting a full-sized sheet into unequal parts with either eight or four pages per side and inserting a four-leaf partial sheet into an eight-leaf partial sheet to create a gathering of twelve leaves. Winshop adds that the printer likely used a complicated variant of the work-and-turn method to print the 288-page volume without wasting paper (a challenge, since two full sheets typically produced 256 pages at this size). Winshop, "Imposing a Thumb Bible," 2.

16. *The Fairy Annual*, n.p. Each page is 2 1/8 by 2 inches before cutting. *Courtesy, Lilly Library, Indiana University, Bloomington, Indiana. Galileo a Madama Cristina di Lorena.* Courtesy Huntington Library. Thanks to Julian I. Edison for his insight into the printing of *Galileo*.

17. William Sale, *Samuel Richardson*, 25.

18. Welsh, *A History of Miniature Books*, 96.

19. Brown, "The Metamorphic Book," 357.

20. *Colgate & Co. Calendar—1883*, n.p.; 2 3/16 by 1 11/16 inches; *Hazeltine's Pocket-Book Almanac for 1885*; 2 × 1 5/16 inches. Courtesy Bridwell Library.

21. *My Tiny Alphabet Book.* Courtesy Lilly Library.

22. Grenby, *The Child Reader,* 46, 61.

23. Welsh, "Book Advertisements," 14.

24. Michals, *Books for Children,* 66.

25. *The Infant's Library;* 5 9/16 × 3 5/8 × 2 3/8 inches. Other examples of highly deco-
rated libraries for children include the very similar set *The Cabinet of Lilliput;* 6 and 3/8 × 3
15/16 × 3 7/16 inches, *The Doll's Library;* 1 3/4 × 1 1/2 inches, *Book-case of Instruction and
Delight;* 3 5/8 × 2 1/2 inches. Courtesy Lilly Library.

26. The Book-Case of Knowledge; box measures 6 3/4 × 4 × 2 15/16 inches. Courtesy
Huntington Library.

27. A Miniature Historic Library; box measures 6 1/2 × 3 × 3 1/8 inches. Courtesy
Huntington Library.

28. French Miniature Bookcase; box measures 5 3/8 × 3 3/4 × 1 5/8 inches. Courtesy
Bridwell Library. Most mid-century British miniature libraries for children are less elabo-
rate; The Nursery Library, for example, consists of twelve paper booklets in a decorated
box measuring 2 3/4 by 2 inches; Chatelain's The Lilliputian Library consists of a series
of "original fairy tale[s]" in a box measuring 3 15/16 inches × 2 13/16 inches. Courtesy
Lilly Library.

29. Greenaway, Kate Greenaway's Alphabet; 2 3/4 × 2 3/8 inches. Courtesy Bridwell
Library.

30. *The Bible in Miniature, or Concise History,* 1. Courtesy Lilly Library.

31. Ibid., 3.

32. Sheringham, "A Library in Miniature. Part II," 167.

33. *The Bible in Miniature, or Concise History,* 9.

34. Ibid., 118.

35. Roscoe, "Early English, Scottish and Irish Thumb Bibles," 190.

36. Welsh, *A History of Miniature Books,* 66.

37. *Verbum Sempiternum* (1693), n.p.; 2 5/16 × 1 13/16 inches. Courtesy Huntington Library.

38. Ibid., n.p. An earlier 1616 *Verbum Sempiternum* similarly claims that "though my
booke be small,/ In substance, t'is no lesse then all in all." John Taylor then "Implores
your Grace [Prince Charles] t'accept this worthlesse mite." *Verbum Sempiternum* (1616), n.p.;
1 13/16 × 1 5/16 inches. Courtesy Huntington Library.

39. *An History of the Bible,* 6; 2 13/16 × 2 3/8 inches. Courtesy Lilly Library.

40. Thanks to Margo Todd for her help in identifying likely dates for each inscription.

41. The Pocket Bible, vi–viii; 2 3/4 × 2 3/8 inches. Courtesy Lilly Library.

42. Adomeit, *Three Centuries,* xiii. *Sketch of the Life,* 6.

43. *An History of the Bible,* 52.

44. All three tales, for example, appear in an 1851 American thumb Bible, which also
labels an illustration of Shadrach, Meeshach, and Abednego as "Hebrew Children in the
Fiery Furnace" and includes an illustration of bears destroying Hebrew children. Janes,
Miniature Bible with Engravings, 57, 100, 197, 85, 77.

45. *The Child's Bible*, 94; 2 3/4 × 2 3/8 inches. Courtesy the Miniature Book Collection, University of North Texas Special Collections.

46. Ibid., frontispiece.

47. *The Juvenile Bible*, vi; 2 7/8 × 1 3/4 inches. Courtesy Lilly Library.

48. *The Child's Bible*, preface.

49. *Wood's Pictorial Bible*, n.p. 1 × 2 1/8 inches. Courtesy Lilly Library.

50. Ibid., n.p.

51. *A Miniature of the Holy Bible*, 3–8. 2 1/2 × 2 1/8 inches. Courtesy Bridwell Library.

52. *The Bible in Miniature, Intended as a Present*, 112–113; 1 1/2 × 1 3/4 inches. Courtesy Lilly Library.

53. Rosser, *The Bijou Gazetteer of the World*. Courtesy, Lilly Library.

54. Ibid., preface.

55. Ibid., "Explanation of Abbreviations."

56. Ibid., 122–123.

57. *The Little Gazetteer;* 2 1/4 × 3 1/4 inches. *The Little Linguist;* 1 3/4 × 2 5/8 inches. Courtesy Lilly Library.

58. *The Little Linguist*, iii; *The Tom Thumb*, title page; 1 3/4 × 2 5/8 inches. Courtesy Lilly Library.

59. *The Diamond Gazetteer*, 4; 3 5/16 × 2 inches. Courtesy Huntington Library.

60. *The Little Linguist*, iv.

61. Charles Lamb, "Detached Thoughts on Books and Reading," 180.

62. Sheringham, "A Library in Miniature: Part I," 223. Such objects continue to pose problems for curatorial staff. Librarians that accept collections of miniature books also often receive objects—such as erasers, pencil cases, earrings, and dollhouse books—that mimic the form of miniature books without possessing their functionality. These abiblia often give to miniature books as a whole the reputation of being tchotchkes rather than "real" books.

63. "The English Bijou Almanac for 1837," *The Gentleman's Magazine*, 188.

64. *The Earth and Its Inhabitants*, n.p. Box: 2 1/8 × 2 9/16 × 2 1/8 inches. Courtesy Bridwell Library.

65. Dahl and Gauvin, *Sphaerae Mundi*, 89–90.

66. *The Infant's Cabinet*, 3 1/2 × 2 9/16 × 1 3/8 inches. Courtesy Lilly Library.

67. Translation by the author: "Approach, ladies and gentlemen, approach; you will see stars in plain day, rivers without water, women without heads, dancers without legs, lawyers without language, Hercules without arms . . ." *La Lanterne Magique;* 1 9/16 × 2 1/16 inches. Courtesy Lilly Library.

68. Koopman, "Miniature Books," 162.

69. Translation by the author: "I think that I may congratulate myself for having achieved, in engraving these little characters, a degree of reduction which the English typographers have not dared to reach; what especially interests me in this artistic endeavor is that I have found a way to demonstrate, with a work that falls outside the ordinary rules,

all the benefits of a discovery that belongs exclusively to France (*polyamatype*) and that I dare say will bring honor to France by virtue of its unquestionable superiority over all known processes." Didot coined the term *polyamatype* to describe his new mold, which cast one hundred and forty letters simultaneously. Didot, "Dedication," n.p.; 2 13/16 × 1 3/4 inches. Courtesy, Bridwell Library.

70. De Vinne, "Microscopic Types," 138.

71. Bondy, *Miniature Books*, 94.

72. Grolier Club. *A Short List of Microscopic Books*, 129.

73. Bondy, *Miniature Books*, 96.

74. *The Mite*, 11, 16, 20. Courtesy UNT Special Collections.

75. Ibid., 5–6.

76. Koopman, "Miniature Books," 164.

77. Bryce, "David Bryce & Sons," 1.

78. Ibid., 2.

79. Welsh, *A History of Miniature Books*, 101.

80. *The Smallest English Dictionary in the World*. Courtesy UNT Special Collections.

81. Bryce, echoing the protests of Schloss at the beginning of the century, claimed that his works were quite practical. He cites one reader who described his miniature Bible as "the most useful book I had ever published." Bryce, "David Bryce & Sons," 2.

82. All three Bibles have the same publication information and dimensions. *The Holy Bible*; 1 7/8 × 1 5/16 inches binding. Courtesy Bridwell Library.

83. Boutique printing presses across the country have crafted miniature volumes in the years since, but these are typically printed on a small scale for select audiences. Miniature alphabets, quote books, and fairy tales continue to be mass-produced and sold on the sales counters of major booksellers, but these lack a serious attention to questions of scale.

Coda

1. Pictures and details on the contents of the dollhouse can be found on the Royal Collections Trust website. Royal Collections, "Queen Mary's Dollhouse."

2. Lambton, *The Queen's Dolls' House*, 14.

3. Quoted in ibid., 25.

4. Ibid., 81.

5. Two of the volumes, *How Watson Learned the Trick* by Sir Arthur Conan Doyle and *J. Smith* by Fougasse, were recently reprinted in miniature and sold commercially for the first time. A few others have been reprinted in larger or collected editions.

6. Fougasse, *J. Smith*, n.p.

7. International Guild, "Guidelines for Artisan Membership Application," 2, 3.

8. Anderson, "Mobile Technology and Home Broadband."

BIBLIOGRAPHY

A., E.S. *Fairyland and Fairies, from Sketches by E.S.A. and other good authority collected, corrected, and improved by Q.* London, 1867.

Acland, Eleanor. *Good-bye for the Present: The Story of Two Childhoods Milly: 1878–88 and Ellen: 1913–24.* London: Hodder and Stoughton, 1935.

Adomeit, Ruth. *Three Centuries of Thumb Bibles: A Checklist.* New York: Garland, 1980.

The Adventures of a Doll in Ainslie Place and Blackfriars Wynd. London: Paton and Ritchie, 1853.

Alexander, Christine. *An Edition of the Early Writings of Charlotte Brontë, Vol. I: The Glass Town Saga 1826–1832.* Oxford: Shakespeare's Head Press, 1987.

Anderson, Monica. "Mobile Technology and Home Broadband." Pew Research Center. June 13, 2019. https://www.pewinternet.org/2019/06/13/mobile-technology-and-home-broadband-2019/ (accessed June 21, 2020).

"Annual Meeting: July 24th 1868." *The Journal of the Quekett Microscopical Club* (January 1868–October 1869), 114–117.

Appadurai, Arjun. "Introduction: Commodities and the Politics of Values." In *The Social Life of Things*, 3–63. Cambridge: Cambridge University Press, 1986.

Armstrong, Frances. "The Dollhouse as Ludic Space, 1690–1920." *Children's Literature* 24 (1996): 23–54.

———. "Gender and Miniaturization: Games of Littleness in Nineteenth-Century Fiction." *English Studies in Canada* 16, no. 4 (December 1990): 403–416.

Armstrong, Isobel. *Victorian Glassworlds: Glass Culture and the Imagination 1830–1880.* Oxford: Oxford University Press, 2008.

Armstrong, Nancy. *Fiction in the Age of Photography: The Legacy of British Realism.* Cambridge, MA: Harvard University Press, 1999.

"The Artist and the Butterflies." In *Zoologist: A Popular Miscellany of Natural History,* vol. 10 (1852), 3396.

Austen, Jane. *The Collected Letters of Jane Austen.* Edited by Deidre Lynch. 3rd ed. Oxford: Oxford University Press, 1995.

———. *Emma.* Reprint. Oxford: Oxford University Press, 2003.

———. *Persuasion.* Reprint. London: Penguin, 1985.

———. *Pride and Prejudice.* Reprint. Oxford: Oxford University Press, 2004.

———. *Sense and Sensibility.* Reprint. Ontario: Broadview Press, 2001.

Bachelard, Gaston. *The Poetics of Space.* Translated by Maria Jolas. Reprint. Boston: Beacon Press, 1994.

Ball, Clara Sue. "The Early History of the Compound Microscope." *Bios* 37, no. 2 (May 1966): 51–60.

Barad, Karen. "Posthumanist Performativity: Toward an Understanding of How Matter Comes to Matter." *Signs: Journal of Woman in Culture and Society* 28. no. 3 (2003): 801–831.

Baring-Gould, Sabine. *A Book of Folk-Lore.* London: Collins, 1913.

———. *Early Reminiscences, 1834–1864.* New York: Dutton, 1924.

Barrett, Elizabeth. *Elizabeth Barrett to Miss Mitford: The Unpublished Letters of Elizabeth Barrett to Mary Russell Mitford.* Edited by Betty Miller. London: Murray, 1954.

Barrie, J. M. *Peter Pan.* Reprint. New York: Modern Library, 2004.

Barthes, Roland. "The Reality Effect" (1969). Reprinted in *The Rustle of Language,* trans. Richard Howard, ed. François Wahl. Berkeley: University of California Press, 1989.

———. "Toys." In *Mythologies.* Translated by Howard and Annette Lavers. New York: Hill and Wang, 2013.

Beale, Lionel. *How to Work with the Microscope.* 4th ed. London: Harrison, 1868.

Behrendt, Stephen C. *British Women Poets and the Romantic Writing Community.* Baltimore, MD: Johns Hopkins University Press, 2009.

Bellamy, Liz. "It-Narrators and Circulation: Defining a Subgenre." In *The Secret Lives of Things: Animals, Objects, and It-Narratives in Eighteenth-Century England,* ed. Mark Blackwell, 117–146. Lewisburg, PA: Bucknell University Press, 2007.

Benjamin, Marina. "Sliding Scales: Microphotography and the Victorian Obsession with the Miniscule." In *Cultural Babbage: Technology, Time and Invention*, edited by Francis Spufford and Jenny Uglow, 99–122. London: Faber, 1996.

Bennett, Jane. *Vibrant Matter: A Political Ecology of Things.* Durham, NC: Duke University Press, 2010.

Benson, Arthur Christopher. *Everybody's Book of the Queen's Dolls' House.* London: Daily Telegraph, 1924.

Bernstein, Robin. *Racial Innocence: Performing American Childhood from Slavery to Civil Rights.* New York: NYU Press, 2011.

Besant, Annie. Reprinted in *Records of Girlhood, Volume Two: An Anthology of Nineteenth-Century Women's Childhoods.* Edited by Valerie Sanders. Farnham: Ashgate, 2012.

The Bible in Miniature, or Concise History of Both Testaments. London: J. Harris, ca. 1802.

The Bible in Miniature, Intended as a Present for Youth. Glasgow: Lumsden and Son, 1815.

"The Bijou Almanac." *The Art-Union* 5 (January 1843): 23.

"The Bijou Almanac." *The Court Magazine and Monthly Critic* (February 1837), 101.

"The Bijou Almanac." *The New Monthly Magazine and Literary Journal* (January 1836), 103.

Bondy, Louis W. *Miniature Books: Their History from the Beginnings to the Present Day.* London: Sheppard Press, 1981.

Book-case of Instruction and Delight. London: Marshall, 1802.

The Book-Case of Knowledge or Library for Youth. London: Wallis, 1800.

"Books for Children" *The Living Age*, vol. 1 (1844), 296–301.

Boole, Mary Everest. *The Preparation of the Child for Science.* Oxford: Clarendon, 1904.

Bowley, May. "Fairy Flights." *Father Christmas: The Children's Annual* 9 (1886): 1–30.

Bown, Nicola. *Fairies in Nineteenth-Century Art and Literature.* Cambridge: Cambridge University Press, 2001.

Bradbury, Saville. *The Evolution of the Microscope.* Oxford: Pergamon, 1967.

Braddon, Mary Elizabeth. *Birds of Prey.* 4th ed. Vols. 2 and 3. London: Ward, Lock, and Tyler, 1867.

———. *Lady Audley's Secret.* Reprint. Oxford: Oxford University Press, 2012.

———. *London Pride, Or When the World Was Younger.* London: Simpkin, Marshall, Hamilton, Kent and co., 1896.

———. *Phantom Fortune.* Vol. 3. London: Maxwell, 1883.

Bradford, Clara. *Ethel's Adventures in the Doll Country.* London: Shaw, 1880.

Bray, Anna Elza Kempe Stothard. *Life of Thomas Stothard, R.A.: With Personal Reminiscences.* Vol. 1. London: Murray, 1851.

Bray, Joe. *The Portrait in Fiction of the Romantic Period.* London: Routledge, 2016.

Briggs, K. M. *The Fairies in Tradition and Literature.* London: Routledge, 1967.

Brontë, Anne. *The Tenant of Wildfell Hall.* Reprint. New York: Harper and Brothers, 1858.

Brontë, Branwell. *The Works of Patrick Branwell Brontë, Vol. I: 1827–1833.* Edited by Victor A. Neufeldt. London: Routledge, 1997.

Brontë, Charlotte. *An Edition of the Early Writings of Charlotte Brontë, Vol. I: The Glass Town Saga 1826–1832.* Edited by Christine Alexander. Oxford: Shakespeare's Head Press, 1987.

———. *Jane Eyre.* Reprint. Peterborough, Ont.: Broadview, 1999.

———. *The Professor: A Tale.* Vol. 1. London: Smith, Elder and co, 1857.

Brontë, Charlotte, Branwell Brontë, Emily Brontë, and Anne Brontë. *Tales of Glass Town, Angria, and Gondal: Selected Early Writings.* Edited by Christine Alexander. Oxford: Oxford University Press, 2010.

Brown, Bill. "Thing Theory." *Critical Inquiry* 28, no. 1 (2001): 1–22.

Brown, Gillian. "The Metamorphic Book: Children's Print Culture in the Eighteenth Century." *Eighteenth-Century Studies* 39, no. 3 (2006): 351–362.

Browne, Annabella Maria. *Live Dolls: A Tale for Children of All Ages.* London: Partridge and Co., 1874.

Bryce, David. "David Bryce & Sons." *The News-Letter of the LXIVMos* 12 (Nov. 15, 1928): 1–2.

Buckley, Arabella. *The Fairyland of Science.* London: Stanford, 1879.

———. *Through Magic Glasses: A Sequel to the Fairyland of Science.* New York: D. Appleton, 1907.

Burlington Arts Club Exhibition of Portrait Miniatures. London: Burlington Arts Club, 1889.

Burnett, Francis Hodgson. *The One I Knew the Best of All: A Memory of the Mind of a Child.* New York: Charles Scribner, 1893.

The Cabinet of Curiosities, or, Wonders of the World Displayed, forming a repository of whatever is remarkable in the regions of nature and art, extraordinary events, and eccentric biography. London: J. Limbird, 1824.

The Cabinet of Lilliput: Stored with Information and Delight. London: J. Harris, 1802.

Campbell, Charles H. "Doll Philosophy." *Chambers's Journal of Popular Literature, Science, and Art,* 4th ser. 933 (Nov. 12, 1881): 721–723.

Carlyle, Thomas, *Reminiscences.* Vol. 1. Edited by Charles Eliot Norton. London: Macmillan and Co., 1887.

Carpenter, William. *Address of William B. Carpenter, M.D., LL.D., F.R.S., Registrar of the University of London.* London: Taylor and Francis, 1875.

———. *The Microscope: and its Revelations.* London: Churchill, 1856.

Carroll, Lewis. *Alice's Adventures in Wonderland and Through the Looking-Glass.* Reprint. New York: Modern Library, 2002.

———. *Lewis Carroll's Diaries: The Private Journals of Charles Lutwidge Dodgson (Lewis Carroll).* Vol. 3. Edited by Edward Wakeling. Luton: Lewis Carroll Society, 1995.

———. *Sylvie and Bruno.* London: Macmillan and Co., 1889.

Catlow, Agnes. *Drops of Water: Their marvelous and beautiful inhabitants displayed by the microscope.* London: Reeve and Benham, 1851.

Cavendish, Margaret. "Of small Creatures; such as we call Fairies." In *Poems and Fancies.* London: Martin and Allestrye, 1653.

Charles, J. F. *Where is Fairyland?: Tales of Everywhere and Nowhere.* London: Low, 1892.

Chatelain, Clara [Mme.] de. *The Lilliputian Library.* London: Joseph Meyers and co., ca. 1861.

"Children's Playthings." *Chambers's Journal of Popular Literature, Science, and Art* 6 (1856): 261–262.

The Child's Bible. With Plates. Philadelphia: Fisher, 1834.

"Christmas Toys." *Household Words* 12 (Jan. 5, 1856), 550–552.

Clark, Timothy. "Scale." In *Telemorphosis: Theory in the Age of Climate Change*, vol. 1, edited by Tom Cohen, 148–166. Ann Arbor, MI: Open Humanities Press, 2012.

Clarke, Edward M. *Direction for using Philosophical Apparatus in Private Research and Public Exhibitions.* London: Clark, 1842.

Clarke, Michael Tavel, and David Wittenberg, Introduction to *Scale in Literature and Culture*, edited by Michael Tavel Clarke and David Wittenberg, 1–32. Geocriticism and Spatial Literary Studies series. London: Palgrave Macmillan, 2017.

Clericus. "M. Daguerre's Discovery." *The Times* (February 21, 1839), *The Daguerreotype: An Archive of Source Texts, Graphics, and Ephemera.* Edited by Gary W. Ewer. Web.

Cohen, Deborah. *Household Gods: The British and Their Possessions.* New Haven, CT: Yale University Press, 2009.

Coleridge, Christabel R. *Charlotte Mary Yonge: Her Life and Letters.* London: Macmillan and Co., 1903.

Colgate & Co. Calendar—1883. New York: Colgate, 1882.

"The Collection of Miniatures at South Kensington." *The Art Journal*, n.s. 4 (1865): 216.

Collins, Wilkie. *After Dark*. Reprint. London: Smith, Elder and Co, 1870.

———. *Armadale*. Reprint. London: Penguin, 1995.

———. *Basil*. Reprint. New York: Harper and Brothers, 1874.

———. *The Evil Genius: A Domestic Story*. Vol. 1. Leipzig: Tauchnitz, 1886.

———. *The Legacy of Cain*. Reprint. London: Chatto and Windus, 1906.

———. *The Woman in White*. Vol. 1. Leipzig: Tauchnitz, 1860.

Coltman, Viccy. "Sojourning Scots and the Portrait Miniature in Colonial India, 1770s–1780s." *Journal for Eighteenth-Century Studies* 40, no. 3 (2017): 421–441.

Connor, Steven. "Thinking Things." *Textual Practice* 24, no. 1 (2010): 1–20.

Cooke, Mordecai Cubitt. *One Thousand Objects for the Microscope*. London: Warne, 1869.

Cooper-Hewitt Museum, *Miniatures*. Washington, DC: Smithsonian, 1983.

"Correct Likeness—Only a Shilling!" *The Leisure Hour* 8, no. 308 (August 11, 1859): 508–510.

The Council of Four, *The Royal Academy Review. A Guide to the Exhibition of the Royal Academy of Arts, 1858. containing original, critical and descriptive notices of upwards of 200 works of art*. London: Thomas F. A. Day, 1858.

Croft, William J. *Under the Microscope: A Brief History Of Microscopy*. Hackensack, NJ: World Scientific. 2006.

Dahl, Edward H., and Jean-François Gauvin, *Sphaerae Mundi: Early Globes at the Stewart Museum*. Montreal: McGill-Queen's University Press, 2000.

Daly, Susannah. *The Empire Inside: Indian Commodities in Victorian Domestic Novels*. Ann Arbor: University of Michigan Press, 2011.

Darwin, Charles. *On the origin of species by means of natural selection, or the preservation of favoured faces in the struggle for life*. London: John Murray, 1859.

Daston, Lorraine, and Peter Galison. *Objectivity*. Brooklyn, NY: Zone Books, 2007.

Davis, Tracy C. "What Are Fairies For?" In *The Performing Century: Nineteenth-Century Theatre's History*, edited by Tracy C. Davis and Peter Holland, 32–59. Basingstoke: Palgrave Macmillan, 2007.

Day, Charles William. *The Art of Miniature Painting, containing instructions necessary for the acquirement of that art*. London: Winsor and Newton, 1852.

De Vinne, Theo L. "Microscopic Types." *The Inland Printer* 4 (December 1886): 137–138.

The Diamond Gazetteer of Great Britain and Ireland: Comprising a Compendious account of the countries, cities, boroughs, towns, capes and forts, rivers, lakes, harbours, seaports, canals, railroads, public institutions, etc. etc. 2nd ed. Glasgow: Blackie and Son, and Smith and Son, 1832.

Dick, Thomas. *The Atmosphere and Atmospherical Phenomenon: The Telescope and Microscope.* London: Religious Tract Society, 1851.

Dickens, Charles. *Bleak House.* Reprint. London: Penguin, 2003.

———. *Dombey and Son.* Reprint. London: Penguin, 2002.

———. *Martin Chuzzlewit.* Reprint. Oxford: Oxford World Classics, 2009.

———. *Nicholas Nickleby.* Reprint. London: Penguin, 2003.

———. *The Old Curiosity Shop.* Reprint. London: Penguin, 2000.

———. *Oliver Twist.* Reprint. London: Penguin, 2002.

———. "The Poor Relation's Story." In *Some Short Christmas Stories.* Reprint. New York: Stringer and Townsend, 1853.

———. *Sketches by Boz.* Reprint. London: Penguin, 1995.

———. *The Uncommercial Traveller.* Reprint. London: Chapman and Hall, 1861.

Didot, Henri. "Dedication." In *Maximes et Réflexions Morales,* by Rochefoucauld. Paris: Didot le jeune, 1827.

"Dolls." *Chambers's Journal of Popular Literature, Science, and Art* 5, no. 216 (February 18, 1888), 97–99.

"Dolls." *Household Words* 7 (June 11, 1853): 352–356.

"Dolls and Dollhouses." In *The Young Lady's Book: A Manual of Amusements, Exercises, Studies, and Pursuits,* edited by Mrs. Henry Mackarness. 4th edition. London: Routledge and Sons, 1888.

The Doll's Library. London: Marshall, ca. 1800.

Doyle, Arthur Conan. *The Coming of the Fairies.* New York: Doran, 1922.

———. *How Watson Learned the Trick.* Somerville, MA: Candlewick, 2015.

Doyle, Richard, illustrator. *In Fairy Land. A Series of Pictures from the Elf-World,* by William Allingham. London: Longmans, 1870.

"A Drop of Thames Water." *Punch* (1850), 188.

Duff, James [2nd Earl of Fife]. *Catalogue of the Portraits and Pictures in the Different Houses belonging to the Earl of Fife.* N.p., 1798.

Eagles, John. "The Natural in Art." *Blackwood's Edinburgh Magazine* 51 (April 1842): 435–444.

The Earth and Its Inhabitants. Nuremberg, ca. 1820.

Eastlake, Elizabeth. "Photography." *The London Quarterly Review,* no. 101 (April 1857): 442–468.

"Echoes from the Club." *Hardwicke's Science-Gossip: An Illustrated Medium of Interchange and Gossip for Students and Lovers of Nature* 1 (October 1, 1867): 231–232.

Edgeworth, Maria. *Helen.* Vol. 2. Philadelphia: Carey, Lea and Blanchard, 1834.

Eliot, George. *Adam Bede.* Reprint. London: Penguin, 2008.

———. *Middlemarch.* Reprint. Oxford: Oxford University Press, 2008.

————. *The Mill on the Floss*. Reprint. London: Penguin, 2003.

————. "Mr. Gilful's Love Story." In *Scenes of Clerical Life*. Reprint. London: Penguin, 1998.

Elliot, Kamilla. *Portraiture and British Gothic Fiction: The Rise of Picture Identification, 1764–1835*. Baltimore, MD: Johns Hopkins University Press, 2012.

Ellis, T. Mullett. *The Fairies' Favourite, or the Story of Queen Victoria told for Children*. London: Ash Partners, 1897.

"The English Bijou Almanac." *Bent's Literary Advertiser* 381 (November 10, 1836): 131.

"The English Bijou Almanac for 1837." *The Gentleman's Magazine* 161 (February 1837): 188.

"The English Bijou Almanack. 1837." *The Metropolitan* 45 (1837): 45.

"The English Bijou Almanack." *The Mirror of Literature, Amusement and Instruction* 27 (1836): 95.

Erchinger, Philipp. *Artful Experiments: Ways of Knowing in Victorian Literature and Culture*. Edinburgh: Edinburgh University Press, 2018.

Ewing, Juliana Horatia. *Dolls Housekeeping*. London: Society for Promoting Christian Knowledge, 1884.

Exhibition of Art Treasures of the United Kingdom, Held in Manchester in 1857. Report of the Executive Committee. Manchester: George Simms, 1859.

"Fair Play for Photography." *Punch, or the London Charivari* 40 (June 1, 1861): 221.

"The Fairies." *Sharpe's London Magazine: A Journal of Entertainment and Instruction for General Readers* 2 (1846): 254–256.

The Fairy Annual, Edited by Robin Goodfellow, Attendant Sprite to their Majesties Oberon and Titania. London: Robins, 1838.

Ferguson, Niall. *Empire: How Britain Made the Modern World*. London: Penguin, 2012.

Ford, Brian J. "The Royal Society and the Microscope." *Notes and Records of the Royal Society of London* 55, no. 1 (January 2001): 29–49.

"Foreign Correspondence." *The Athenaeum*, no. 587 (Jan. 26, 1839): 69.

Foskett, Daphne. *British Portrait Miniatures: A History*. London: Methuen, 1963.

Fougasse [Cyril Kenneth Bird]. *J. Smith*. Reprint. London: Walker Books, 2012.

Fourth Report of the Quekett Club and List of Members. London, July 1869.

Freedgood, Elaine. *The Ideas in Things: Fugitive Meaning in the Victorian Novel*. University of Chicago Press, 2006.

French Miniature Bookcase. Paris: Pairault, 1896.

Freud, Sigmund. "The Uncanny." In *The Standard Edition of the Complete Psychological Works of Sigmund Freud*, edited and translated by James Strachey. Vol. 17. London: Hogarth Press, 1999.

Fromer, Julie. *A Necessary Luxury: Tea in Victorian England.* Athens: Ohio University Press, 2008.

Fumerton, Patricia. *Cultural Aesthetics: Renaissance Literature and the Practice of Social Ornament.* Chicago: University of Chicago Press, 1993.

Galileo a Madama Cristina di Lorena (1615). Padua: Tipogr. Salmin, 1896.

Gaskell, Elizabeth. *Cranford.* Reprint. Oxford: Oxford University Press, 2011.

———. "My Lady Ludlow." Reprinted in *Round the Sofa.* Vol. 1. London: Sampson Low, Son and Co., 1859.

———. *The Life of Charlotte Brontë.* Reprint. London: Penguin, 1997.

———. *Wives and Daughters.* Reprint. London: Penguin, 2003.

Gere, Charlotte. "In Fairyland." In *Victorian Fairy Painting,* edited by Jane Martineau. 62–73. London: Royal Academy of Arts, 1997.

Gibson-Graham, J. K. "Beyond Global vs. Local: Economic Politics Outside a Binary Frame." In *Geographies of Power: Placing Scale,* edited by Andrew Herod and Melissa W. Wright, 25–60. John Wiley and Sons, 2002.

Gosse, Philip Henry. *Evenings at the Microscope; or, Researches among the minuter organs and forms of animal life.* London: Society for Promoting Christian Knowledge, 1859.

———. *The Romance of Natural History.* 2nd ed. London: Nisbet, 1861.

Gourand, Julie. *Memoirs of a Doll, Written by Herself: A New Year's Gift.* Adapted by Jane Besset. 2nd ed. London: Routledge, 1856.

Greenaway, Kate. *Kate Greenaway's Alphabet.* London: Routledge, 1885.

Green-Lewis, Jennifer. *Victorian Photography, Literature, and the Invention of Modern Memory.* London: Bloomsbury, 2017.

Grenby, Matthew Orby. *The Child Reader, 1700–1840.* Cambridge: Cambridge University Press, 2011.

Grolier Club. *A Short List of Microscopic Books in the Library of the Grolier Club mostly presented by Samuel P. Avery.* New York: Grolier, 1911.

Grootenboer, Hanneke. *Treasuring the Gaze: Intimate Vision in Late Eighteenth-Century Eye Miniatures.* Chicago: University of Chicago Press, 2012.

Groth, Helen. *Victorian Photography and Literary Nostalgia.* Oxford: Oxford University Press, 2013.

Gubar, Marah. "Innocence." In *Keywords for Children's Literature,* edited by Philip Nel and Lissa Paul, 121–127. New York: NYU Press, 2011.

Hall, Basil. *Patchwork.* 2nd ed. Vol. 3. London: Moxon, 1841.

Hamlin, Christopher. *A Science of Impurity: Water Analysis in Nineteenth Century Britain.* Berkeley: University of California Press, 1990.

Hardy, Thomas. *Desperate Remedies.* Reprint. London: Ward and Downey, 1889.

Harvey, James Clarence. "Modern Miniature Painting." *Munsey's Magazine* 12 (1894–1895): 295–303.

Hassall, Arthur Hill. *A Microscopical Examination of the Water supplied to the Inhabitants of London and Suburban Districts*. London: Highley, 1850.

Hawthorne, Nathaniel. *The House of Seven Gables: A Romance*. Boston: Ticknor, Reed, and Fields, 1851.

Hazeltine's Pocket-Book Almanac for 1885. 7th ser. Warren, PA: Hazeltine, 1884.

Henisch, Heinz K., and Bridge Ann Henisch. *The Painted Photograph, 1839–1914: Origins, Techniques, Aspirations*. University Park: Penn State University Press, 1996.

Hill, John. *An History of Animals, Containing Descriptions of the Birds, Beasts, Fishes, and Insects, of the Several Parts of the World; and Including Accounts of the several Classes of Animalcules, visible only by the Assistance of Microscopes*. London: Osborne, 1752.

An History of the Bible and Apocraphy Versified and Adorned with Cuts. N.p.: n.p., 1805.

Hobson, Julian. "Baccillaria Paradoxa." *Hardwicke's Science-Gossip* (June 1, 1869), 139.

Hogg, Jabez. *The Microscope, Its History, Construction and Applications. Being a familiar introduction to the use of the instrument and The Study of Microscopical Science*. London: Illustrated London Library, 1854.

Holland, Major. "Prehensile Antennae of the Entomostraca." *Hardwicke's Science-Gossip* (June 1, 1869), 127–129.

Holloway, Sally. *The Game of Love in Georgian England: Courtship, Emotions, and Material Culture*. Oxford: Oxford University Press, 2019.

The Holy Bible, Containing the Old and New Testaments, Translated out of the original tongue: and with the former Translations Diligently Compared and Revised by his Majesty's Special Command. Glasgow: Bryce, 1901.

Hood, Edwin Paxton. *Self-Formation: Twelve Chapters for Young Thinkers*. 3rd ed. London, Judd and Glass, 1858.

Hood, Thomas. "Queen Mab." Reprinted in *The Works of Thomas Hood*, edited by T. Hood and F. F. Broderip, vol. 6. London: Ward, Lock and Co., 1882.

Hooke, Robert. *Micrographia*. London: Martyn and Allestry, 1665.

Horne, Richard H. *Memoirs of a London Doll*. Boston: Tickner, Reed, and Fields, 1852.

Ibsen, Henrik. *Nora; or A Doll's House*. Translated by Henrietta Francis Lord. London: Farran, 1890.

The Infant's Cabinet of the Cries of London. London: Marshall, ca. 1807.

The Infant's Library. London: Marshall, 1800.

Ingelow, Jean. *Mopsa the Fairy*. London: Longmans, Green, 1869.

International Guild of Miniature Artisans. "Guidelines for Artisan Membership Application 2019." International Guild of Miniature Artisans Ltd., 2019. http://www.igma.org/PDF/2019_ArtisanGuidelines.pdf.

"Jack-in-the-Pulpit." *St. Nicholas: An Illustrated Magazine for Young Folks* 16 (1889): 632–633.

Jackson, Emily. *Toys of Other Days*. London: Offices of "Country Life," 1908.

Jacyna, L. S. "Moral Fibre: The Negotiation of Microscopic Facts in Victorian Britain." *Journal of the History of Biology* 36, no. 1 (Spring 2003): 39–85.

Jaffé, Deborah. *A History of Toys: From Spinning Tops to Robots*. Stroud: Sutton, 2006.

James, Henry. "The Aspern Papers." Reprinted in *The Aspern Papers, Louisa Pallant, The Modern Warning*. London: Macmillan and Co., 1888.

Janes, Edmund S. *Miniature Bible with Engravings, abridged and collated*. Philadelphia, Wiatt, ca. 1851.

Johnson, Dale T. *American Portrait Miniatures in the Manney Collection*. New York: Metropolitan Museum of Art, 1990.

Jones, Thomas Rymer. *The Natural History of Animals*. London: Van Voorst, 1852.

Josephson-Storm, Jason A. *The Myth of Disenchantment: Magic, Modernity, and the Birth of the Human Sciences*. Chicago: University of Chicago Press, 2017.

The Juvenile Bible. London: Bush, ca. 1819.

"Juvenile Theatricals." *Chambers's Journal of Popular Literature, Science and Arts*, no. 330 (April 28, 1860): 307–309.

Keightley, Thomas. *The Fairy Mythology: Illustrative of the Romance and Superstition of Various Countries*. 2nd ed. London: Bohn, 1850.

Kelly, Catherine E. *Republic of Taste: Art, Politics, and Everyday Life in Early America*. Philadelphia: University of Pennsylvania Press, 2016.

Kemble, Frances Ann. *Records of a Girlhood*. 2nd ed. New York: Holt, 1883.

Kendall, May, and Andrew Lang. *That Very Mab*. London: Longmans, 1885.

Kendrick, Emma Eleanora. *Conversations on the Art of Miniature Painting*. London: Lloyd and Co., 1830.

Kennedy, Meegan. "'Throes and struggles ... witnessed with painful distinctness': The oxy-hydrogen microscope, performing science, and the projection of the moving image." *Victorian Studies* 62, no. 1 (Autumn 2019): 85–118.

Kilburn, William Edward. "Photographic Miniatures." *The Atheneum* 1012 (March 20, 1847): 298.

Kingsley, Charles. "How to Study Natural History." Reprinted in *Scientific Lectures and Essays*, 289–310. London: Macmillan, 1880.

———. *Madam How and Lady Why, or, First lessons in earth lore for children*. Reprint. New York: The Macmillan Company, 1901.

———. *The Water-Babies: A Fairy-Land Tale of Science*. Reprint. London: Macmillan and Co., 1880.

Kipling, Rudyard. *Puck of Pook's Hill.* New York: Doubleday, Page and Co., 1906.

Klemann, Heather. "The Matter of Moral Education: Locke, Newbery, and the Didactic Book-Toy Hybrid." *Eighteenth-Century Studies* 44, no. 2 (Winter 2011): 223–244.

Koopman, Harry Lyman. "Miniature Books." *The Printing Art* 30, no. 3 (November 1917), 161–165.

Korkow, Cory. *British Portrait Miniatures: The Cleveland Museum of Art.* London: D. Giles Limited, 2013.

Kuznets, Lois. *When Toys Come Alive: Narratives of Animation, Metamorphosis, and Development.* New Haven, CT: Yale University Press, 1994.

La Lanterne Magique. Paris: Marcilly, ca. 1925.

Lamb, Charles. "Detached Thoughts on Books and Reading." In *Elia: Essays which Have Appeared Under that Signature in the London Magazine.* 2nd ser. Philadelphia: Carey, Lea, and Carey, 1828.

Lambton, Lucinda. *The Queen's Dolls' House.* London: Royal Collection, 2010.

Landon, Letitia Elizabeth. *The English Bijou Almanack for 1837.* London: Schloss, 1836.

———. *The English Bijou Almanac of 1838.* London: Schloss, 1837.

———. *The English Bijou Almanac of 1839.* London: Schloss, 1838.

Lang, Andrew. Introduction to *The Secret Commonwealth of Elves, Fauns, and Fairies: A Study in Folk-Lore and Psychical Research,* by Robert Kirk, i–lxv. London: Nutt, 1893.

Lankester, Edwin. *Half-hours with the microscope: being a popular guide to the use of the microscope as a means of amusement and instruction.* 2nd ed. London: Hardwicke, 1860.

Latham, Minor White. *The Elizabethan Fairies: The Fairies of Folklore and the Fairies of Shakespeare.* New York: Columbia University Press, 1930.

Levine, George. *Darwin Loves You: Natural Selection and the Reenchantment of the World.* Princeton, NJ: Princeton University Press, 2008.

Lewes, George Henry. *Studies in Animal Life.* London: Smith, Elder and Co., 1862.

Lightman, Bernard. "The Microscopic World." *Victorian Review* 36, no. 2 (Fall 2010): 46–49.

The Little Gazetteer or, Universal Geographical Dictionary in Miniature. London: Maunder, ca. 1845.

The Little Linguist; or, A Complete Guide to English Philology. London: Maunder, 1847.

Long, Helen. *Victorian Houses and Their Details: The Role of Publications in Their Building and Decoration.* Oxford: Architectural Press, 2002.

Luckhurst, Roger, and Josephine McDonagh. "Introduction: 'Encounter Science.'" In *Transactions and Encounters: Science and Culture in the Nineteenth Century,*

edited by Roger Luckhurst and Josephine McDonagh, 1–15. Manchester: Manchester University Press, 2002.

MacDonald, George. *At the Back of the North Wind*. Reprint. Peterborough, Ont.: Broadview, 2011.

———. *Lilith: A Romance*. Reprint. Mineola, NY: Dover, 2008.

Mack, John. *The Art of Small Things*. Cambridge, MA: Harvard University Press, 2007.

Macleod of Skye. "Microscopical Research." *Hardwicke's Science-Gossip* 1 (October 1, 1869): 230–231.

MacRitchie, David. *Fians, Fairies and Picts*. London: Paul, 1893.

Maitland, Julia Charlotte. *The Doll and Her Friends, or Memoirs of the Lady Seraphina*. 5th ed. London: Griffith and Farran, 1863.

Mansion, L. [André Léon Larue]. *Letters upon the Art of Miniature Painting*. London: Ackermann, 1823.

Mantell, Gideon Algernon. *Thoughts on Animalcules; or, A Glimpse of the Invisible World Revealed by the Microscope*. New edition. London: Murray, 1850.

Marcus, Sharon. *Between Women: Friendship, Desire, and Marriage in Victorian England*. Princeton, NJ: Princeton University Press, 2007.

Martyn, Lily. *Princess and Fairy; or the Wonders of Nature*. London: Chambers, 1899.

McPherson, J. Gordon. *The Fairyland Tales of Science*. 2nd ed. London: Simpkin, 1891.

Meredith, George. *Celt and Saxon*. Reprint. New York: Scribner, 1916.

———. *The Ordeal of Richard Feverel: A History of Father and Son*. Vol. 2. London: Chapman and Hall, 1859.

Merrill, Lynn L. *The Romance of Victorian Natural History*. New York: Oxford University Press, 1989.

Meynell, Alice. *Childhood*. New York: Dutton and Company, 1913.

Michals, Teresa. *Books for Children, Books for Adults: Age and the Novel from Defoe to James*. Cambridge: Cambridge University Press, 2014.

"Microscopical Research." Reprint. *Hardwicke's Science-Gossip: An Illustrated Medium of Interchange and Gossip for Students and Lovers of Nature* 1 (August 1, 1869): 177–178.

Mill, Jane. "How we Furnished our Dollhouse." *Sunshine*, nos. 170 and 173–177 (February and May–September 1876): 22, 80, 85–87, 110–111, 126–128, 142–143.

"Miniature." In *Arts and Sciences or Fourth Division of "the English Cyclopaedia,"* edited by Charles Knight, 5:666–669. London: Brabury, Evans, and Co., 1867.

A Miniature Historic Library. London: Darton, Harvey and Co., 1810–1825.

A Miniature of the Holy Bible, being a Brief of the Books of the Old and New Testaments. Boston: Sherburne, ca. 1837.

Mister, Mary. *The Adventures of a Doll, Compiled with the Hope of Affording Amusement and Instruction.* London: Darton, Harvey, and Darton, 1816.

The Mite. Grimsby: Robinson, 1891.

Morgan, Benjamin. *The Outward Mind: Materialist Aesthetics in Victorian Literature and Culture.* Chicago: University of Chicago Press, 2017.

Morus, Iwan Rhys. "'More the Aspect of Magic Than Anything Natural': The Philosophy of Demonstration." In *Science in the Marketplace: Nineteenth-Century Sites and Experiences,* edited by Aileen Fyfe and Bernard V. Lightman, 336–370. Chicago: University of Chicago Press, 2007.

———. "Worlds of Wonder: Sensation and the Victorian Scientific Performance." *Isis* 101, no. 4 (December 2010): 806–816.

Moseley-Christian, Michelle. "Seventeenth-Century *Pronk Poppenhuisen:* Domestic Space and the Ritual Function of Dutch Dollhouses for Women." *Home Cultures* 7, no. 3 (2010): 341–363.

Moseley, Henry. "Report for the Year 1854, on the Church of England Training Schools for Schoolmasters." In *Minutes of the Committee of Council on Education; Correspondence, Financial Statements &c. and Reports by Her Majesty's Inspectors of Schools 1854–5,* 275–318. London: Eyre and Spottiswoode, 1855.

"Mrs. Bray's Life of Stothard," *Littell's Living Age* (Feb. 14, 1852), 318–320.

Muller, Max. "Comparative Mythology." In *Chips from a German Workshop* (1856). 2nd ed. London: Longmans, 1868.

Murray, Charles O., illustrator. *Merry Elves or, Little Adventures in Fairyland.* London: Seeley, 1874.

My Tiny Alphabet Book. Glasgow: Bryce, ca. 1900.

N., W.M. "Miniature Painting." *The Mercenberg Review* (1849), 222–228.

Nesbit, Edith. "My School Days." Reprinted in *Records of Girlhood, Volume Two: An Anthology of Nineteenth-Century Women's Childhoods.* Edited by Valerie Sanders. Farnham: Ashgate, 2012.

New Hints, by an old Professor, on Miniature Painting. London: Ackermann and Co., 1837.

"Notes." *The Photographic News: A Weekly Record of the Progress of Photography* 28 (August 8, 1884): 504–506.

Novak, Daniel A. *Realism, Photography and Nineteenth-Century Fiction.* Cambridge Studies in Literature and Culture. Cambridge: Cambridge University Press, 2008.

O'Brien, Fitz James. "The Diamond Lens." *The Atlantic Monthly: A Magazine of Literature, Art, and Politics* (January 1858), 354–367.

"Odd Notions and Old Ones." *All the Year Round* 13 (May 27, 1865): 418–421.

The Nursery Library. London: Routledge and Sons, ca. 1865–1869.

P., J. "Microscopes and How to Use Them." *The Cultivator and Country Gentleman* 27 (June 7, 1866), 370.

"Painting Microscopic Slides." *Popular Science News* 20, no. 8 (August 1886), 108.

Pardoe, Julia. *Lady Arabella, or, The Adventures of a Doll.* London: Kerby and Son, 1856.

Parsey, Arthur, *The Art of Miniature Painting on Ivory.* London: Longman, Rees, Orme, Brown, and Green, 1831.

Pascoe, Judith. "Tiny Tomes." *The American Scholar* 75, no. 3 (2006): 133–138.

"The Photographic or Daguerreotype Miniatures." In *The Times* (May 24, 1841), *The Daguerreotype: An Archive of Source Texts, Graphics, and Ephemera,* edited by Gary W. Ewer. Web.

"Playthings." *Household Words* 6 (January 15, 1853): 430–432.

Plotz, John, *Portable Property: Victorian Culture on the Move.* Princeton, NJ: Princeton University Press, 2011.

The Pocket Bible, for Little Masters and Misses. Birmingham: Russell, ca. 1817–1829.

Pointon, Marcia. "'Surrounded with Brilliants': Miniature Portraits in Eighteenth-Century England." *The Art Bulletin* 83, no. 1 (March 2001): 48–71.

"Popular Toys." *Every Saturday* 1, no. 6 (February 10, 1866): 149–151. Reprinted from the *London Review.*

"Portraits, Busts and Statues." *Frasier's Magazine* 51 (June 1855): 703.

Pope, Alexander. *The Rape of the Lock, an Heroi-comical Poem. In Five Cantos.* London: Bernard Lintott, 1714.

Propert, J. Lumsden. "The English School of Miniature Art. With Special Reference to the Exhibition at the Burlington Fine Arts Club. From the Origin to Sir Antonio More." *Magazine of Art* 14 (1891): 7–11.

———. *A History of Miniature Art, with Notes on Collectors and Collecting.* London, Macmillan and Co., 1887.

———. Introduction to *Burlington Arts Club Exhibition of Portrait Miniatures,* v–lxvii. London: Burlington Arts Club, 1889.

Purkiss, Diane. *At The Bottom of the Garden: A Dark History of Fairies, Hobgoblins, and Other Troublesome Things.* New York: New York University Press, 2000.

Queen, James W. and Co. *Priced and Illustrated Catalogue of Optical Instruments, Made, Imported and Sold, wholesale and retail.* Philadelphia: n.p., 1870.

Quekett, John. *Practical Treatise on the Use of the Microscope.* Library of Illustrated Standard Scientific Works. London: Bailliere, 1848.

R., H.C. "A Struggle for Life." *Hardwicke's Science-Gossip* (April 1, 1868), 91.

Rabb, Melinda Alliker. "Johnson, Lilliput, and the Eighteenth-Century Miniature." *Eighteenth-Century Studies* 46, no. 2 (2013): 281–298.

―――. *Miniature and the English Imagination: Literature, Cognition, and Small-Scale Culture, 1650–1765*. Cambridge: Cambridge University Press, 2019.

Rands, William Brighty. *Lilliput Lectures*. London: Strahan, 1872.

―――. *Lilliput Legends*. London: Strahan, 1871.

―――. *Lilliput Levee: Poems of Childhood, Child-fancy and Child-like Moods*. London: Strahan, 1867.

―――. *Lilliput Revels*. London: Strahan, 1871.

Ratcliffe, Marc J. *The Quest for the Invisible: Microscopy in the Enlightenment*. Farnham: Ashgate, 2009.

Reade, J. B. "Microscopic Test Objects under Parallel Light and Corrected Powers." *Popular Science Review* 9 (1870): 138–148.

Redgrave, Samuel. "Introductory Notice." In *Catalogue of the special exhibition of portrait miniatures on loan at the South Kensington museum*. London: Whittingham and Wilkins, 1865.

Remington, Vanessa. *Victorian Portrait Miniatures in the Collection of Her Majesty the Queen*. 2 vols. Royal Collections. London, 2010.

Reports on the Paris Universal Exhibition, 1867. Vol. 3. London: Eyre and Spottiswoode, 1868.

Reynolds, Graham. *British Portrait Miniatures*. Cambridge: Cambridge University Press, 1998.

―――. *English Portrait Miniatures*. Cambridge: Cambridge University Press, 1988.

"Richard Cosway—the Macaroni Miniature Painter." *The Art Amateur* 8 (January 1, 1883): 38.

Ricks, Christopher. *Tennyson*. 2nd ed. London: Palgrave Macmillan, 1989.

Roberts, George E. *Book for Fairies*. Kidderminster: Friend, 1860.

Robertson, Andrew. *Letters and Papers of Andrew Robertson, A.M., miniature painter to his late Royal Highness the Duke of Sussex; Also A Treatise on the Art by his eldest brother Archibald Robertson, of New York*. Edited by Emily Robertson. London: Eyre and Spottiswoode, ca. 1895.

Roscoe, Sydney. "Early English, Scottish and Irish Thumb Bibles." *The Book Collector* 22 (1973): 189–207.

Rosser, William Henry. *The Bijou Gazetteer of the World*. London: Warne, 1871.

Rovee, Christopher. *Imagining the Gallery: The Social Body of British Romanticism*. Stanford, CA: Stanford University Press, 2006.

"The Royal Academy: The Eightieth Exhibition 1848." *The Art Journal* 10 (June 1, 1848): 165–180.

"The Royal Academy: The Eighty-Second Exhibition—1850." *The Art Journal* 12 (June 1, 1850): 165–178.

"The Royal Academy: The Eighty-Third Exhibition 1851." *The Art Journal* 13 (July 1, 1851): 153–162.

Royal Collections. "Queen Mary's Dollhouse." *The Royal Collections Trust.* https://www.rct.uk/collection/themes/trails/queen-marys-dolls-house (accessed September 1, 2019).

Ruskin, John. "Fairy Land." Reprinted in *The Art of England: Lectures given in Oxford*, 81–107. New York: Wiley and Sons, 1884.

Russell, Gilbert. *The Art of Miniature Painting in Oil, on Ivory etc.* London: n.p., 1855.

Sala, George Augustus, and William Henry Wills. "Fairyland in 'Fifty-Four." *Household Words* 8, no. 193 (December 3, 1853): 313–325.

Sale, William. *Samuel Richardson: Master Printer.* Ithaca, NY: Cornell University Press, 1950.

Saler, Michael. *As If: Modern Enchantment and the Literary Prehistory of Virtual Reality.* Oxford: Oxford University Press, 2012.

Schickore, Jutta. *The Microscope and the Eye: A History of Reflections 1740–1870.* Chicago: University of Chicago Press, 2007.

Schor, Naomi. *Reading in Detail: Aesthetics and the Feminine.* Abingdon: Routledge, 2007.

Schülting, Sabine. *Dirt in Victorian Literature and Culture.* New York: Routledge, 2016.

Seibold-Buitmann, Ursula. "Monster Soup: The Microscope and Victorian Fantasy." *Interdisciplinary Science Reviews* 25, no. 3 (2013): 211–219.

Shakespeare, William. "A Midsummer Night's Dream." In *The Riverside Shakespeare.* Edited by G. Blakemore Evans. Boston: Houghton, 1974.

———. "Romeo and Juliet." In *The Riverside Shakespeare.* Edited by G. Blakemore Evans. Boston: Houghton, 1974.

Shee, Martin Archer. *Rhymes on Art; or, The Remonstrance of a Painter.* 2nd ed. London: Murray, 1805.

Shelley, Mary. *Frankenstein: The 1818 Text.* Oxford: Oxford University Press, 2008.

———. "Matilda." In *Mary* and *Maria; Matilda,* by Mary Wollstonecraft and Mary Shelley. London: Penguin, 1992.

Sheringham, H. T. "A Library in Miniature. Part I. Books of the Sixteenth and Seventeenth Centuries." *The Connoisseur* 3 (August 1902): 222–228.

———. "A Library in Miniature. Part II. Books of the Eighteenth and Nineteenth Centuries." *The Connoisseur* 4 (November 1902): 166–171.

Siegel, Jonah. *Desire and Excess: The Nineteenth-Century Culture of Art.* Princeton, NJ: Princeton University Press, 2000.

Silver, Carole. *Strange and Secret Peoples: Fairies and Victorian Consciousnesses.* Oxford: Oxford University Press, 1998.

Simmel, Georg. *The Philosophy of Money.* Edited by David Frisby. Translated by Tom Bottomore and David Frisby. 2nd ed. London: Routledge, 1990.

Sinclair, Catherine. "Uncle David's Nonsensical Story about Giants and Fairies." In *A Holiday House: A series of tales.* New York: Robert Carter, 1839.

Sketch of the Life, Personal Appearance, Character, and Manners, of Charles S. Stratton: The Man in Miniature, Known as General Tom Thumb. New York: Van Norden and Amerman, 1847.

Slack, Henry J. *Marvels of Pond-Life; or A Year's Microscopic Recreations among the Polyps, Infusoria, Rotifers, Water-Bears, and Polyzoa.* London: Groombridge, 1861.

The Smallest English Dictionary in the World. Glasgow: Bryce, 1900.

"Solar Microscope." *Cabinet of Literature, Amusement, and Instruction* 2, no. 5 (August 8, 1829): 141–142.

"Some Christmas Pleasures." *Chambers's Journal of Popular Literature, Science, and Art,* 5th ser., 5, no. 260 (December 22, 1888): 801–802.

Stafford, Barbara Maria, and Frances Terpak. *Devices of Wonder: From the World in a Box to Images on a Screen.* Los Angeles, CA: Getty Research Institute, 2001.

Stern, Wilma Olch, and Danae Hadjilazaro Thimme. *Kenchreai, Eastern Port of Corinth: Results of Investigations by the University of Chicago and Indiana University for the American School of Classical Studies at Athens: IV: Ivory, Bone, and Related Wood Finds.* Leiden: Brill NV, 2007.

Sternlieb, Lisa. "Jane Eyre: 'Hazarding Confidences.'" *Nineteenth-Century Literature* 53, no. 4 (1999): 452–479.

Stewart, Susan. *On Longing: Narratives of the Gigantic, the Miniature, the Souvenir, the Collection.* Durham, NC: Duke University Press, 1993.

Stirling, Catherine Georgiana. Catherine Georgiana Stirling to John Stirling, October 1841. London: Victoria and Albert Museum. Prints & Drawings Study Room, level F, case RMC, shelf 6, box 3.

"Stothard the Artist, and the Butterfly." *The Gardeners' Chronicle and Agricultural Gazette* (June 2, 1860), 508.

Sully, James. *Children's Ways: Being Selections from the Author's 'Studies in Childhood,' with some additional matter.* New York: Appleton and Co., 1897.

Talairach-Vielmas, Laurence. *Fairy Tales, Natural History and Victorian Culture.* London: Palgrave Macmillan, 2014.

Taylor, Paul. *Dot's Diary, or Banished from Fairyland.* London: Griffith and Farran, 1883.

Temple, Crona. *Etta's Fairies: A Little Story for Little Folks.* London: Society for Promoting Christian Knowledge, 1879.

Templeton, J. S., and Alfred H. Wall. *The Guide to Miniature Painting and Colouring Photographs: with a few words on portrait painting in water colours.* London: Rowney and Co., 1867.

Tennyson, Alfred Lord. *Locksley Hall.* Boston: Ticknor and Fields, 1869.

Thackeray, William Makepeace. *The Book of Snobs.* London: Punch Office, 1848.

———. "De Juventute." Reprinted in *Roundabout Papers* from *The Works of William Makepeace Thackeray.* Vol. 24. London: Smith, Elder, and Co., 1879.

———. *The History of Samuel Titmarsh and the Great Hoggarty Diamond.* Reprint. Leipzig: Tauchnitz, 1849.

———. *The Newcomes: A History of a Most Respectable Family.* Vol. 2. London: Bradbury and Evans, 1855.

———. "Our Street." Reprinted in *The Christmas Books of Mr. M. A. Titmarsh.* London: Smith, Elder, and Co., 1869.

———. *The Paris Sketchbook of Mr. M. A. Titmarsh.* Reprint. Boston: Estesa and Lauriat, 1896.

———. *Vanity Fair.* Reprint. London: Penguin, 2001.

Tidey, Alfred. Alfred Tidey to Unknown, November 1885. London: Victoria and Albert Museum.

The Tom Thumb Pronouncing Dictionary of the English Language. London: Davidson, ca. 1850.

"Toys, Past and Present." *All the Year Round* 4, no. 96 (October 1870): 416–419.

Trachtenberg, Alan. "Seeing and Believing: Hawthorne's Reflections on the Daguerreotype in *The House of Seven Gables.*" *American Literary History* 9, no. 3 (1997): 460–481.

Treat, Mary. "The Microscope; and what I saw through it." *St. Nicholas: Scribner's Illustrated Magazine for Girls and Boys* (ed. Mary Mapes Dodge), 6 (December 1878): 116–117.

Tucker, Charlotte. *Fairy Frisket: or, Peeps at Insect Life.* London: Nelson, 1874.

———. *Fairy Know-a-bit; or, a Nutshell of Knowledge.* London: Nelson, 1866.

Tylor, Edward B. *Primitive Culture: Researches into the Development of Mythology, Philosophy, Religion, Art, and Custom.* Vol. 1. London: Murray, 1871.

Tyndall, John. *Our Invisible Friends and Foes.* London: Spottiswoode, 1893.

———. "Scientific Use of the Imagination." In *Scientific Use of the Imagination and other Essays.* London: Longmans, 1872.

"The University Extension Scheme." *The Lancet* (February 1, 1890), 272.

Vallone, Lynn. *Big and Small: A Cultural History of Extraordinary Bodies.* New Haven, CT: Yale University Press, 2018.

Varat, Deborah. "Family Life Writ Small: Eighteenth-century English Dollhouses." *Journal of Family History* 42, no. 2 (2017): 147–161.

Verbum Sempiternum. London: Beale, 1616.

Verbum Sempiternum. London: Collins, 1693.

Victoria. Queen Victoria's Journals (RA VIC/MAIN/QVJ). Royal Archives, 2012. http://qvj.chadwyck.com/marketing.do.

Victoria and Albert Museum. *Review of the Principal Acquisitions during the Year 1918.* London: Stationery Office, 1920.

Wagner, *Miniature Painting.* Philadelphia: n.p., 1876.

Waine, Andrew. "Diatoms." *Hardwicke's Science Gossip* (Jan. 1, 1867), 9–11.

Wall, Cynthia Sundberg. *The Prose of Things: Transformations of Description in the Eighteenth Century.* Chicago: University of Chicago Press, 2006.

Wallace-Dunlap, Marion, and Marion Rivett-Carnac. *Fairies, Elves and Flower Babies.* London: Duckworth, 1899.

Walton, Kendall L. *Mimesis as Make-Believe: On the Foundations of the Representational Arts.* Cambridge, MA: Harvard University Press, 1990.

Ward, Mary. *Microscope Teachings: descriptions of various objects of especial interest and beauty: adapted for microscopic observation.* London: Groombridge and Sons, 1864.

"Water Supply." *Chambers's Encyclopaedia: A Dictionary of Universal Knowledge for the People.* Vol. 10. London: Chambers, 1868.

Watts, Alaric Alexander. "A Lament for Fairies." *Household Words* (October 12, 1850), 59–60.

Wells, H. G. "Mr. Skelmersdale in Fairyland." In *Twelve Stories and a Dream.* New York: Scribner's 1909.

Welsh, Charles. "Book Advertisements in the Eighteenth Century." *Literary Collector* 4, no. 1 (April 1902): 13–16.

Welsh, Doris V. *Bibliography of Miniature Books, 1470–1965.* Cobelskill, NY: Rickard, 1989.

———. *A History of Miniature Books.* Albany, NY: Fort Orange, 1987.

West, Robert J. "On Some Microscopic Tracings of Lissajous' Curves." *The Journal of the Quekett Microscopical Club* 5 (1878–1879): 38–44.

White, T. G. "Photography Popularly Explained." *The Leisure Hour* 1465 (Jan. 24, 1880): 53–55.

Whitehead, Christopher. *The Public Art Museum in Nineteenth-Century Britain: The Development of the National Gallery.* Aldershot, UK: Ashgate, 2004.

Whitelock, Louise Clarkson. *Fly-Away Fairies and "Baby blossoms."* London: Griffith and Farran, 1882.

Whittock, Nathaniel. *The Miniature Painter's Manual, containing progressive lessons on the art of drawing and painting likenesses from life on cardboard, vellum, and ivory; with concise remarks on the delineation of character and caricature.* London: Sherwood, Gilbert, and Piper, 1844.

Williamson, George Charles. *Portrait Miniatures: From the Time of Holbein 1521 to that of Sir William Ross 1860. A Handbook for Collectors.* London: George Bell and Sons, 1897.

Wilson, Catherine. *The Invisible World: Early Modern Philosophy and the Invention of the Microscope.* Princeton, NJ: Princeton University Press, 1997.

Winnicott, D. W. *Playing and Reality* (1971). Reprint. New York: Routledge, 2005.

Winshop, George Parker. "Imposing a Thumb Bible." *The News-Letter of the LXIVMos* 8 (May 15, 1928): 2.

Winter, Andrew. "The Pencil of Nature." *People's Journal* 2 (London, November 21, 1846): 288–289. *The Daguerreotype: An Archive of Source Texts, Graphics, and Ephemera,* edited by Gary W. Ewer. Web.

Wood, John. *Common Objects of the Microscope.* London: Routledge, ca. 1861.

Wood's Pictorial Bible. London: Wood, ca. 1845.

"A Word on Toys." *Leisure Hour* (September 1, 1867): 615–618.

Wright, Bridget, and Susan Owens. "'Such wonderful method': Prince Albert and the Royal Library." In *Windsor-Coburg: Divided Estate—Common Heritage; The Collections of a Dynasty,* ed. Franz Bosbach and John R. Davis, 49–60. Munich: Saur, 2007.

Wright, Lewis. *A Popular Handbook to the Microscope.* London: The Religious Tract Society, 1895.

INDEX